Jim Dine
Drawing from the Glyptothek

Jim Dine

Drawing from the Glyptothek

Essays by
Jim Dine
Ruth E. Fine
Stephen Fleischman

Hudson Hills Press, New York
in association with
Madison Art Center, Wisconsin

First Edition

© 1993 by Madison Art Center

All rights reserved under International and Pan-American Copyright Conventions.

Published in the United States by Hudson Hills Press, Inc., Suite 1308, 230 Fifth Avenue, New York, NY 10001−7704.

Distributed in the United States, its territories and possessions, Canada, Mexico, and Central and South America by National Book Network, Inc.

Distributed in the United Kingdom and Eire by Shaunagh Heneage Distribution.

Distributed in Japan by Yohan (Western Publications Distribution Agency).

Editor and Publisher: Paul Anbinder
Copy Editor: Eve Sinaiko
Indexer: Karla J. Knight
Designer: Lorraine Ferguson
Composition: U.S. Lithograph
Manufactured in Japan by Toppan Printing Company

Library of Congress Cataloguing-in-Publication Data

Dine, Jim, 1935−
 Jim Dine : drawing from the Glyptothek / essays by Jim Dine, Ruth E. Fine, Stephen Fleischman. — 1st ed.
 p. cm.
 Exhibition catalogue.
 Includes bibliographical references and index.
 1. Dine, Jim. 1935− —Exhibitions.
 2. Glyptothek München—Exhibitions.
I. Fine, Ruth, 1941− . II. Fleischman, Stephen. III. Madison Art Center. IV. Title. V. Title: Drawing from the Glyptothek.
NC139.D56A4 1993 92-21123
741.973—dc20 CIP

ISBN: 1-55595-096-5 (alk. paper)

This volume was published on the occasion of the exhibition *Jim Dine: Drawing from the Glyptothek,* organized by the Madison Art Center, Wisconsin. Major funding for the exhibition, as well as this publication, has been provided by Nicolet Instrument Corporation, Rayovac Corporation, David and Paula Kraemer, Joseph and Deirdre Garton, and Rick and Banana Shull. Additional support has been provided by the Exhibition Initiative Fund, the Art League of the Madison Art Center, the Madison Art Center's 1992−1993 Sustaining Benefactors, and a grant from the Wisconsin Arts Board with funds from the state of Wisconsin.

Exhibition Itinerary

Madison Art Center
Madison, Wisconsin
April 17−June 13, 1993

Cincinnati Art Museum
Cincinnati, Ohio
October 23, 1993−January 2, 1994

The Contemporary Museum
Honolulu, Hawaii
April 26−June 19, 1994

The Montreal Museum of Fine Arts
Montreal, Canada
July 16−September 11, 1994

Center for the Fine Arts
Miami, Florida
October 8−December 31, 1994

All works courtesy the Pace Gallery, New York, unless otherwise indicated.

All dimensions given in inches, followed by centimeters; height precedes width; all dimensions are for paper sizes.

Photograph Credits

Unless otherwise noted, all photographs are by Bill Jacobson, New York, and are courtesy the Pace Gallery, New York.
Prudence Cuming Associates, London: pages 14 (bottom), 80−97, 112−116, 118
Nancy Dine, New York: pages 21 (bottom), 32
Hartwig Koppermann, Courtesy the Staatliche Antikensammlungen und Glyptothek, Munich: pages 9 (top), 10 (top and bottom)
Al Mozell, New York: pages 8 (bottom), 14 (top), 18, 21 (top)
Courtesy the National Gallery of Art, Washington, D.C.: page 16
Philipp Schönborn, Munich: pages 6, 11
Courtesy the Staatliche Antikensammlungen und Glyptothek, Munich: page 10 (second from top, third from top)
Michael Tropea, Chicago: page 12
Ellen Page Wilson: pages 109−111

Contents

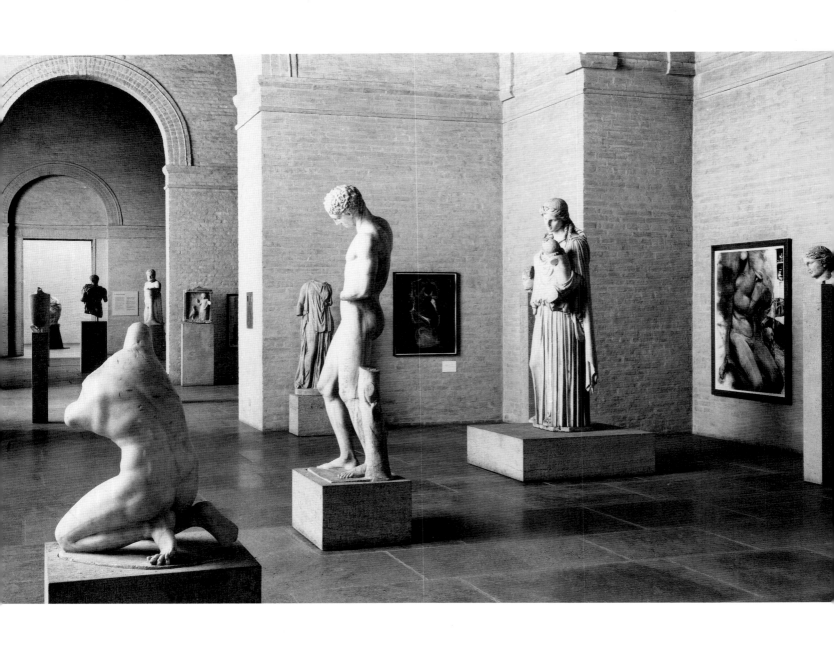

Stephen Fleischman

The Object Takes Human Form

Jim Dine entered the New York art scene in 1958, fresh from a year of graduate school at Ohio University. His early paintings, incorporating tools and other everyday objects, linked him closely with the Pop art movement of the 1960s. In some respects, the association was superficial. Dine had little interest in the object as a purely banal symbol of culture in the United States. His love of objects was never well hidden. From the beginning, his work embodied a more expressive sensibility than that of his fellow Pop artists—a more personal agenda lay beneath the surface. The object has always served Dine as a metaphor, an enigmatic personal code.

Along with that of several talented young artists with whom Dine associated in the 1960s—Jasper Johns, Robert Rauschenberg, and Claes Oldenburg, among others—his work has evolved and grown over the decades, an impressive accomplishment for an artist who reached such stature so early in his career. Over the years, his work has become increasingly expressive and personal. In a time when new artistic directions have rapidly come and gone, Dine has continued to chart his course with an internal compass. His passion remains, giving form to his inner landscape. Dine, by his own admission, is not involved with abstraction. "It doesn't interest me. I'm not a minimal person, hardly an abstract person. I need that hook . . . something to hang my landscape on. Something."[1]

Although initially celebrated as a painter, Dine quickly established his reputation as a draftsman and printmaker. Drawing has always been as significant to him as painting and sculpting: "[Drawing is] the way I can speak best, the clearest. Essentially I'm a draftsman."[2]

Dine's ability to focus has long been evident in his careful exploration of such themes as tools, bathrobes, hearts, and gates. During the late 1970s, this intensity was manifested in an extensive series of life drawings. His wife, Nancy, as well as a number of other models, served as subjects for these. The artist has stated that in many of these works dozens of drawings lie hidden under the surface.[3] They were purposefully overworked. Ironically, at the same time Dine was drawing the figure, he was also working on a series of large-scale bathrobe paintings. These paintings, initially inspired by a men's clothing ad in the *New York Times*, function loosely as self-portraits in which the human form is conspicuously absent, though almost palpable. For Dine, the robe—the object—

Installation View of "Jim Dine in der Glyptothek" 1990
Courtesy the Staatliche Antikensammlungen und Glyptothek, Munich

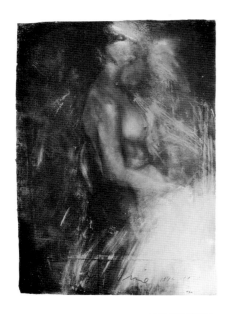

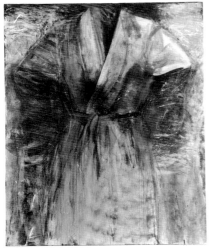

(top)
THE SITTER PROGRESSES FROM
LONDON TO HERE IN THREE YEARS
1976–1979
pastel, oil pastel, charcoal, acrylic, and
gesso on paper
45½ x 31¾ (115.6 x 80.6)
Collection of the artist

(bottom)
TONIGHT THERE IS WEATHER 1979
oil on canvas
102½ x 81 (260.4 x 205.7)
Collection of the artist

describes the human form and spirit very much as figure drawing does.

These life drawings of the 1970s heightened Dine's interest in and understanding of human anatomy. They provided an important underpinning for all his subsequent work, but especially for the Glyptothek drawings that followed a decade later. In 1979, while visiting the Israel Museum in Jerusalem, Dine drew a male torso from its collection of antiquities. This drawing (see page 22) was a direct predecessor of the Glyptothek series. It reflects Dine's ongoing interest in antiquity, a passion that the artist attributes partially to his high-school education in Cincinnati. In the late 1970s, Dine also began to incorporate variations of the Venus de Milo in his work. Currently, he continues to use and alter this pillar of Western civilization to suit his expressive purposes.

In the winter of 1984, Dine, in Munich to view paintings at the Alte Pinakothek, made a fortuitous visit to the Glyptothek. This museum of antiquities, founded by Ludwig I and designed in the early 1800s by the architect Leo von Klenze, immediately caught Dine's attention. The structure's ornate detail had been lost in the bombing raids of World War II, and the rebuilt interior was pristine. The Glyptothek and its collections of Greek and Roman sculpture captivated Dine; he has since returned there frequently to look and draw. The museum has served as a source of inspiration and sometimes as a studio for a series of powerful drawings that both celebrate and transform their sculptural subjects.

Dine has used his intense vision to translate ancient statuary into rich drawings. His intent was to make these stone figures come alive, just as he had previously done with hammers, pliers, robes, hearts, and a variety of other objects. In the Glyptothek series the objects in question happen to be human in form, but this has not prevented them from undergoing the same alchemy that Dine has applied to other objects.

Between 1987 and 1988, Dine produced forty drawings on Mylar and drafting paper, which, with the assistance of the master printmaker Kurt Zein, were transformed into a large limited-edition book and later a portfolio of prints. The forty original drawings constitute a single work, *Glyptotek Drawings*, that together make a powerful statement.[4] A number of these drawings were produced from photographs of the Glyptothek's and other museums' collections of antiquities.[5] By drawing from many sources, Dine, in a sense, created his own Glyptothek. It is interesting

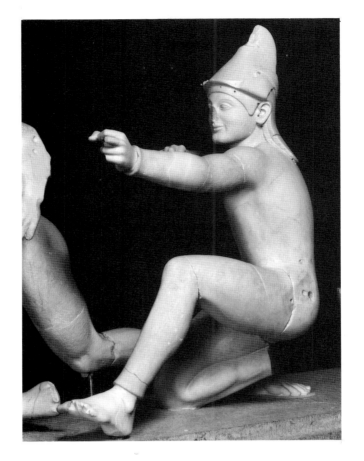

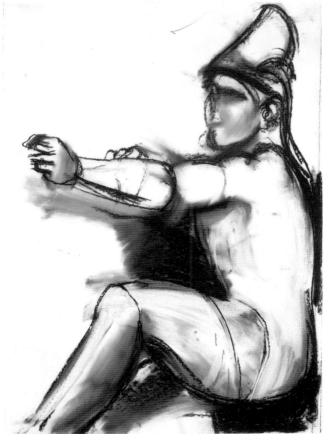

(top)
Archer, from the West Pediment of the
Temple of Aphaia at Aegina, perhaps
Paris, ca. 500 B.C.
Collection of the Staatliche Antiken-
sammlungen und Glyptothek, Munich

(bottom)
GLYPTOTEK DRAWINGS / *Drawing 21*
1987–1988
chalk on Mylar
17½ x 12½ (44.5 x 31.8)

9

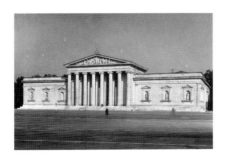

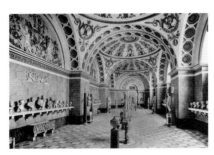

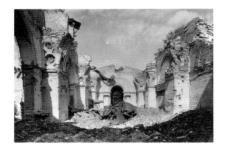

to note that the ordering of the images that comprise this work varies, depending on the particular installation.

Shortly after learning about this body of work, the Glyptothek's director, Klaus Vierneisel, invited Dine to work in the museum during nonpublic hours. Numerous early-morning sessions produced many of the seventeen large-scale, mixed-media drawings that constitute the series In der Glyptothek. As is often his practice, the artist reworked some of these drawings and initiated others in his London studio. As in his life drawings of the late 1970s, he often builds these images in numerous layers, applied to thick paper. Despite this technique, the work retains a spontaneous, expressive quality.

This publication and the exhibition it accompanies expand on European presentations of these drawings at the Glyptothek in Munich and the Ny Carlsberg Glyptotek in Copenhagen, as well as an exhibition at the Nelson-Atkins Museum of Art in Kansas City as part of its Horizons series. The present exhibition also includes new work executed by Dine in January 1992. These drawings appear further removed from their original subject matter and seem to reflect increasingly the artist's emotional landscape. When questioned about the shift in direction apparent in these recent works, Dine simply states that he is not the same person he was a year ago. He also emphasizes that his trips to Munich will continue into the foreseeable future.[6]

Jim Dine: Drawing from the Glyptothek presents an important body of work by one of this century's most noted artists and highly regarded draftsmen. These powerful drawings provide valuable insight into a career that is evolving and growing richer with time.

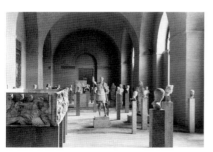

Notes

1. Graham W. J. Beal et al., *Jim Dine: Five Themes*, exh. cat. (New York: Abbeville Press, in association with Walker Art Center, 1984), 11.
2. Frank Robinson and Michael Shapiro, "Jim Dine at 40," *Print Collector's Newsletter* 7 (September–October 1976): 101.
3. From a conversation between the author and the artist, New York, December 13, 1991.
4. Dine made the decision to alter the spelling of the word "Glyptothek" to "Glyptotek" for this work.
5. In the *Glyptotek Drawings*, Dine drew from collections that include the British Museum, London; National Archaeological Museum, Athens; Ny Carlsberg Glyptotek, Copenhagen; Agora Museum, Athens; the Prado, Madrid; and Skulpturensammlung Albertinum, Dresden.
6. From a conversation between the author and the artist, New York, December 13, 1991.

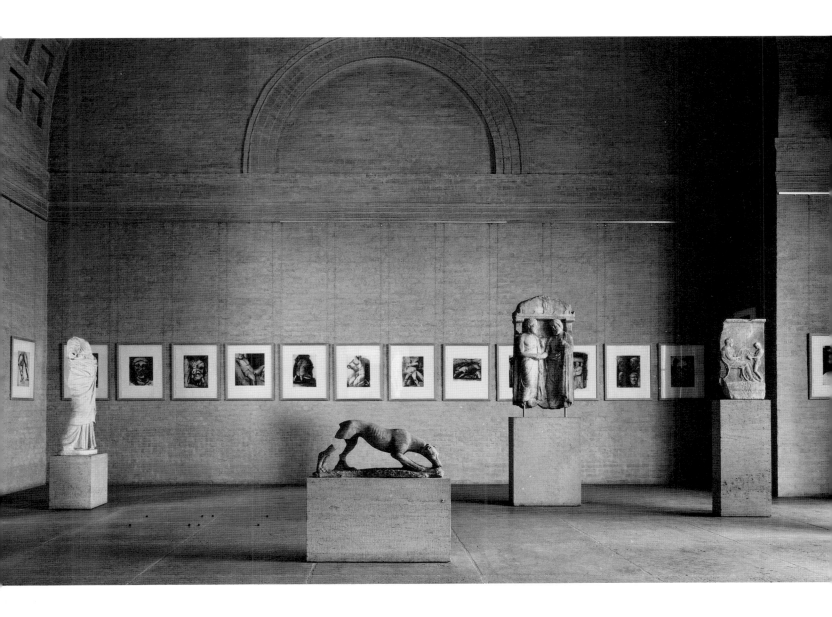

Installation View of "Jim Dine in der
Glyptothek" 1990
Courtesy the Staatliche Antiken-
sammlungen und Glyptothek, Munich

(opposite, from top)
Main Facade of the Munich Glyptothek
Courtesy the Staatliche Antiken-
sammlungen und Glyptothek, Munich

The Hall of Romans, Munich Glyptothek,
before World War II
Courtesy the Staatliche Antiken-
sammlungen und Glyptothek, Munich

The Hall of Romans immediately after
World War II
Courtesy the Staatliche Antiken-
sammlungen und Glyptothek, Munich

The Hall of Romans Restoration
Courtesy the Staatliche Antiken-
sammlungen und Glyptothek, Munich

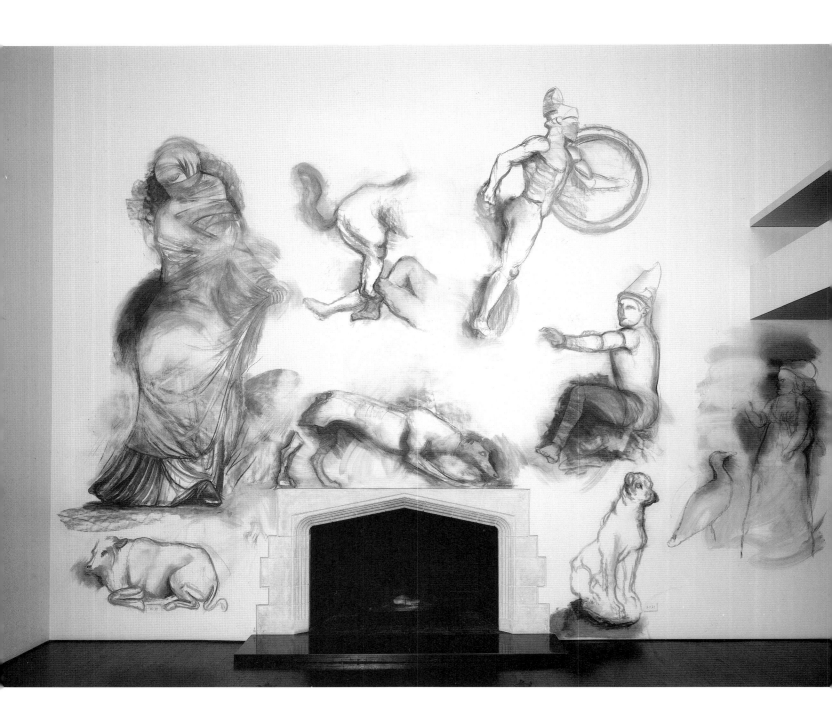

Ruth E. Fine

Inventing History:
Jim Dine's Glyptothek Drawings

Jim Dine has told us that as a young boy he "simply couldn't stop painting."[1] Born in Cincinnati in 1935, Dine studied art at the University of Cincinnati, the Boston Museum School, and Ohio University. He married Nancy Minto in 1957, and the following year the couple moved east, where Dine soon found himself at the heart of the New York art world. Jasper Johns, Allan Kaprow, Claes Oldenburg, and Larry Rivers, all some years older than Dine, became his mentors and friends. Dine was an active participant in the Happenings of the time, and his paintings, many of which incorporated objects from everyday life, associated him with the Pop art movement, although he has long since moved far afield.[2]

In 1967 Dine and his family, which by then included three sons, left New York for London, remaining abroad until 1971.[3] Returning to the United States, they resided for almost fifteen years in the relative solitude of Putney, Vermont, but in 1985, their sons essentially on their own, Jim and Nancy Dine shifted their home base back to New York.[4] They since have lived a peripatetic existence, spending periods of time in a variety of places. Among those that have become key to their extensive travels are Walla Walla, Washington (where Dine makes sculpture in a bronze foundry), London, Venice, Paris, and Munich, the home of the Glyptothek, which inspired many of the drawings collected here.

Drawing What One Is

The poet and art historian David Shapiro has described Jim Dine's career as "a constant scrutiny of the competing dogmas of his day."[5] One might elaborate: in painting (or drawing, or sculpting, or printing) "what one is," Dine is engaged in a constant inward scrutiny, examining the competing emotions and responses in his life.

Jim Dine: Drawing from the Glyptothek brings together twenty-seven works based on antique sculptures, executed between 1987 and 1992. Several of them are composed of multiple units, the most extensive of which is a forty-drawing group referred to as *Glyptotek Drawings*, that the artist considers a single work. Mythic in their sources, heroic in their

Interior View with Untitled,
Chicago 1991
charcoal on painted plaster wall
18½ x 23 feet (5.6 x 7.0 meters)
Private collection, Chicago

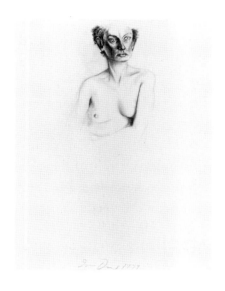

(top)
NANCY AT CARNEGIE HALL (#1) 1979
graphite on paper
50 x 38½ (127.0 x 97.8)
Collection of Pierre and Marguerite
Magnenat, Lausanne

(bottom)
STUDY FOR THE SCULPTURE OF THE
CROMMELYNCK GATE WITH TOOLS
(TWO HAMMERS) 1983
charcoal, spray enamel, and acrylic on
paper with objects
73 x 59 (185.4 x 149.9)
Andrew J. Crispo Collection

embrace of Western culture and in the sweeping grandeur of their facture, these drawings combine Dine's probing curiosity with his penchant for exuberant display.[6] Distinctive within the artist's oeuvre in terms of their subject, the Glyptothek drawings build on his many years as a devoted draftsman and are infused with his broad understanding of what the art of drawing may embody.

In Dine's drawings generally, two essential considerations come into play. First, he places importance on *what* he is drawing and how he sees it (when, indeed, he is actually working from life). One might call this his analytical (Giacomettian) response, which celebrates the work of the eye. Second, and equally crucial, is *how* he is drawing something, how he responds to what he sees or imagines; one might call this an expressive (van Goghesque) response, which celebrates the work of the hand, and of tools and materials.[7] Throughout Dine's career, depending upon the balance and proportion of these responses, certain sheets have seemed to emphasize the probing aspect of drawing. In them the model (whether person or thing) is of most immediate import when one approaches the work: the viewer responds initially to the "what" of the drawing, and then to the "how."

Other drawings suggest summation or presentation, rather than probing. Often as much paintings on paper as drawings, they tend to be worked from memory, rather than from a model: here the "how" evokes the most immediate response; the "what" is of secondary impact. A totality of probing, summation, and presentation marks all of the drawings, of course, but to use a musical metaphor, the probing drawings—for example, *Nancy at Carnegie Hall (#1)*—are most like études; the summation/presentation drawings, such as *Study for the Sculpture of the Crommelynck Gate with Tools (Two Hammers)*, like symphonies. And many of the summation drawings comprise multiple panels as diverse as different symphonic movements; for example, *The Lessons in Nuclear Peace, Second Version*, 1982–1983.[8]

David Shapiro has placed Jim Dine, along with Albert Pinkham Ryder and Jasper Johns, in a "tradition of American darkness," which Shapiro contrasts with American Luminism's celebration of a distinctly American light.[9] Dine's orientation was apparent virtually from the mo-

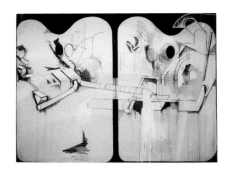

ment of his move to New York in the late 1950s; for example, in *Crash Pastel #1*, 1959.[10] In this early sheet one sees qualities that have continued to dominate Dine's vision: his homage to other art (in this case, the Abstract Expressionist rigor that was of central importance to the artistic generation that immediately preceded his own); his simultaneous embrace of a confluence of visual languages and its resulting richness of surface (loose, open gestural markings; a taut clarity of delineation juxtaposed with areas of glowing softness); his autobiographical bent (a friend had recently been killed in an automobile crash). Dine's dark side, however, is mediated by his finely honed wit and his passionate responses to things in the world.

By 1961 the works that included everyday objects and brought Dine his early acclaim were under way—for example, *Wash Tie*, in which careful delineation of one of the "absurd items of masculine haberdashery" placed the necktie's shape in sharp contrast to the washes and drips that resulted from spraying fixative on powdery charcoal.[11] One reading of the title tells us that the method, or the results of the method—that is, the washes of gray that suggest shirt front and trousers—are as important to the artist's sense of his subject as is the enormous tie itself.

At this time drawn elements were also a central aspect of Dine's painted canvases; examples are the mass of curvilinear marks that constitute the surface hair of *Hair*, 1962,[12] and the pipes and other architectonic elements in *Two Palettes (Sears Roebuck; Francis Picabia)*, a work that surely is as much about drawing as it is about painting. This same fusion of draftsmanlike and painterly means is apparent in a painting with collage titled *3 Palettes (3 Self-Portrait Studies)*, 1964, in which Dine's now-familiar symbolic self-portrait appears to be fully formed.[13] Three palettes signify the artist; three bathrobes signify the man; these objects are fragmented, figureless, their solidity and use only implied. Added to them are footprints (the imprints in Dine's oeuvre often also include handprints and fingerprints). All are images that will continue to play an important role in the developing methodology and psychology of Dine's art. If we are aware of his evolving dictionary of themes, we can see that the curvature of the palettes across the top of this painting suggests the shapes of three lopsided hearts.

Two Palettes (Sears Roebuck; Francis Picabia) 1963
oil on canvas
96 x 120 (243.8 x 304.8)

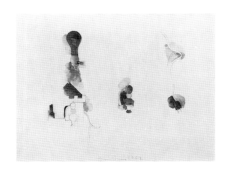

Perhaps foretelling Dine's more recent fascination with the antique, another work from this period, *Charcoal Self-Portrait in Cement Garden*, 1964, shows a linear bathrobe portrait on canvas juxtaposed with fragments of actual columns set on the floor in front of it.[14]

Dine's orientation was not so totally linear as some of these examples suggest. He was also developing beautiful, fluid surfaces. For his works on paper, watercolor was one medium of choice, often combined with graphite, as in *Study for a Child's Blue Wall*, exemplary of the painterly delicacy of which the artist was capable at this early point in his career. Related to a painting of the same time, this subtle yet luminous sheet suggests a track parallel to Dine's darker, more flamboyant approach. A similar gentleness remains evident, more than a decade later, in Dine's drawings of plants, such as *Jade Plant Still Life*, 1976–1977. Drawn in graphite, its clarity seems sufficient even for a botanical book.[15]

As has already been suggested, Dine's collage methodology was also fully formed in his early years in New York, and it too remains central to his work today. In drawings done as early as the sixties, the use of three-dimensional objects was a factor, as in two drawings titled *Toothbrush and Tumbler with Screws*, both 1962, which incorporated actual screws. Dimensional elements were less important to Dine's work of the 1970s, but throughout the 1980s they again came to play an active role in the paintings.[16] In the drawings, by contrast, while there are exceptions (for example, *Crommelynck Gate with Tools*, which incorporates hammers), collage came to take the form of multiple layers of paper, and several papers pieced together to make larger sheets, rather than the inclusion of objects. Notions of collage also dominate Dine's juxtapositions of subjects and themes. Whether on canvas or paper or as sculpture, Dine brings together an accumulation of images, layering and associating them by proximity, often with the unpredictable scale relationships one anticipates in collage. The 1989 work *San Marco with Meissen Figure and the Buddha* is exemplary.

Tools, with which Dine's art remains closely associated, were among the first objects he used in his work: garden tools (lawnmowers, shovels, rakes) and tools that artists use (saws, hammers, scissors, brushes, tubes of paint). And as we have seen, the bathrobe was also in place early as

STUDY FOR A CHILD'S BLUE WALL
1962
watercolor with graphite on paper
22 7/16 x 28 7/8 (57.0 x 73.3)
National Gallery of Art, Washington
Gift of the Woodward
Foundation, Washington, D.C.

one of Dine's themes. The heart was added in the mid-1960s, in sets he designed for Shakespeare's *A Midsummer Night's Dream.* By 1970 he was affixing twigs and branches to his canvases, and in the 1980s trees and gates were added to the artist's landscapes.[17] They presented new twists on the subject that had inspired some of Dine's most important early multipanel paintings with objects, such as *Long Island Landscape* and *The Studio Landscape*, both of 1963.[18]

Through the 1980s other images became increasingly important, including self-portraits and portraits of Nancy, skulls, and Hellenistic figures. Indeed, Greek sculpture, hearts, landscapes, self-portraits, skulls, and tools all have been conflated in individual works, sometimes composed of multiple panels or sheets, as Dine's layering of his own image history has become a pervasive subject of his art. The seven sheets in the Untitled Tool Series, 1973, now in the collection of the Museum of Modern Art, are among the best known and most impressive of Dine's drawings.[19] Worked in charcoal and graphite, they are dramatic in their iconic structures and offer evidence of Dine's superb skills as a draftsman. They also demonstrate that for this artist the expressive weight of a drawing's structure is as crucial to its totality as is its capacity for mimesis.

With a body of work so powerful as this behind him — drawings that clearly reveal not only his immense capabilities, but also his ambition — during the winter of 1974–1975 Dine set out to "upgrade the content of the subject matter and instead of dealing with the obscure metaphor for the human figure, the tool, to deal with the human and make that metaphor go for itself, which then makes it more powerful in content."[20] For three years the artist worked only on drawings, and from that time to this, works on paper have held a primary position in his oeuvre.

In drawing the figure, Dine has called upon a variety of friends and neighbors over the years, and his primary model has been his wife.[21] Like the serial portrait of Georgia O'Keeffe that Alfred Stieglitz composed in a body of hundreds of photographs, Jim Dine's multiple portrait of Nancy — clothed, nude, in three-quarter figure, head and shoulders, or head only, in charcoal, oil, crayon, graphite — magnificently portrays a gaze, directed both inward and outward, of penetrating emotional range on the part of both artist and model.

Untitled Black Drawing #5 1978
pastel, color pencil, and graphite on paper
31¾ x 45½ (80.6 x 115.6)
Private Collection, Switzerland

(opposite)
Little Self-Portrait 1989
graphite, watercolor, and charcoal on paper
12½ x 9½ (31.8 x 24.1)

Self-portrait drawings have been even more persistent in Dine's oeuvre than his portraits of Nancy. His bathrobe as self-portrait is paralleled by images, mainly of his head or head and shoulders, gleaned by peering intently into a mirror. This ongoing self-portrait reveals a tough, multi-faceted man; the drawings have great emotional intensity and demonstrate that Dine has little fear of plumbing his own depths in this exercise in self-discovery. He has long been engaged in the psychoanalytic process; his inwardness is at the essence of the man and his art. In these detailed self-descriptions he may be nude, or, as his titles tell us, smoking a cigar, in Cambridge, in a Scottish overcoat, with red ears, looking in the dark.[22] At the same time, the bathrobe image has gradually become a metaphor for Everyman.

In addition to Dine's engagement with the figure, in 1977 and 1978 he brought the traditional still life—objects on a table—into his repertoire in a group of massive paintings of glasses and pitchers, mugs, vases, decanters, and beakers, for the most part made of clear glass.[23] The subject of these works was light and air: rims and edges and bases of objects glisten as they dance across canvas and into depth, disappearing, reappearing, as if of no substance. Squashes and peppers, a conch shell, a skull may be seen in these paintings too. Dine also rendered still lifes on paper, here depicting a greater variety of elaborate objects than he had on canvas, and combining a wide range of media, including watercolor, oil, enamel, charcoal, graphite, pastel, crayon, chalk, and an assortment of other materials and tools for erasing, inscribing, sanding. A group of still lifes of particular interest in the context of the Glyptothek drawings is the Untitled Black Drawings series, 1978, which includes reproductions of Egyptian sculptures.

Dine's interest in two-dimensional images of three-dimensional objects has often led him to make drawings and paintings with sculptures in them. In addition, while his paintings, drawings, and prints are more numerous, he also has worked extensively in three dimensions. During the early 1960s he completed an important body of sculpture, to which he added intermittently through the following decade. In recent years, however, sculpture has again become a forceful presence in his art. He has developed complex metaphorical works, such as *Ancient Fishing*, for

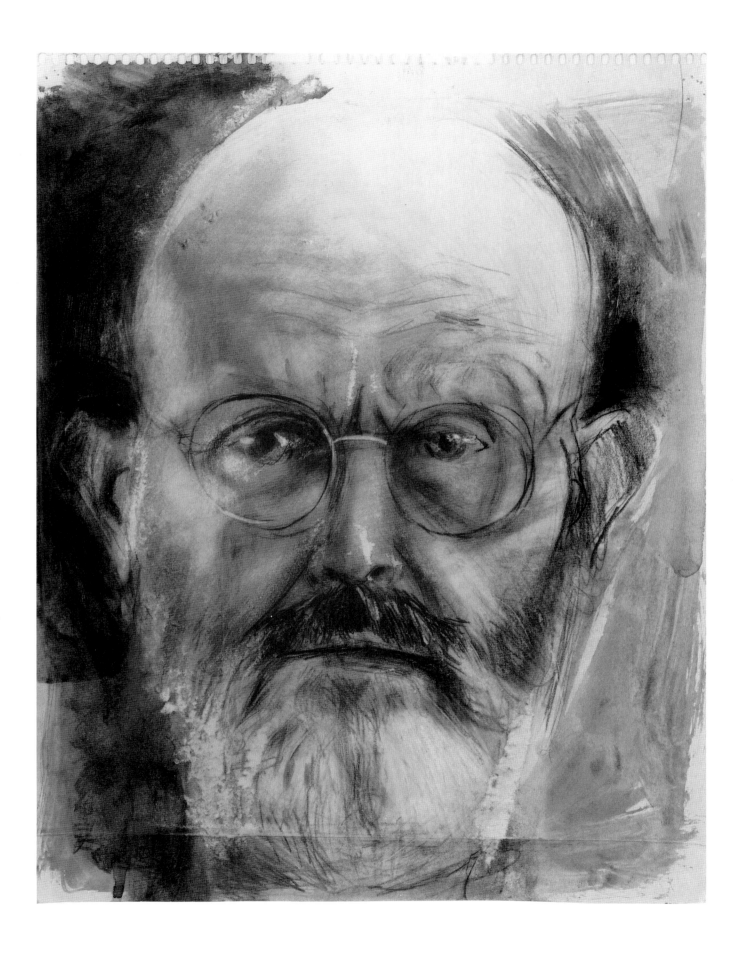

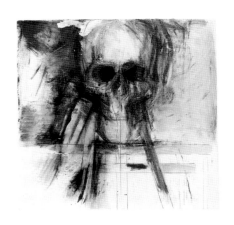

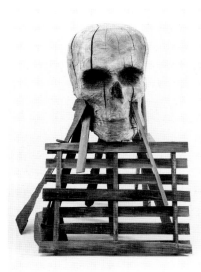

which he made a dramatic mixed-media study, and for some years he has explored a Venus de Milo figure in numerous versions.[24] The Venus figure also appears in many of Dine's paintings, drawings, and prints. Moreover, as he has been working more in sculpture, he also has immersed himself in the study of sculpture of other cultures. Not only Greek marbles and Egyptian figures, but Buddhist bronzes and Chinese porcelains have appeared in his two-dimensional work, reflecting his search to locate himself and his art in the widest possible context.[25]

The Glyptothek Drawings

It is virtually impossible to discern or set traditional boundaries in Jim Dine's art. His paintings have sculptural elements; the surfaces of his sculpture may be painted extensively. His prints, too, often combine several print processes and are further worked with paint or crayon or both. This inclusive approach has long been characteristic of the drawings as well. His strong predilection for collage, both literal and metaphysical, is reflected in his accumulative use of media, his tearing and layering of papers, his movement across cultures and epochs for images and ideas. All of these elements may be seen vividly in the Glyptothek drawings. Their subjects are manifold, as specific as the artist's encounter with his model, as broad as the history and meaning of art.

The idea of drawing from earlier art is hardly unique to Dine. His august predecessors in the modern period alone include Delacroix, Cézanne, van Gogh, and Derain, to say nothing of Picasso.[26] One of the artists Dine most admires, Giacometti, made studies from subjects as diverse as Hellenistic, Gothic, and Romanesque sculpture, Byzantine mosaics, and paintings by Dürer, Rembrandt, and Matisse. Giacometti has reflected upon these encounters:

> Suddenly I see myself in Rome at the Borghese Gallery copying a Rubens, one of the great discoveries of my journey; but at this very instant I see myself simultaneously throughout my entire past: at Stampa near a window in about 1914, absorbed in copying a Japanese

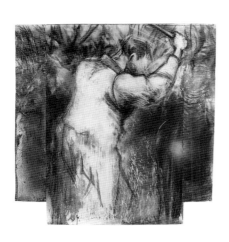

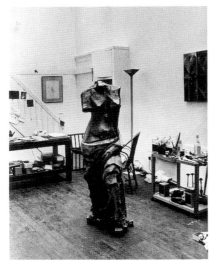

print—I could still describe every single one of its details; and in 1915 Rembrandt's *Supper*; and then a Pinturicchio suddenly comes to mind and all the Quattrocento frescoes in the Sistine Chapel. But then I also see myself four years later, returning to my studio in Paris in the evening, leafing through books and copying this or that Egyptian sculpture or a Carolingian miniature, but also Matisses. How can one describe all that? The entire art of the past, of all periods, of all civilizations rises before my mind, becomes a simultaneous vision, as if time had become space.[27]

Dine's study of antique sculpture in his Glyptothek drawings has roots not only in other artists' work, however, but also in his own earlier works from other artists. Noteworthy is an important series of large-scale mixed-media drawings he made in 1983 from reproductions of drawings by van Gogh, to whom Dine has referred affectionately as "the Babe Ruth of art."[28] One purpose of the process was for Dine to examine related languages of form—that of van Gogh's drawings and that of his own—seeking a way to understand the earlier artist's expressive means, while discovering, as a parallel experience, possibilities for conveying his own responses to them. The drawings from van Gogh were made only a year before Dine first became captivated by the Glyptothek, and may be seen as precursors of the drawings made there.

Dine's earliest drawing from sculpture is an untitled sheet of a putto from 1974.[29] Highly modeled in graphite, this little stone figure functions as a segue from Dine's earlier drawings of tools to the drawn figures of flesh that will soon follow. The most important precedent for the Glyptothek series, however, is *Study of Roman Copy of a Hellenistic Statue Found at Caesarea*. Done in 1979 in the Israel Museum in Jerusalem, this was the first drawing Dine made in a museum as a mature artist. The encounter was not, however, without youthful precedent. As an eleven-year-old, in the summer of 1946, Dine had studied art with a teacher, Carlos Cervantes, who took a class of about twenty boys to paint in the Cincinnati Art Museum. Dine has recounted other early museum visits, too:

I painted a lot in school because it was my ticket to freedom from the other subjects. . . . In high school I went to adult night classes and began to realize that I was already formed. . . . I spent a lot of

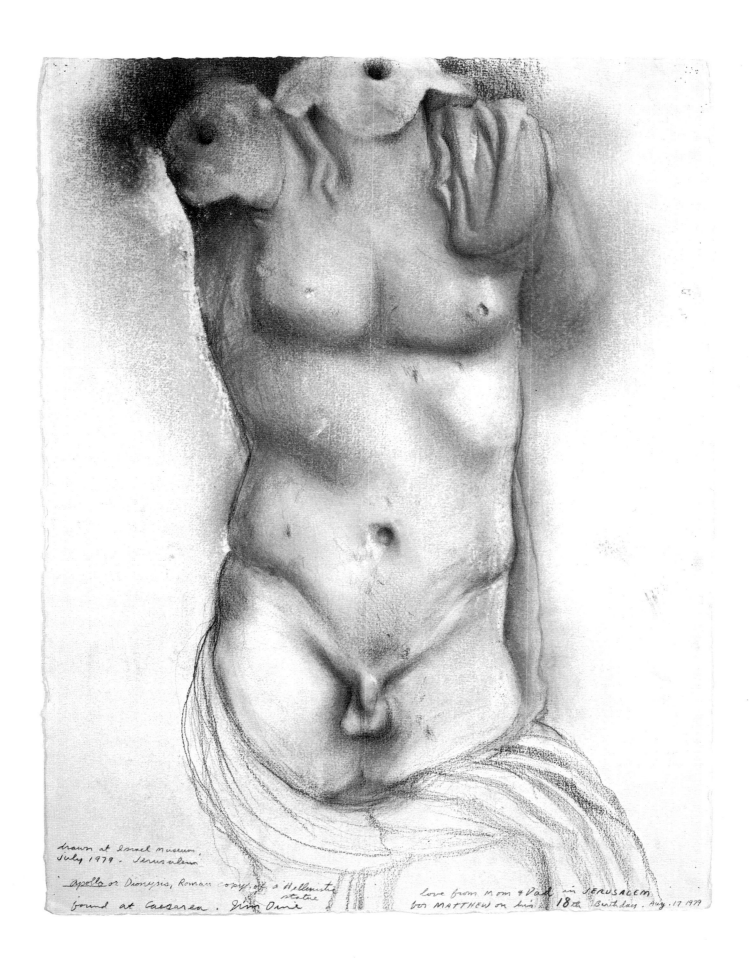

drawn at Israel Museum,
July 1979. Jerusalem

"Apollo or Dionysus, Roman copy of a Hellenistic
statue
found at Caesarea. Jim Dine

love from Mom & Dad in JERUSALEM.
for MATTHEW on his 18th Birthday. Aug. 17 1979

time at the Museum looking at pictures, particularly those Cincinnati painters like Frank Duveneck and his pupil Twachtman, who went to Munich in the second part of the 19th century and learned to paint with so much bravura. The museum also had beautiful Harnetts and Petos. These early illusionists made sense in our new history of the found object.[30]

Despite his early attachment to museums, when Dine moved to Europe in 1967, he at first avoided them, wary of going against the position established by the previous generation of American artists, intent on "shrugging off the bonds of Europe."[31] Living abroad had a profound effect on him, however, and by the mid-1970s he had realized that "mainly my interest is in older art. That is really what I like best. Nothing gives me more pleasure than looking at van Gogh drawings or Degas drawings, I love Cézanne."[32] His knowledge of the power of art, its power across time to speak to new generations in pointed and meaningful ways, is at the center of his Glyptothek drawings. They demonstrate that his own art functions in an expansive artistic terrain, crossing or stopping at some points, totally omitting others.

Ancient art now has become as pervasive a subject for Dine as are the bathrobes and hearts, gates and trees, hammers and palettes with which he has long been associated. And the earlier art serves a parallel metaphoric role: whereas the tools, as subject, speak to the physical sources of art (among other things), art, as subject, speaks to its own intellectual roots.

Dine did not seek out the Glyptothek. Rather, he came upon it quite accidentally, while visiting Munich in 1984 to see paintings at the Alte Pinakothek. Having stumbled upon the museum, however, he felt an immediate fascination with the collections. He returned to Munich during the winters of 1986–1987 and 1987–1988 and spent many days in the Glyptothek, making numerous sketches during public hours, while other visitors were walking around him. These sketches eventually were the basis for the forty drawings that were used for the prints in Dine's limited-edition book *Glyptotek*.[33] These drawings are all similar in size and are done on tracing paper, translucent architect's paper, and Mylar, materials chosen at least in part because they allow the passage of light,

and so may be used for transferring drawn images to etching plates. This purpose also accounts for Dine's use of black media only, although their range is nonetheless quite varied, including inks, charcoal and fixative, and enamel, all worked with the artist's characteristic verve. Smudges, scrapes, drips all play their part. Dine developed the drawings in 1987–1988 in London, New York, and Venice. In addition to his sketches from the Glyptothek, other image sources for the series included photographs, postcards, catalogue reproductions, and whatever other materials the artist could gather during his visits to Munich. A few of the drawings are based on sculptures from other collections, such as the British Museum, London, the National Archaeological Museum, Athens, and the Prado, Madrid.

The idea for the *Glyptotek* book is in itself fascinating. Dine has suggested that he wanted to create his own museum—one that could be carried with him wherever he might go—a catalogue of images, a personal history of art. To accompany the prints he wrote a description of the museum and his appreciation of it: "I have spent such quiet hours here." He also translated a poem of Sappho:

> The flower delights my body's force.
> It shines on the bitter-sweet
>> limbs of our long companionship.
> Moonlight covers the earth.

The time spent at the Glyptothek became even quieter when Dine was offered the opportunity to draw there during nonpublic hours.[34] The resulting drawings, much larger in scale and incorporating color, were worked in 1989 (pages 80–87, 92, 95, 97).

The experience of drawing in a museum has ramifications in itself. Surely the museum is a kind of temple, a spiritual place, in which the mystical vibrations from artistic predecessors accelerate the excitement of the moment, but also heighten the challenge, the dare. And a museum in the early hours of the morning—this, too, has its own romance: being present in such a space, at a time when one is usually forbidden access, and alone, sets up a one-to-one duel of wills, the will of the art in all its three-dimensional fullness challenging the will of the artist to capture its magnitude on a flat surface.

For these working sessions inside the Glyptothek, Dine set himself specific goals. His intention was to do a drawing a day, and he insisted each one be finished within this time frame. Essentially he held to this plan, although he did in the end add finishing touches to a number of the drawings later, in his London studio. Further drawings were developed entirely in London. Among these are *Twisted Torso of a Youth* and *Kouros Figure* (pages 93, 96), both of which were drawn onto screenprints Dine had had made from a photograph, taken by his wife, of a Venus sculpture in progress in his London studio (similar to *The Cubist Venus*, page 21): pentimenti, layering, the artist's own history intertwined with the history of art.

In his travels Dine sought out museums of antique sculpture elsewhere. In November 1990, while he was working on etchings in Copenhagen, he set aside some time to draw (during public hours) in the Ny Carlsberg Glyptotek, completing the multipart drawing titled *Seven Views of the Hermaphrodite* (pages 100–106), based on a single sculpture. Seeing the piece in more than one view permits us to track the artist as he moved around his subject, carefully studying it from different vantage points. This also may be seen by comparing the larger drawings of sculpture included among the forty for the *Glyptotek* book. As he had after Munich, once back in the studio Dine continued to make drawings stemming from his Copenhagen museum visits, for example, *Roman Head from Glyptotek in Copenhagen*, 1991, drawn on a beautifully textured sheet of handmade paper (page 117).

The most recent drawings are six Dine made in mid-January 1992, working alone in the privacy of the Munich Glyptothek in the early-morning hours, when the building was closed. They developed through a process very different from that of the 1989 drawings: without the self-imposed restriction of completing a drawing a day, Dine worked on the sheets over several days and continued to work on them later, in his London studio. Several are softer and less flamboyant than the earlier sheets, as if the artist were settling in with his subjects and seeking a greater intimacy. This is vividly apparent in his close study of toes in *Feet of the Kneeling Boy* (page 113), or his attention to musculature in *A Pantheress* (page 116), the details of which obviously thoroughly captivated him.

In the Glyptothek drawings as a whole, Dine displays an extraordinary range of expression. There are moments of serenity, of grace, as in *Portrait of a Roman* and *Head of a Roman Woman* (pages 91, 114); of a sensuous caressing of form, as in *Panther* (page 83); of passion about materials and process, as in *Drunken Old Woman with a Wineskin* and *Trojan War Hero* (pages 90, 118). Drawings such as *Aged Silenus with Wineskin* and *Shield and Arm* (pages 95, 115) are quite open, composed of a few loose, flowing lines and gestures of paint, as if a readily achieved demonstration of Dine's immediate grasp of his subject. Others, such as the diptych *Tanagra Figures* (page 94), drawn in the studio rather than in the museum, are visibly worked and reworked; *Trojan Archer* (page 92) is enlarged by additional sheets of paper, as if it had resulted from a longer encounter between the artist and the idea, as he struggled to get at the essential image. (Dine often adds sheets as necessary, as can be seen also in the drawing *San Marco with Meissen Figure and the Buddha*; neither is it unusual for him to cut parts of drawings off, before calling them complete.)

Some of the drawings seem like studies, the études of the repertoire: for example, the two titled *Sleeping Satyr* (pages 80, 81). Others, such as the *Wounded Trojan* (pages 88–89), are symphonies, the summation or presentation drawings, with more highly developed themes, carrying densely worked, heavy passages as well as lyrical touches that dance gracefully across the sheet.

A large-scale drawing not included in this collection, but related to it, is a charcoal mural drawing Dine made on a wall measuring 18½ x 23 feet, in the home of a Chicago collector (page 12). In it one sees the hunting hound and the Trojan warrior from the Munich Glyptothek, as well as other figures and animals Dine has used elsewhere, such as the Hellenistic sculpture of a woman that appears in several of his paintings, prints, and drawings, among them *Red Dancers on the Western Shore*, 1986.[35] Through proximity, these fragments of remembered friends establish a dialogue, suggesting passages from a long-lost tale central to classical knowledge. They are deftly worked, as if on paper, with all the freedom of touch associated with Dine's smudged and reworked charcoal layers. He also used the power tools associated with his methods to incise into the plaster wall networks of lines and marks that add to the weight

SAN MARCO WITH MEISSEN FIGURE AND THE BUDDHA 1989
watercolor, charcoal, pastel, shellac, oil, and collage on paper
79 x 95 (200.7 x 241.3)
The Minneapolis Institute of Arts, gift of Ruth and Bruce Dayton, Cargill and Donna MacMillan, and the John R. Van Derlip Fund

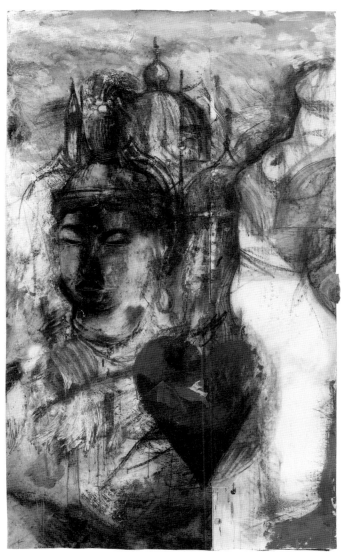
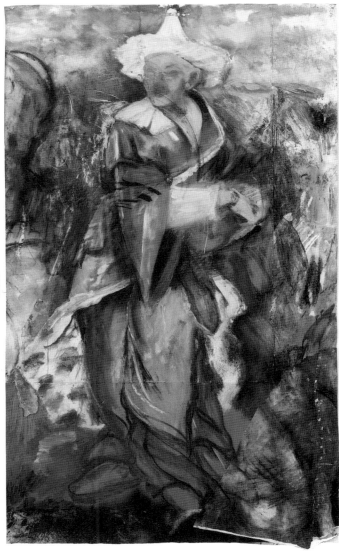

of his forms. Heroic in scale, the wall drawing functions as a compendium of these forms of a more public sort than the *Glyptotek* book, an idea confounded by the fact that a book—even a large one—is an intimate object available to a broad public, while this mural-size work is visible only in a private environment.

All of the Glyptothek subjects are fragments, fragments with the capacity to seem quite complete, despite allusions to decay or breakage, to age, to history. The sense of fragmentation inherent in the subject matter is nonetheless enhanced by the position of the images on the page: virtually none of the figures is contained within the dimensions of the sheet. Images may be centrally located, but some move off the sheet gently, while others seem to be exploding beyond all boundaries. A sense of expansiveness is heightened by surfaces pieced together to form larger sheets, and by the iconic nature of such images, set in unspecified spaces. These agitated figures of stone are energized by an effusive array of marking languages and a rich variety of media, each of whose characteristics is enriched by its proximity to others. There is a sense of form simultaneously becoming and breaking up, emerging and withdrawing. The colors of the papers vary from cream to gray to blue to brilliant white, and this color acts to establish a mood, an ambience.

The Glyptothek drawings are both sculptural and painterly, animate and inanimate. Modeling suggests volume; painterly markings deployed across the surface order the flatness and counter the sculptural subject. The spirit of dimensionality yields a lifelike quality to the stone, and the tough insistence of Dine's approach reveals the capacity of drawing to deconstruct and restructure nature from multiple points of view.

The Glyptothek drawings are direct, yet distanced; highly refined in their ability to grasp and delineate form, yet rough and brazen in their dismissal of slick finish; meditative, yet ebullient; cerebral, yet physical. The drawings are urgent: worked, reworked, laid in, rubbed out; intellectual impatience is paralleled by the impatience of the hand. Based on sculptures that are thousands of years old, the drawings collapse time (in the way that Giacometti has suggested art may do), posit cross-cultural metaphors, suggest the continuity of the human spirit. The Glyptothek drawings are elegant: the mess of Dine's process never masks his innate skill. They are made by a highly practiced hand—a hand seeking cor-

respondences to forms observed by a probing eye, to forms conceived by a deeply penetrating imagination.

They are romantic: passion plays an essential role in these works, layered as they are by experiences of a life lived fully, by connections to family and friends, to places visited and revisited, and by the probing of lengthy analysis. Steeped in the continuum of art, the drawings evoke history and myth and their personal parallels in memories and dreams, as traced in C. G. Jung's writings, which Dine has long studied. It seems eccentric to be unabashedly romantic today (perhaps it is eccentric to be unabashedly anything). But for Dine, the romance of this art must stem in part from the elation of pursuing the tracks of the painters of the Fayum portraits, the carvers of Hellenistic dancers, and Vincent van Gogh, whose art, like that of the creators of the Glyptothek sculptures, has been incorporated into Dine's own.

The Glyptothek drawings are about possession. By drawing something we make it a part of ourselves; we absorb it, contain it. One senses Dine's intuitive belief that his understanding of himself as an artist in history is dependent upon his subsuming these sculptures, the stories behind them, and the skills of their makers, as filtered through two millennia of thought and civilization and wear. In so doing he conveys aspects of their evolving meaning to an audience as yet unknown. Through the Glyptothek drawings our capacity to know the ancient world is changed: Homer and Socrates, Trajan, the emperor Titus, an anonymous but charming boy with a goose, a hunting hound, a palmette from the Parthenon, a girl with a dove are not as they once were. Nor are we as we once were. In experiencing the drawings we too possess and are possessed, both by the sculptures themselves and by Jim Dine's deeply felt interpretations and translations of a classical past forever potent and endlessly renewed.

Notes

I would like to thank Jim Dine, Larry Day, Blake Summers, the staffs of the Pace Gallery and Waddington Gallery, and collectors who wish to remain anonymous, for their assistance and hospitality while I was writing this essay; thanks also to Eve Sinaiko, for her graceful editing, as always.

1. Excerpt from a talk Dine gave at the 92d Street YMHA, November 12, 1985, published in *Jim Dine: Paintings, Drawings and Sculpture*, exh. cat. (New York: Pace Gallery, 1986), n.p.

2. The major overviews of Jim Dine's work are David Shapiro, *Jim Dine: Painting What One Is* (New York: Harry N. Abrams, 1981); and Graham W. J. Beal et al., *Jim Dine:*

Five Themes, exh. cat. (New York: Abbeville Press, in association with Walker Art Center, 1984). On Dine's drawings specifically, see Constance W. Glenn, *Jim Dine Drawings* (New York: Harry N. Abrams, 1985); and Sarah Rogers-Lafferty, *Drawings: Jim Dine, 1973–1987*, exh. cat. (Cincinnati: Contemporary Arts Center, 1988). Other references are included in the bibliography.

3. Dine spent some of his time abroad writing poetry. In 1969, his *Welcome Home Lovebirds*, a volume of poems that has long been out of print, was published by Trigram Press in London. *Diary of a Non-Deflector: Selected Poems by Jim Dine* was published in 1987 by Arion Press, San Francisco. Most of the pieces included were written in London between 1967 and 1970.

4. Nancy Dine is a photographer and film producer.

5. Shapiro, *Jim Dine: Painting What One Is*, 14.

6. Previous exhibition catalogues that reproduce Dine's Glyptothek drawings include *Jim Dine: Youth and the Maiden*, exh. cat. (London: Waddington Graphics, 1989), with essays by Konrad Oberhuber and Donald Saff; *Jim Dine in der Glyptothek*, exh. cat. (Munich: Staatliche Antikensammlungen und Glyptothek, 1990), with an introduction by Klaus Vierneisel and an essay by Wieland Schmied; and *Jim Dine: Glyptotek Drawings*, exh. brochure (Kansas City: Nelson-Atkins Museum of Art [1990]), with an essay by Deni McIntosh McHenry.

7. To limit Giacometti and van Gogh to these simple categories is obviously too narrow a reading of both artists, but these designations suggest important elements in each artist's work and I think suggest aspects that spark Dine's admiration for them.

8. Reproduced in Glenn, *Jim Dine Drawings*, 178–79.

9. Shapiro, *Jim Dine: Painting What One Is*, 19.

10. Reproduced, ibid., ill. 59.

11. Reproduced in Glenn, *Jim Dine Drawings*, 66. The quotation is from Arthur C. Danto, in *The Transfiguration of the Commonplace: A Philosophy of Art* (Cambridge: Harvard University Press, 1981), 39. Danto is discussing the portrayal of the tie in art.

12. Reproduced in Shapiro, *Jim Dine: Painting What One Is*, ill. 10.

13. Reproduced in Beal et al., *Jim Dine: Five Themes*, 29.

14. Reproduced in Shapiro, *Jim Dine: Painting What One Is*, ill. 94.

15. Dine made his own botanical book, *The Temple of Flora*, with various texts and twenty-nine prints in drypoint, direct engraving, and electric-tool engraving, published by Arion Press, San Francisco, 1984. The painting *A Child's Blue Wall* is reproduced in Shapiro, *Jim Dine: Painting What One Is*, ill. 21. *Jade Plant Still Life* is reproduced in Rogers-Lafferty, *Drawings: Jim Dine, 1973–1987*, 44.

16. That Dine became more involved with sculpture in the 1980s probably has had an impact on his renewed use of sculptural elements in paintings. The two *Toothbrush and Tumbler with Screws* drawings are reproduced in Glenn, *Jim Dine Drawings*, 67.

17. See Beal et al., *Jim Dine: Five Themes*, passim.

18. Reproduced in Shapiro, *Jim Dine: Painting What One Is*, ills. 88, 89.

19. Reproduced in Glenn, *Jim Dine Drawings*, 88–90.

20. Frank Robinson and Michael Shapiro, "Jim Dine at 40," *Print Collector's Newsletter* 7 (September–October 1976): 103.

21. No study has been devoted to Dine's dozens of drawings of Nancy, but on his printed portraits of her, see Clifford S. Ackley, *Nancy Outside in July: Etchings by Jim Dine* (New York: ULAE, 1983).

22. For reproductions of several self-portraits, see Glenn, *Jim Dine Drawings*, 137, 145–47; and Rogers-Lafferty, *Drawings: Jim Dine, 1973–1987*, 36, 82, 83.

23. See Shapiro, *Jim Dine: Painting What One Is*, ills. 167–71.

24. On the Venus figures see Jean E. Feinberg, "Not Marble: Jim Dine Transforms the Venus," in Ellen G. D'Oench and Jean E. Feinberg, *Jim Dine Prints: 1977–1985* (New York: Harper and Row, in association with Davison Art Center and Ezra and Cecile Zilkha Gallery, Wesleyan University, 1986). On Dine's sculpture in general, see Michael E. Shapiro, "Methods and Metaphors: The Sculpture of Jim Dine," introductory essay in *Jim Dine: Sculpture and Drawings*, exh. cat. (New York: Pace Gallery, 1984); and Martin Friedman, *Jim Dine: New Paintings and Sculpture*, exh. cat. (New York: Pace Gallery, 1991), with an interview with the artist.

25. For a selection of recent drawings that incorporate some of these themes, see *Jim Dine: Drawings*, exh. cat. (New York: Pace Gallery, 1990).

26. For a fascinating study of this subject, see K. E. Maison, *Themes and Variations: Five Centuries of Master Copies and Interpretations*, introduction by Michael Ayrton (London: Thames and Hudson, 1960).

27. From the first of three introductory notes Giacometti wrote in October and November 1965, quoted in Luigi Carluccio, *Giacometti: A Sketchbook of Interpretive Drawings*, trans. Barbara Luigia La Penta (New York: Harry N. Abrams, [1967]), vii. In the last of these notes (xi) Giacometti wrote: "Now I copy works of art only very rarely. The gap between a work of art and the immediate reality of anything has become too wide, and in fact what interests me is reality and nothing more, and I know I could spend the rest of my life copying a chair. Perhaps the aim of all my copying was always precisely that, and it is also the reason I can no longer say anything about it."

28. From an unpublished transcript of a conversation between Clifford S. Ackley and Jim Dine, held at the Museum of Fine Arts, Boston, March 23, 1983, 2. My thanks to the education department of the museum for supplying me with the transcript.

29. Reproduced in Glenn, *Jim Dine Drawings*, 112.

30. Quoted in *Jim Dine: Paintings, Drawings and Sculpture*, exh. cat. (New York: Pace Gallery, 1986), n.p. It is a coincidental closing of a circle that these artists, whom Dine so admired as a high-school student, worked in Munich, where Dine also has found great inspiration.

31. Conversation, Ackley and Dine, 2.

32. Robinson and Shapiro, "Jim Dine at 40," 102.

33. The book was printed in an edition of ninety, with ten artist's proofs, by the Viennese printer Kurt Zein and copublished in 1988 by the artist, Pace Editions, New York, and Waddington Graphics, London. A portfolio of fourteen images from some of the plates, printed on chine collé of various hues, was published as well. The richness of the prints is dependent upon their raised surfaces of dense black ink; they are equal to the drawings in intensity, but their tone and tactile qualities are different. Some of the photographically transferred images were enhanced by additional drawing done directly on the printing plates, while others remained pure photo-transfers from the drawings.

34. While many artists might require a period of adjustment before being able to work in a new space, especially a space as daunting as a museum at night, Dine has a long-standing practice of working in hotel rooms in various cities, as well as in print workshops and foundries throughout the world.

35. Reproduced in Rogers-Lafferty, *Drawings: Jim Dine, 1973–1987*, 97.

In the Glyptothek

I went to Munich in 1984 to look at the great pictures in the Alte Pina-kothek. I had no idea the Glyptothek existed. I just went by and thought I would go in. I was amazed by the building's interior. The museum was transformed after the war because of the damage done by the Allied bombing of Munich. All the Rococo plaster detail had been knocked off the walls, and it had to be rebuilt. They decided to just patch it and show the bare bones of the original building, designed by Leo von Klenze in 1816. The structure was left intact and the brick was whitewashed in a beautiful way. It's not too bright and you can just see the brick coming through. Warm limestone floors were added and a contemporary archi-tect designed appropriately minimal plinths for the antiquities. In the big hall of Roman portrait heads there must be over one hundred heads. You feel like you're in a crowd of people, but there is nothing heroic about it. It's very much on a human scale, right at the viewer's eye level. The sculpture is allowed to speak for itself. I have never felt closer to the Ancient World than in the Glyptothek. It allows you to be at home with the art, it's so uncluttered. I realized that there were these little stools stacked against the walls and people could pick them up and just go and sit in front of something and draw. All types of people were drawing—art students, archaeologists, and amateurs.

Everyone goes there. The archaeologists and classical scholars come to study the sculpture. The artists come to draw. You can sit and read; it's very human that way. There are masterpieces and there are secrets, too. There are small pieces that you can discover if you go to the Glyptothek enough. I stare into space and invariably see something I have never seen before, like a hand on a Greek gravestone.

I started by making little odd drawings during hours when everybody was there. Once I went with one of my sons, who is a furniture designer. He and I sat there and drew in our sketchbooks. Then, in the autumn of 1986, I went to Venice. We went up to Munich from Venice during the winter and several times I made drawings and photographs at the Glyptothek. My wife took photographs of pieces I thought I would like to draw and I bought reproductions at the shop. I brought these back to Venice and started to work on a group of drawings on Mylar and tissue and drafting paper, materials that one could put light through. I

did this to make gravure prints in Vienna; the master printer Kurt Zein said this is how it could be accomplished.

I sat in my studio that winter and made drawings, all of a certain size, not too big. I wanted to make a portfolio, a book of my drawings. Then I started to draw antiquities from books that weren't in the Glyptothek. In a sense, I was making my own Glyptothek. I did that over two and a half winters. I would go to Venice and then to Munich and then come back and work on these black-and-white drawings on Mylar or tissue paper. Eventually, the series turned into a book of gravure prints and then a portfolio of prints.

The original forty drawings on Mylar, drafting paper, and tissue paper combined to make one work, which I call the *Glyptotek Drawings*. I think each individual drawing could stand alone, but as a single work all forty make a narrative about learning from the Ancient World. That's why I regard them as a single work. I wanted it to be like an installation; it became a room. The prints made from these drawings were shown at the Graphische Sammlung Albertina in 1989 and a Munich dealer, Barbara Gross, saw them there and was surprised that they had come from Munich. She told Dr. Klaus Vierneisel, director of the Glyptothek, about my work, and he wrote that he would be glad to have me come again. Vierneisel was sorry that I had never identified myself, but it honestly had never occurred to me to do that.

In October 1989, I schlepped to Munich again, and this time I brought a big tube with rolls of paper. I had prepared the paper's surface with pumice so it would take watercolor and charcoal. These sheets were about four feet by forty-three inches. Vierneisel graciously invited me to come work when nobody was in the Glyptothek.

I came in usually around five in the morning, before the sun came up. I would ring the bell and a guard let me in. I told him where I wanted to go and he put the lights on for me and left me alone. I worked until ten, when the museum opened; then I would stop and clean up. I got about seven or eight drawings from that stay.

This time, there was no limit to the scale, as long as I had the right-size board to put the paper on. But there's a limit to what you can do in terms of the expressiveness of your method in a museum. All the draw-

ings were about the same size. I went back to my studio in London with the drawings and photographs that I'd taken or bought at the Glyptothek and made more finished works. I could have made them in the Glyptothek, but I couldn't throw the material around as much. I had to be careful not to get paint on the Glyptothek's walls. I went back to London to my studio to make the two figures from Tanagra, the two large ladies (page 94). I also did the dying Trojan warrior (pages 88–89) off-site, because I needed to glue paper together. I needed to use some paint, too, so there were some limitations, but not many.

In recent years I've been interested in making charcoal drawings and mixed-media drawings that incorporate paint, watercolors—just doing what is appropriate. Usually, I have no interest in sitting there and doing a careful pencil drawing. Charcoal is a more expressive medium, and the kind of paper that I take with me is paper that I can work at, build on, and scrape at.

There is a certain tension when you're working in the building, in front of the works, that I don't have when I'm working from a photograph. There's a tension to succeed immediately. I'm not as relaxed as I am when I'm alone in the studio. In the Glyptothek, every time you look around, there's a cleaning lady over your shoulder. She doesn't bother you, but she's there, so there's a tension to succeed. You're put on the line . . . you put yourself on the line. It is an obligation to the work.

When Vierneisel invited me in the first time, without anybody there, I made a pact with myself. I promised to make a drawing a day while I was there. It was great because it made me focus and forced me to look harder. It took lots of concentration, and it worked. I like that kind of self-imposed limitation.

It's very much like "succeed," or the "firing squad." There's always tension in front of great art. Anyway, it's not a relaxing experience; it's very moving and I'm usually overwhelmed by the art, particularly when I examine it closely. What human can stand up to looking at stone for five hours and trying to translate it? I really get into the romance of the carver, and that's a very inspiring part of the process.

I have always made reference to the Ancient World. I have some sort of cultural DNA link with the Ancient World. It's hard for me to place

its source. I went to a classics high school, but I was a very poor student. I learned Latin, but I didn't really. Through my wits I cheated my way through, but somewhere a seed was planted about the beginnings of our culture. I feel very strongly about Greek myth. These stories permeate my inner life. I'm interested in keeping the tools of history around me, not necessarily using them; they're like relics of the saints, in some ways. Sometimes I invent from them and transform them into something that's mine, as I've done with certain themes, like bathrobes or tools or hearts.

While I'm drawing I don't ever think about where the sculptures were done, although I often pause and reflect on their age. A lot of the things I draw from are Roman copies of Greek sculptures. It is purely what speaks to me in some curiously numinous way: what's right to be drawn, what's asking for it, somehow. I choose things that I think can come alive. I don't want to draw these things as dead objects, as stone. I want to observe them carefully, and then I want to put life into them and make them vigorous and physical.

I couldn't have done this work without the knowledge that I gained from looking at the figure. I couldn't have done anything I've accomplished in recent years without the figure drawing I did from 1975 until 1980, when I drew almost every day from the figure. That's all I did. I kept correcting—I would make maybe twenty drawings a year. They were incredibly overworked. There were probably 365 drawings under those twenty. So the knowledge I gained about how to invent the human figure helped me in all my drawing and particularly in interpreting and making lifelike these Greek and Roman antiquities.

I find the human figure totally inspiring. The sculptures function as live models (except they don't move). I feel no obligation to the original in terms of purity of rendering, accuracy, etc. It's there to be used like everything else. It's grist for my mill.

There are two different ways of thinking about the work. It could be viewed as life-affirming because it deals with the human body and the mystery of art and it's about a celebration of the human spirit; others might perceive the work as being about the decay of civilizations, our own mortality. Mainly, they are beautiful objects to be drawn from and made alive.

GLYPTOTEK DRAWINGS

The GLYPTOTEK DRAWINGS are a series of forty images produced by Jim Dine between 1987 and 1988 that constitute a single work. The images were drawn from sculpture in the Glyptothek on numerous visits to Munich and from photographs the artist found in books and other sources. None of the individual drawings is titled.

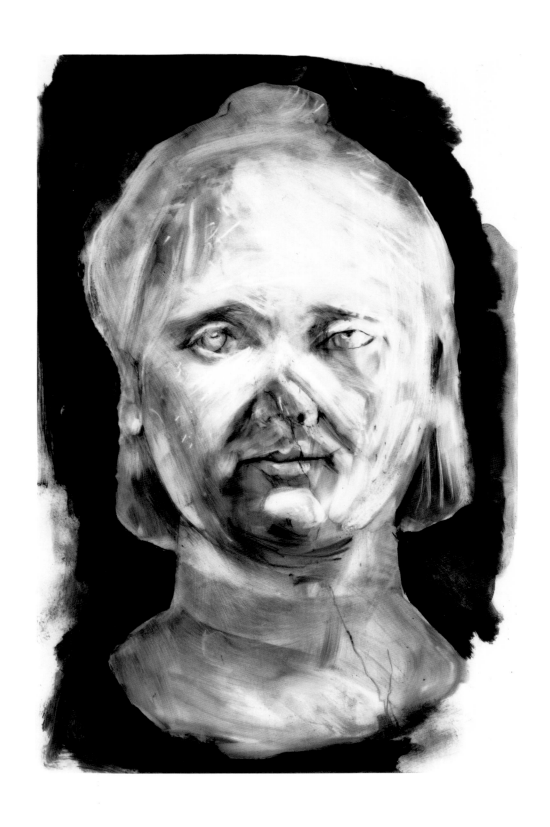

GLYPTOTEK DRAWINGS / *Drawing 1* 1987–1988
india ink and charcoal on Mylar
17 x 11 (43.2 x 27.9)

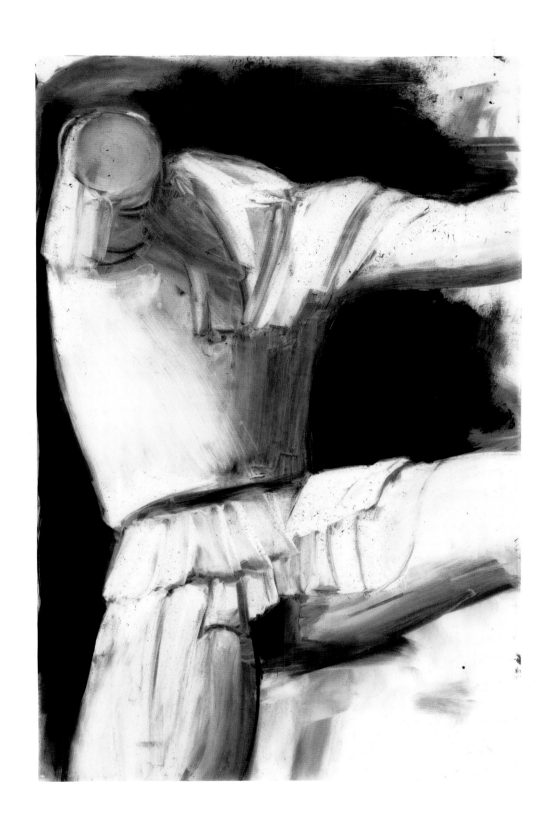

GLYPTOTEK DRAWINGS / *Drawing 2* 1987–1988
charcoal and enamel on Mylar
17 x 11 (43.2 x 27.9)

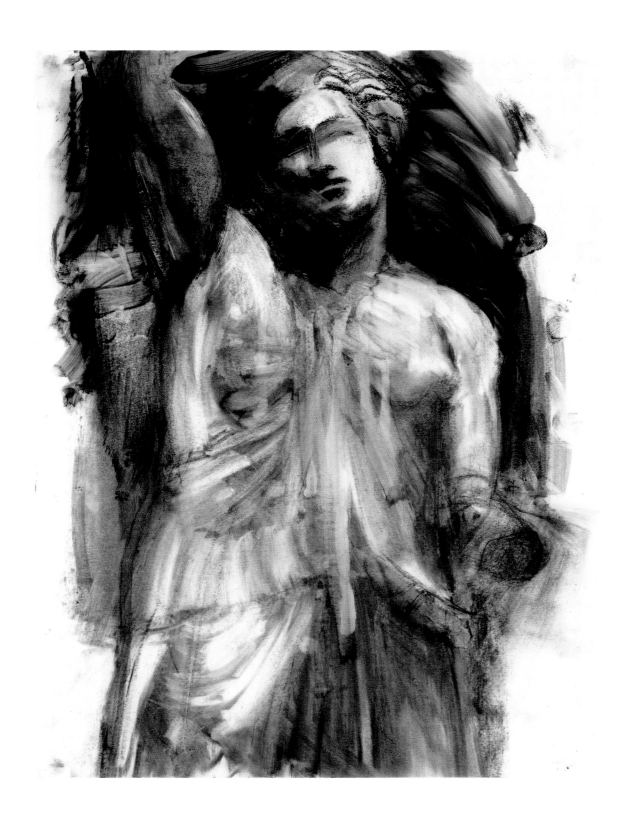

GLYPTOTEK DRAWINGS / *Drawing 3* 1987–1988
charcoal, chalk, and enamel on drafting paper
17¼ x 13 (43.8 x 33.0)

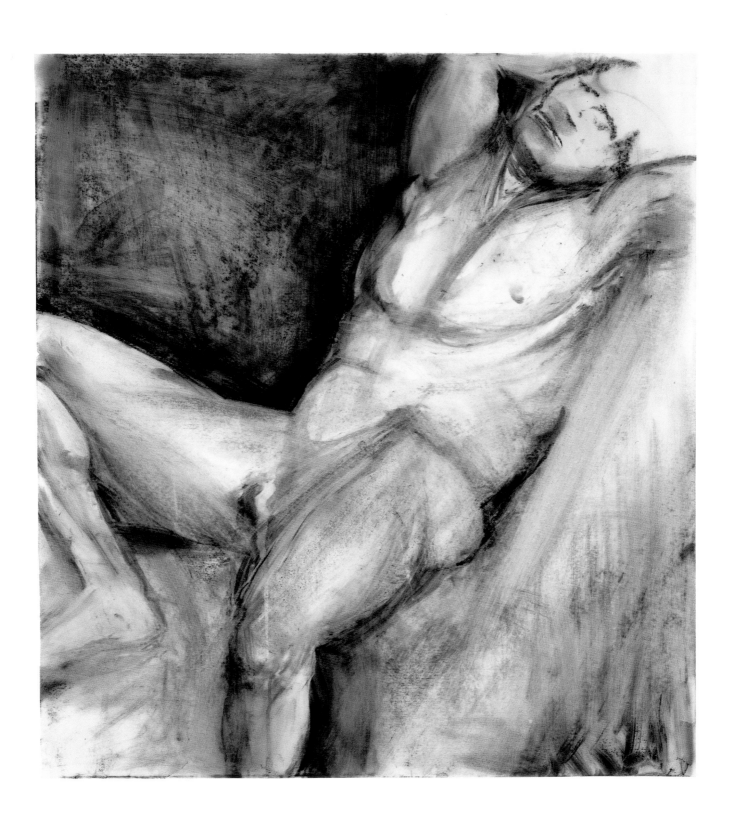

GLYPTOTEK DRAWINGS / *Drawing 4* 1987–1988
charcoal on Mylar
17¾ x 15½ (45.1 x 39.4)

41

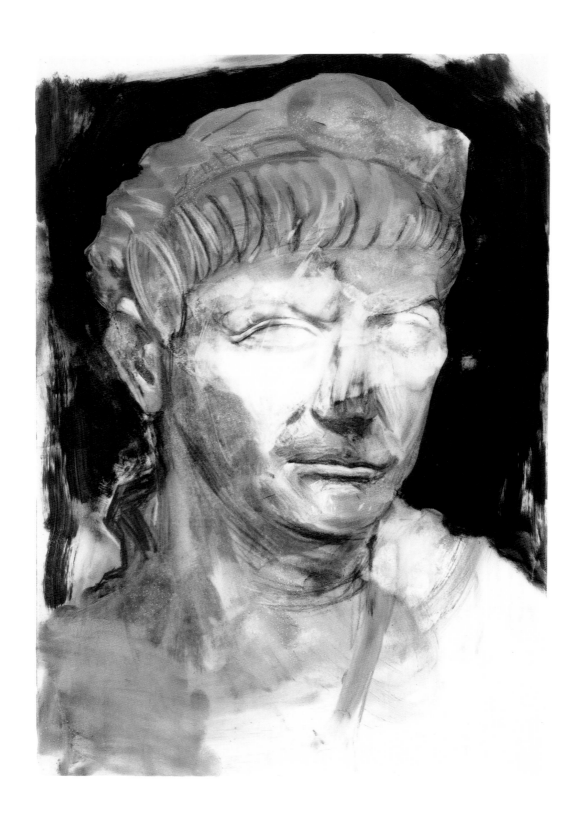

GLYPTOTEK DRAWINGS / *Drawing 5* 1987–1988
charcoal and india ink on Mylar
18¾ x 12¾ (47.6 x 32.4)

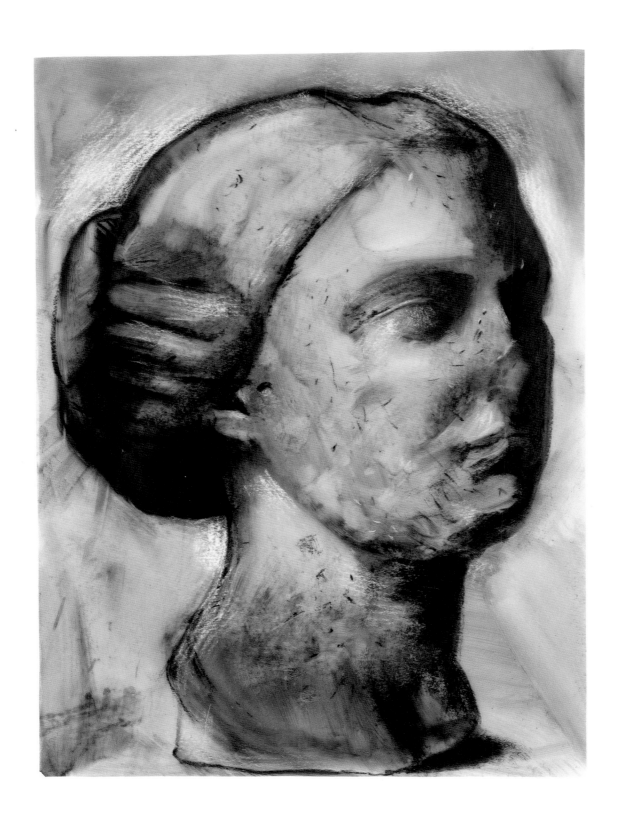

GLYPTOTEK DRAWINGS / *Drawing 6* 1987–1988
charcoal and chalk on Mylar
14¾ x 10¾ (37.5 x 27.3)

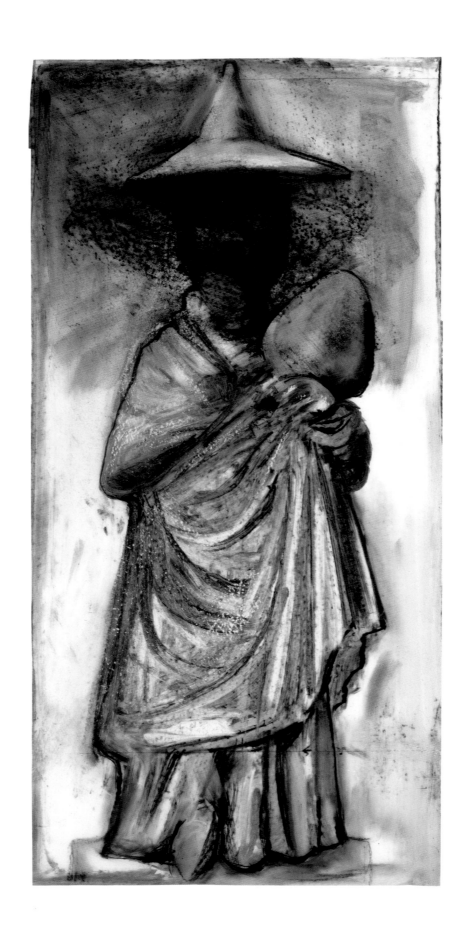

GLYPTOTEK DRAWINGS / *Drawing 7* 1987–1988
charcoal and chalk on Mylar
22 x 10½ (55.9 x 26.7)

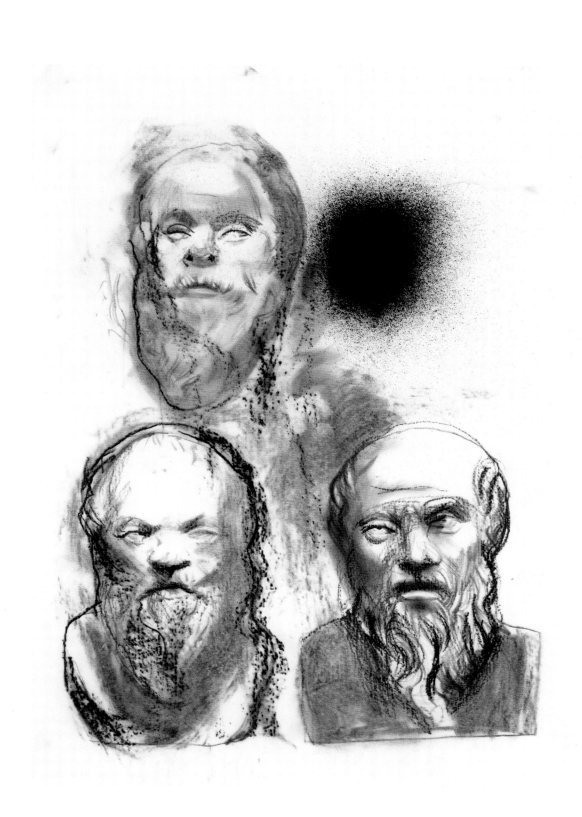

GLYPTOTEK DRAWINGS / *Drawing 8* 1987–1988
lithographic crayon, chalk, charcoal, and spray
enamel on drafting paper
17½ x 12⅞ (44.5 x 32.7)

45

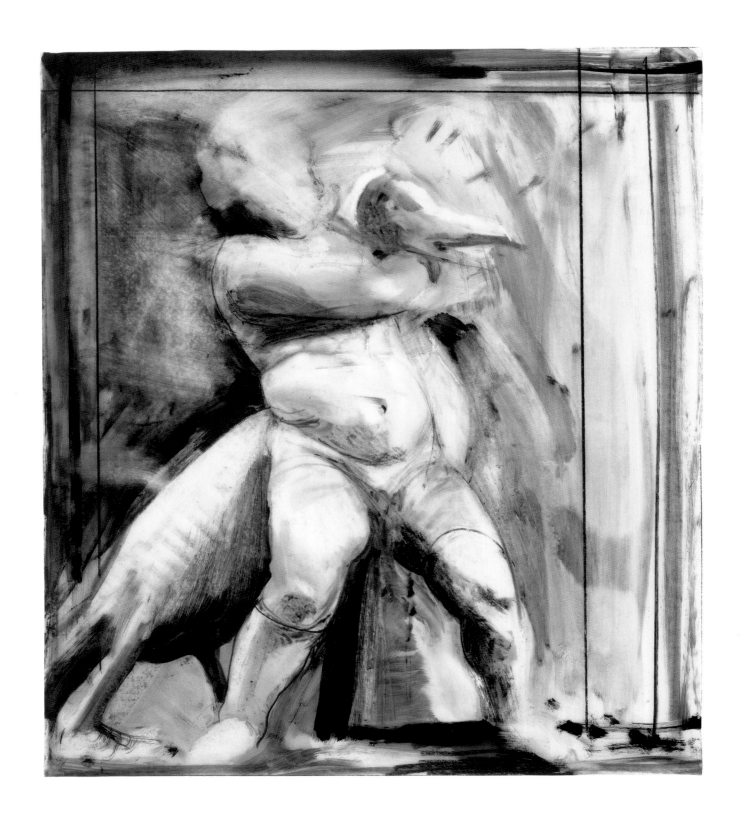

GLYPTOTEK DRAWINGS / *Drawing 9* 1987–1988
charcoal and enamel on Mylar
17⅞ x 15½ (44.7 x 39.4)

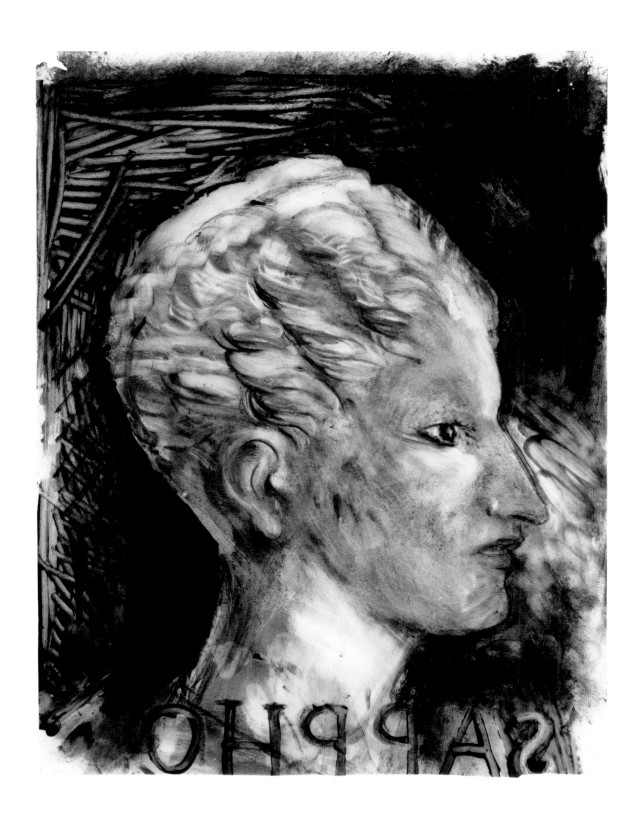

GLYPTOTEK DRAWINGS / *Drawing 10* 1987–1988
charcoal and enamel on Mylar
17 x 12⅞ (43.2 x 32.7)

GLYPTOTEK DRAWINGS / *Drawing 11* 1987–1988
charcoal on drafting paper
17½ x 13 (44.5 x 33.0)

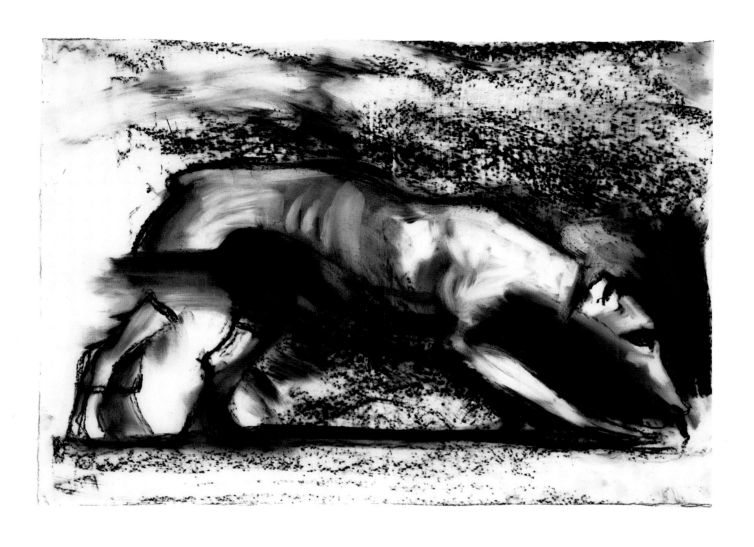

GLYPTOTEK DRAWINGS / *Drawing 12* 1987–1988
chalk and charcoal on drafting paper
12¾ x 17½ (32.4 x 44.5)

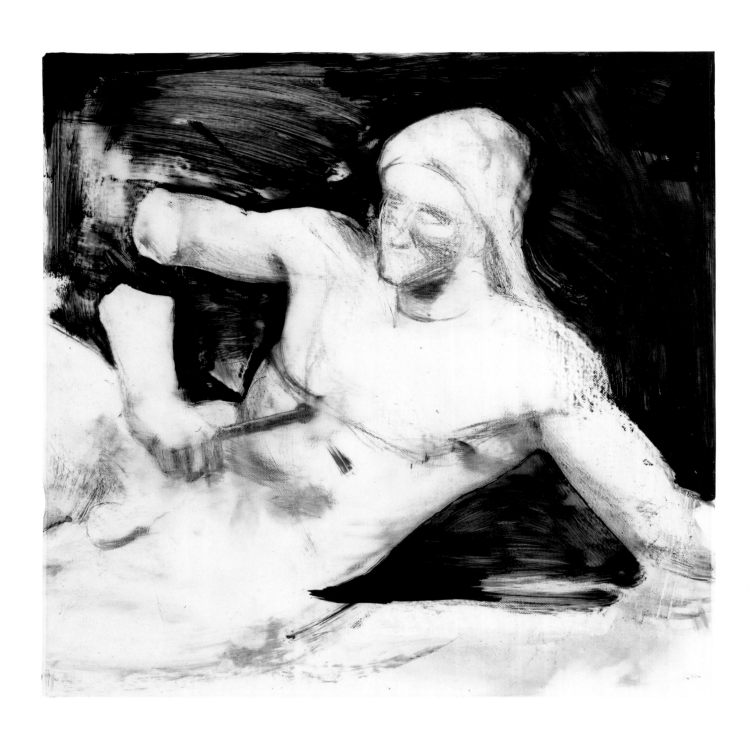

GLYPTOTEK DRAWINGS / *Drawing 13* 1987–1988
charcoal and enamel on Mylar
14 x 14 (35.6 x 35.6)

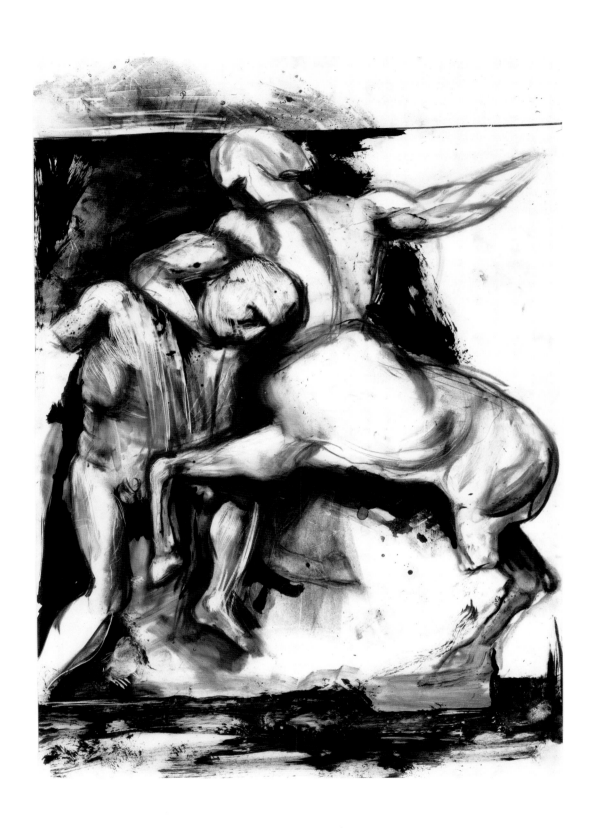

GLYPTOTEK DRAWINGS / *Drawing 14* 1987–1988
charcoal and india ink on Mylar
16½ x 11½ (41.9 x 29.2)

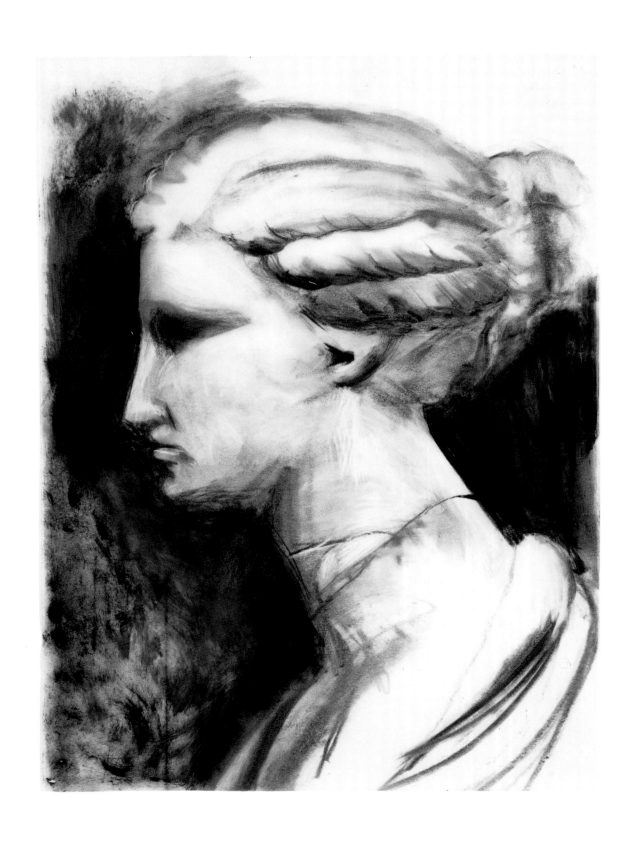

GLYPTOTEK DRAWINGS / *Drawing 15* 1987–1988
charcoal and color pencil on drafting paper
17½ x 13 (44.5 x 33.0)

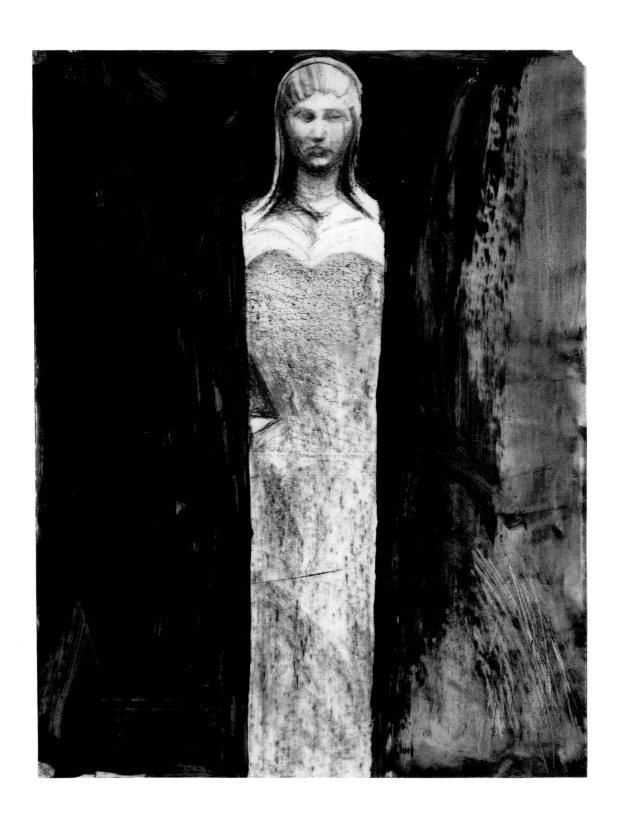

GLYPTOTEK DRAWINGS / *Drawing 16* 1987–1988
enamel, charcoal, and chalk on drafting paper
17½ x 13 (44.5 x 33.0)

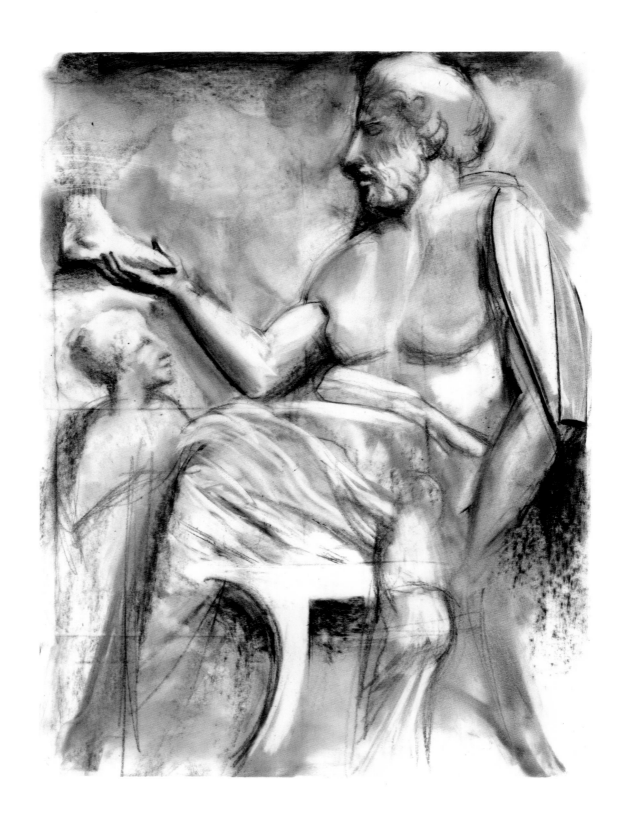

GLYPTOTEK DRAWINGS / *Drawing 17* 1987–1988
charcoal on Mylar
17½ x 13 (44.5 x 33.0)

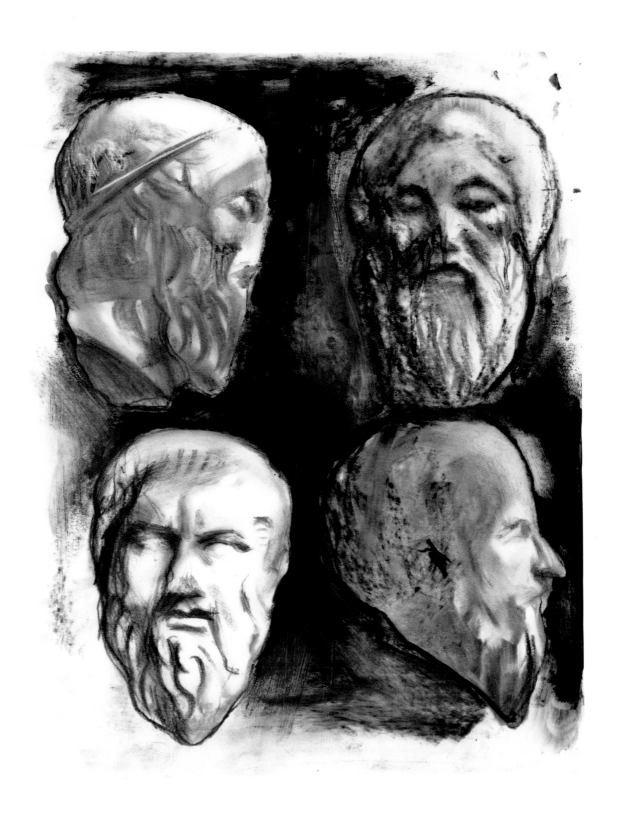

GLYPTOTEK DRAWINGS / *Drawing 18* 1987–1988
charcoal and india ink on drafting paper
17½ x 13 (44.5 x 33.0)

GLYPTOTEK DRAWINGS / *Drawing 19* 1987–1988
charcoal and lithographic crayon on Mylar
18¾ x 13⅞ (47.6 x 35.2)

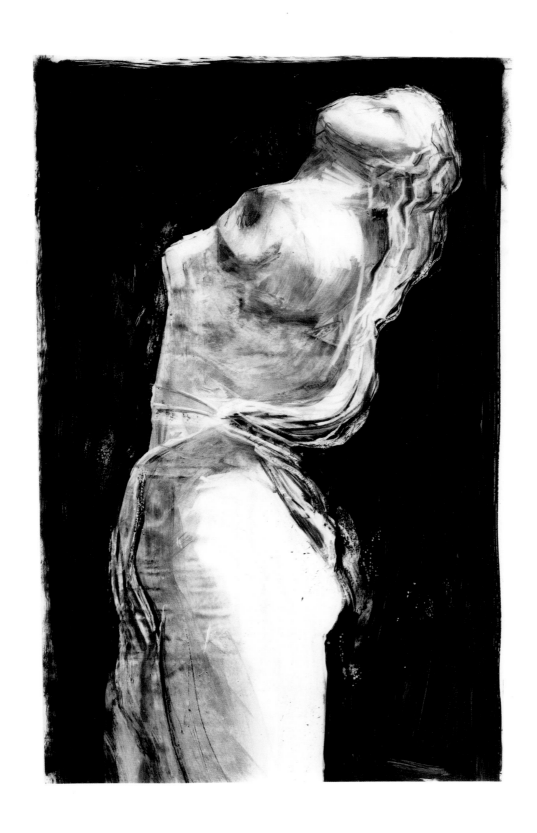

GLYPTOTEK DRAWINGS / *Drawing 20* 1987–1988
charcoal and enamel on Mylar
17 x 10¾ (43.2 x 27.3)

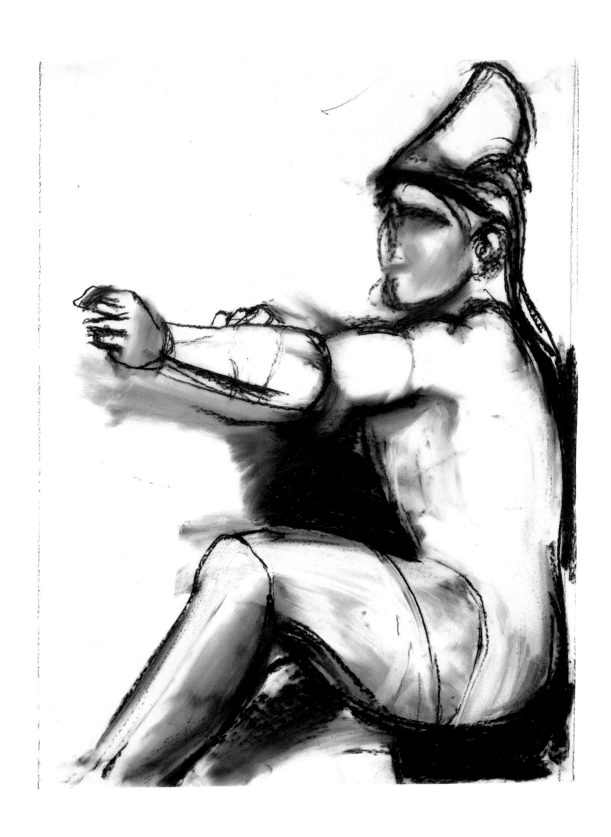

GLYPTOTEK DRAWINGS / *Drawing 21* 1987–1988
chalk on Mylar
17½ x 12½ (44.5 x 31.8)

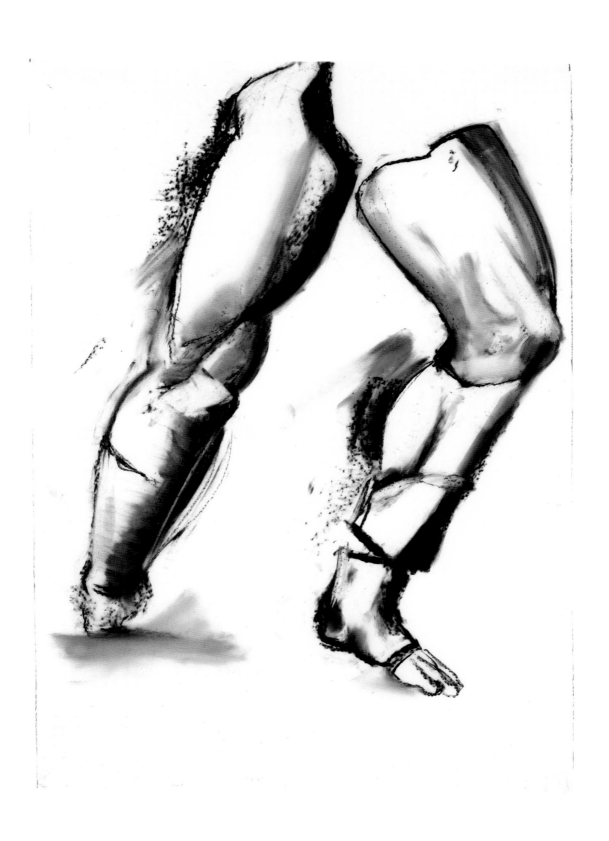

Glyptotek Drawings / *Drawing 22* 1987–1988
charcoal and chalk on Mylar
17½ x 12⅛ (44.5 x 32.0)

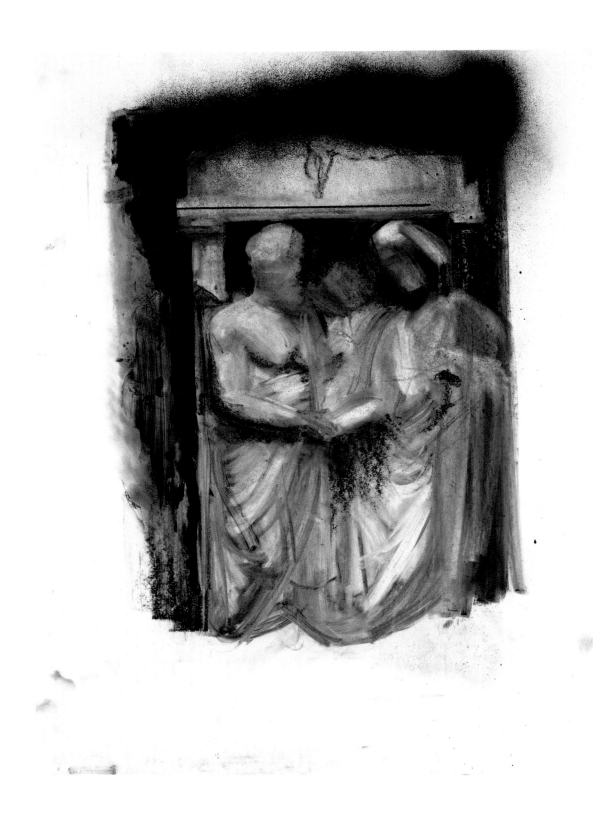

GLYPTOTEK DRAWINGS / *Drawing 23* 1987–1988
charcoal, chalk, spray enamel, and tape on drafting paper
25½ x 19⅞ (64.8 x 49.8)

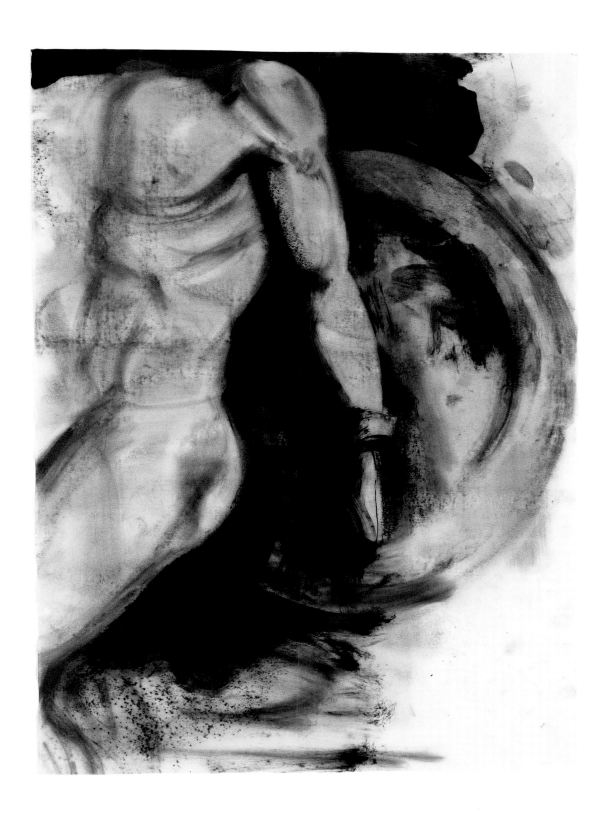

GLYPTOTEK DRAWINGS / *Drawing 24* 1987–1988
charcoal and india ink on drafting paper
17¼ x 12½ (43.8 x 31.8)

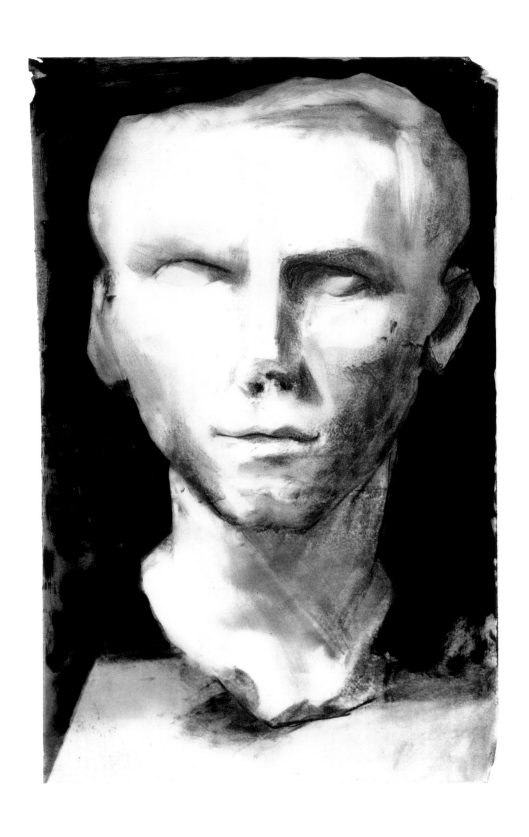

GLYPTOTEK DRAWINGS / *Drawing 25* 1987–1988
charcoal and india ink on drafting paper
17½ x 11 (44.5 x 27.9)

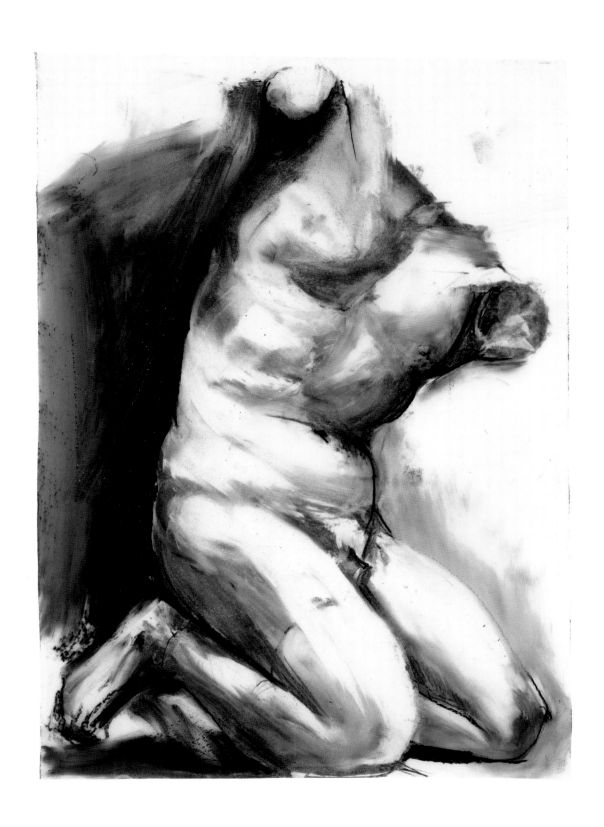

GLYPTOTEK DRAWINGS / *Drawing 26* 1987–1988
charcoal and chalk on drafting paper
17¾ x 12⅝ (45.1 x 32.0)

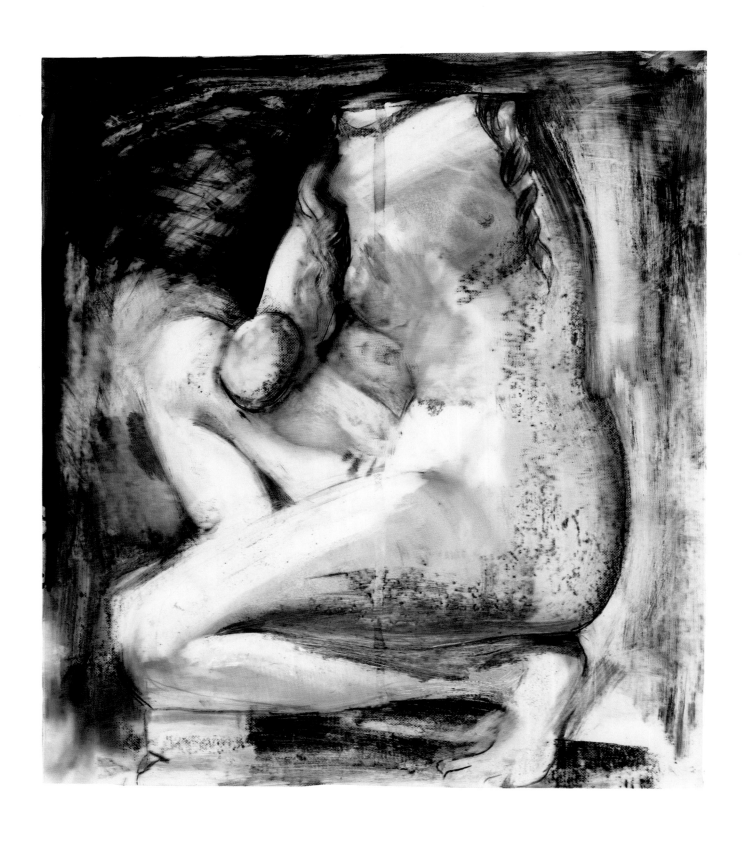

GLYPTOTEK DRAWINGS / *Drawing 27* 1987–1988
charcoal and india ink on Mylar
14¾ x 13 (37.5 x 33.0)

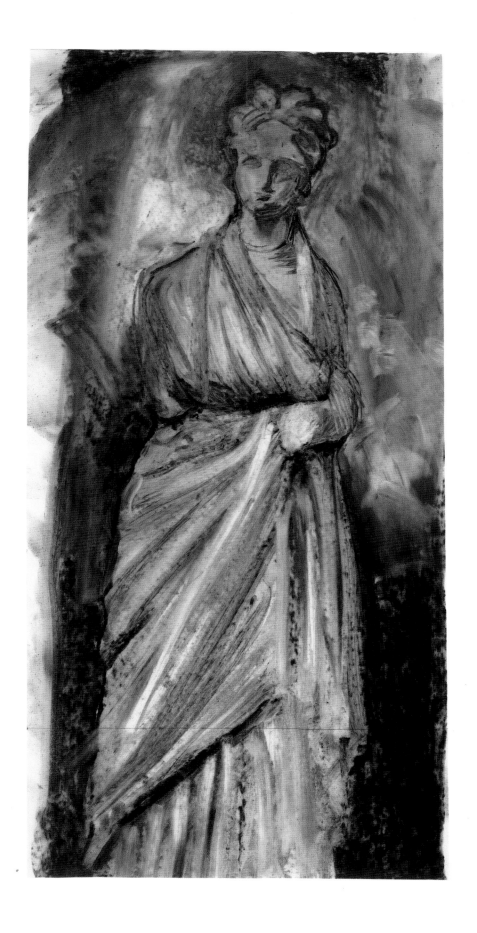

GLYPTOTEK DRAWINGS / *Drawing 28* 1987–1988
lithographic crayon and charcoal on drafting paper
22½ x 11 (57.2 x 27.9)

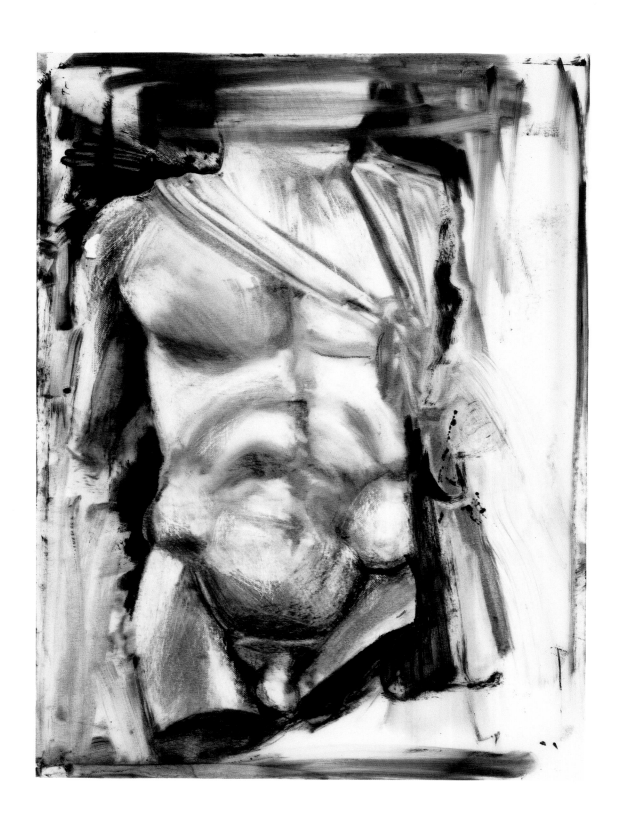

GLYPTOTEK DRAWINGS / *Drawing 29* 1987–1988
charcoal and enamel on drafting paper
17½ x 12¾ (44.5 x 32.4)

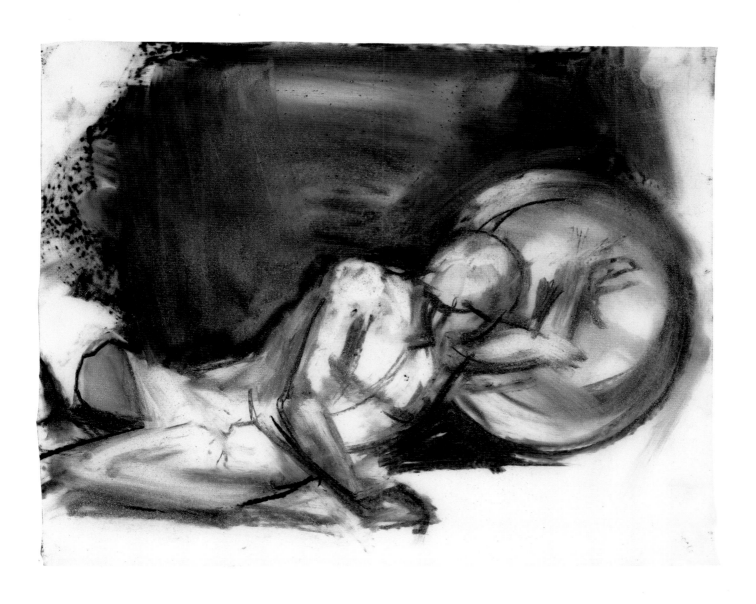

GLYPTOTEK DRAWINGS / *Drawing 30* 1987–1988
charcoal on drafting paper
8⅞ x 10¾ (21.9 x 27.3)

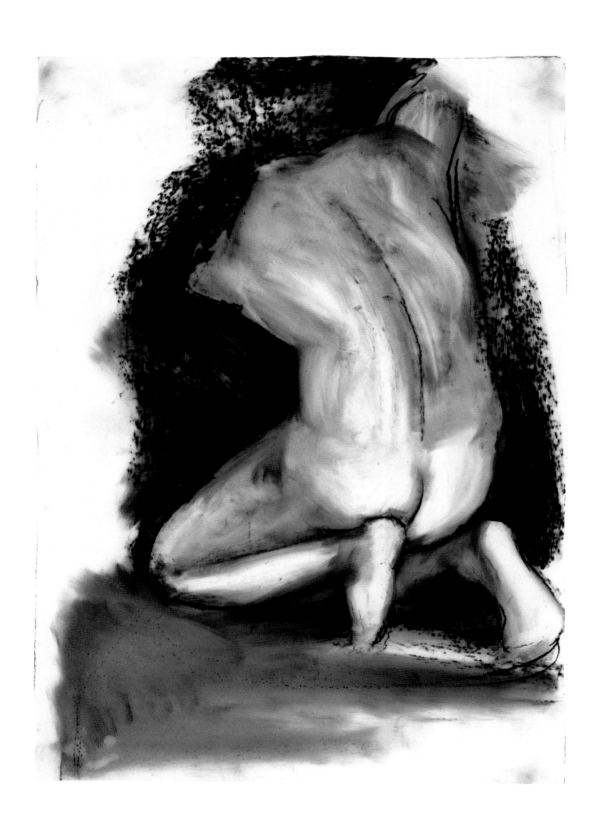

GLYPTOTEK DRAWINGS / *Drawing 31* 1987–1988
chalk and charcoal on Mylar
17½ x 12½ (44.5 x 31.8)

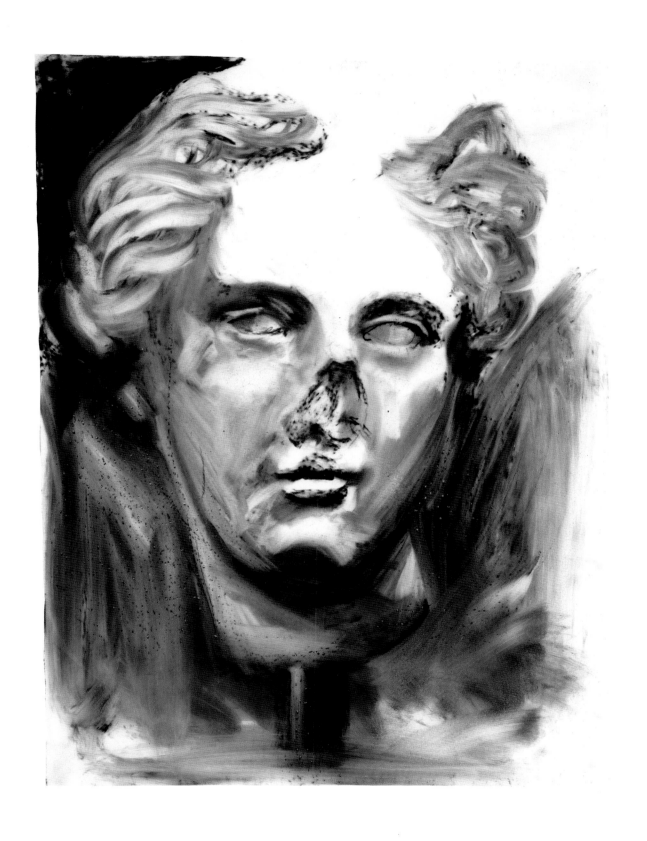

GLYPTOTEK DRAWINGS / *Drawing 32* 1987–1988
charcoal on Mylar
17 x 13 (43.2 x 33.0)

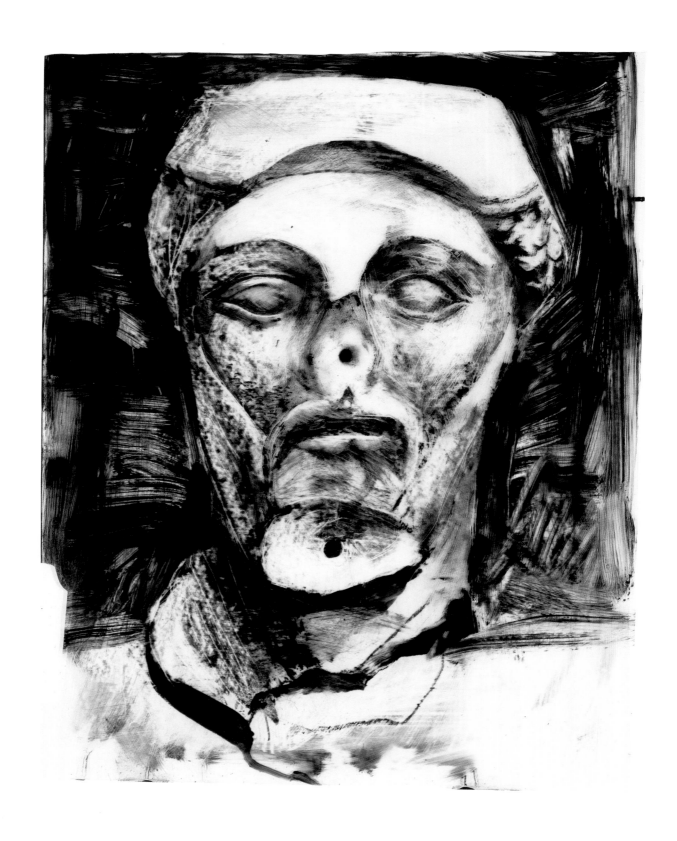

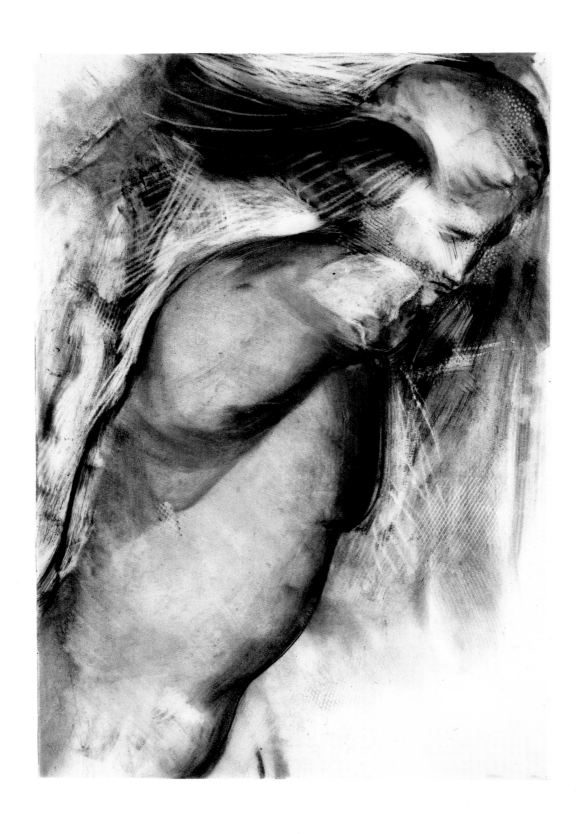

GLYPTOTEK DRAWINGS / *Drawing 34* 1987–1988
charcoal and enamel on drafting paper
18¾ x 12¾ (47.6 x 32.4)

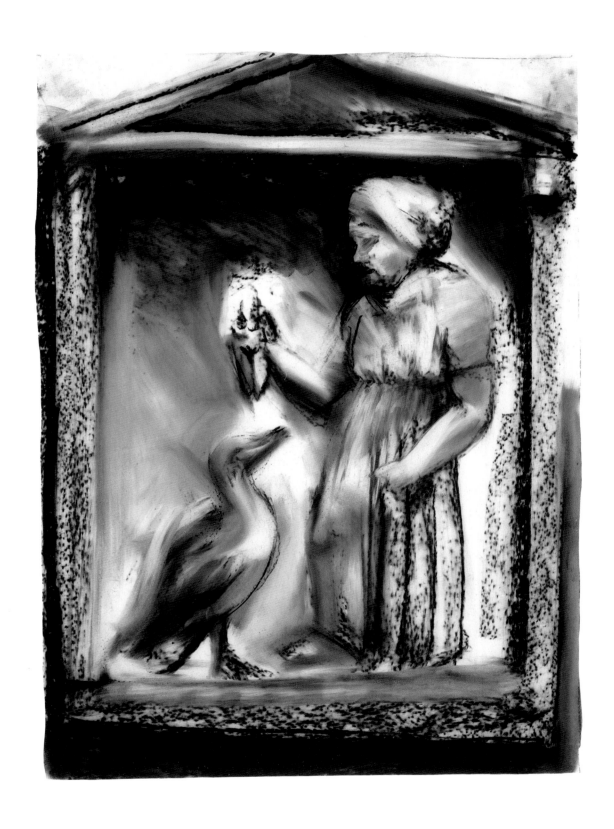

GLYPTOTEK DRAWINGS / *Drawing 35* 1987–1988
charcoal on drafting paper
17⅞ x 12¾ (44.7 x 32.4)

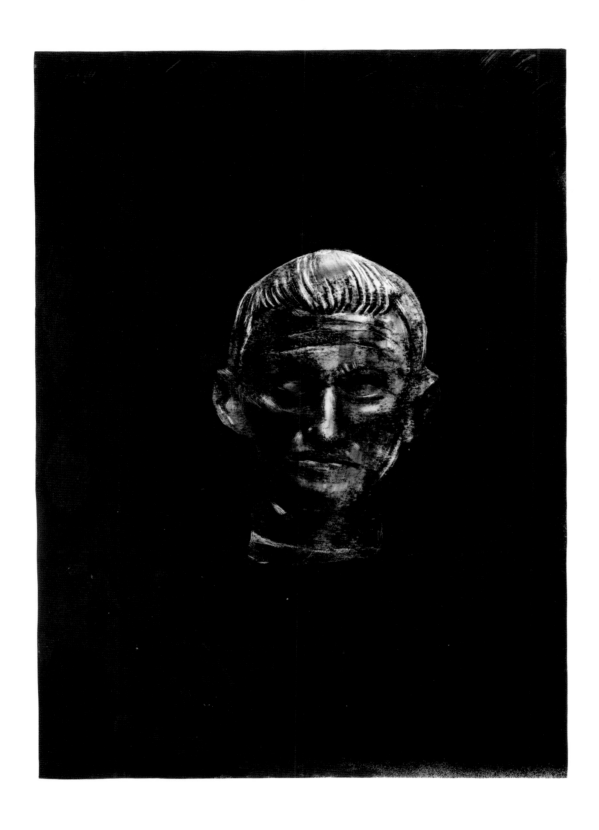

GLYPTOTEK DRAWINGS / *Drawing 36* 1987–1988
enamel and chalk on drafting paper
14½ x 10¼ (36.8 x 26.0)

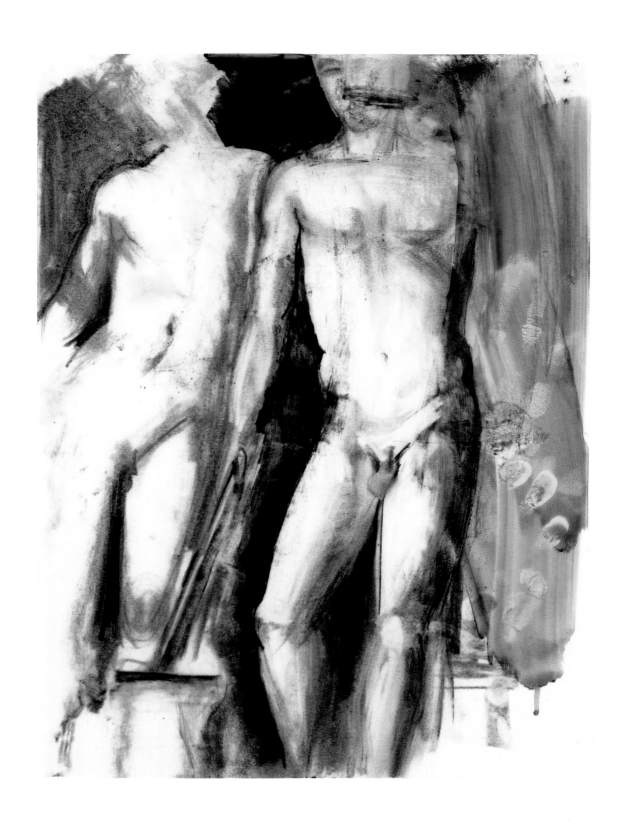

GLYPTOTEK DRAWINGS / *Drawing 37* 1987–1988
enamel and charcoal on Mylar
17½ x 12⅞ (44.5 x 32.7)

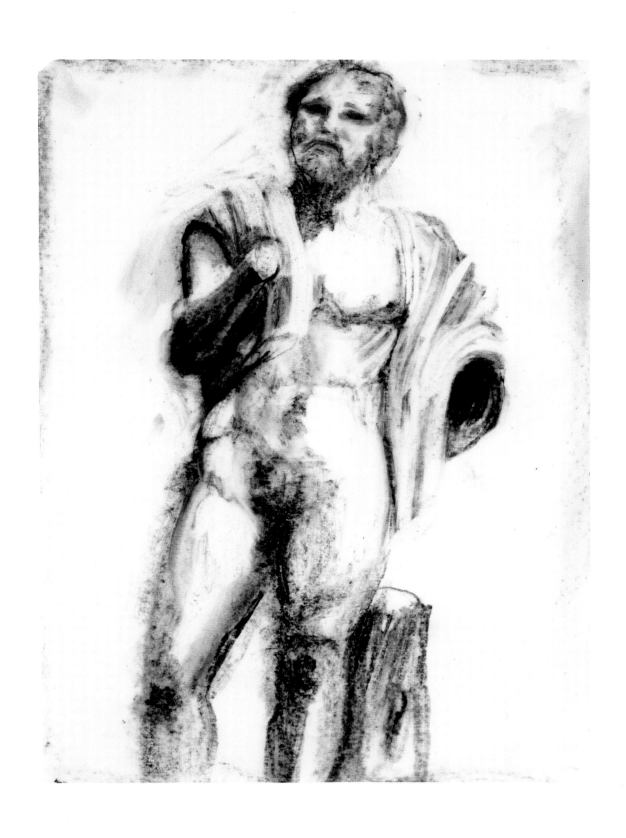

GLYPTOTEK DRAWINGS / *Drawing 38* 1987–1988
charcoal on drafting paper
17½ x 13 (44.5 x 33.0)

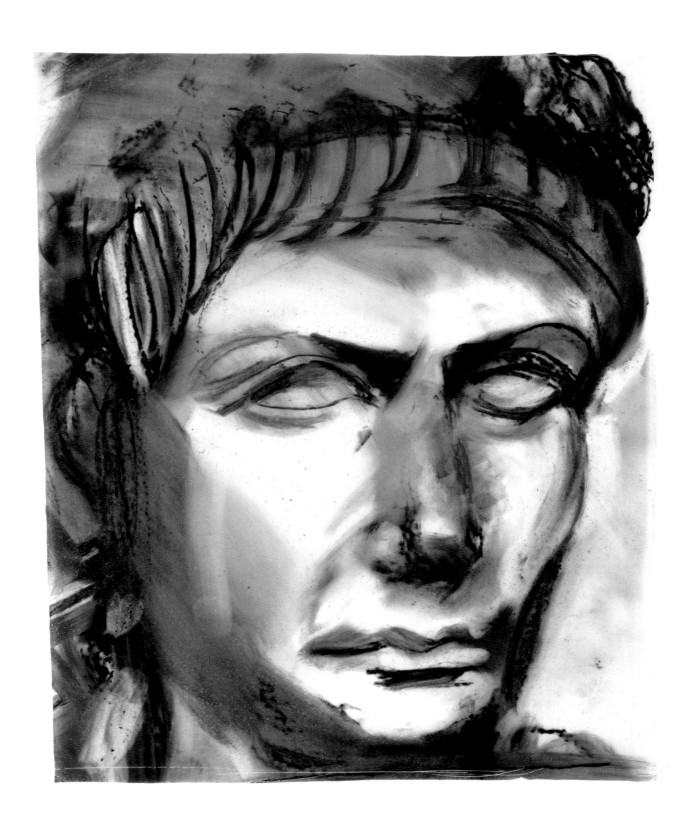

GLYPTOTEK DRAWINGS / *Drawing 39* 1987–1988
chalk and charcoal on Mylar
10⅛ x 8¼ (25.7 x 21.0)

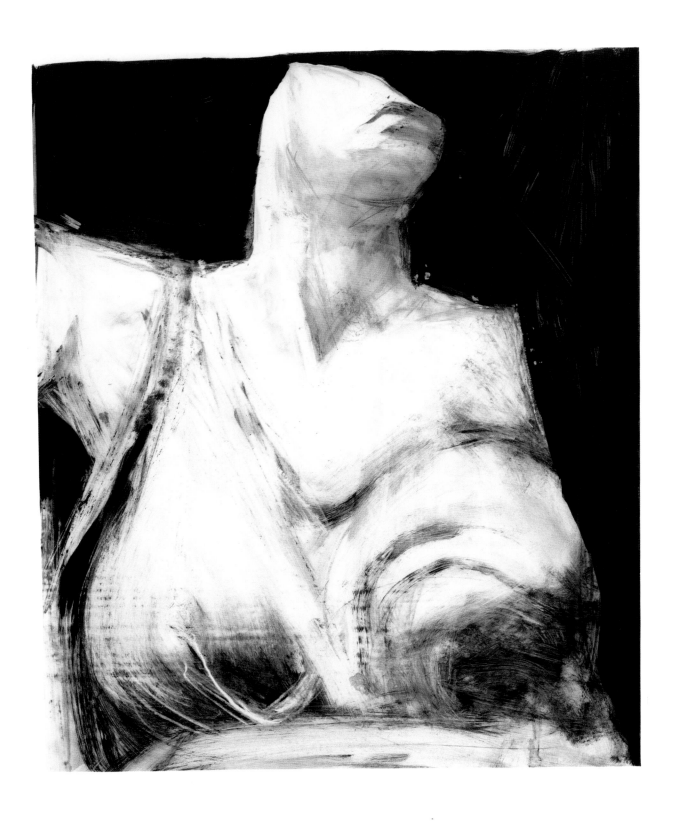

GLYPTOTEK DRAWINGS / *Drawing 40* 1987–1988
enamel, charcoal, and ferric chloride on Mylar
16⅛ x 13 (41.6 x 33.0)

IN DER GLYPTOTHEK

IN DER GLYPTOTHEK is a series of seventeen individual works produced by Jim Dine in 1989. Though many of these drawings were made at the Glyptothek in Munich, some were completed or initiated upon the artist's return to his London studio.

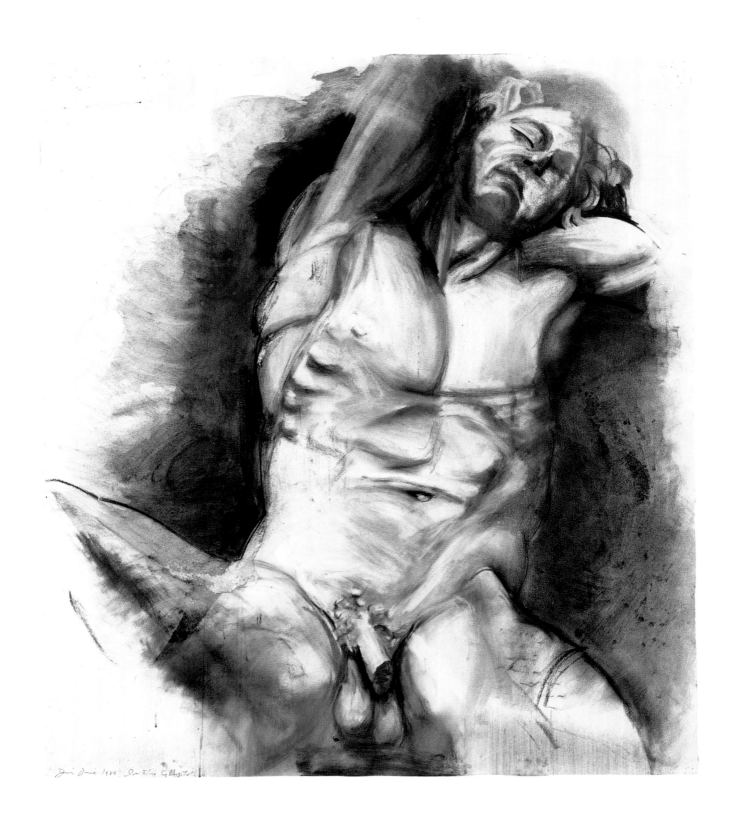

SLEEPING SATYR / *Barberini Faun, ca. 220 B.C.* 1989
watercolor and charcoal on paper
47¾ x 41¾ (121.3 x 106.0)

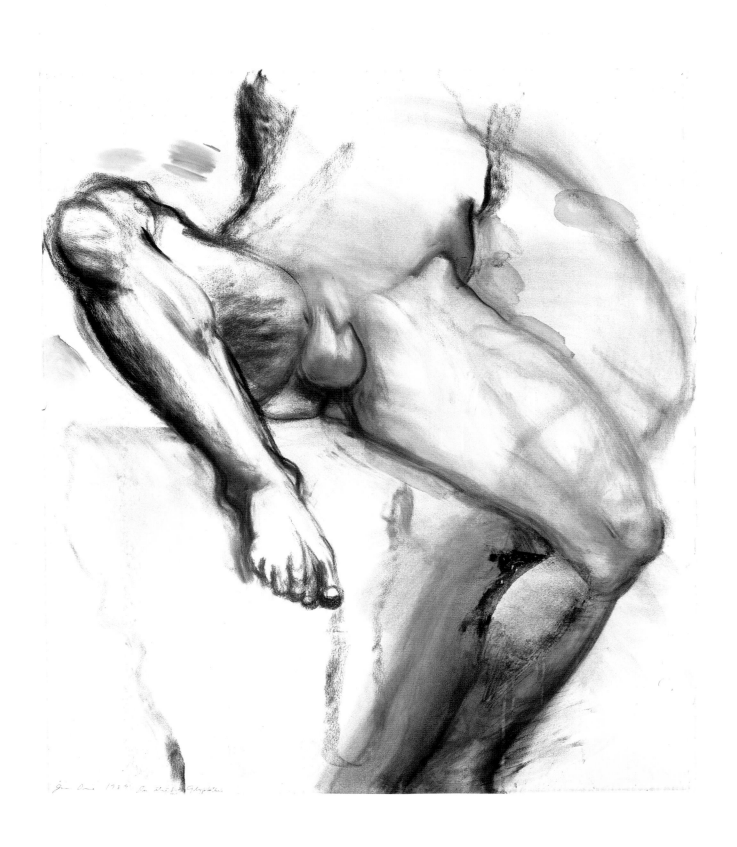

SLEEPING SATYR / *Barberini Faun, ca. 220 B.C.* 1989
watercolor, charcoal, and color pencil on paper
47¾ x 41¼ (121.3 x 106.0)

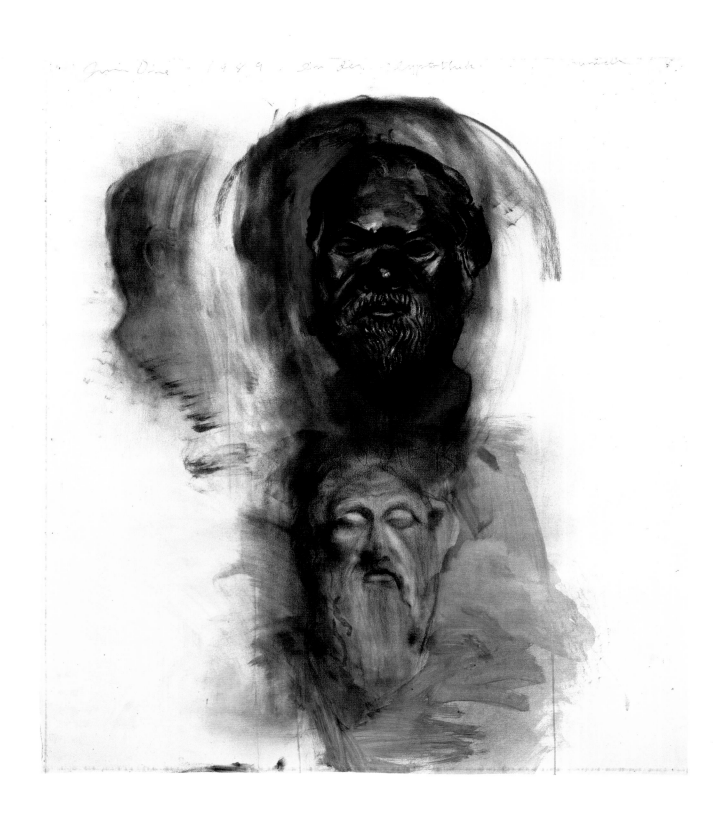

HOMER AND SOCRATES / *Homer, Roman copy of a bronze,*
ca. 460 B.C. Socrates, late bronze version of the original, ca. 380 B.C.
1989
charcoal and watercolor on paper
47¾ x 41¾ (121.3 x 106.0)

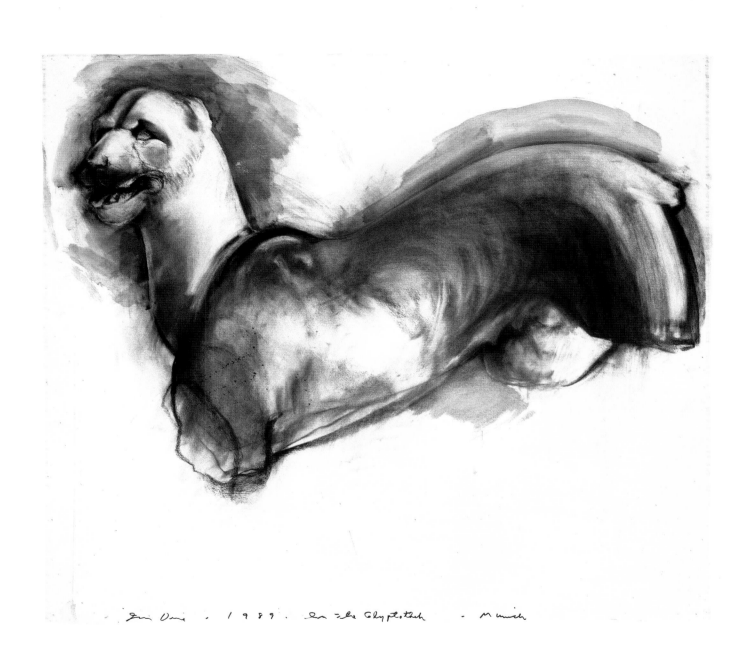

Jim Dine · 1989 · In the Glyptothek · Munich

PANTHER / *from a grave monument in Attica, ca. 360 B.C.*
1989
charcoal and watercolor on paper
41¾ x 47½ (106.0 x 121.3)

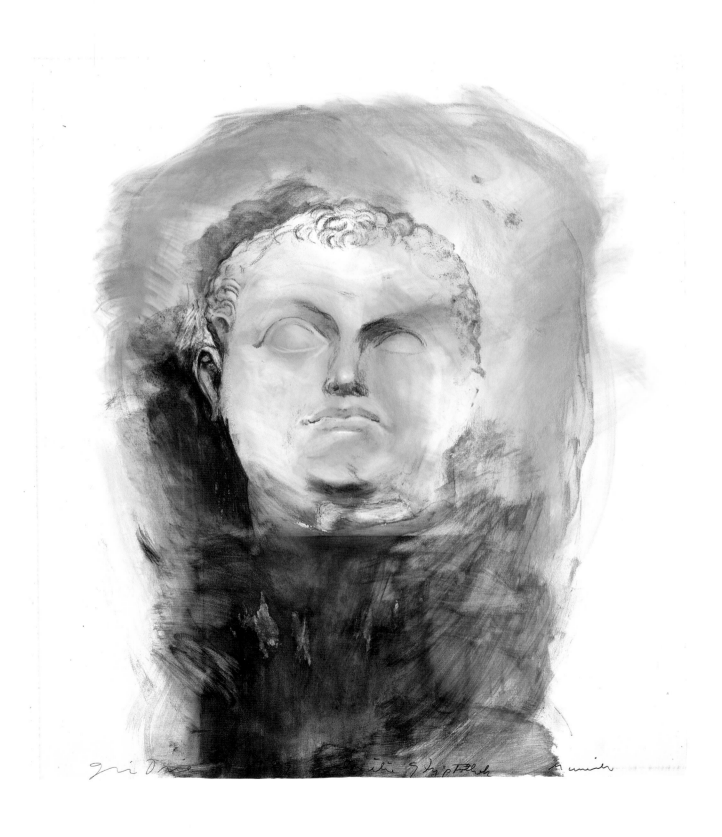

COLOSSAL PORTRAIT OF THE EMPEROR TITUS / *ca. A.D. 80*
1989
conté crayon, charcoal, and watercolor on paper
47⅞ x 41⅞ (120.9 x 106.4)

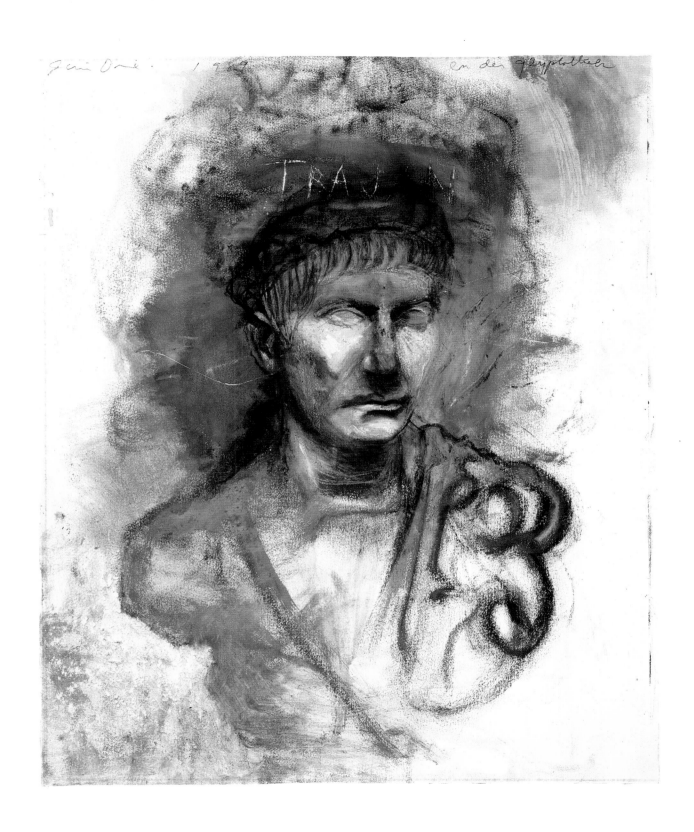

PORTRAIT BUST OF THE EMPEROR TRAJAN / *ca. A.D. 100*
1989
charcoal, watercolor, acrylic, and enamel on paper
48⅛ x 39⅞ (122.9 x 101.3)

85

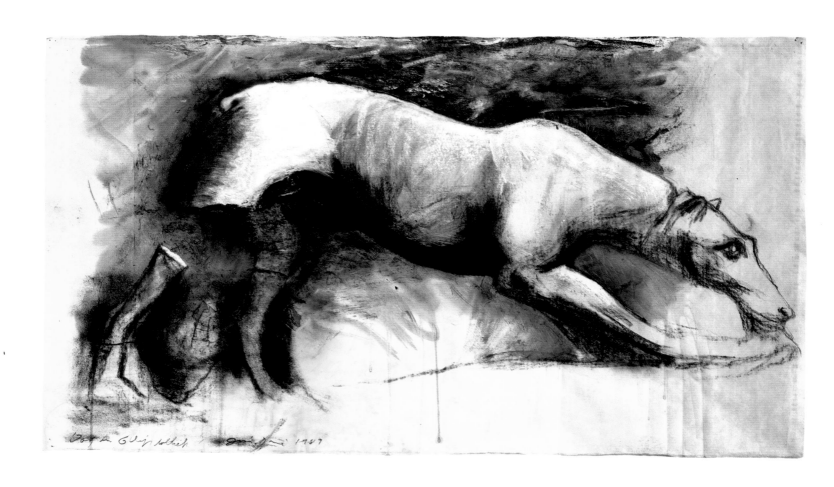

HUNTING HOUND / *from a grave monument in Attica, ca. 360–350 B.C.*
1989
oil stick, charcoal, watercolor, color pencil, and collage on paper
38 x 66⅛ (96.5 x 169.2)

für Drue · 1989 — In der Glyptothek.

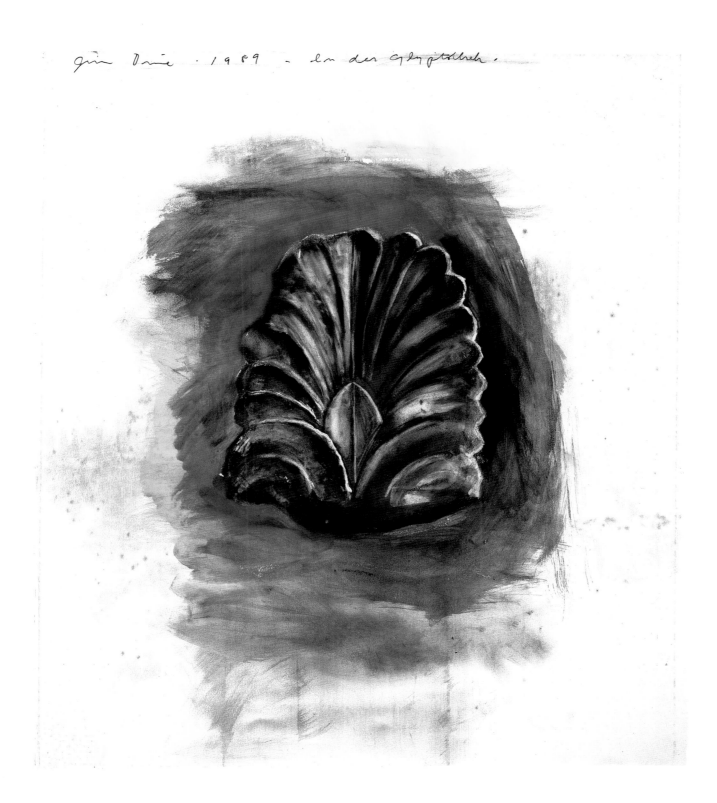

PALMETTE FROM THE PARTHENON / *ca. 440–430 B.C.* 1989
charcoal and watercolor on paper
47⅞ x 41¼ (120.9 x 106.0)

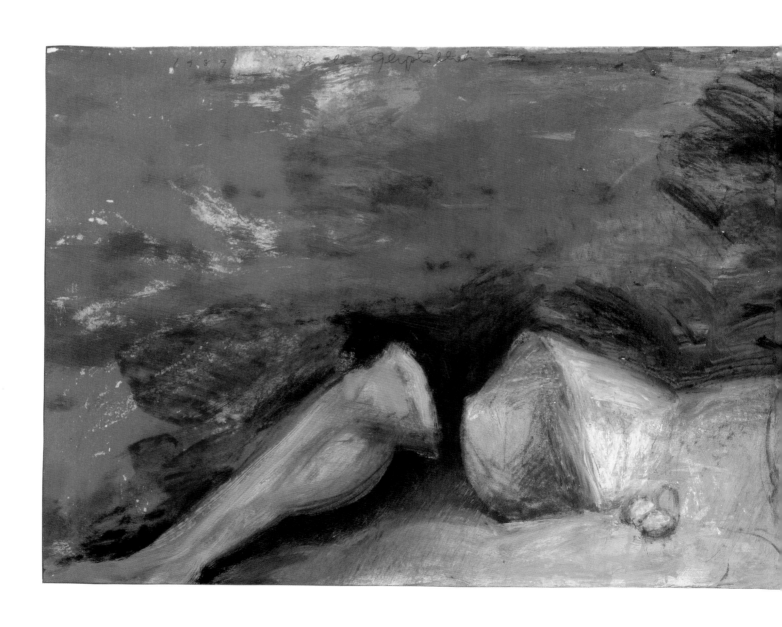

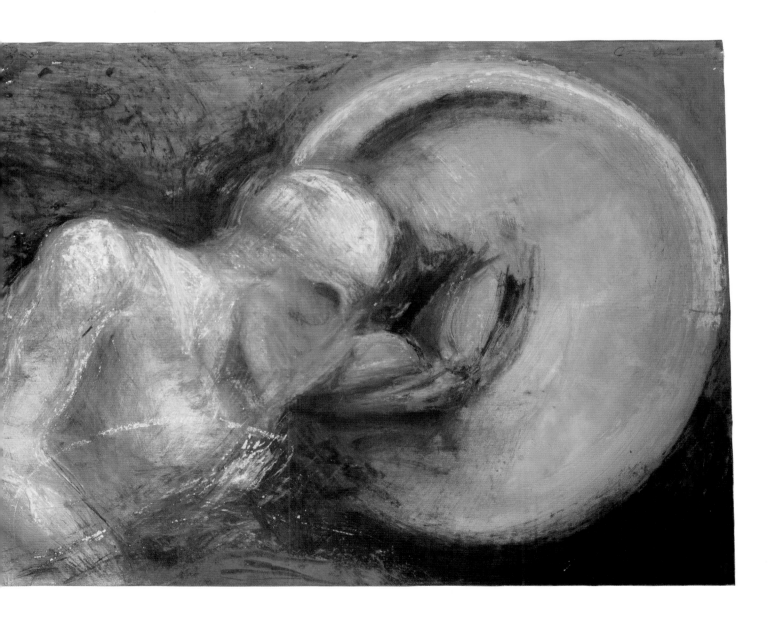

WOUNDED TROJAN / *Laomedon, from the east pediment of the Temple of Aphaia at Aegina, ca. 500–490 B.C.* 1989
acrylic, oil stick, and charcoal on two sheets of paper
35 x 95⅛ (88.9 x 242.8)

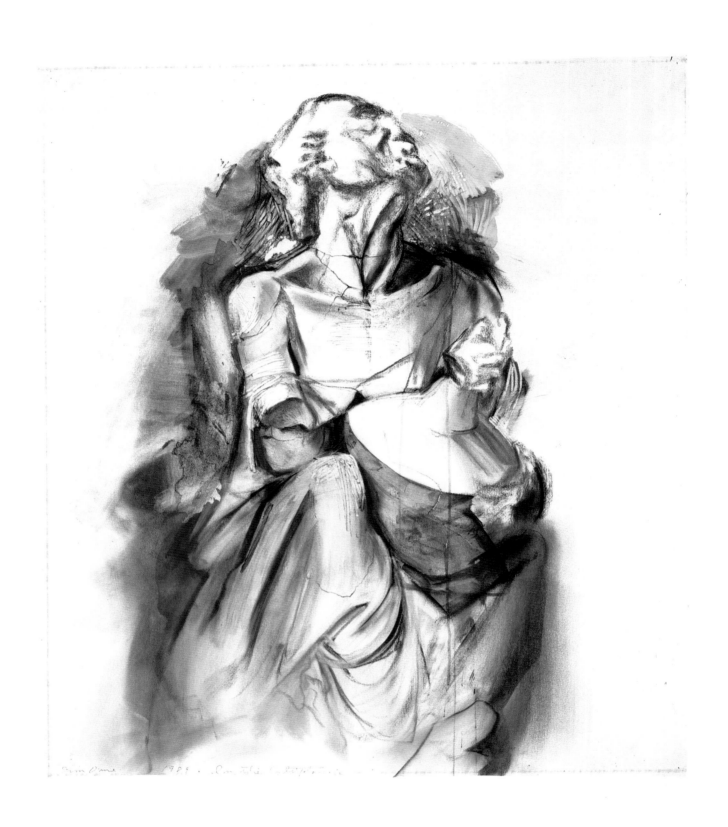

DRUNKEN OLD WOMAN WITH A WINESKIN / *Roman copy
after a work in bronze, ca. 200 B.C.* 1989
charcoal and watercolor on paper
47⅛ x 42 (120.9 x 106.7)

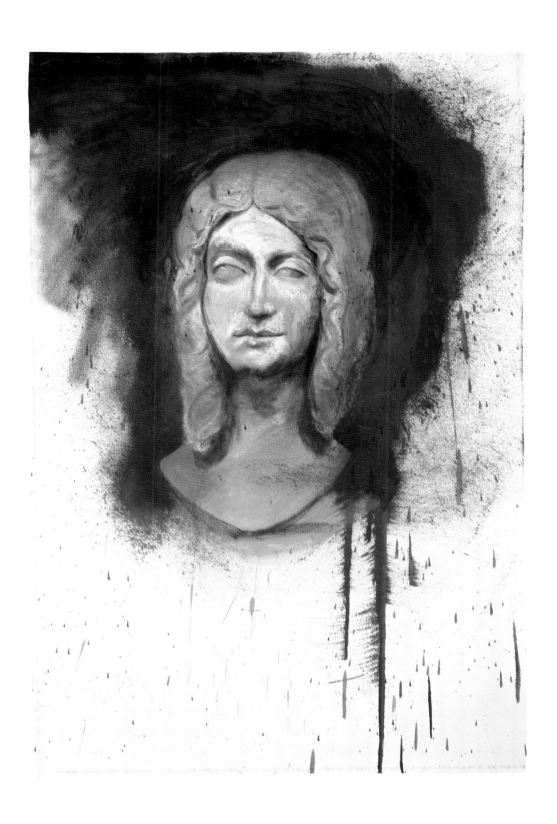

PORTRAIT OF A ROMAN / *from the time of the*
Empress Julia Domna, ca. A.D. 190 1989
charcoal, watercolor, oil stick, and enamel on paper
59⅞ x 39⅞ (152.1 x 101.3)

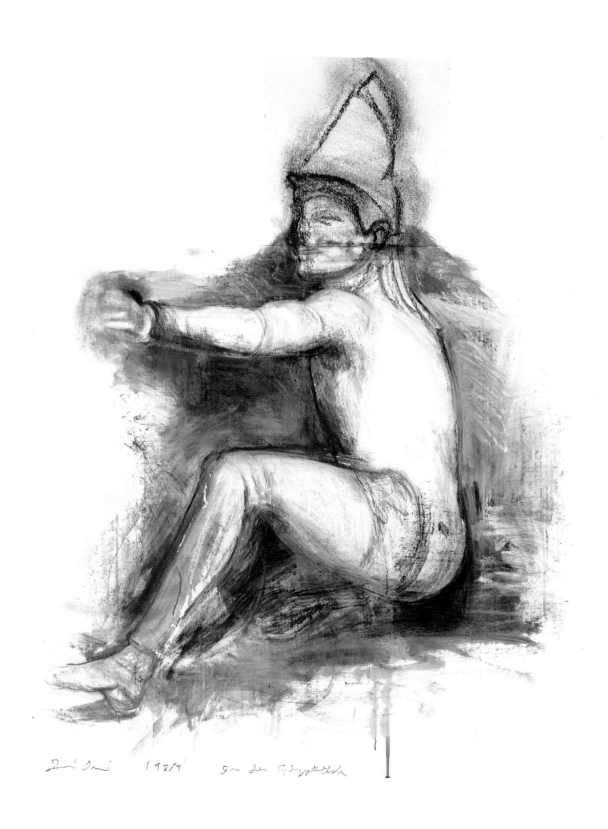

Trojan Archer / *Paris, from the west pediment of the Temple of Aphaia at Aegina, ca. 500 B.C.* 1989
charcoal, oil stick, watercolor, acrylic, and turpentine wash on two sheets of paper
67⅛ x 51⅛ (171.1 x 131.0)

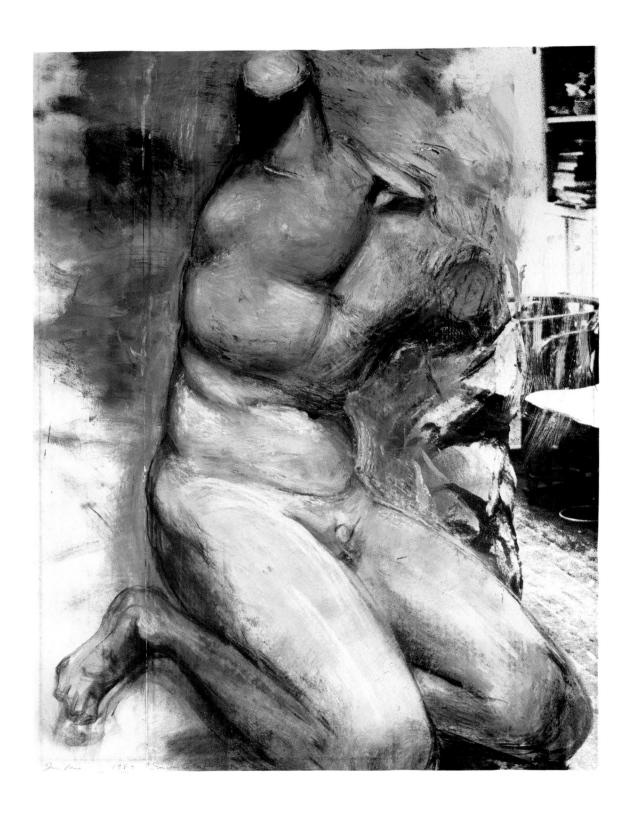

Twisted Torso of a Youth / *Ilioneus, ca. 300 B.C.* 1989
oil stick, acrylic, charcoal, and watercolor over
screenprinted photograph on two sheets of paper
58 x 44¼ (147.3 x 112.4)

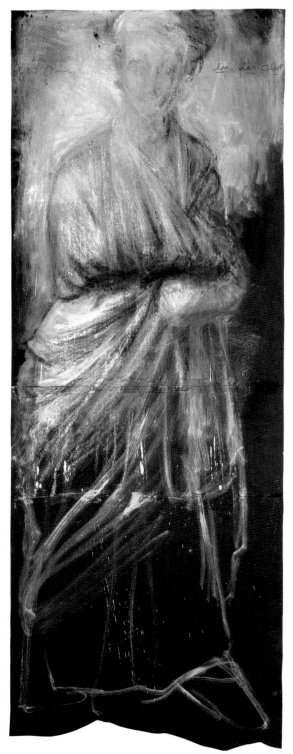

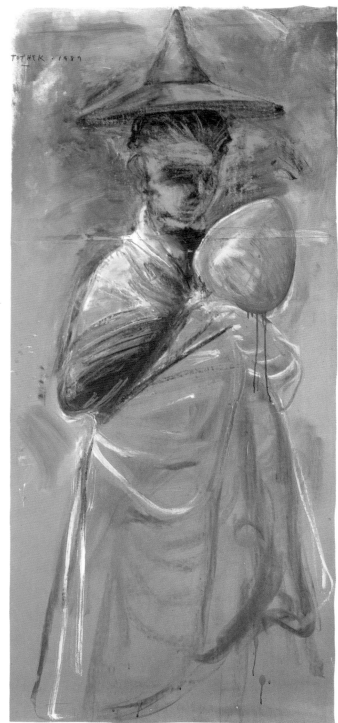

TANAGRA FIGURES / *ca. 300 B.C.* 1989
charcoal, oil stick, and enamel on paper
(diptych)
left: 82¼ x 29½ (208.9 x 74.9) [three sheets]
right: 79⅛ x 35 (201.0 x 88.9) [two sheets]

94

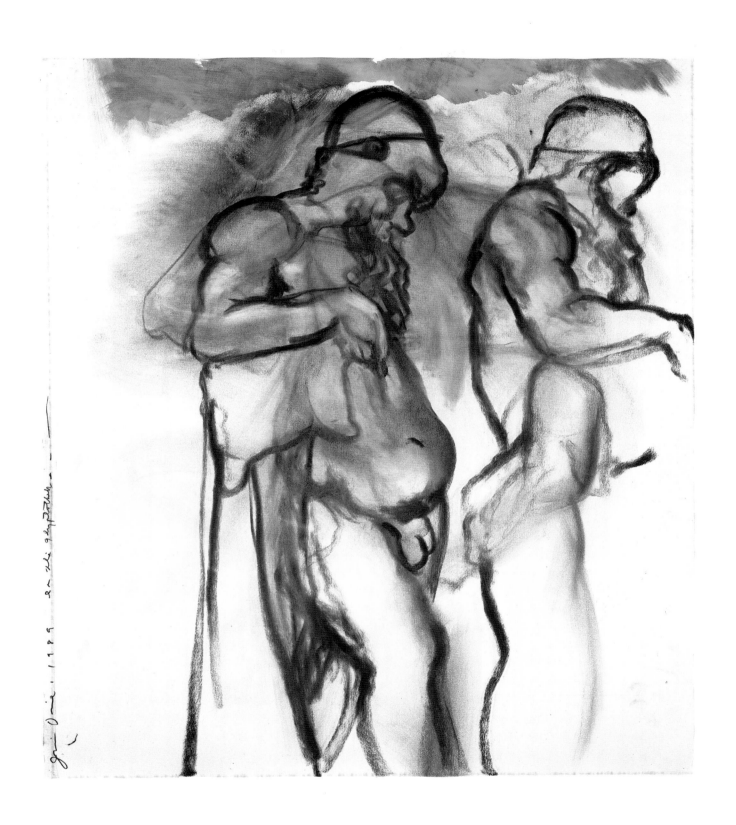

AGED SILENUS WITH WINESKIN / *Roman work after
the Hellenistic original* 1989
charcoal and watercolor on paper
47¾ x 41¾ (121.3 x 106.0)

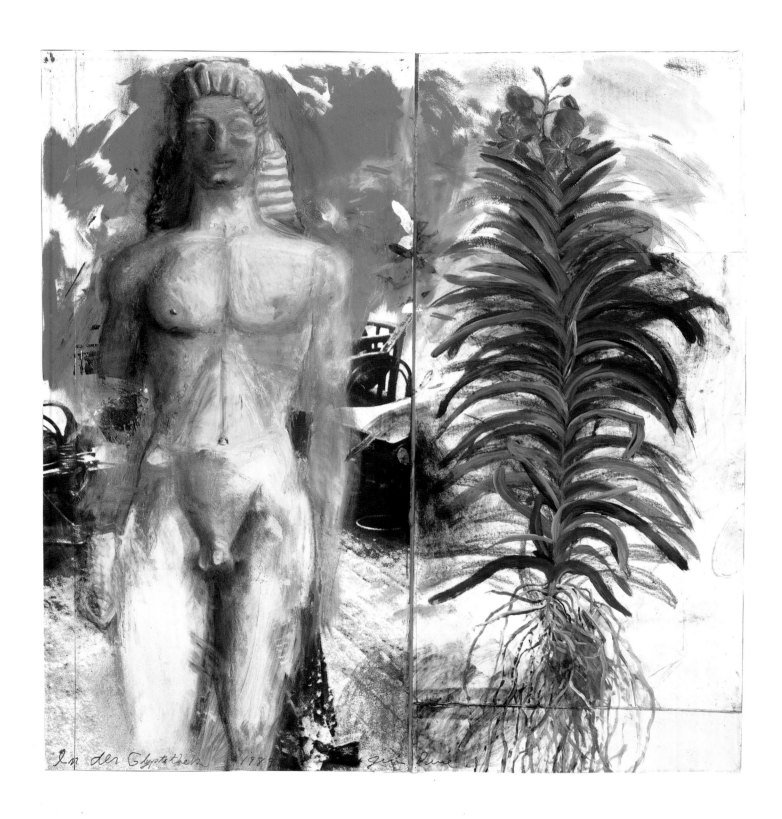

KOUROS FIGURE / *from Tenea and Lily Kouros, ca. 560 B.C.* 1989
acrylic, gesso, charcoal, watercolor, and conté crayon
over screenprinted photograph on four sheets of paper
62 x 58¼ (157.5 x 148.0)

96

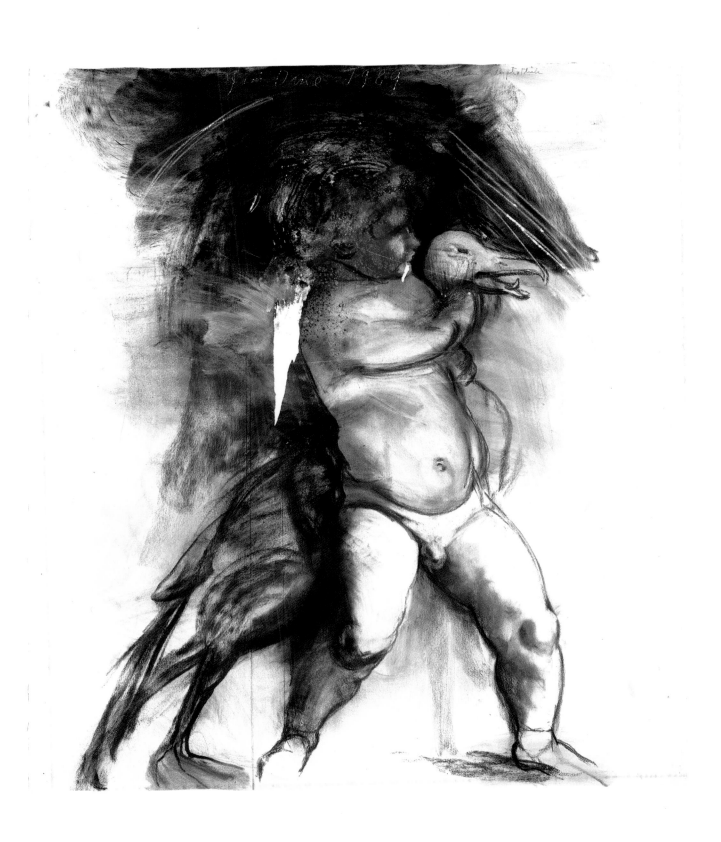

BOY WITH A GOOSE / *Roman copy after a work in bronze,*
ca. 220 B.C. 1989
charcoal, watercolor, chalk, and conté crayon on paper
47¾ x 41⅞ (121.3 x 106.4)

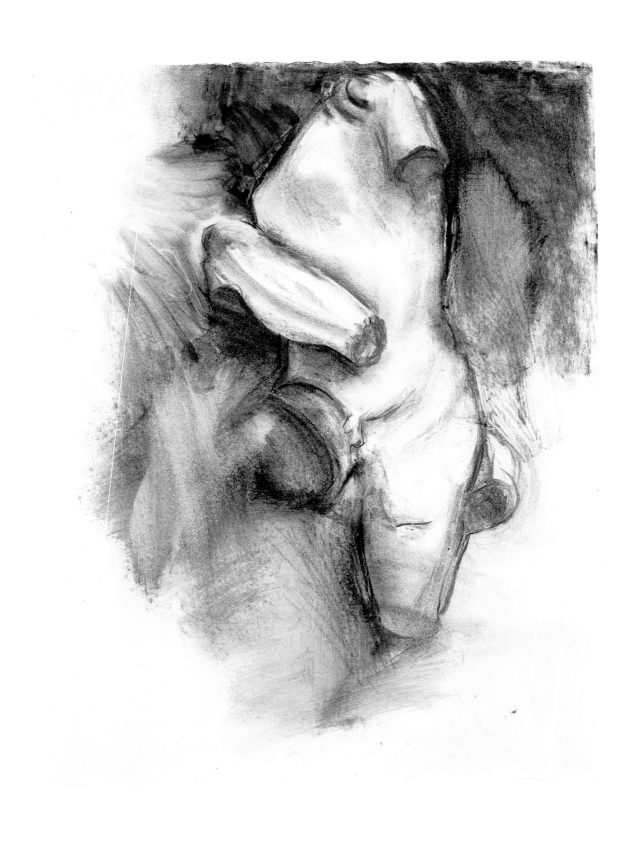

SEVEN VIEWS OF THE HERMAPHRODITE / *Drawing 3*
1990
charcoal on blue paper
24¾ x 18½ (62.9 x 47.0)

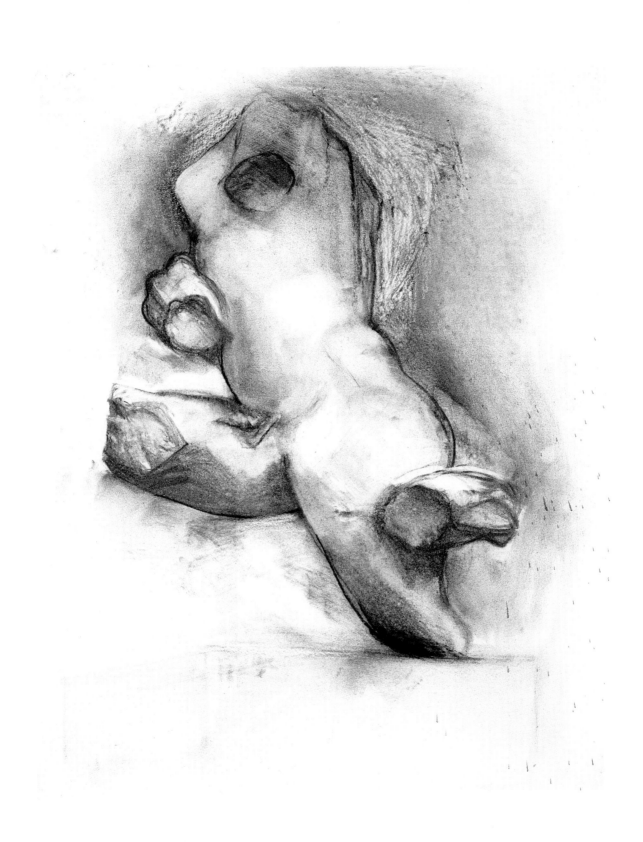

Seven Views of the Hermaphrodite / *Drawing 2*
1990
charcoal on blue paper
24¾ x 18½ (62.9 x 47.0)

SEVEN VIEWS
OF THE HERMAPHRODITE

In 1990 Jim Dine produced this work at the Ny Carlsberg Glyptotek in Copenhagen. The seven images were drawn on consecutive days at the museum.

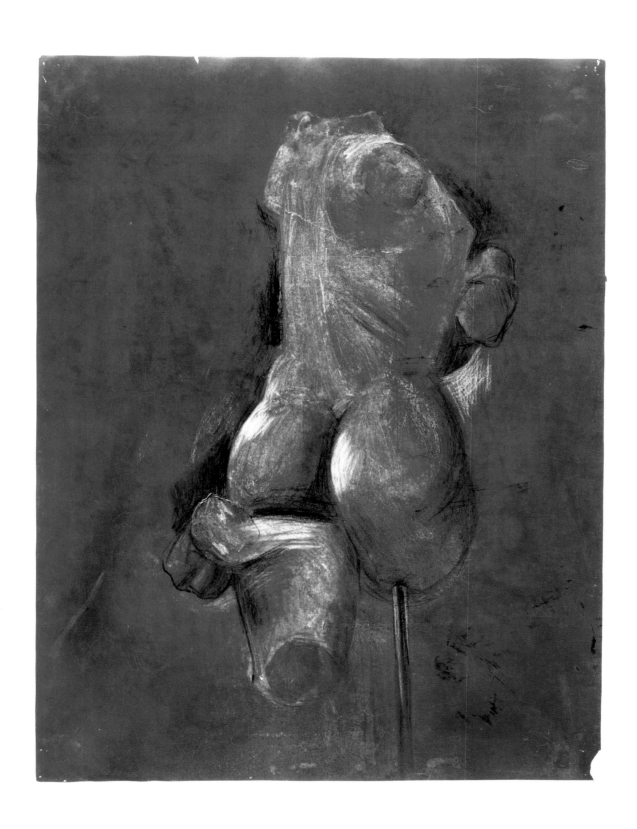

SEVEN VIEWS OF THE HERMAPHRODITE / *Drawing 1*
1990
charcoal and chalk on blue paper
24¾ x 18½ (62.9 x 47.0)

100

RECENT DRAWINGS

In 1991 and 1992 Jim Dine continued to draw from antiquities.
Roman Head from Glyptotek in Copenhagen and *Three Roman Heads* were
made from photographs of sculpture at the Ny Carlsberg Glyptotek.
The other six drawings included here were the result of a spring 1992
trip to the Glyptothek in Munich.

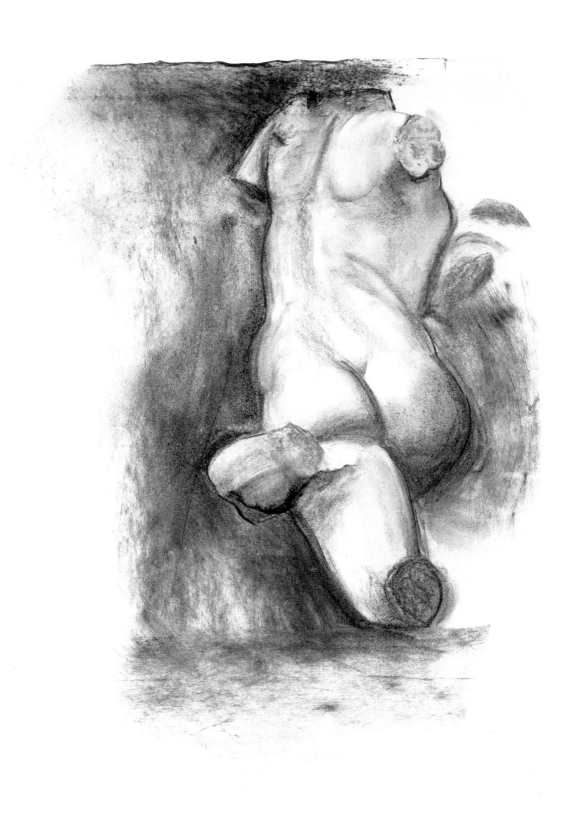

SEVEN VIEWS OF THE HERMAPHRODITE / *Drawing 6*
1990
charcoal on blue paper
24¾ x 18½ (62.9 x 47.0)

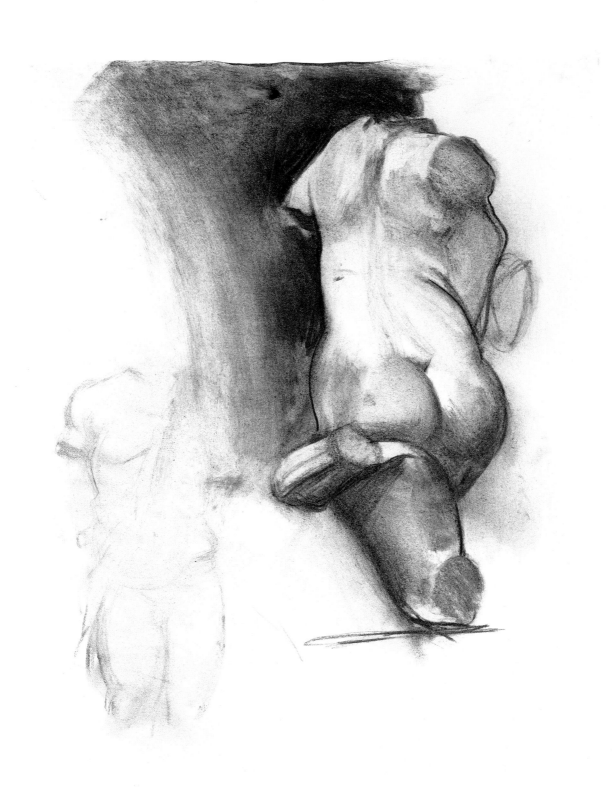

Seven Views of the Hermaphrodite / *Drawing 7*
1990
charcoal on blue paper
24¾ x 18½ (62.9 x 47.0)

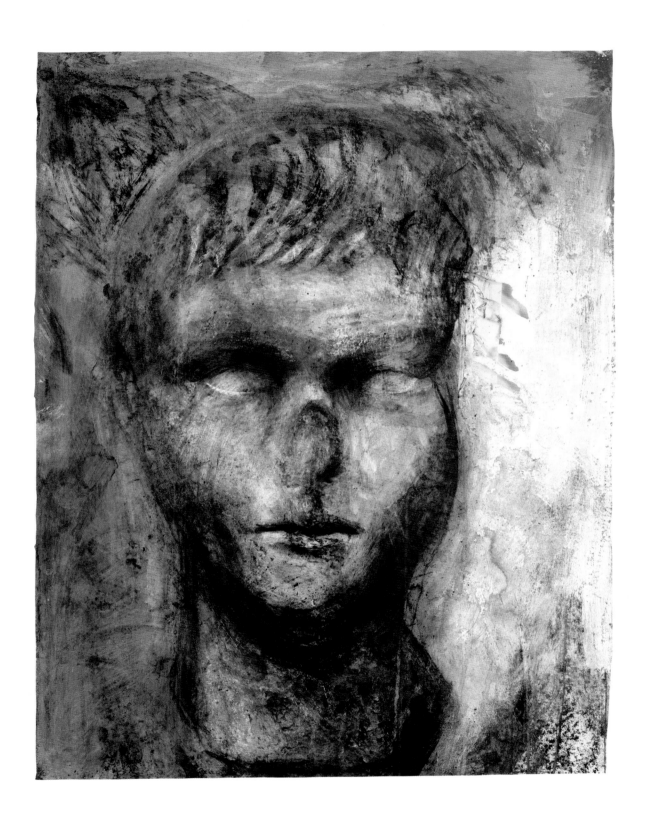

THREE ROMAN HEADS / *Drawing 2* 1991
charcoal, oil stick, acrylic, shellac, ferric chloride,
automotive enamel, enamel, watercolor wash, and chalk
on paper
38½ x 29 (97.8 x 73.7)

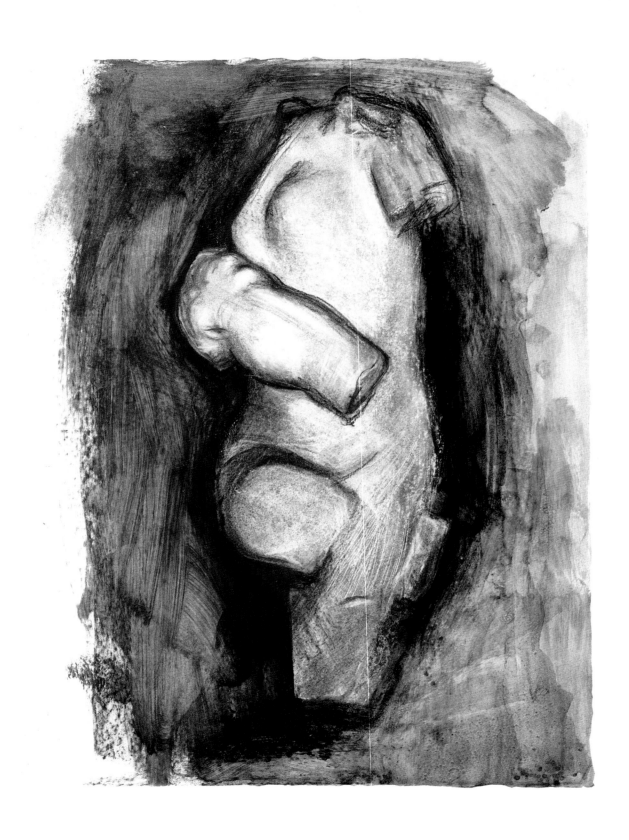

SEVEN VIEWS OF THE HERMAPHRODITE / *Drawing 4*
1990
charcoal on blue paper
24¾ x 18½ (62.9 x 47.0)

103

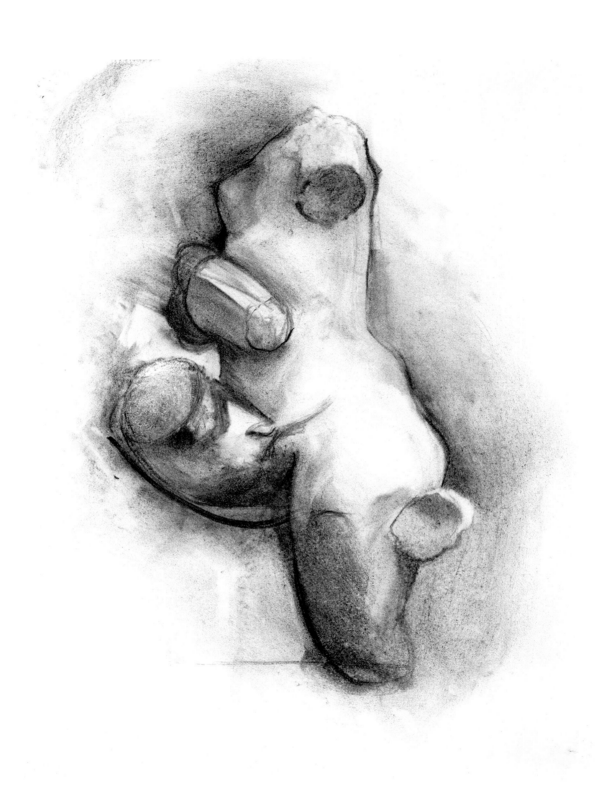

SEVEN VIEWS OF THE HERMAPHRODITE / *Drawing 5*
1990
charcoal on blue paper
24¾ x 18½ (62.9 x 47.0)

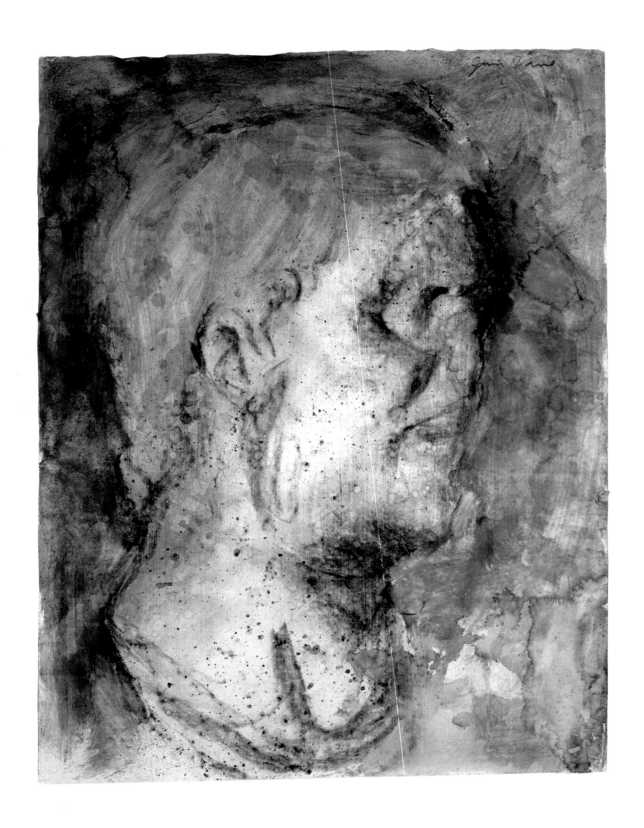

THREE ROMAN HEADS / *Drawing 1* 1991
charcoal, oil stick, acrylic, shellac, ferric chloride,
automotive enamel, enamel, watercolor wash, and chalk
on paper
38½ x 29 (97.8 x 73.7)

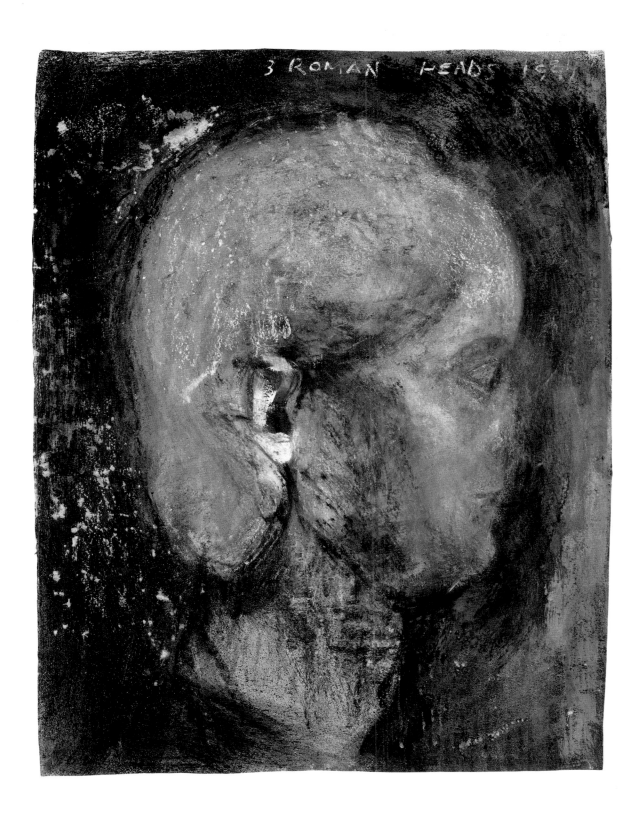

THREE ROMAN HEADS / *Drawing 3* 1991
charcoal, oil stick, acrylic, shellac, ferric chloride,
automotive enamel, enamel, watercolor wash, and chalk
on paper
38½ x 29 (97.8 x 73.7)

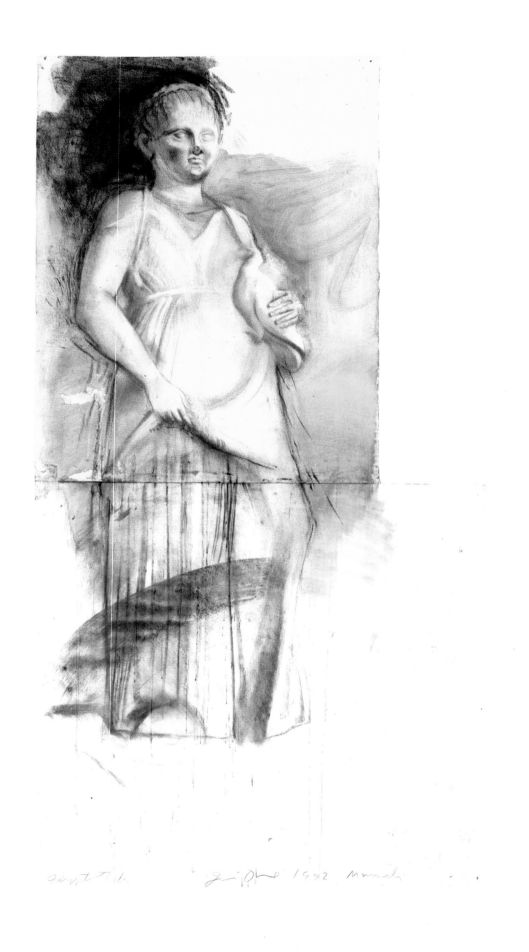

Girl with a Dove / *Attica, ca. 360 B.C.* 1992
charcoal and watercolor on two sheets of paper
55½ x 29 (141.0 x 73.7)

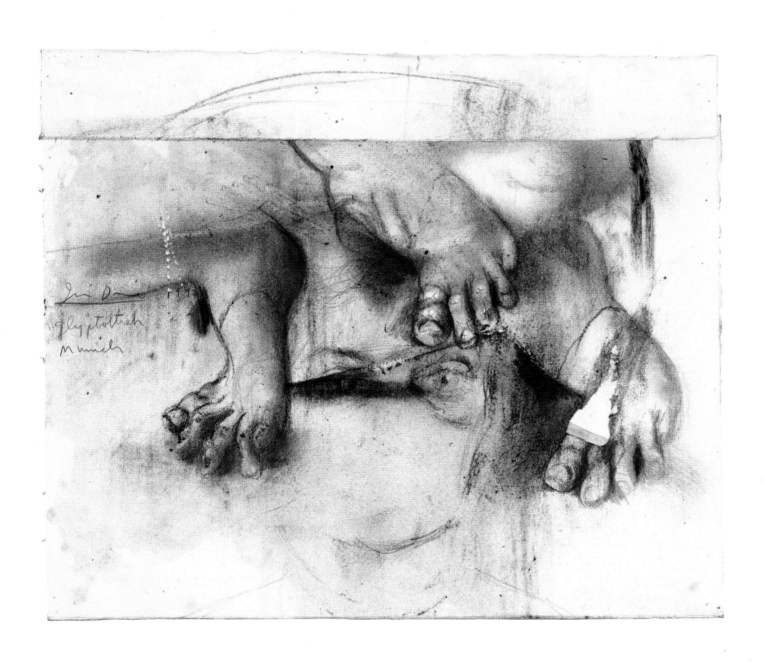

FEET OF THE KNEELING BOY 1992
charcoal on two sheets of paper
17½ x 20¼ (44.5 x 51.4)

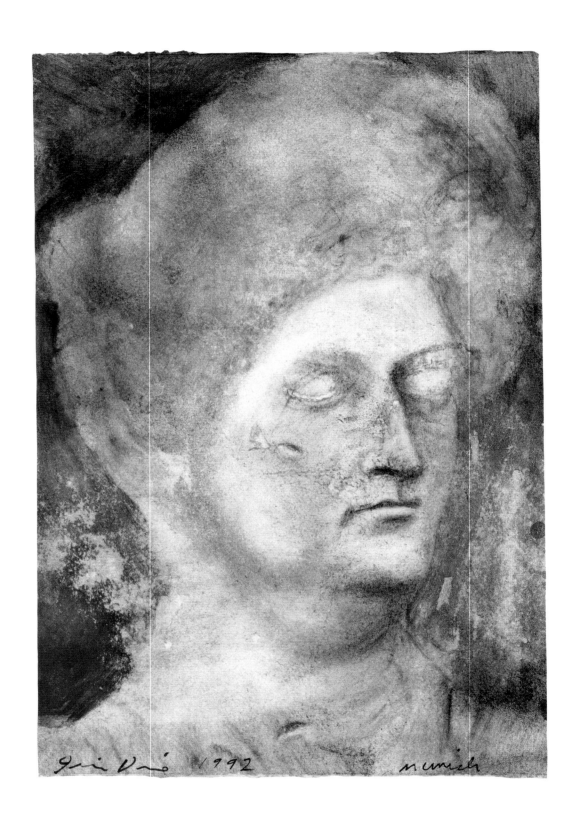

HEAD OF A ROMAN WOMAN 1992
charcoal and watercolor on paper
15 x 10⅛ (38.1 x 25.7)

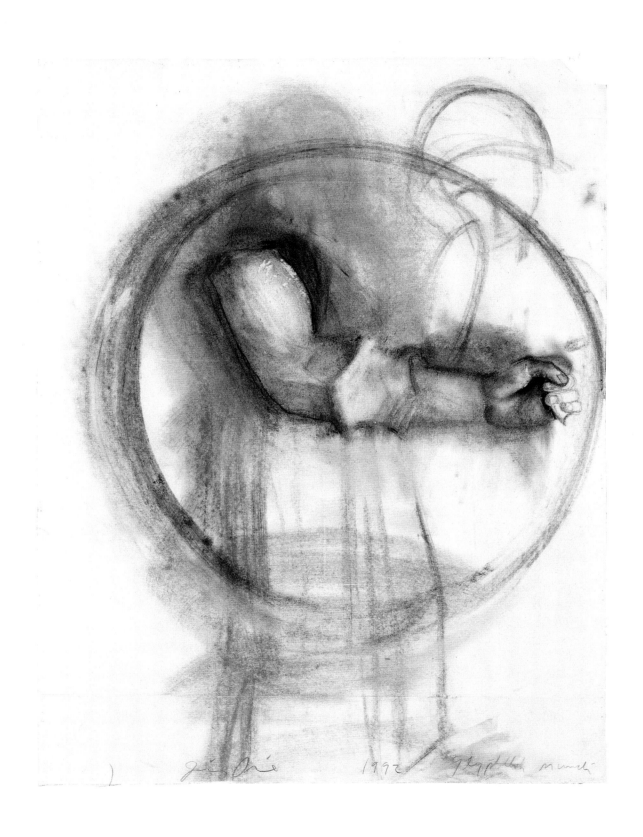

SHIELD AND ARM 1992
charcoal and conté crayon on paper
38¾ x 29½ (101.0 x 74.9)

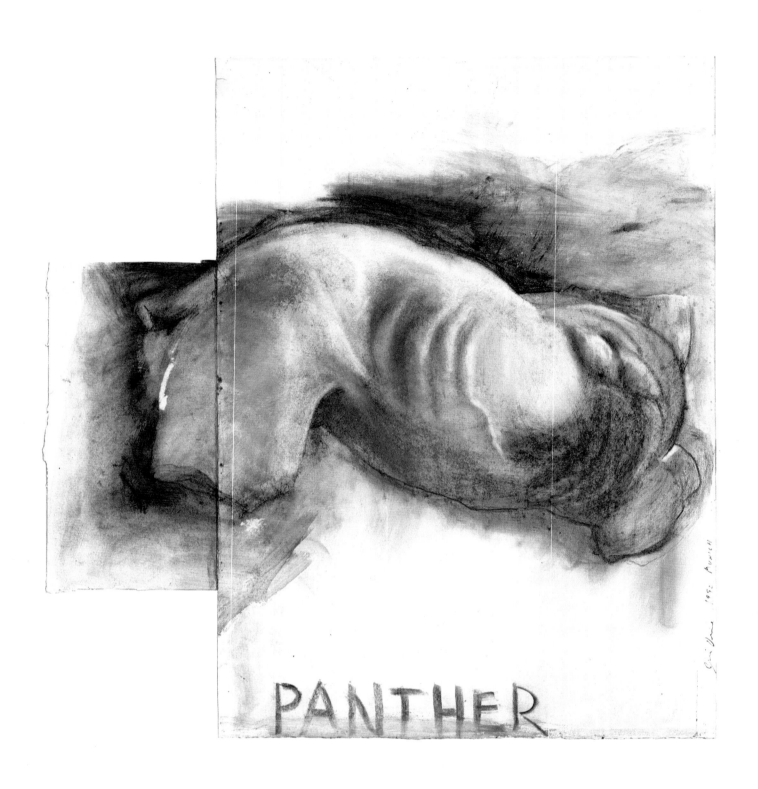

PANTHER

A PANTHERESS / *Attica, ca. 380 B.C.* 1992
watercolor and charcoal on two sheets of paper
41½ x 39¾ (105.4 x 101.0)

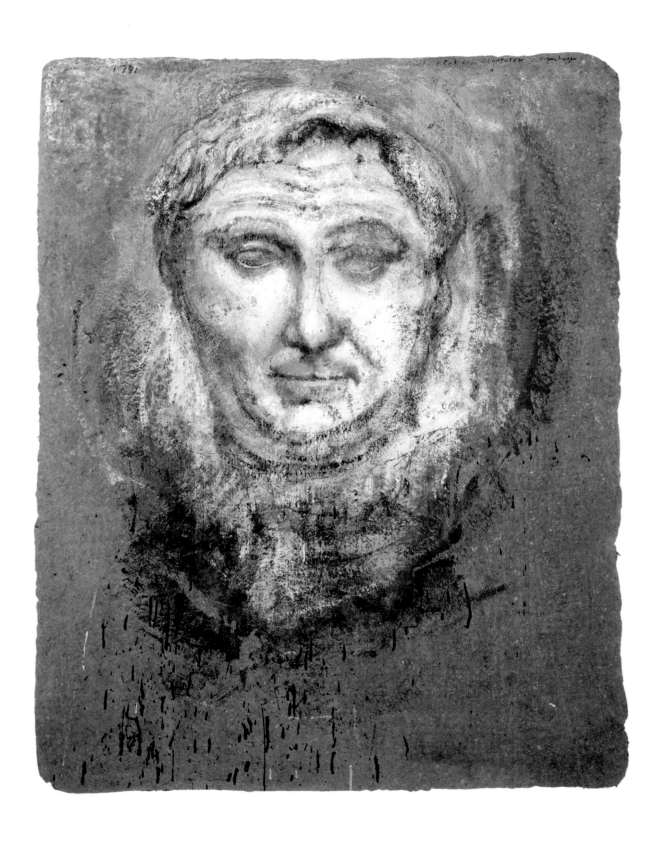

ROMAN HEAD FROM GLYPTOTEK IN COPENHAGEN 1991
acrylic, chalk, enamel, and charcoal
on handmade pulp paper
68 x 53 (172.7 x 134.6)

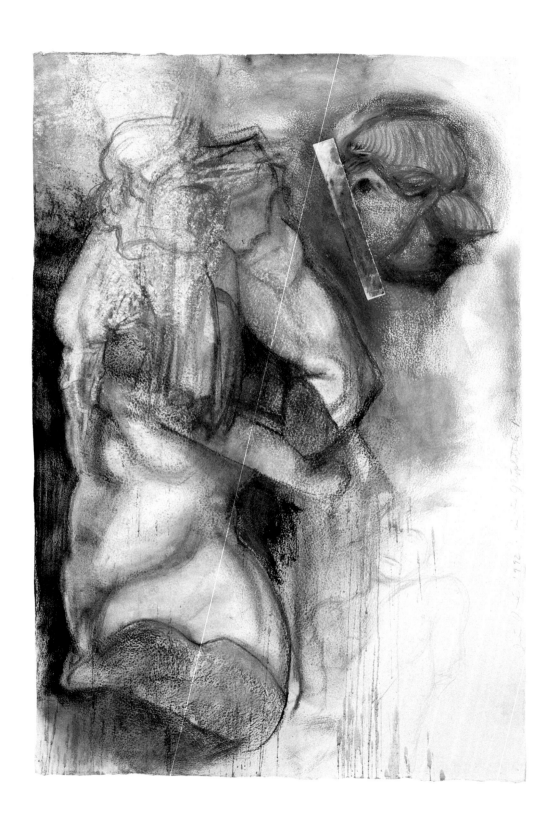

TROJAN WAR HERO 1992
charcoal, watercolor, color pencil, and collage on paper
51 x 33½ (129.5 x 85.1)

Documentation

Chronology

Born June 16, 1935, in Cincinnati, Ohio.

1947
Mother dies; subsequently lives with maternal grandparents.

1951–1953
Participates in Art Academy of Cincinnati adult night classes while in high school.

1954–1958
Studies at University of Cincinnati, Boston Museum School, and Ohio University, Athens, where he receives a bachelor's degree in fine arts, June 1957. Marries Nancy Minto in 1957. One year of postgraduate studies in drawing with Frederick Leach.

1958–1959
Moves to New York and teaches at the Rhodes School. Joins Claes Oldenburg and Marc Ratliff in founding Judson Gallery, where Dine's first performance of the Happening *The Smiling Workman* is held in 1959. Joins Reuben Gallery, New York.

1960
Car Crash performance and first solo exhibition at Reuben Gallery.

1961
Joins Martha Jackson Gallery, New York, and is offered a subsidy for full-time painting. First solo exhibition incorporating everyday objects at Martha Jackson Gallery.

1962
Meets Ileana Sonnabend, who organizes a solo exhibition of his painting; his association with Sonnabend will continue for fourteen years.

1963
Produces the first of a series of bathrobe works, inspired in part by a photograph from the *New York Times Magazine.*

1964
First exhibition of bathrobe paintings at Sidney Janis Gallery, New York. Has work included in the American section of the Venice Biennale.

1965
Designs set and costumes for *A Midsummer Night's Dream* at the Actor's Workshop, San Francisco. Solo exhibition at Allen Memorial Art Museum, Oberlin College, Ohio.

1966–1967
Solo exhibition at Stedelijk Museum, Amsterdam. Moves to London with his family. "Jim Dine: Designs for 'A Midsummer Night's Dream,'" exhibition of sets and costumes, Museum of Modern Art, New York. Work included in "Documenta IV" in Kassel. Influenced by his association with the New York School poets, Dine begins to write poetry.

1970
"Jim Dine," retrospective exhibition, Whitney Museum of American Art, New York.

1971–1973
Moves to Vermont with his family in 1971. First etchings printed in Paris with master printmaker Aldo Crommelynck. Traveling exhibition, organized in 1971 by Museum Boymans-van Beuningen, Rotterdam, opens (subsequently travels to Staatliche Kunsthalle, Baden-Baden; Staatliche Museum, Nationalgalerie, Berlin; Städtische Kunsthalle, Düsseldorf). Exhibition of tool drawings at Sonnabend Gallery, New York, 1973. "Dine-Kitaj" exhibition at Cincinnati Art Museum, Ohio, 1973.

1974
Solo exhibition at Hopkins Center Art Galleries, Dartmouth College, Hanover, New Hampshire. Solo exhibition at Institute of Contemporary Art, London. Solo exhibition drawn from the Summers Collection at La Jolla Museum of Contemporary Art, California.

1975
Initiates six years of intense drawing from the figure, often using his wife as a model. Solo exhibition at Centre des Arts Plastiques Contemporains, Bordeaux.

1976–1977
"Jim Dine Prints 1970–1977," organized by Williams College Museum of Art, Williamstown, Massachusetts, opens (subsequently travels to Hayden Gallery, Massachusetts Institute of Technology, Cambridge; Johnson Gallery, Middlebury College, Vermont; University Art Gallery, State University of New York, Albany; Herbert F. Johnson Museum of Art, Cornell University, Ithaca, New York).

1977
First solo exhibition at Pace Gallery, New York, includes bathrobe paintings and figure drawings. First use of plaster Venus de Milo figure in a still-life composition. "Jim Dine: Works on Paper, 1975–1976," a solo exhibition at Waddington and Tooth Galleries II, London. Work included in "Documenta VI" in Kassel.

1978
"Jim Dine's Etchings," exhibition, Museum of Modern Art, New York.

1979–1980
While visiting Jerusalem, draws an antique sculpture from Israel Museum's collection.
"Jim Dine Figure Drawings 1975–1979," organized by the University Art Museum, California State University, Long Beach, opens (subsequently travels to the Helen Foresman Spencer Museum of Art, University of Kansas, Lawrence; Reed College, Portland, Oregon; Boise Gallery of Art, Idaho; Springfield Art Museum, Missouri; Arkansas Arts Center, Little Rock).

1980
Becomes a member of American Academy and Institute of Arts and Letters, New York.
Begins to spend part of each year working in London.

1981
"Jim Dine: An Exhibition of Recent Figure Drawings, 1978–1980," Richard Gray Gallery, Chicago.

1982
Initiates series of sculptures incorporating figures based on the Venus de Milo.

1983
"Nancy Outside in July: Etchings by Jim Dine," exhibition, Art Institute of Chicago.

1984
"Jim Dine: Five Themes," a mid-career survey organized by Walker Art Center, Minneapolis, opens (subsequently travels to Phoenix Art Museum; Saint Louis Art Museum; Akron Art Museum, Ohio; Albright-Knox Art Gallery, Buffalo; Hirshhorn Museum and Sculpture Garden, Washington, D.C.).
First visit to Glyptothek in Munich.

1985
Reestablishes a home in New York.

1986–1987
"Jim Dine: Paintings, Drawings, Sculpture," exhibition, Pace Gallery, New York.
"Jim Dine," solo exhibition of paintings and drawings organized by Fuji Television Gallery, Tokyo.
"Jim Dine Prints, 1977–1985," organized by Davison Art Center and Ezra and Cecile Zilkha Gallery, Wesleyan University, Middletown, Connecticut, opens (subsequently travels to Archer M. Huntington Art Gallery, University of Texas, Austin; Los Angeles County Museum of Art; Toledo Museum of Art, Ohio; Des Moines Art Center; Nelson-Atkins Museum of Art, Kansas City; University Gallery, Memphis State University, Tennessee; Williams College Museum of Art, Williamstown, Massachusetts).
Spends winter in Venice and begins creating a collection of drawings of antique sculpture. Entitled *Glyptotek Drawings*, this series of forty images is produced on Mylar and drafting paper.

1987–1988
"Drawings: Jim Dine, 1973–1987," exhibition organized by Contemporary Arts Center, Cincinnati, opens (subsequently travels to Fort Lauderdale Museum of Art, Florida; Santa Barbara Museum of Art, California; Henry Art Gallery, University of Washington, Seattle; Modern Art Museum of Fort Worth, Texas; Minneapolis Institute of Arts; Arts Club of Chicago; Joslyn Art Museum, Omaha, Nebraska; M. H. de Young Memorial Museum, San Francisco).
"Jim Dine: Paintings, Sculpture, Drawings, Prints 1959–1987," exhibition, Galleria d'Arte Moderna Ca' Pesaro, Venice, September 1988.

1989
"Jim Dine: Youth and the Maiden and Related Works," exhibition, Graphische Sammlung Albertina, Vienna, includes *Glyptotek* prints and indirectly leads to Dine's working sessions in the Glyptothek during nonpublic hours, with the production of numerous large-scale drawings.

1990
"Jim Dine in der Glyptothek," exhibition of Dine's Glyptothek drawings at the Glyptothek, Munich, among the sculptures that inspired them. Subsequently travels to Ny Carlsberg Glyptotek, Copenhagen.
"Jim Dine: Drawings," exhibition including Glyptothek drawings at Pace Gallery, New York.
"Jim Dine: Glyptotek Drawings" presented as part of the Horizons series at Nelson-Atkins Museum of Art, Kansas City.
Solo exhibition organized by Isetan Museum, Tokyo, opens (subsequently travels to Museum of Art, Kintetsu, Osaka, and Hakone Open Air Museum).
Makes series of seven Hermaphrodite drawings, based on sculpture at Ny Carlsberg Glyptotek, Copenhagen.

1991
"Jim Dine: New Paintings and Sculpture" exhibition, Pace Gallery, New York.

1992
Produces six drawings at Glyptothek, Munich, in anticipation of "Jim Dine: Drawing from the Glyptothek" at Madison Art Center.

Selected Bibliography

Books and Catalogues

Ackley, Clifford. *Nancy Outside in July: Etchings by Jim Dine*. Exh. cat. New York: ULAE, 1983.

————. *Ten Painters and Sculptors Draw*. Exh. cat. Boston: Museum of Fine Arts, 1984.

Alloway, Lawrence. "Jim Dine." In *American Drawings*. New York: Solomon R. Guggenheim Foundation, 1964.

Beal, Graham W. J., with contributions by Robert Creeley, Jim Dine, and Martin Friedman. *Jim Dine: Five Themes*. Exh. cat. New York: Abbeville Press, in association with Walker Art Center, 1984.

Boyle, R. J., and Kitaj, R. B. *Dine-Kitaj: A Two Man Exhibition at the Cincinnati Art Museum*. Exh. cat. Cincinnati: Young and Klein, 1973.

Castleman, Riva, and Krens, Thomas. *Jim Dine Prints: 1970–1977*. New York: Harper and Row, in association with Williams College Museum, 1977.

Codognato, Attilio; Shapiro, David; Ratcliff, Carter; and Livingstone, Marco. *Jim Dine*. Milan: Nuove edizioni Gabriele Mazzotta, 1988.

Compton, Michael. *Pop Art: Movements of Modern Art*. London: Hamlyn Publishing Group, 1970.

D'Oench, Ellen G., and Feinberg, Jean E. *Jim Dine Prints: 1977–1985*. New York: Harper and Row, in association with Davison Art Center and Ezra and Cecile Zilkha Gallery, Wesleyan University, Middletown, Connecticut, 1986.

Fine, Ruth E., and Corlett, Mary Lee. *Graphicstudio: Contemporary Art from the Collaborative Workshop at the University of South Florida*. Exh. cat. Washington: National Gallery of Art, 1991.

Friedman, Martin. *Jim Dine: New Paintings and Sculpture*. Exh. cat. New York: Pace Gallery, 1991.

Galerie Claude Bernard. *Jim Dine: Oeuvres sur papier 1978–1979*. Exh. cat. Paris, 1980.

Glenn, Constance W. *Jim Dine Drawings*. New York: Harry N. Abrams, 1985.

————. *Jim Dine Figure Drawings 1975–1979*. Exh. cat. New York: Harper and Row, in association with the Art Museum and Galleries, California State University, Long Beach, 1979.

Glyptothek Munich. *Jim Dine in der Glyptothek*. Exh. cat. Munich: Staatliche Antikensammlungen und Glyptothek, 1990.

Gordon, John. *Jim Dine*. Exh. cat. New York: Praeger, in association with Whitney Museum of American Art, 1970.

Kitaj, R. B. *Jim Dine Works on Paper 1975–1976*. Exh. cat. London: Waddington and Tooth Galleries II, 1977.

McHenry, Deni McIntosh. "Jim Dine: Glyptotek Drawings." *Horizons*. Exh. brochure. Kansas City: Nelson-Atkins Museum of Art, 1990.

Pace Gallery. *Jim Dine: Drawings*. Exh. cat. New York, 1990.

————. *Jim Dine: Paintings, Drawings and Sculpture*. Exh. cat. New York, 1986.

Ratcliff, Carter. *Jim Dine: New Paintings*. Exh. brochure. New York: Pace Gallery, 1988.

Richard Gray Gallery. *Jim Dine: Looking in the Dark*. Exh. cat. Chicago, 1985.

————. *Jim Dine, New Paintings and Figure Drawings 1980–1982*. Exh. cat. Chicago, 1983.

Rogers-Lafferty, Sarah. *Drawings: Jim Dine, 1973–1987*. Exh. cat. Cincinnati: Contemporary Arts Center, 1988.

Schefer, Jean-Louis. *Jim Dine: Trembling for Color*. Paris: L'autre Musée/Grandes Monographies, Editions de la différence/Galerie Beaubourg, 1991.

Shapiro, David. *Jim Dine: An Exhibition of Recent Figure Drawings, 1978–1980*. Exh. cat. Chicago: Richard Gray Gallery, 1981.

————. *Jim Dine: Painting What One Is*. New York: Harry N. Abrams, 1981.

Shapiro, Michael E. "Methods and Metaphors: The Sculpture of Jim Dine." In *Jim Dine: Sculpture and Drawings*. Exh. cat. New York: Pace Gallery, 1984.

Solomon, Alan R. "Dine Drawings." In *Jim Dine: Tekeningen*. Exh. cat. Amsterdam: Stedelijk Museum, 1966.

Waddington Graphics. *Jim Dine: Youth and the Maiden*. Exh. cat. London, 1989.

————. *Rise Up, Solitude! Prints 1985–1986*. New York, 1986.

Articles and Reviews

Ackley, Clifford S. "Face in a Frame." *Art News* 81 (September 1982): 63.

Ament, Deloris Tarzan. "Jim Dine." *Seattle Times*, May 24, 1989.

Artner, Alan G. "All I Am Here for Is to Paint and Draw." *Chicago Tribune*, February 20, 1983, sec. 6, p. 19.

―――. "Jim Dine Flings Down Challenge—and Wins." *Chicago Tribune*, September 27, 1985, sec. 7, p. 58.

Billeter, Erika. "Jim Dine: Zeichnung als Totalität." *Du* 7 (1988): 82.

Burn, Guy. "Jim Dine." *Arts Review*, April 7, 1989.

Caruso, Laura. "That Kernel of Mystery." *Kansas City Star*, October 21, 1990, p. I1.

Dagbert, Anne. "Plus près du centre avec Jim Dine." *Art Press* (May 1986): 4.

Davis, Douglas. "Personal Pop." *Newsweek*, March 9, 1970, p. 98.

Glenn, Constance W. "Artist's Dialogue: A Conversation with Jim Dine." *Architectural Digest* (November 1982): 74.

Gruen, John. "Jim Dine and the Life of Objects." *Art News* 76 (September 1977): 38.

Hackett, Regina. "Two Former '60s Pop Painters Are Art Worlds Apart Today." *Seattle Post Intelligencer*, May 24, 1989, p. C1.

Hennessy, Susie. "A Conversation with Jim Dine." *Art Journal* (Spring 1980): 168.

Henry, Gerrit. "O'Hara & Dine: A Free Association." *Print Collector's Newsletter* 22 (July–August 1991): 80.

Johnson, Ellen H. "Jim Dine and Jasper Johns: Art about Art." *Art and Literature* 6 (Autumn 1965): 128.

Kangas, Matthew. "Rebirth of Venus: The Persistence of the Classical in Contemporary Sculpture." *Sculpture* (November–December 1990): 49.

Koch, Kenneth. "Test in Art." *Art News* 65 (October 1966): 54.

Kozloff, Max. "The Honest Elusiveness of James Dine." *Artforum* 3 (December 1964): 36.

Kramer, Hilton. "The Best Paintings Jim Dine Has Yet Produced." *New York Times*, January 9, 1977, p. D23.

Kutner, Janet. "Dine Art." *Dallas Morning News*, August 26, 1989, p. 5C.

"Poet of the Personal." *Time*, March 9, 1970, p. 50.

Ratcliff, Carter. "Jim Dine at Pace." *Art in America* 65 (May–June 1977): 116.

Robinson, Frank, and Shapiro, Michael. "Jim Dine at 40." *Print Collector's Newsletter* 7 (September–October 1976): 101.

Schjeldahl, Peter. "Artists in Love with Their Art." *New York Times*, November 3, 1974, p. D30.

Schmidt, Doris. "Die Antike zum Leben erwecken." *Suddeutsche Zeitung*, January 23, 1990.

Solomon, Alan R. "Jim Dine and the Psychology of the New Art." *Art International* 8 (October 1964): 52.

Stein, Jerry. "Jim Dine: A Double Barreled Salute to His Art." *Cincinnati Post*, March 9, 1988, p. 1D.

Stevens, Mark. "Color Them Masters: Pace Gallery Show, New York City." *Newsweek*, February 14, 1977, p. 80.

Taylor, Robert. "Jim Dine: A Summer Special at the MFA." *Boston Globe*, July 30, 1989, p. A1.

Warning, Wilhelm. "Statuen gesehen mit den Augen von Jim Dine." *Gazette* (Munich) (January 1990): 1.

Weiss, Hedy. "Jim Dine Drafts a Dark Surprise." *Chicago Sun Times*, September 29, 1985, p. 20.

Woodard, Amanda. "Dine on Death and Venus Dolls." *The Independent*, April 11, 1989.

Acknowledgments

In the spring of 1991, Martin Friedman thoughtfully brought to my attention a substantial body of drawings that Jim Dine has been producing since the mid-1980s. In May of that year, Dine and I met in Chicago to discuss the possibility of organizing a traveling exhibition of drawings inspired by his experiences at the Glyptothek in Munich, Germany. A subsequent trip with the artist to a New York warehouse allowed me to experience the richness and power of these works. The result of these early meetings was the present exhibition, *Jim Dine: Drawing from the Glyptothek.*

I wish to extend my gratitude to Jim Dine, whose support and cooperation made working on this exhibition and publication a pleasure. During the course of this project, he willingly submitted to myriad questions from the Madison Art Center's staff. He provided an insightful statement that adds immeasurably to this book. Dine's longtime assistant, Blake Summers, also played an important role in the development of the exhibition. In addition Klaus Vierneisel, director of the Glyptothek, supplied valuable information and photographs for this publication.

The Pace Gallery, through its knowledgeable staff, made significant contributions to the development of the exhibition and this publication. Arnold Glimcher's good counsel and encouragement were very much appreciated. Susan Dunne played an instrumental role in coordinating the gallery's considerable efforts on behalf of the project.

Several generous funders helped make *Jim Dine: Drawing from the Glyptothek* a reality. Major funding for the exhibition, as well as this publication, has come from Nicolet Instrument Corporation, Rayovac Corporation, David and Paula Kraemer, Joseph and Deirdre Garton, and Rick and Banana Shull. Additional support has been provided by the Exhibition Initiative Fund, the Art League of the Madison Art Center, the Madison Art Center's 1992–1993 Sustaining Benefactors, and a grant from the Wisconsin Arts Board with funds from the state of Wisconsin.

Ruth E. Fine, curator of modern prints and drawings at the National Gallery of Art, wrote a thoughtful essay that carefully documents Dine's development as an artist and draftsman. It was a pleasure to collaborate with Paul Anbinder, president of Hudson Hills Press, on the production of this publication. Special thanks are also due to Lorraine Ferguson, who served as the graphic designer of this book.

I wish to thank the Madison Art Center's Board of Trustees for its ongoing support. It is also a pleasure to acknowledge the considerable efforts of the Madison Art Center's staff in bringing this exhibition and publication to fruition. Ina Dick worked meticulously on the preparation of this volume. The contributions of many other staff members at the Madison Art Center deserve special recognition: Marilyn Sohi, registrar; Sandy Rodgers, assistant registrar; Tina Yapelli, curator of exhibitions; Sheri Castelnuovo, curator of education; Kathy Paul, director of development and community relations; Jonathan Zarov, publicist; Mark Verstegen, technical services supervisor, and his entire crew.

SF

Index

S0-BOG-187

THE WILDERNESS ROAD

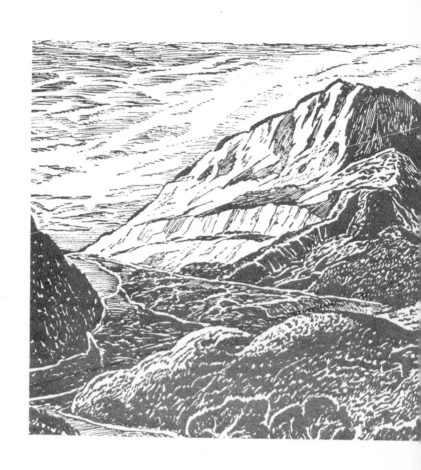

The
WILDERNESS
ROAD

By

ROBERT L. KINCAID
Died May, 1960

MIDDLESBORO, KENTUCKY, 1966

976.9
K57 w
75415
Sept., 1971

In Memory of
my son
Robert Hugh
Who sleeps by the Road

INTRODUCTION

It snowed at Cumberland Gap January 15, 1912. There is nothing extraordinary about that because it often snows in the Cumberlands in the winter time. But what I felt on that bleak and lonely day must have been the experience of many thousands of people in pioneer times who crossed through the great pass in ice, snow, sleet or rain.

The two-coach passenger train on which I arrived at the Gap slowly puffed to a stop at the little depot. The engine faced a smoking hole in the mountain which towered 1500 feet above the station. I did not know it then, but the engine was in Virginia, the cars were in Tennessee, and the station was split by the state line. When I got off, I looked up at the sheer, gray face of the Pinnacle and the Three States Knob which framed a huge notch a thousand feet deep in the mountain wall before me. The barren peaks were almost obscured in the swirling snow.

I whiffed the acrid fumes of the coal smoke as I stood shivering by the little train. It puffed again and slowly crawled into the big hole. When it had disappeared, clouds of black and white smoke rolled out of the tunnel and drifted upward into the snow flurries. In a moment the train would cross into Kentucky 500 feet underground; then it would roll out of the north side of the mountain nearly a mile away.

I picked up my telescope suitcase and trudged down into the nearby village at the foot of the Pinnacle. I found a grocery store, ate some crackers and cheese, and set out on foot to find Lincoln Memorial University.

There was no overpowering weight of history upon me then. As I tramped along in the snow, I did not know I was mingling

my footprints with those of Daniel Boone, Geoge Rogers Clark, Henry Clay, and little Tom Lincoln. I did not hear the voices of the phantom legions which spoke to James Lane Allen when he passed that way in 1885. All I could feel was the biting wind; all I could see were the ghostly mountains in their winter nakedness; all I could hear were my own muffled footfalls and the quiet breathing of a little town under a four-inch blanket of snow.

That was my first introduction to the Wilderness Road at Cumberland Gap. To me there could have been no drearier place on earth.

Since then I have passed over the high-flung cleft in the mountains thousands of times. I have often traveled the entire route of the settlers from Virginia and the Carolinas to the "paradise lands" of the Bluegrass. I have read thousands of books, diaries, articles, and manuscripts dealing with the westward migration through Cumberland Gap. And the cold, gray mountain lying across the path of the pioneers is no longer a terrifying spectacle. To me it has become a monument of rugged grandeur to the men and women who scaled its heights and passed over to the other side for their empirical conquests in the Great West.

This book was written to tell that story. It was first published in 1947 by Bobbs-Merrill Company to initiate a series on historical American Trails. Arrangements were then made with the Lincoln Memorial University Press for its republication in 1955. It was appropriate that this educational institution should be the sponsor of that edition, because it is located at the pass where the Wilderness Road enters Kentucky and had its beginning as the result of an important episode on the Road in the early nineties. Since it has long been out of print this third edition is being printed by Mrs. Robert L. Kincaid, with the cooperation of the Kingsport Press.

A road is usually a dead, inanimate thing and has no significance except its utility. But when it is an instrument by which empires are built and civilization maintained, it becomes a pulsing, dynamic artery of vast historical importance.

Such was the Wilderness Road of Virginia, Tennessee, and Kentucky. It was originally the lifeline connecting the eastern

seaboard with the untamed and unexplored wilderness west of the Appalachian barrier. Through it flowed the tide of migration which gave the new nation the limitless reaches of the West. The men, women, and children who braved the hardships and dangers of the trail cut out by Daniel Boone and his thirty axemen in 1775 founded, nurtured, and developed the settlements which have become our metropolitan centers and productive civilization in the fertile valleys of "the waters that ran Westward."

In frontier times, the Wilderness Trail was a southern loop of connecting pioneer roads reaching from the Potomac to the Falls of the Ohio. The portion of the Road from Kingsport, Tennessee, to the Bluegrass regions of Kentucky, which gave the Road its name, was no more than a narrow, difficult, hazardous trail winding over mountains, across streams, through marshes and canebrakes, and penetrating dark forests where hostile Indians and wild animals lurked. From 1775 to 1796 this segment was only a horse path. No wagon passed over it during that period when more than 200,000 people made their way into Kentucky and beyond. It continued as an important feeder thoroughfare for the western settlements until the Civil War. During that conflict, it was of strategic military significance when Union forces attempted to divide the Confederacy into two parts. In the early 'nineties, the Road witnessed a spectacular industrial development at Cumberland Gap when the last wilderness area along the route succumbed to an orgy of exploitation by English capitalists.

Today the original route of the Wilderness Road has been straightened and modernized into a highway over which millions of motorists travel. But each curve, dip, and section touches hallowed ground. James Lane Allen sensed this when he wrote his famous tribute to the Road. Felix Gregory de Fontaine in 1872 spoke glowingly of the "old, old region" through which the road passed, "covered with the rime of centuries." Novelist Winston Churchill in *The Crossing*, published in 1903, pictured the difficulties and terrors of the settlers who made their way

across the mountains. Scores of other writers have used the Road as the locale for many stories, novels, and historical accounts.

A grateful nation has established at Cumberland Gap a national historical park as a fitting memorial to the valiant men and women who traveled the Road to a great destiny. Historical features are being marked and scenic areas in the 20,000-acre tract, wantonly despoiled in recent years, are being restored. This park is a national shrine where the American people can feel the pulse-beat of a young nation emerging into greatness. It was at this point the birth-throes of national expansion took place.

Writing this book was a fascinating task. I lived with the Boones, Clays, Clarks, Logans, Shelbys, and other leaders who gained heroic stature on the wild and rampaging frontier of the Old West. But my admiration and sympathy must include the multitudes of emigrants seeking freedom, adventure, fortune, and always good land for homes. In this wave of struggling humanity breaking over the Appalachians and spreading out into eddies along river bottoms and fallow uplands were the nameless and unknown who lie long forgotten in unmarked graves by the side of the Road. Their valor, sacrifice and suffering merit equal recognition with those who gained the triumphant fulfillment of their hopes.

—Robert L. Kincaid

Harrogate, Tennessee

PREFACE

On today's road maps, criss-crossed with a network of highways, it is difficult to pick out the long Southern loop of pioneer roads which formed the Wilderness Road of Virginia, Tennessee, and Kentucky. But a close look at a relief map of the Appalachian range reveals the geographical features which determined its location and importance in the migration period from 1775 to 1800.

The eastern segment of the Road began at Wadkin's Ferry on the Potomac River, passed up the Shenandoah River through the giant trough in Virginia between the Blue Ridge and Allegheny ranges, and crossed the low divide where the Great Valley ends near the headwaters of the James and Roanoke (Staunton) Rivers. It then crossed New River at Ingles Ferry, near Radford, Virginia, and continued westward down the middle fork of the Holston to Long Island, the present site of Kingsport, Tennessee. The present road following this route is known as Federal Highway No. 11, or the Robert E. Lee Highway. In pioneer times it was variously called the "Great Wagon Road," the "Irish Road," the "Valley Turnpike" and the "Pennsylvania Road."

The true Wilderness Road to Kentucky and the Northwest cut out by Daniel Boone took up this feeder Valley Road at Kingsport, the southern base of the loop, and turned northwest to leave the Holston Valley at Moccasin Gap in Clinch Mountain near present Gate City, Virginia. Winding a hundred miles through a jumble of close hills and narrow valleys drained by the Clinch and Powell Rivers, it picked its way to Cumberland Gap, a deep cleft in the high Cumberland Mountain wall separating Virginia and East Tennessee from Kentucky. This

segment generally conforms to the route taken later by Virginia Highway No. 421.

After 1785, an alternative and somewhat easier route from Long Island to Cumberland Gap was also used. This route continued down the Holston Valley to Bean's Station, turned north across Clinch Mountain, and approached Cumberland Gap from the south. This alternative route is shown on the map printed on the end papers.

Fifteen miles north of Cumberland Gap the Road cut through the Cumberland River gorge in Pine Mountain, at present Pineville, Kentucky, and from there wandered through the rugged country of eastern Kentucky, crossing Laurel and Rockcastle Rivers. At Hazel Patch it forked, the right prong leading directly north to Big Hill and to the site of Boonesborough on the Kentucky River, and the left going to Crab Orchard, Danville, Harrodsburg, and finally to the Falls of the Ohio, now Louisville, Kentucky. From Cumberland Gap to Corbin, with the advent of modern roads, the route is known as Federal Highway No. 25-E, and from Corbin to Richmond and Lexington as Federal Highway No. 25. The left prong from Mount Vernon to Crab Orchard, Danville, Bardstown, and Louisville is designated as Kentucky Highway No. 150.

--This brief description of the Wilderness Road as it relates to the present highway system is given for the convenience of the reader who may wish to journey over the famous path of the pioneers.

TABLE OF CONTENTS

Part I

ADVANCING FRONTIER

Part II

PATH OF EMPIRE

LIST OF ILLUSTRATIONS

Part 1

ADVANCING
FRONTIER

Chapter 1

Discovery of the Trail

WHEN Opechancanough called his warriors together on the banks of the Pamunkey in April 1644 his physical fires were burning low. At the age of ninety-two, he could no longer stand in the council house and drive a tomahawk into a post as a signal for war. He reclined on a couch, unable to hold up his eyelids, as he told of his plans to exterminate the hated Englishmen crowding upon his lands from the Atlantic seacoast.

The brother of King Powhatan did not want to die until he had delivered his country from the menace of the white men who came with Captain John Smith in 1607. Powhatan, before his death in 1619, had temporized with the newcomers from across the seas. Opechancanough, succeeding his brother as chieftain, had been tolerant of the white visitors and friendly except for one violent revolt in 1622. He had furnished them corn when they were starving. He called them brothers, had attended the marriage of his niece Pocahontas to a white man and had permitted the newcomers to build shelters in the forest.

But in late years the old Pamunkey king had done much reflecting. He was disturbed by the increasing stream of people who came from across the great waters. At first he had accepted these strange creatures with curious interest, but as they grew in number and demanded more and more territory, he realized his brother had let in intruders who would never be satisfied until they had driven his people from their lands.

So Opechancanough came to a decision. He sent runners to

21

the surrounding tribes in the Virginia forests to summon their leaders to his council house. When they had gathered, he made a last appeal and outlined his strategy: Sweep down upon the white settlements; kill all and leave not one to tell the tale; the paleface interlopers must be driven forever from the land. Although worn by his years, his will to fight was strong, and his vengeful words were cool and confident.

Carried on a litter into the battle, Opechancanough led his warriors against the outlying settlements between the York and Pamunkey Rivers and swept them clean. In two days more than three hundred white men, women and children were massacred. Sir William Berkeley, governor of the little colony, hastily assembled an armed force, met the marauding Indians as they swarmed closer to Jamestown and defeated them with great slaughter. Unable to flee, the aged chieftain was captured. At the Jamestown jail, a young guard, maddened by the loss of loved ones in the uprising, shot the helpless old man. As life ebbed away, the King of the Pamunkey asked for Governor Berkeley. He requested that his eyelids be raised that he might see his enemy. A light of hatred gleamed from his dull old eyes as he said reproachfully:

"Had it been my fortune to take Sir William Berkeley prisoner, I would not meanly have exposed him as a show to my people."

Opechancanough's eyelids dropped and he stretched out upon the earth and died.[1]

~This defeat of the eastern Indians in 1644 began a new period in the development of the Virginia colony. It removed the barrier to westward expansion for the English settlement held at great peril and hardship for twenty-seven years. With the death of Opechancanough, the eastern Indians no longer had a strong leader and they were forced to accept a peace treaty in which they acknowledged their allegiance to the English crown and surrendered their rights to the tidewater lands. The colonists

were now ready to push beyond the fall line along slender trails and trading paths. Forts were built by the order of Governor Berkeley and the Virginia Council at the falls of the Appomattox, James and Pamunkey Rivers and on the Chickahominy Ridge, and the frontier was moved inland for the advancing settlers. From these outposts at the edge of the limitless wilderness, many explorations were launched in the next half century west and south toward the "endless mountains," and at last over the divide into the Mississippi basin.

Abraham Wood was the colonist of the seventeenth century primarily responsible for opening the western wilderness to Indian trade and colonization. Sometimes acting on the authority of Governor Berkeley and often at his own expense, he led or sent expeditions along trading paths to inland towns of various Indian tribes. He instructed his agents to gather information from the friendly Indians, to spy out the trackless forest for good lands and minerals, and to check feasible routes into the unknown interior. A possible overland route to the "South Sea" and the rich lands of fabled India was still a fascinating possibility. Wood's agents from time to time brought back vague tales of gold, silver, copper and other valuable minerals in the western lands and these rumors whetted the acquisitive appetites of the Virginians and the speculating noblemen around the court of Charles II.

Wood was an ideal frontier leader for this role. He had come to America as a lad by working out his passage, and within twenty years he had accumulated considerable property. He moved to the frontier on the Appomattox and bought a tract of land at Charles City. Because he was located in the section where Governor Berkeley desired a fort erected, he was put in charge of the garrison of Fort Henry in 1645, the present site of Petersburg. A year later the fort and six hundred acres of land in the environs of the falls were deeded to him in return for the protection which the fort would give the settlements.

Operating from this outpost, Wood gradually extended his trade and rapidly attained a prominence in Virginia affairs. He

was a member of the House of Burgesses in 1654 and was later appointed to the powerful Virginia Council of eighteen men, advisers to Governor Berkeley. He was soon advanced from the rank of colonel in the militia to major general and often took part in repelling small Indian raids or in negotiating trade and peace treaties with the various tribes.

Wood made his first important trip into the Southwest in 1650. Setting out from Fort Henry, he and four companions followed the trading path of the Occaneechi for one hundred and twenty miles to the chief town of that tribe at the junction of the Roanoke and Dan Rivers, now the site of Clarksville. The Englishmen were welcomed by the Occaneechi, and trade relations were established. Stemming from the Occaneechi village were Indian roads leading deeper into the western wilderness. These Wood marked down for future explorations.

After this first expedition far beyond the line of colonization in the tidewater, Wood rapidly enlarged his trade radius east of the mountains. But it was twenty years before the mysteries of the region beyond the great wall were opened to him.[2] Stimulated by the reports of three trips made into the West in 1669 and 1670 by Dr. John Lederer,[3] a German physician, who journeyed to the top of the Blue Ridge chain at Front Royal and caught a glimpse of the beautiful Shenandoah Valley, Wood directed an expedition in 1671 deep into the West, which for the first time reached beyond the Appalachian divide and came upon an Indian trail later to be a segment of the Wilderness Road.

Having carefully selected men on whom he could depend, he appointed as leader Captain Thomas Batts, an English colonist of good family. With Batts he sent Robert Fallam as assistant, Thomas Wood, perhaps a kinsman, and an unnamed former indentured servant. He employed Perecute, an Appomattoc chief, as guide and interpreter, and provided five horses and an ample supply of food and provisions for an extended journey. Wood gave his emissaries an official paper establishing their identity as his authorized agents and indicating that their mission was to find "the ebbing and flowing of the Waters on the other

NATURAL BRIDGE OF ROCKBRIDGE COUNTY, VIRGINIA

The bridge is crossed by the "Great Valley Road" leading over the divide between the eastern and western waters.

Ingle's Ferry, Pulaski County.

INGLES FERRY ON NEW RIVER

Photograph made in 1907, showing the Andrew Lewis Ingles home. The ferry has been in continuous operation by the Ingles family since it was built in 1762.

MODERN VIEW OF ROANOKE VALLEY

A view of Roanoke Valley near Elliston, Virginia, showing the Norfolk and Western Railroad which generally follows the route of the Wilderness Road through Southwest Virginia.

side of the Mountaines in order to the discovery of the South Sea."[4]

After leaving the Appomattoc Indian village near Fort Henry on September 1, 1671, Batts and Fallam made rapid progress over a good trail leading almost directly west. On the fourth day out they came to a Saponi Indian village where they were kindly received and provided with another Indian guide. Thomas Wood became seriously ill, was left with some friendly Hana-* haskie Indians, twenty-five miles farther on, and before long died. The rest of the party continued until they came in sight of the Blue Ridge. After twice crossing Roanoke River they found a tree marked with the letters, "M.A. NI," indicating that some white men, possibly traders, had preceded them. On September 8 they crossed the first range of the Blue Ridge and camped for the night. The next day they arrived at a town of the Tutelo near where the city of Roanoke now stands. Here Perecute became ill with fever and ague, and they were forced to linger two days. When they continued their journey they secured a local guide and left their horses with the Tutelo.

The going was now much slower in the rough terrain. After crossing some more mountains and the Roanoke River two or three times, they again found two trees marked with the letters, "M.A. NI," and another with "MA" and other carvings which they could not understand. They crossed a creek which subsequently became known as Swift Creek and seven miles beyond came upon a large stream flowing northward. They had come to New River, which was known for many years as Wood's River in honor of their employer. They journeyed southwest up this river, noting many bare meadows and old fields which Indians had previously cultivated.

The path into which Batts and Fallam had come was old and well traveled. This was a portion of the Great Warpath connecting two important Indian kingdoms, the powerful Iroquois Confederacy of Five Nations[5] in the North and the Cherokee and Catawba empires in the South. The path led across central Pennsylvania, entered Virginia at the mouth of the Shenandoah

River on the Potomac, continued southwest up the Great Valley, crossed the southern divide at the headwaters of .the James, forded the New River, and proceeded into the Holston country and to the mountainous realm of the Cherokee in the future state of Tennessee. A southwest branch, near where the men had come upon the trail, reached into the Catawba country of the Carolina piedmont. They had found the Indian path which would become the eastern link of the Wilderness Road.[6]

Although their provisions were now exhausted, the explorers were anxious to probe farther into the inviting valleys where the waters ran westward. Following the Indian road, they came to a clear place on top of a high hill. Here the distant view was so entrancing, Batts imagined he saw sails on the western horizon, but Fallam supposed they were white cliffs. Continuing for another twenty miles, they stopped to camp and send out their Indian guides to see if they could kill some deer. They lay in camp for a day, and their hunger became intense. Their hunters secured only some wild gooseberries and large haws.

On September 16 the Indian hunters came in with some wild grapes and two turkeys and reported they had heard a drum and a gun go off to the north of them. After feasting on the grapes and turkeys, the party set out again and came to another bend in the New River and an abandoned Indian settlement where they found cornstalks in deserted fields. This was the limit of their journey. They had reached the point where New River breaks through Peter's Mountain in Giles County, Virginia, on its northward sweep to the Ohio as the Kanawha.

Before starting on their return journey, Batts and Fallam selected four large trees standing out in a clearing and inscribed their initials with branding irons, also recording the names of Charles II, Governor Berkeley and General Wood. They marked one tree with the letter P in recognition of the faithful service of Perecute. After firing a volley in commemoration of their discovery of the western waters, they turned back to Fort Henry, where they made a full report to General Wood.

The adventure of Batts and Fallam was significant because they had touched rivers of the West two years before the explorations of Jolliet and Marquette in the Mississippi basin. In 1673 Wood sent out another expedition to probe deeper into the unknown.[7] Tragedy followed this distant penetration into the great wilderness where the states of Kentucky and Tennessee were to be established a century later. Out of it, however, a young indentured servant, Gabriel Arthur, emerged as the first white man of record to travel the route of the Wilderness Road and find Cumberland Gap, the most significant pass through the mountain wall separating the East from the West.

To lead this expedition General Wood chose James Needham, a successful South Carolina planter, explorer and Indian trader. As Needham's chief assistant he sent along Gabriel Arthur. The young man could not read but had been a faithful employee around the fort. Wood provided his men with horses and provisions for a long journey, and hired eight Appomattoc Indians as hunters and guides.

The little company set out from Fort Henry on April 10, 1673, following the trading path of the Occaneechi. They soon returned and reported to Wood that hostile Occaneechi had turned them back. Wood insisted that they try again. On May 17 Needham and Arthur set out once more, this time with an extra horse apiece. They met a company of Tomahitan (Cherokee) who lived beyond the mountains, and, accompanying these friendly Indians along a new route, they skirted the village of the Occaneechi and reached the Indian town of Sitteree on the headwaters of the Yadkin River in the Carolina mountains. From this point they traveled directly toward the setting sun and came upon the lofty Blue Ridge. It took them four days to reach the main divide, but only a half day to get down on the other side where they found much level ground, vast canebrakes and many streams running northwest.

In two more days of travel through this broken country they lost all their horses except one, and at last came in sight of a

great range of mountains over which hung a fog or cloud. They had reached the towering Great Smokies. They marveled at the great abundance of elk, deer, bear, wolves, turkey and other wild game, and the continual unfolding of expansive forests, veined with beautiful streams winding in a general westward direction. On the fifteenth day after leaving Sitteree, they came upon a river running in a more westerly course than the other streams they had crossed. The Tomahitan guides said it was their own. Here they found a large Indian town built on a high bank of the river and surrounded with a twelve-foot barricade of big logs stuck on end in the ground. They had come to the chief town of the Cherokee Indians, probably Chota, on the Little Tennessee. They were at the southern terminus of an Indian trail which led north along the western base of the Appalachian chain to the Great Lakes region.

Needham and Arthur were fed and entertained with elaborate ceremonies by the Tomahitan. Their lone surviving horse, the first the Indians had ever seen, was tied to a stake in the middle of the town and supplied with corn and a "pulse" made of fish, flesh and bear's oil. The white men and visiting Appomattoc Indians were mounted on a scaffold so that the Tomahitan could look upon them more advantageously.

After remaining with the Indians nine days, studying their customs and habits, Needham decided to return to Fort Henry and make a report for General Wood. Accompanied by twelve Tomahitan, he left Arthur at the big town with instructions to learn the language and pick up information which would be of advantage in establishing trade relations with the distant Indian tribes. Wood was greatly pleased with the report of Needham and immediately passed the news of his agent's discoveries to the Virginia Assembly.

Wood soon dispatched Needham on a return journey to the land of the Tomahitan, but treachery was afoot in the person of his chief guide, Indian John or Hasecoll, a fat, thick, bluff-faced fellow who took advantage of every opportunity to quarrel with Needham. The Englishman showed increasing

exasperation as they traveled through the wilderness. When they made camp at a crossing of the Yadkin River, Needham took a hatchet and threw it on the ground by the side of Indian John, and said, "Are you minded to kill me?" Thoroughly enraged, the Indian grabbed a gun and shot Needham through the head despite the efforts of the friendly Tomahitan to stop him. He stooped over the fallen man, ripped the body open, tore out the heart and, holding it high over his head, shook it toward the east, shouting defiance against all Englishmen. Then turning upon the frightened Tomahitan, Indian John threatened them and demanded that they go back to their village on the Tennessee River and kill Arthur. He filled his packs with Needham's effects, took the white man's horse and rode off eastward.

During the absence of Needham, young Arthur was treated kindly by the Tomahitan. The old chief took a liking to him and showed him every consideration. But when the braves accompanying Needham returned to their town, the chief was away on a hunt. They reported the death of Needham and the violent imprecations of Indian John against the English. The village was thrown into a turmoil, with the warriors arguing among themselves whether they should follow John's demand and kill Arthur. Some of the young hotheads adopted in the tribe seized the helpless Englishman, bound him to a stake and piled dry canes about him. Just as they were ready to set fire to the pile, the chief returned to the village and heard the commotion. He ran to the scene and demanded who was going to put fire to the Englishman. A Waxhaw (Weesock) brave declared he would do it, and started with a firebrand in his hand. The chief shot the impetuous warrior, cut the thongs binding Arthur and dared the other Waxhaw to lay a hand upon him.

After this dramatic rescue, young Arthur remained with the Tomahitan for the rest of the winter. He was forced to go on war expeditions with them, once down the river to the Spanish settlement, once to Port Royal in South Carolina where at Christmas time an Indian settlement near the whites was attacked, and once on a visit to the friendly Moneton on the

Kanawha River, a day's journey from where it empties into the Ohio at Point Pleasant.

In a fight with the Shawnee in Ohio Arthur received two arrow wounds and was taken prisoner. Because his hair was long, his captors suspected that he was not a Tomahitan. They scrubbed his skin with water and ashes, and were amazed to find it white. They admired his gun, knife and metal hatchet, but never having used such weapons, they gave them back to him. When they brought in a beaver and began to singe off the hair in preparation for cooking, Arthur explained by signs that the English would trade hatchets and firearms for such skins. The Shawnee agreed to let him return to the Tomahitan on the promise he would go back to the white men on the east coast to work up a trade with them.

Arthur was given a pouch of parched corn meal for provisions and conducted by Shawnee guides to a path leading southward across the meadowlands of Kentucky to the Great Gap in the Cumberland Mountains, where the present states of Kentucky, Virginia and Tennessee meet, and thence southeastward to the Cherokee empire in the Carolina mountains. There was no danger of his getting lost in the vast wilderness lying west of the Appalachian range which never before had been penetrated by a white man. The trail was well defined, called by the Indians the Athawominee, or the "Path of the Armed Ones." Along it for centuries northern and southern Indians had traveled on long hunts, on missions of peaceful commerce. and on raids of revenge or conquest. It was a major link in the trail system of the red men on the North American continent long before Columbus discovered America.

Arthur journeyed south in the spring of 1674, along a trail already famous in the vague and unrecorded history of the aborigines and destined to be of vital importance in the settlement of the West by white men a full century later. Unlettered as he was, he kept no written record of his impressions and discoveries but, camping out under the skies which later looked down on Daniel Boone, he was pioneering in an adventure no

The Warriors' Path of Kentucky, and the Great Indian Warpath in Virginia (later to be the route of the Wilderness Road). (From map by W. E. Myers, p. 748, *42nd Annual Report of the Bureau of American Ethnology*, 1928).

less great than the experiences of the first Kentucky hunters. He came upon frequent salt licks where Indians often camped and hunted, crossed the lands of central Kentucky ribbed by hills and drained by pretty streams and came into the heavy shadows of southeastern Kentucky where the Shawnee River (Cumberland) broke out of a jumble of mountains.

The trail led Arthur into the Cumberland Mountains, called by the Shawnee the Wasioto, "mountains where the deer are plentiful," and to the great cleft in the range now known as ⌐Cumberland Gap. It passed into the rich valleys of East Tennessee and brought Arthur back to the big village of the Tomahitan on the Tennessee, which he had left several months before. Here he was received joyfully by the friendly chief, who had given him up for lost.

Within a few days Arthur, accompanied by his Indian godfather, started back to Fort Henry to report to General Wood. He arrived there on June 18, 1674, after more than a year's absence. General Wood had already learned of the unhappy fate of Needham and he welcomed Arthur as one returned from the dead. He immediately recounted Arthur's wanderings to John Richards, of London, agent of the Lords Proprietors of the Carolinas, and anticipated an increase in trade with the distant Indians whom Arthur had visited.

General Wood did not realize the real significance of the discoveries his agents had made. They had come upon the easiest route across the great barrier of the Appalachians and had found the trail which would become the great channel for the movement of settlers into the still unknown Mississippi and Ohio basins. Between the Roanoke and New Rivers,[3] Batts and Fallam had touched the route of the future Wilderness Road leading westward; Needham and Arthur had invaded the domain of the Cherokee in the Carolina and Tennessee mountains where the road would pivot toward the northwest; and Arthur had traveled from the Ohio across Kentucky through Cumberland Gap along the trail which would become the Wilderness Road.

[1] Robert Beverley, *The History of Virginia* (London, 1722), second ed., pp. 50-51; Henry Howe, *Historical Collections of Virginia* (Charleston, S. C., 1845), p. 61.

[2] Some historians credit Wood with a trip into the West in 1654 when he was reported to have discovered "several branches of the great rivers of the Ohio and the Meschaceba" (Mississippi), and personally came upon New River which bore his name until the first white settlers poured over the Blue Ridge range into the valleys of the West. This has never been thoroughly authenticated.

3 Lederer is believed to be the first white man to make written reference to Cumberland Gap. In *The Discoveries of John Lederer,* translated by Sir William Talbot (London, 1672), Lederer is quoted: "Two breaches there are in the Apalataen mountains, opening a passage into the western parts of the continent. One, as I am informed by Indians, at a place called Zynoda, to the northward; the other Sara, where I have been myself." Sara has been identified as Swanannoa Gap, in North Carolina. "Zynoda Gap" could well correspond to Cumberland Gap.

4 Clarence W. Alvord and Lee Bidgood, *The First Explorations of the Trans-Allegheny Region by the Virginians, 1650-1674* (Cleveland, 1912), pp. 183-205.

5 The Iroquois Confederacy originally was composed of the Cayuga, Mohawk, Oneida, Onondaga and Seneca and was then called the Five Nations. In 1722 the Tuscarora were admitted, and the English subsequently called the Confederacy the Six Nations.

6 William E. Myer, "Indian Trails of the Southeast," *42nd Annual Report of the Bureau of American Ethnology,* pp. 779-784.

7 Alvord and Bidgood, *Op. Cit.,* pp. 209-226.

8 The Roanoke River has two sources in Montgomery County, Virginia, which the "Great Valley Road" into the West crosses. In 1729 it was named the Staunton River (pronounced "Stanton") in honor of Lady Staunton, when Colonel William Byrd surveyed the line between Virginia and North Carolina to the eastern base of the Blue Ridge. In some Virginia counties it continues to bear that name to its confluence with the Dan River at Clarksville, Mecklenburg County, Virginia, but modern maps list it only as Roanoke River from its source to its mouth in Albemarle Sound. To avoid confusion, Roanoke is used throughout this book.

The New River, rising in North Carolina and flowing north into the Ohio River at Point Pleasant, West Virginia, becomes the Kanawha River when it leaves Virginia.

Chapter 2

Settling the Great Valley

THE frontier community of Germanna on the Rapidan rushing down out of the hills east of the Blue Ridge was astir with excitement on the morning of August 30, 1716. Nothing like it had been seen in the little colony of Dutch and German families who two years before had cut down the trees and built their homes on a tract assigned them by Alexander Spotswood, lieutenant governor of Virginia. Far in advance of other settlements moving up from the fall line of the rivers, the settlers had been out of touch with the colonial culture rapidly developing at Williamsburg under the driving power of their new soldier governor who had taken charge of affairs in 1710.

On this August morning, the Germanna settlers poured from their homes to watch their royal governor, dressed in a suit of green velvet, Russian boots and a jaunty hat with flowing plume. He rode out of the village toward the distant mountains at the head of a column of fifty gaily dressed colonial gentlemen. The company was heavily armed and accoutered for a long excursion. In the group were servants and Indian guides, hunters and frontiersmen schooled in forest lore, and a train of packhorses loaded with provisions and a big supply of wine, brandy, rum, champagne and "punch water." But it was not a military campaign on which they were embarking. The dashing commander who had fought with the Duke of Marlborough and was wounded at the battle of Blenheim was journeying

west to search out the impenetrable mysteries which lay beyond the distant Blue Ridge.

Spotswood had injected a new spirit into the colony of Virginia. He had imported artisans, established ironworks and extended colonial trade. He had many arguments with his stubborn and sometimes belligerent House of Burgesses, but he imparted to his associates a spirit of expansion which had passed with the death of Abraham Wood and his agents a half century before. The perimeter of penetration had not been extended much beyond the tidewater, and the great wilderness continued uncharted while colonists developed their plantations and started their towns. It required a full century before the island of English civilization in Virginia was ready to break out into a spectacular spread into the West. Spotswood was sparking this movement with his exploratory expedition.

The governor and his courtiers found easy going for the first three days out of Germanna. The Indian and hunting trails were plain and the land was open and rolling. But as the party moved deeper into the hills, the forest became thick and impenetrable. They crossed many streams, were plagued with hornets and other insects, and their clothes were torn by overhanging limbs. Five days out, they came to the base of a mountain towering to a great height. After an arduous climb to the peak, they arrived at Swift Run Gap in the afternoon of September 5, 1716, where they looked down upon a broad valley of limitless scope.

Charmed by the magnificent panorama spread before them, Spotswood called for drinks all around. The kegs were tapped and the gentlemen drank to the health of the King, then to the members of the party. Thus refreshed, the excited party rode down the western slopes into the valley never before reached by white men. They waded through grass and pea vines as high as their horses and came upon a beautiful river, called by the Indians the Shenandoah, "the daughter of the stars." Spotswood promptly dubbed it the "Euphrates."

The horsemen crossed the river, buried a bottle with a paper

claiming all the territory beyond for King George I, partook of a feast of turkey and deer and finished off with the currants, grapes and cucumbers that grew in abundance all about them. Then they drank to the King's health again, and fired a volley. They drank to the Princess' health, and fired another volley, to Spotswood's health, and fired a third volley. The cavalier celebrants were making much of their discovery of a virgin paradise.

Spotswood and his horsemen stood about midway in the great rectangular basin lying between the Blue Ridge and the Alleghenies, where Massanutten Mountain splits the valley. Two hundred miles in length and from twenty to seventy miles broad, boxed in on the east and west by parallel mountain ranges, and separated from the western waters on the southwest by the divide where the James and Roanoke Rivers head, this magnificent valley was drained by the Shenandoah and its tributaries flowing northeastward into the Potomac River. Through it passed the Great Warpath connecting the Iroquois Confederacy and the Cherokee and Catawba in the South. Spotswood had come upon the trail more than two hundred miles northeast of the point where it was touched by Batts and Fallam on the Roanoke and the New in 1671.

Spotswood did not proceed farther in his exploration. He thought he had discovered an easy passage to the region of the Great Lakes about which he had heard from Indians, that indeed he was only a three days' journey from a great nation of aborigines living on a river which flowed into Lake Erie, and that the lake was clearly visible from the peak of the western mountain bordering the valley. He felt it would be feasible in a short time to take possession of the lake country in the name of his King and forestall any claims which the French might make.

After concluding the festivities, Spotswood and his adventurers turned back across the Blue Ridge for their homeward journey. When he reached Williamsburg he wrote a report of his trip to "World's End," as he called it, and established the

"Order of the Golden Horseshoe" for the cavaliers in his party. He presented each with a small horseshoe of gold, inscribed with the motto, *Sic jurat transcendere montes*—Thus he swears to cross the mountains.

Spotswood came into the Shenandoah Valley when it was no longer the permanent home of any Indian tribes. It was a neutral hunting ground, traversed by the war path used only by hunting and warring parties passing through. For many years it had been burned off in the quest for game, and except for occasional clumps of great trees, the forest line began at the base of the mountains. Temporary camping parties lingered for weeks in the area, and stray Indians were nearly always to be found up and down the Shenandoah River and along the old war trail.

Although his visit to the valley was limited, Spotswood saw that this great meadowland of canebrakes and waving grass was an ideal haven for the Virginia colonists crowding westward toward the base of the Blue Ridge. Wild life of all kinds abounded, buffalo, elk, deer, panther, fox, wolf and beaver. Great springs, some of them of mineral water, provided excellent sites for homes and towns. Settlers were ready to move in, claim and hold the territory more effectively than Spotswood had with his grandiose gesture of burying a paper in the ground.

Thomas, the sixth Lord Fairfax of Cameron, was a sour, pudgy, middle-aged bachelor when he came into the Shenandoah in 1735 to look over the wilderness lands inherited from his mother, Catherine, the daughter of Lord Culpeper. Jilted in love by a lady of rank, he hated all women. Disillusioned in his effort to attain distinction as an English nobleman, he had retired to his castle in Scotland to hunt and breed fox hounds. But something was happening in far-off Virginia which caused him to abandon his self-imposed seclusion and hurry to America. He learned that his proprietorship of all the lands lying between the Rappahannock and Potomac Rivers, known as the "Northern Neck," was in demand and worth a great deal of money.

Unable to visualize the great stretches of the American wilder-

ness, Fairfax decided to find out what they included. He visited his cousin, William Fairfax, at Belvoir on the Potomac twelve miles below the site of Mount Vernon, and arranged to have the boundaries of his own property checked. Lieutenant Governor William Gooch appointed William Byrd II, of Westover on the James, to head the surveying commission. But Fairfax quarreled with Byrd and employed his own commission to make the survey. He found to his delight that the Potomac rose west of the Blue Ridge, that his property cut straight across the lower part of the fertile Shenandoah Valley and embraced more than 5,000,000 acres. He returned to England in 1737 to secure a definition of his boundaries. The points at issue between himself and the Virginia Assembly were settled in 1745. Under the terms of the agreement he was to respect the minor grants in the Northern Neck already made to independent settlers but he was permitted to collect quitrents. He hurried back to Virginia to take personal charge of his properties.

In 1747 Fairfax moved into the Valley on a manor of 10,000 acres reserved for himself. He built a house and land office which he called Greenway Court, eleven miles southeast of a new settlement beginning at Shawnee Springs which later developed into Winchester, Virginia. He found the Valley spotted with homesteads. Many families had moved in during his absence, boldly locating on his land in complete disregard of his rights. Chief of these settlers was the stolid old German, Joist Hite, who had come into the lower Shenandoah in 1732 from Pennsylvania. Hite was a native of Strasbourg in Alsace, who had embarked for America in his own vessel in 1709. A thrifty farmer and manufacturer in Pennsylvania, he became disgusted with the lack of protection given him against the Indians, and bought 40,000 acres from the Van Meter brothers which they had previously secured on Opequon Creek before the Fairfax lands were surveyed. Virginia had granted him an additional 100,000 acres and both these tracts were shown by the survey to be within the Fairfax boundaries. Hite built a stone house for himself on the ancient war trail, where it crossed the creek five and a half miles

from the abandoned Indian town at Shawnee Springs, and announced that he had come to stay.

The "Old Baron" had brought sixteen families with him, including his three sons-in-law, George Bowman, Jacob Chrisman and Paul Froman, who were rapidly developing big estates. His five sons, John, Jacob, Isaac, Abraham and Joseph also branched out and established homes. The progeny of Cap Baron Hite was spreading rapidly in the Valley.

The inviting acres of the beautiful Shenandoah in the Fairfax domain quickly attracted other settlers. Jacob Stover, a native of Switzerland, took up 10,000 acres on the south fork of the Shenandoah at a place called Massanutten, the "Indian old fields," and brought in a number of German and Swiss families. Alexander Ross and Morgan Bryan, also from Pennsylvania, started a big development on the west side of the Opequon, five miles north of Shawnee Springs, and settled a colony of Quakers who built the Hopewell Church, the first in the Valley. John Fishback, of Germanna, brought nine Protestant German families across the Blue Ridge along the route followed by Spotswood in 1716 and located on a grant of 30,000 acres on the east side of the second fork of the Shenandoah.

All these settlements were flourishing when Fairfax arrived. From Greenway Court, he sent out his agents and demanded quitrents. Most of the tenants complied with his demands, but some objected. Old Cap Baron stubbornly refused to pay a tribute which he regarded as unjust, and instituted a lawsuit which was in the courts until long after both litigants were dead. The quitrent, whether to Fairfax or to the Crown, was always paid reluctantly since it was regarded as a cloud on the title.

Never popular and always regarded as a money-grabbing royalist, Fairfax was nevertheless an important figure in the lower Shenandoah Valley. He took part in local and colonial affairs, was a public benefactor and in 1748 had incidentally befriended a young surveyor, George Washington, whom he employed at the age of sixteen to help run out his property lines. Living alone at Greenway Court, surrounded by servants and

slaves, entertaining his men friends lavishly but never permitting a woman in his house, and hunting and riding to the hounds on his estate, he watched the tide of humanity move slowly up the Great Valley toward the divide at the head of the James and Roanoke Rivers. He saw the ancient trail of the Indians enlarged into a channel of commerce, inching its way deeper into the southwest.

Beyond Fairfax' line across the Valley where the county of Rockingham begins, Fairfax observed the growth of additional settlements. William Beverley, son of Robert Beverley, first historian of Virginia, and some associates were granted 118,491 acres by Governor Gooch. They comprised almost the entire present county of Augusta. John Lewis, native of Ireland, who fled to Virginia in 1729 after killing his landlord in a quarrel, brought with him three sons, Thomas, Andrew and William, and thirty tenant families. Stopping at Williamsburg, Lewis persuaded Governor Gooch to give him 100,000 acres in separate parcels in the new country. He located his home on a tract near the site of Staunton on the old Indian trail.

Lewis went back to Williamsburg a year later and met Benjamin Borden, Sr., lately of East Jersey, who for a time had been an agent for Fairfax. Borden was anxious to explore the western region on his own account. He returned with Lewis to the frontier. While hunting and prospecting for several months in the upper Valley, he captured a buffalo calf which he took to Williamsburg as a present for Governor Gooch. Delighted with the gift and always accommodating to his favorites, the governor entered an order on his official book authorizing Borden to locate 500,000 acres on the upper Shenandoah and James Rivers, on the condition that he should settle there a hundred families within ten years.

Borden immediately sailed for Ireland, recruited a large number of Scotch-Irish families and brought them into the Valley to comply with the conditions of the grant. Chief of the men with whom he got in touch was his son-in-law James Patton, a prosperous navigator who had been in the Royal Navy

Caufield & Shook

MODERN VIEW OF CUMBERLAND GAP

The Cumberland Gap pass as it appears today, looking north into Kentucky. The Pinnacle is on the right, and the corner of Kentucky, Tennessee and Virginia is on the crest near the gap in the foliage on the left. The town of Cumberland Gap is in the right center foreground.

WILDERNESS ROAD ON YELLOW CREEK IN KENTUCKY

Scene on Yellow Creek four miles north of Middlesboro, Kentucky, where the Wilderness Road passed, showing the location of the L. & N. Railroad which followed a portion of the Road.

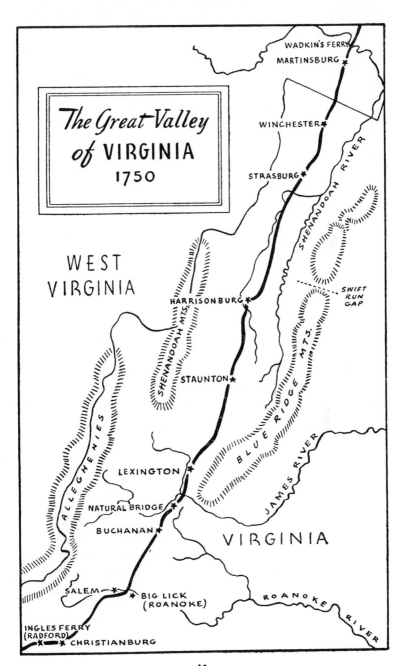

The Great Valley
of VIRGINIA
1750

WADKIN'S FERRY
MARTINSBURG

WINCHESTER

STRASBURG

SHENANDOAH RIVER

WEST
VIRGINIA

HARRISONBURG

SWIFT
RUN
GAP

SHENANDOAH MTS.

BLUE RIDGE MTS.

STAUNTON

ALLEGHENIES

JAMES RIVER

LEXINGTON

NATURAL BRIDGE

BUCHANAN

VIRGINIA

SALEM
BIG LICK
(ROANOKE)

ROANOKE RIVER

INGLES FERRY
(RADFORD)
CHRISTIANBURG

41

during the Netherlands wars. Patton had become a sea captain, had crossed the Atlantic twenty-five times with shiploads of "redemptioners" to settle in the new country. After arriving in Virginia with Borden, Patton persuaded Gooch to grant him 120,000 acres of the land lying still farther southwest across the headwaters of the James and on down to the headwaters of the Holston.

Fairfax, lolling about Greenway Court in his fine clothes and with baronial dignity, contrasted strangely with most of the people who poured into the Great Valley to develop a new type of colonial civilization. No matter how poor the settler, his enterprise and the will to tame the forest brought good reward. Redemptioners soon paid for their passage across the Atlantic. Caste lines were forgotten in the democracy of frontier life. The measure of a man was his ability to throw up a cabin, fell the forest and put in crops. Achievement and recognition came from physical labor.

A story went the rounds in connection with the Borden tract which brought a chuckle whenever the name of Polly Mulhollin was mentioned. This girl from Ireland had indentured herself to a neighbor to pay her passage. When she had completed her period of service she put on a hunting shirt, pantaloons and moccasins and strode off to establish her "cabin rights" to a home. She understood that for each cabin she built she would receive a grant of a hundred acres surrounding it. The chips flew, logs went up, and when one cabin was completed, she moved on to a new inviting spot and began another. Within a short time she had thirty cabins scattered through the forest.

When young Borden, heir of his father, came in to make deeds to the settlers, he was surprised to find so many cabins built in the name of Mulhollin. Investigating, he discovered that the "man" who had been so energetic and resourceful was an attractive, strong-limbed daughter of Erin. Polly Mulhollin won her lands, married and became the mother of a brood of children whose descendants are yet numbered in the Valley.

Chapter 3

Spying Out the Land

SIX horsemen rode leisurely down the western slopes of the Blue Ridge, March 14, 1750, to the old Indian road leading to the Big Lick on a branch of the Roanoke River, where the present city of Roanoke, Virginia, stands. They crossed the mountain divide at Buford's Gap on a wagon road recently made to connect the lower settlements east of the mountains with advanced outposts in Roanoke Valley between the Blue Ridge and Allegheny ranges. Eight days out from their starting point near Charlottesville in Albemarle County, they had entered the western region traversed by the Great Warpath where Batts and Fallam had journeyed seventy-nine years before. But instead of a wilderness untouched by white civilization, they found frequent clearings and cabins of settlers who had pushed southwestward from the Shenandoah Valley.

The horsemen were on a serious mission. They had been employed by the recently organized Loyal Land Company to locate a boundary for 800,000 acres in the western reaches of Virginia suitable for settlement. The leader was Dr. Thomas Walker, a blue-eyed little man of prodigious strength who had abandoned his profession to speculate in western lands. His companions were trained woodsmen like himself.

Walker was well qualified for his position in the company. Educated at William and Mary College and trained as a physician, after his marriage to the widow of Nicholas Meriwether he

moved in 1742 from Fredericksburg to his wife's estate, Castle Hill, near Charlottesville. He became acquainted with a number of men who were interested in the expansion movement, and joined them in their activities, taking up surveying and going on frequent exploratory trips. In 1748 he went deep into the Holston country with Colonel James Patton.

Walker was therefore upon familiar ground after crossing the Blue Ridge and turning down into the headwaters of the Roanoke. He and his five companions stopped each night with settlers along the way, picked up what information they could of the region beyond the settlements and added to their food supply before plunging into the wilderness. They had two packhorses loaded with ammunition, camping equipment and provisions, and a number of hunting dogs.

On March 15 the travelers reached the Big Lick on a branch of the Roanoke River. The huge bottom where salt springs welled up in the mud had long been a rendezvous for herds of buffalo, elk, deer and other wild game. They found the game already scarce around the lick, due to the slaughter of the buffalo, apparently for diversion, and the elk and deer for their skins.

After following the north fork of the Roanoke along the distinct Indian trail now being used by white men, the party came to New River which cuts northward across the basin hemmed in by the Blue Ridge on the south and the Alleghenies on the north. The road led to a ford in the river, where a young frontiersman, William Ingles, had recently erected a mill on a tributary creek. They turned their horses across the river and came to a new settlement of Dunkards in a bottom on the west side. Walker wrote in his journal:[1]

> The Duncards are an odd set of people, who make it a matter of Religion not to Shave their Beards, ly on Beds, or eat Flesh, though at present, in the last, they transgress, being constrained to it, as they say, by the want of a sufficiency of Grain and Roots, they having not long been seated here. I doubt the plenty and deliciousness of the

Venison & Turkeys has contributed not a little to this. The unmarried have no private Property, but live on a common Stock. They dont baptize either Young or Old, they keep their Sabbath on Saturday, & hold that all men shall be happy hereafter, but first must pass through punishment according to their Sins. They are very hospitable.

Having his own ideas about observing the Sabbath, Walker did not continue his journey the next day, which was Sunday. Indeed he lingered in the neighborhood for three days. He bought half a bushel of corn and some parched meal from the Dunkards, passed on to Reed Creek, a western affluent of the New River, and got a supply of bacon from a settler. The party reached the head of the middle fork of the Holston River on March 22, went down it four miles and camped. They were at last upon the river which would lead them southwestward into a fertile valley rivaled only by the Shenandoah.[2]

At this point, Walker looked up the camp of Samuel Stalnaker, a white trader among the Cherokee whom he had met two years before on Colonel Patton's expedition. Knowing that Stalnaker was familiar with the western regions Walker offered to employ him as a pilot but he was too busy establishing a home of his own on the Indian road nine miles west of the headwaters of the Holston—the deepest penetration into the wilderness of the advancing settlements in 1750.

Leaving the last of the settled country on March 26, Walker and his party rode west on Reed Creek and crossed to a branch of the north fork of the Holston. They encountered much thunder, lightning, rain and snow in the fickle early spring weather. The land was hilly to the north and they could see snow lying on the tops of the high Appalachians. Three nights later they were disturbed by the restlessness of their dogs and the next morning discovered near by the tracks of twenty Indians who had passed without incident in the darkness. The white men caught two young buffalo, killed one, marked the other and turned it out. Keeping down Reed Creek, they were attracted

by the fine timber and found one giant elm which measured twenty-five feet around.

They also discovered two groups of Indian houses built of logs and covered with bark. About the camps was an abundance of bones, pots and pans, some broken, and many pieces of mats and cloth, indicating a considerable period of occupancy. Four miles farther on they camped on the Holston opposite a large Indian fort. Lingering at this spot over Sunday, April 1, they found in the river perch, mullet, carp and large catfish. Walker carved his name and the date on several beech trees.

The journey was slowed the following day because Walker's horse choked on the young cane growing in abundance along the streams. The men turned northwest toward Clinch Mountain,[3] the divide between the Holston and Clinch Valleys which runs southwestward for nearly two hundred miles. Walker commented in his diary: "This Ridge may be known by Sight, at a distance. To the Eastward are many small Mountains, and a Buffaloe Road between them and the Ridge. The growth is Pine on the Top and the Rocks look white at a distance." They traveled along the eastern base of the mountain for a considerable distance, observing the small licks, many deer and great masses of tangled holly, laurel and ivy in the low ground.

After finding a point on the Clinch which appeared less stony and precipitous than the previous gaps, they crossed over at what is probably the present Looney's Gap in East Tennessee, and camped about a mile from the top. Here Walker's horse was again choked on the cane and Walker drenched the animal with water to wash down the reeds.

The weather continued bad, with much rain and snow, and the party got through the broken country with great difficulty. Toward evening on April 7, the dogs cornered a big bear. The men rode up in time to see one of the dogs badly mauled. Walker took the disabled animal up beside him and carried him until he recovered.

On April 9 the adventurers reached Clinch River, at a point near the present town of Sneedville, Tennessee. Walker noted:

we marked several Beeches on the East side. we could not find a ford Shallow eneough to carry our Baggage over on our horses. Ambrose Powell Forded over on one horse, and we drove the others after him. We then made a Raft and carried over one Load of Baggage, but when the Raft was brought back, it was so heavy that it would not carry anything more dry.... we waded and carryed the remainder ... on our shoulders at two turns over the River, which is about one hundred and thirty yards wide. ...

On leaving Clinch River, they traveled five miles over a high mountain and entered the narrow valley between Newman's Ridge and Powell Mountain. They turned down Big Sycamore Creek for two miles, veered northwest along a buffalo road running along a northern tributary of the Big Sycamore to cut through Powell Mountain, and came to Powell River. Walker called this smaller parallel stream of the Holston and Clinch "Beargrass," but it was later named by the hunters for Ambrose Powell because of the frequent appearance of his name which he carved on beech trees during this journey. Walker wrote:

Small Cedar Trees are very plenty on the flat ground nigh the River, and some Barberry trees on the East side of the River. on the banks is some Bear-Grass. We kept up the River two miles. I found some Small pieces of Coal[4] and a great plenty of very good yellow Flint. The water is the most transparent I ever saw. It is about 70 yds. wide.

Walker's entry for April 13, 1750, is the first written record of the discovery of Cumberland Gap:

We went four miles to large Creek, which we called Cedar Creek, being a Branch of Bear-Grass, and from thence Six miles to Cave Gap, the land being Levil. On the North side of the Gap is a large Spring, which falls very fast, and just above the Spring is a small Entrance to a large Cave, which the Spring runs through, and there is a constant

Stream of Cool air issuing out. The Spring is sufficient to turn a Mill. . . . On the South side is a plain Indian Road. on the top of the Ridge are Laurel Trees marked with crosses, others Blazed and several Figures on them. . . . The Mountain on the North Side of the Gap is very Steep and Rocky, but on the South side it is not So. We called it Steep Ridge. At the foot of the hill on the North West Side we came to a Branch, that made a great deal of flat Land. We kept down it 2 miles, Several other Branches Coming in to make it a large Creek, and we called it Flat Creek. We camped on the Bank where we found very good Coal. . . .

Walker was making a detailed description of what was the most important discovery of his entire journey. The Indian road into which he had come in the little vale at the southern base of the pass was the famous Athawominee, or Warriors' Path, over which Gabriel Arthur had traveled seventy-six years before. The sharp break in the high mountain wall on the western rim of the Appalachians was the gateway through which hundreds of thousands of people would pass on their way to the limitless West. The coal he had discovered on the banks of Flat Creek (Yellow Creek) would bring riches to the mountains more than a century later and cause towns and cities to be built along the road. Walker did not speculate on the meaning of the crosses, blazes and figures found on the laurel trees. Had he copied them in his diary, hieroglyphists might have been able to decipher a mighty saga of the Indian road.

Walker and his party broke camp on Saturday, April 14, and continued leisurely down the creek along the road. The weather was good but he did not explain why they traveled only a short distance. He undoubtedly noted more outcroppings of coal along the stream and admired the rugged precipice on his right, later known as Rocky Face, which stemmed perpendicularly from the main Cumberland range.

Easter Sunday dawned in full brightness. Because the horses had poor grazing along the narrow banks of the creek, Walker

broke his usual custom of not traveling on Sunday and moved down the Indian road for seven miles. He camped on a stream later called Clear Creek where he found clover and hop vines growing in abundance. Delayed on account of rain, he made some moccasins to replace a pair in bad condition and the next day went on a hunting trip down Clear Creek. About a mile from the camp he came to a large stream sweeping out of the hills from the northeast. He had come upon the headwaters of the Shawnee River, named for the last permanent Indian residents of Kentucky. Unaware of this he called it the Cumberland in honor of the Duke of Cumberland, then a national hero because of his victory in leading an English army at Culloden two years before. Hunters later fixed the same name upon the mountains and the great pass.[5]

On April 18 the explorers followed the Indian road along the Cumberland River through a narrow pass, later known as Wasioto Gap, where the river cuts through Pine Mountain, a wall parallel with the main Cumberland range. A half mile below these narrows, they came to the point where the road crossed the stream. They did not ford the river due to high water but turned left off the Indian road and followed the west bank for several miles. Walker and his men wandered through difficult hills and came to a big lick in the bend of a creek much used by buffalo and with many animal paths leading to it. In a fight with a bear, one of the men suffered a severe bite in his knee.

The men turned east again to Cumberland River, but it was still too full to ride across. They halted to make a bark canoe, but their work was delayed by thunder and lightning, hail and rain. After a delay over Sunday, April 22, they crossed the river in their canoe and forced their horses to swim the current.

On the northeast side of the river, Walker found a large bottom of fertile land. He decided to build a cabin and to divide his party for further exploration. The men drew lots to determine who should continue with him. Three men remained behind to build the cabin, salt down bear meat, plant corn and peach stones. Walker knew that he was now nearly fifty miles

north of latitude 36° 30', the Virginia and North Carolina dividing line, and he desired to establish technical claim to the land by erecting a cabin.[6]

Walker and his two companions journeyed westward about eighteen miles from the cabin site and found the land thin and covered with underbrush. They came upon some fresh Indian tracks and followed them, hoping to find the Indians and get firsthand information about the country. The land continued poor, the laurel grew more tangled, and grazing for the horses more inadequate. Walker climbed a tree on an elevated point to look at the territory. He found it unpromising in all directions and decided to return to the camp where he had left his three companions. He led his two men back to the Cumberland and cut his initials on some trees and blazed several, adding three chops over each blaze. The men discovered the remains of several Indian cabins and a large burial mound. In another fight with a bear, one of Walker's dogs suffered a broken leg.

When Walker got back to his old camp, his men had completed the erection of a log cabin, eight by twelve feet in size, the first to be built by white men in what was to be Kentucky. They had also prepared the meat of several bears and had put in a small patch of corn and planted a number of peach trees. Walker was distressed that the lame horse was still in bad condition and that another had been bitten on the nose by a snake. "I rub'd the wounds with Bears oil, and gave him a drench of the same and another of the decoction of Rattle Snake root some time after. . . . This day Colby Chew and his Horse fell down the Bank. I Bled and gave him Volatile drops, & he soon recovered."

Before he left the cabin, Walker noted that less than a mile down the river was a large pond, a quarter of a mile long and 200 yards wide, much frequented by wild fowl. This pond was later rediscovered by Daniel Boone on one of his hunts and named Swan Pond. Walker called attention to the markings which identified the location of his cabin: "On the other side

of the River is a large Elm cut down and barked about 20 feet
and another standing just by it with the Bark cut around at the
root and about 15 feet above. About 200 yards below this is a
white Hiccory Barked about 15 feet." These landmarks ex-
plained how he had made the canoe which his party had used to
cross the river.

He made a final entry for April 30: "The bitten Horse being
much mended, we set off and left the lame one. He is white,
branded on the near Buttock with a swivil Stirrup Iron, and is
old." It can be imagined with what reluctance Walker left this
faithful horse to forage alone in the wilderness, an easy prey
for wolves, bears and panthers.

On May 1 the explorers headed north, crossed Laurel River
and came to a much frequented Indian road. Walker correctly
surmised that this was the same road which he had found at
Cumberland Gap and traveled to Cumberland Ford. They con-
tinued northward along Laurel River, came to a lick where at
least a hundred buffalo were cavorting, and pitched camp in a
shower of rain. The next day they discovered a recently deserted
Indian camp in which they took refuge from the rain. For two
days they crossed many more streams, flushed young wild geese
and found the trail clogged with windfalls.

Walker was now deeply enmeshed in the trackless forests
which covered the tangled hills of eastern Kentucky. On May
11 his party camped under a rock large enough to shelter 200
men. They rested for two days, observed the Sabbath and made
new foot gear from the hide of an elk they had killed. "When
our Elk's Skin was prepared [we found] we had lost every Awl
that we brought out, and I made one with the Shank of an old
Fishing hook, the other People made two of Horse Shoe Nailes,
and with these we made our Shoes or Moccosons. We wrote
several of our Names with Coal under the Rock, & I wrote our
names, the time of our comeing and leaving this place on paper
and stuck it to the Rock with Morter, and then set off."[7]

From this point, evidently on one fork of the Rockcastle
River, the Walker party headed generally eastward for the

journey back to Virginia. They returned by the worst possible route traveling more than two hundred miles in difficult mountains and crossing the headwaters of the Kentucky, Licking and Big Sandy Rivers before reaching New River at its junction with the Greenbrier. They reached Staunton near the head of the Great Valley on July 11, 1750. Next day Walker left his companions and returned to his home at Castle Hill.

In a final recapitulation, Walker wrote: "We killed in the Journey 13 Buffaloes, 8 Elks, 53 Bears, 20 Deer, 4 Wild Geese, about 150 Turkeys, besides small Game. We might have killed three times as much meat, if we had wanted it." He made no mention of his evident disappointment in failing to find a proper place to locate his company's grant of 800,000 acres. He had bogged down in the rugged and barren territory of eastern Kentucky and had failed to reach the magnificent stretches of rolling bluegrass land farther north on the Ohio-bound rivers and streams he had discovered. He could only turn to the thought of the abundant game which he and his companions had bagged. At least his hunter's ambition had been satisfied.

In this journey, Walker had traveled from the New River crossing in Virginia to the rough Rockcastle country in the Kentucky mountains on the route which the future Wilderness Road would generally follow. As an observant explorer and competent surveyor he had discovered the easiest entry into the West from the southeast and had charted a considerable portion of the unknown region drained by the southern tributaries of the Ohio River. He furnished Lewis Evans and Thomas Pownall with essential details of the terrain, licks, streams and Indian trails for their important map of 1754. However, his exploration did not result in immediate settlement beyond the New River line. The French and Indian War, soon to engulf the border, would halt for more than a decade the settlements advancing over the Appalachian divide from the Great Valley.

[1] J. Stoddard Johnston, *First Explorations of Kentucky* (Louisville, 1898), pp. 4-84.

[2] The Holston River was named for Stephen Holston who built a house thirty

feet from the headspring of the Middle Fork about 1746. Walker does not mention him in his diary, although his cabin had already been erected on the Indian road leading into the West.

3 Clinch Mountain took its name from Clinch River, which was named for a hunter some time before Walker's trip.

4 No coal exists on this portion of Powell River. The lumps Dr. Walker found must have been washed down from its headwaters in the coal-producing section of Lee County, Virginia.

5 Some historians state that Walker first discovered Cumberland Gap when he accompanied Patton and Buchanan into East Tennessee in 1748. Walker's diary of 1750 makes no mention of a previous visit to the pass. His journal would indicate he was upon territory he had never seen.

6 A replica of the cabin erected by Dr. Walker has been built on the site of this first house in Kentucky, and the area preserved by Kentucky as the Dr. Thomas Walker State Park, eight miles southwest of Barbourville, in Knox County.

7 The location of this rock has never been accurately determined. A number of such shelving rocks are in the Rockcastle region. The most notable is a huge castlelike rock overlooking the river, plainly discernible from Highway 25, on the Wilderness Road, a few miles south of Livingston, Kentucky. It is for this rock that the river and county of Rockcastle are named.

Chapter 4

Grim Days on the Virginia Frontier

GRAIN fields were turning to gold in Draper's Meadows the first days of July 1755. Corn was in the milk, vegetable gardens were green and luxuriant, and the residents in the little settlement of New River Valley where Blacksburg, Virginia, would one day stand were ready to harvest their grain. William Ingles looked over his crops and was content. The owner of fine land, blessed with a wife and two little boys, he was prospering at twenty-five. Not a bad beginning for a penniless lad who had come from Ireland to seek his fortune in the New World.

Ingles owed his start to his friend and benefactor, Colonel James Patton, who took a special interest in him. The most important figure on the western frontier, County Lieutenant Patton, of Augusta County, had been dealing in western lands for twenty years, spotting good tracts and picking key people to develop them. Draper's Meadows was one of his developments. Located near the horseshoe bend of New River, the fertile basin lay a few miles north of the crossing of the old Indian road through the main valley between the Blue Ridge and the Alleghenies. In 1748 Patton staked Ingles and John Draper, another Irish boy, both in their teens, to a start in this beautiful spot in the western wilderness. Seven years of hard work had brought good returns.

The settlement was named Draper's Meadows in memory of George Draper, John's father, who came over from Ireland a few years before, got acquainted with Colonel Patton, went on a hunt in the wilderness and never returned. Patton befriended his widow and her two children, John and Mary, and located Ingles and John on the New River tract. Ingles had married Mary in 1750—first wedding of English colonists west of the Alleghenies. She was the kind of wife he needed. Strong and athletic, she could turn her hand to any job with the best of the men, could ride, shoot, cut wood, work in the fields and do all the heavy labor required of the rugged life on the frontier. She had borne William two fine little boys, Thomas, now four years old, and George, two, and her time was near for another child.

While Ingles and the other menfolk in the settlement prepared to cut their ripened grain, Colonel Patton and his nephew William Preston made an unexpected visit to Ingles' home. They brought exciting news. Far to the north, in Pennsylvania, trouble was brewing. The northern Indians and the French had formed an alliance to resist the westward spread of the English colonists. General Braddock with his British Regulars and colonial troops was marching to Fort Duquesne at the forks of the Ohio River. A test of strength was soon to come.

As a precaution against possible Indian raids, Patton and Preston brought a supply of powder and lead for the men at Draper's Meadows. But no one expected any trouble down here on the old Indian road into the southwest. The Cherokee were at peace, and the occasional bands of stray Shawnee passing through the distant settlements had shown no hostility. Patton and Preston lingered for several days, checking on new boundaries and helping with the harvest.

In the cool early morning of July 8, 1755, Ingles and Draper went to their separate grain fields. They left Colonel Patton in the Ingles cabin, writing, the broadsword he always carried lying on the table before him. Preston had gone to Sinking Creek, fifteen miles away, to ask Philip Lybrook to come to the Meadows to help with the harvest. The women were busy at their morn-

ing chores. Three men in the cabins had not yet gone to their fields.

While Ingles was at work, he heard screams and gunfire in the cluster of homes in the clearing. He rushed home, and saw a band of marauding Shawnee assaulting the cabins. As he approached he realized that the attacking force was too large to oppose. He turned to run but two warriors spied him. Ingles dashed into the woods, jumped over a fallen tree, stumbled and fell. His pursuers circled the uprooted tree without seeing him and ran on ahead. This gave him a chance to dive deeper into the woods in another direction and escape.

When the shrieks of the victims and the war whoops of the savages died down, Ingles ventured out of his hiding place. Draper came in from a far field, and the two men scratched in the ruins of the smoldering cabins. They discovered the body of John's baby with its head broken open. Inside the Ingles home they found the giant frame of Colonel Patton, lying scalped before the table, with the bodies of two warriors whom he had struck down with his sword before he was shot. The bodies of Mrs. George Draper and a neighbor, Casper Barrier, lay near by. One man, James Cull, was found alive but seriously wounded. He told the tragic details of the massacre. Mrs. John Draper had been shot in the arm as she fled with her baby. A warrior had caught her, snatched the baby from her and brained it against the end of a log. The rest of the settlers, Mrs. Ingles and her two boys, the wounded Mrs. Draper and Henry Leonard, had been taken away by the marauders. Draper's Meadows had been completely wiped out, the homes plundered or burned, the store of ammunition brought by Patton and Preston stolen, the horses ridden away, and the other livestock killed or scattered in the woods.

The raiders had come out of the north and they retreated by the same route. In a final gesture of cruelty and savage humor they stopped at the cabin of Philip Barger, a white-haired old man living alone in the valley. They cut off his head and put it in a bag. When the savages passed the home of Philip Lybrook

on Sinking Creek, they gave the bag to Mrs. Lybrook, whom they did not molest, and told her if she would look inside she would find an acquaintance. Lybrook himself was already on his way with Preston to the Meadows by another path, and thus both escaped.

Distraught over the fate of their loved ones, Ingles and Draper realized that haste in pursuit was imperative, but it required time to get word to Colonel John Buchanan at Pattonsburg, deputy of Colonel Patton in charge of the Augusta County militia. When Buchanan was at last on the trail with a force of pursuers, the savages were deep in the northern mountains and beyond reach. Ingles and Draper could only turn to the task of burying the victims near the scene of the tragedy and hasten to Dunkard's Fort on New River where alarmed settlers on the outskirts were taking refuge.

This unexpected attack upon Draper's Meadows and news the next day that General Braddock had been defeated and killed in western Pennsylvania terrified the settlers along the road from the lower Shenandoah to New River. Without doubt red hordes allied with the French would sweep down upon them. Governor Dinwiddie turned the command of the colonials over to Colonel George Washington at Winchester and Major Andrew Lewis at Staunton. Every available rifleman in the valley enlisted and the erection of forts at strategic points along the road was begun.

Ingles and Draper, brooding in their sorrow at Dunkard's Fort, had no opportunity to organize a search for their missing families. An ominous silence hung over the hostile Shawnee country. At last the men made a trip to the friendly Cherokee on the Tennessee and conferred with Virginia traders there, particularly Richard Pearis, a favorite among the Overhill Indians, as the settlers called the Cherokee. They also laid their troubles before Chief Attakullaculla, the Little Carpenter, who was always well disposed toward the English when other chiefs had been noncommittal or hostile. The distraught white men offered to employ Cherokee emissaries to go to the Shawnee nation to ran-

som their wives and children. But they had no success and could get no message from the prisoners. In despair, they returned to Dunkard's Fort.[1]

A happy surprise awaited them. They arrived just in time for breakfast, and were overjoyed to find Mrs. Ingles. She had been brought in the previous night. Adam Harmon had found her a few days before when she came out of the northern mountains at the present site of Eggleston's Springs, after a journey of forty days in the wilderness.

Ingles asked her about the boys. She could not tell him much. After the Indians and their captives had arrived in their town north of the Ohio River and held a big celebration, the boys had been separated from her and taken to Detroit. Their fate she knew not. Her brother's wife, she understood, had been carried to Chillicothe and adopted into the home of an Indian chief. Perhaps she was still alive.

But what of the expected baby? Mrs. Ingles sobbed out the answer for her husband. The third night after the raid she had given birth to a little girl. Knowing that she and the child would be killed if she were unable to continue with the Indians, she insisted she could go on the next day and she did—on a horse and carrying the baby in her arms.

After many weeks with the Indians, she and the baby had been brought by a band of French and Indian hunters and saltmakers to Big Bone Lick in what is now Boone County, Kentucky, where the bones of prehistoric animals of enormous size lay about in abundance. Using pots and kettles taken on the raid of Draper's Meadows, Mrs. Ingles helped in making salt.[2] With her was another white captive, an old Dutch woman taken some time before in a foray on the Pennsylvania settlements.

Mrs. Ingles explained that she and the old woman often talked about escaping. Their opportunity came one day at the salt lick when the warriors were away hunting. The young mother realized it was impossible to take her baby, only three months old, on a journey of several hundred miles through the wilderness. The thought of abandoning it tore her heart. Was her

greater duty to the helpless infant, or to her husband back at home and her little boys who might still be rescued? She made up her mind. She put her little baby down in a bark cradle, tucked a blanket tenderly about it, kissed it and then turned away.

Ingles listened soberly to this recital. He could understand. He took his sobbing wife into his arms and tried to comfort her.

Then little by little, Mrs. Ingles pieced out the story of her return to the settlements. She and the old Dutch woman had taken a blanket and hatchet and slipped into the forest. Knowing of no direct route to Virginia, they chose the longer but surer way of following familiar streams. They went directly to the Ohio and followed up the south bank. Their first major destination was the mouth of the Kanawha. If they could find that stream, Mrs. Ingles was sure they could follow it to the broad valley near Draper's Meadows.

Long fatiguing days the women had traveled through cane-brakes and marshes, across streams and over mountains, with no shelter at night except the forest or an occasional cave, hollow log, or deserted Indian camp. They lived on nuts, berries, papaws, roots and tender bark. They came upon a patch of corn in an abandoned Indian field across the Ohio from the Shawnee town where they had been prisoners. Here they feasted on parched corn and took a supply with them.

The women also found an old horse with a bell, grazing in a meadow. They caught him, muffled the bell clapper and took turns at riding. But many times both had to walk over terrain which became increasingly rough. At last they reached the Big Sandy River, not far from the present town of Catlettsburg, Kentucky. Unable to cross near its mouth, they went up the stream until they came to a log drift over which they could walk in safety. How to get the horse across was a problem. The Dutch woman insisted the animal also could walk over. They started with him, but a short distance from shore his legs broke through the floating drift, leaving his body suspended helplessly

on top. They had abandoned him thus entrapped in midstream. They took the small supply of corn which the horse had been carrying, and the old woman cut the collar around his neck and took the bell.

After crossing the Big Sandy, they added more miles by going downstream to the Ohio again to be sure of a safe route to the Kanawha. Over the Guyandot and finally to the Kanawha at Point Pleasant they had trudged. Now upon the stream that would lead them to Draper's Meadows, Mrs. Ingles took new courage, but the worst of their journey lay ahead. Day after day they dragged their weary limbs along, suffering and starving; night after night they shivered in the frosty woods.

At last the old Dutch woman's reason snapped. Weak from fatigue and hunger, she began to blame Mrs. Ingles for their suffering and threatened to kill her. The younger woman had soothed and cajoled her raving companion but the outbursts became more frequent and violent. The final break came when they were within a few days of home and safety. Completely insane, the tattered old woman now threatened to kill and eat Mrs. Ingles. To temporize, Mrs. Ingles had proposed they draw lots to see who should be the victim. Losing in this bizarre gamble, Mrs. Ingles tried other arguments and the promise of a big reward when they got home. But the old woman seized her companion in a death grapple. For a few minutes they rolled and thrashed about on the ground. Mrs. Ingles, the more agile and the stronger of the two, had torn herself away and stumbled off into the forest alone, the old woman screaming imprecations after her.

Soon Mrs. Ingles found a leaf-filled canoe on the riverbank. Using a shattered branch from a tree struck by lightning, she poled herself to the east bank and continued upstream. A day or two later she saw her companion through a break in the trees on the other side and they hallooed to each other. In vain the older woman pleaded for Mrs. Ingles to rejoin her.

After further tortures in her struggle to get through the defiles of the mountains cut by New River, Mrs. Ingles had come out at the present site of Eggleston's Springs, Virginia, fifteen miles

from her home, where Adam Harmon had a cabin. She had been traveling for forty days. Her clothes were in strings. Her arms, feet and legs were bruised and swollen. When Harmon answered her feeble cries she collapsed, her indomitable will at last breaking under the strain. Food, rest and sleep in Harmon's cabin quickly revived her and she had been brought on to the fort.

When Mrs. Ingles concluded her story, she pleaded that searchers be sent for the old Dutch woman. A party of frontiersmen immediately set out into the region where she had last been seen. They found her at the edge of the valley, riding leisurely along on an old horse with the bell around his neck, the bell to which she had clung so tenaciously during her wanderings. After she had last seen Mrs. Ingles across the river, she came upon a hunter's camp in the forest and a supply of food. Tarrying there until she recovered her strength, she caught a stray horse and rode toward the settlements in style, frequently hallooing to attract attention. When she was reunited with Mrs. Ingles, the two embraced, forgetting their former difficulties in the joy of rescue.

Ingles moved his wife for greater safety from Dunkard's Fort to Vaux's Fort ten miles west of Christiansburg, and the old Dutch woman joined a party going through the Shenandoah Valley to her home in Pennsylvania. Ingles remained with Mary at Vaux's for some time, but she became obsessed with the fear of another Indian raid and persuaded him to take her south of the Blue Ridge into Bedford County. They set off, and the first night after they left, Shawnee raiders attacked the fort, killing or taking prisoner all its occupants. Among those slain were John Ingles, younger brother of William, and the wife and child of Matthew Ingles, another brother. Matthew suffered wounds from which he died a few months later.

William Ingles, his wife safe again, joined the militiamen of Augusta County to help protect the frontier. There was nothing he could do for the time being to find his lost sons, or his sister-in-law, Mrs. John Draper. Not only had Draper's Meadows been wiped out, but another scalping party had attacked the

family of Samuel Stalnaker, whose cabin Dr. Walker had helped to build on the Holston in 1750. Stalnaker had been taken prisoner, his wife and son Adam slain. These and other raiders roaming the frontier had gone unpunished. The time had come to stop the menace.

Because of his knowledge of the mountainous country north of the settlements through which the raiders came, Ingles was selected as a scout for an expedition which Major Andrew Lewis organized to go against the Shawnee early in 1756. The frontiersmen gathered three hundred and forty strong at Fort Prince George, four miles west of the present city of Salem, Virginia. As allies, a hundred Cherokee warriors joined them under the leadership of Chief Ostenaco (Outacity or Judd's Friend), and Captain Richard Pearis, the Virginia trader. A company of rangers, commanded by Captain William Preston, who had vowed to avenge the death of his uncle, Colonel Patton, was designated as the advance troops for the march. Ingles was a lieutenant in this company.

The expedition left Dunkard's Fort on February 19, 1756, for the long, hard march through the mountainous country penetrated by the Big Sandy River and its tributaries. Known in pioneer history as the "Big Sandy Voyage," it proved a disastrous failure. Although most of Lewis' men were able to get to the mouth of the Big Sandy on the Ohio, his force was so depleted and underwent so much suffering and privation in the extreme winter weather, he was unable to cross the Ohio and attack the offending Shawnee. Fearing a rout of his grumbling and disorganized men should they meet a superior force, Major Lewis ordered a retreat without striking a single blow at the enemy.

The hardships of the men through the pathless mountains on their return were even more extreme than on their outward march. A heavy snow fell, the weather continued bitter cold, and provisions were completely exhausted. Subsisting on such game as they could find, extremely scarce at that season, they almost starved. When they reached Burning Spring, the present site of Warfield, they took the hides of the buffalo they had hung

in trees on their outward march, cut them into strips or tugs and broiled them to eat. From this incident the branch of the Big Sandy on which they camped is called Tug River.

Military discipline broke down completely, and the men scattered into the mountains, foraging for food and reaching home the best they could. Many of them either starved, froze to death or were killed by Indians who followed them in their tragic retreat. Broken and discouraged, the survivors filtered back to the forts along the valley road, biding their time for another effort at revenge.

Ingles rejoined his wife, but much of the time during the following years he was on active duty with the frontier militia stationed at various points along the road. Restive and anxious about his missing sons, he busied himself with his military duties and kept a sharp eye on the swiftly moving events of the border. The old Indian trail which crossed the New River where he had patented a tract of 2,600 acres in 1748 was rapidly changing into a military highway. Hundreds of men galloped up and down the road every day, militia companies passed back and forth to scattered outposts, and crews of workmen widened it for heavy supply wagons. The New River crossing would be a focal point of trade, commerce and travel, and Ingles was already dreaming of going into business there when conditions on the frontier had settled.

Early in 1758 he took time out to build a cabin on his land at the crossing and a small fort for the protection of the near-by settlers. This dwelling was a one-room log house with two doors and an attic with narrow steps leading to it. The room was sixteen feet long and fourteen feet wide, with a stone chimney and a broad fireplace at the south end. Fifty yards from the house a cold spring bubbled out of the foot of a bluff, and two hundred yards away the barn stabled horses and cattle. Into this house by the side of the Wilderness Road, where in reality it began, Ingles brought his wife as soon as conditions were comparatively safe.

From this vantage point at the entrance into the West, Ingles witnessed the development of the Great Road from the Shenandoah Valley, bringing caravans of westbound settlers. Already

it had been built into a wagon road south from Wadkin's Ferry above Harper's Ferry on the Potomac, up the Shenandoah, across the headwaters of the James and Roanoke, and to his home on the New. Travelers were accustomed to refer to the Valley road as the "Pennsylvania Road," or the "Irish Road," the latter term obvious because of the large number of Scotch-Irish emigrants who had followed it.

A military necessity projected the road from Ingles' home into the Holston country. In 1760 Colonel William Byrd III, in command of the old regiment of George Washington's colonial troops, was ordered to the relief of the besieged garrison of South Carolinians at Fort Loudoun, in the fork of the Little Tennessee and Tellico Rivers. Byrd made slow progress in his westward march and lingered during the summer at the forts in the vicinity of New River while he gathered supplies, strengthened the outposts and improved the road. Because of his delay he furnished no aid for the stranded South Carolinians, and Fort Loudoun was wiped out by the enraged Cherokee.

Byrd's advance, however, was not without its influence on the frontier. He built Fort Chiswell nine miles east of Wytheville, Virginia, which he named for his intimate friend, Colonel John Chiswell, who in 1756 had found and developed important lead mines on the New. But more important, three companies of his troops under Major Lewis widened and improved the old Indian trail for the passage of wagons from the crossing on the New to Long Island on the Holston. This deep penetration into the West by a good wagon road was a material factor in the rapid settlement of the Holston country immediately following the French and Indian Wars.

Quick to take advantage of his strategic location on the advancing road, Ingles built a ferry in 1762 across New River and obtained a charter for its operation. He placed his brother-in-law, John Draper, in charge as the first ferryman, and the business was successful from the beginning. It ran day and night, and the tolls ultimately amounted to a thousand dollars a month. Because of the increasing travel and activity at the ferry, Ingles

added a tavern, a general store and stables to care for the teams
of wagoners. Ingles Ferry thus became a prominent center and
important way station on the Wilderness Road.[3]

But prosperity did not banish the shadow of sorrow which
hung over the Ingleses' home. Mrs. Ingles, normally cheerful,
could not forget her little boys, Thomas and George. Although
other children came along, three girls and a boy, she brooded
over the fate of her missing first-born. Her sympathetic husband
did all he could to get word of them. He talked with persons
who had been in the Northwest. He made inquiries on his busi-
ness trips up and down the Valley, and the people on the frontier
became as familiar with the tragedy of Draper's Meadows as if
it had happened to their own families.

The first break in the mystery came with the recovery of Mrs.
John Draper by her husband. Draper made a number of trips
and also sent agents into the Shawnee country in an effort to find
his wife, but each time he had learned nothing. At last, he was
present at the making of a treaty in 1761 between the Cherokee
and the whites and learned from an Indian chief that his wife was
still living. After much negotiation and the payment of a heavy
ransom, she was released and returned to him. She told the
Ingles family that little George, the younger of the two boys,
had died soon after he was taken from his mother. About
Thomas she knew nothing.

In 1763 Ingles learned the first authentic news of Thomas. A
man named Baker who stopped at the Ferry said he had lived for
a time as a captive of the Shawnee in a village where a boy
believed to be the missing Thomas was the adopted son of an
Indian. Ingles at once employed Baker to go to the Shawnee
nation and ransom the boy. Within a few months Baker was
back with a discouraging report. He said he had found Thomas
and after much bargaining had paid a hundred dollars for his
release, but the boy, unable to speak English and unwilling to
leave his Indian home, had to be bound and brought away by
force. Fifty miles out of the Scioto village, he got away. Baker

followed the lad back to the town, but Indian squaws had hidden him and he could not be found.

The news that their son was really alive, although unwilling to return, cheered the father and mother. Accompanied by Baker, Ingles immediately set out himself to persuade the youngster to come home. They went through the Valley of Virginia by Staunton to Winchester, by Fort Cumberland to Fort Pitt, and down the Ohio to the Scioto village. When they arrived, they found the boy had gone to Detroit with an Indian party, so they had to wait several weeks for his return.

It was a strange meeting of father and son. Knowing no words in common they could not talk to each other. The lad, now seventeen, was tall and straight. His feet were small and terribly disfigured because as a little boy he had stepped into some coals of fire in an Indian camp. He had known no father except the brave who had adopted him, but something in the warmth and kindliness of the middle-aged white man who looked upon him so tenderly, flowed into his own wild, primitive heart. Yes, he would go back to the white settlements with the man who said he was his real father. Another ransom of a hundred and fifty dollars was paid to his Indian godfather and friend, and Ingles and Baker set off for home with their strange charge.

Mary Ingles took her long-lost son into her home by the side of the Wilderness Road and taught him the ways of the white people. She understood and tolerated his moods, when he would take his bow and arrow and go off into the woods and stay for days. Finally she sent him to their old family friend, Dr. Thomas Walker, in Albemarle County, where he was put in school. His rescue from a savage life brought a measure of solace, but she never ceased to be haunted by the memory of the baby she had left in a bark cradle in the Kentucky wilderness. She never saw or heard of it again.

[1] It is believed that Ingles and Draper sounded out the Cherokee on the possibility of giving aid to the colonists against the Shawnee.

[2] Mrs. Ingles was the first white woman of record to visit the Kentucky land.

[3] F. B. Fitzpatrick, *History of Ingles Ferry* (MS. in Library of State Teachers College, East Radford, Virginia).

Chapter 5

Trail-Blazing Long Hunters

E LISHA WALDEN did not wait for the troubles with the northern Indians to end before he went on his first long hunt into the West. A squatter on the "Round-About" of Smith's River in Henry County, Virginia, two miles east of Martinsville, he lived east of the Blue Ridge and did not enlist in the Valley militia to hold the frontier. Unlike most of the settlers crowding west, he had no passion for land and no urge to chop out a clearing, build a home and accumulate property. A typical, easygoing backwoodsman, he was content to make his living with his long rifle and hunting knife.

Walden emerged on the southwestern frontier out of a vague past. Nobody knew where he came from or what was his ancestry. A dark-skinned, squarely built, rough-featured fellow with little education, he would go off into the woods for months at a time and leave his little family to scratch out a living as best they could. Nearly everybody on the frontier went on hunts as a matter of necessity or diversion, because it was good sport and game was plentiful, but Walden made a business of it.

As soon as the Cherokee had been pacified in 1761 after their brief uprising when Fort Loudoun was destroyed, Walden gathered a group of relatives and friends for a big hunt far beyond the settlements in the valleys of New River. With him were his father-in-law and brother-in-law, William and Jack Blevins, Henry Skaggs, Walter Newman, Charles Cox and about a dozen other trained woodsmen.

Walden and his men carried long, flintlock Deckard rifles. Each man had a powder horn and shot pouch, in which he kept his powder, bullets, tow, pieces of punk and extra flints for the gun and for striking fire on the punk. Because of the danger of hostile Indians, Long Hunters, as they were called, usually established a central camp for their skins and furs and hunted from it in pairs. Their camp equipment consisted of crude cooking utensils, hand vises and bellows, files and screw plates for repairing guns, and reserve supplies of powder and lead.

A man's hunting shirt was made of linsey or dressed deerskin, and was a loose frock reaching halfway down the thighs and big enough to lap over a foot in front when belted. The bosom served as a wallet to hold bread, jerk, and tow for wiping out a gun barrel. A large cape, usually fringed with ravelings of cloth of different color from the shirt, hung over the shoulders. A tomahawk was suspended from the belt on the right side and a hunting knife in a leather sheath on the left. Breeches, leggings and moccasins of deerskin with flaps reaching up the legs completed the costume. Raccoon caps with tails hanging behind were commonly worn, although a few men, like Daniel Boone, clung to the conventional beaver hat.

Crossing the Blue Ridge into the road leading beyond the New River, Walden and his men left the main trail and began to range in the hidden coves and valleys of the Holston, Clinch and Powell Rivers. They followed buffalo paths to big licks, wandered up and down small tributary streams, crossed over high mountains and set up permanent camps from which they operated. They found a veritable hunter's paradise. Hardwood forests mantled the hills, and luxuriant meadows of deep grass and wild pea vine extended in interminable reaches. Canebrakes lined the streams in rich, loamy lands. Animal wallows at salt licks were the rendezvous of enormous herds of deer, elk and buffalo. Beaver, otter and mink denned along the streams, and bears, turkeys, grouse, quail and other wild game abounded. The hunters feasted on the game and collected and prepared skins and furs for the eastern markets.

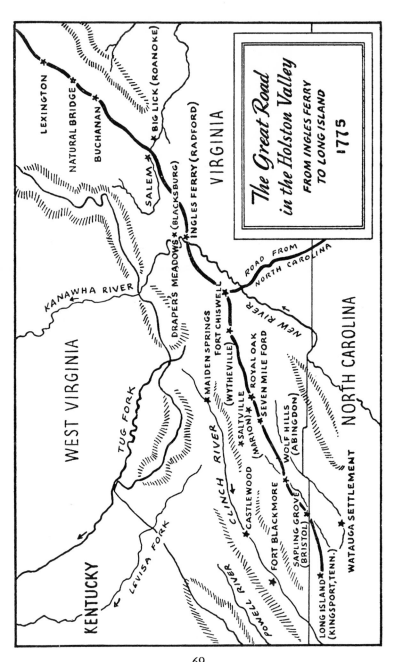

The Great Road
in the Holston Valley

FROM INGLES FERRY
TO LONG ISLAND

1775

LEXINGTON

NATURAL BRIDGE

BUCHANAN

SALEM

BIG LICK (ROANOKE)

DRAPER'S MEADOWS (BLACKSBURG)

INGLES FERRY (RADFORD)

VIRGINIA

ROAD FROM NORTH CAROLINA

KANAWHA RIVER

MAIDEN SPRINGS

FORT CHISWELL

NEW RIVER

WEST VIRGINIA

TUG FORK

(WYTHEVILLE)

ROYAL OAK

SEVEN MILE FORD

SALTVILLE

(MARION)

WOLF HILLS (ABINGDON)

NORTH CAROLINA

CLINCH RIVER

CASTLEWOOD

FORT BLACKMORE

SAPLING GROVE (BRISTOL)

POWELL RIVER

LEVISA FORK

KENTUCKY

WATAUGA SETTLEMENT

LONG ISLAND (KINGSPORT, TENN.)

In camp they built pole scaffolds several feet from the ground on which they piled their pelts. A pole on top kept the skins packed together. An elk or buffalo hide or strips of peeled bark protected them from the weather. When enough were collected the men folded and packed the pelts in bales weighing fifty to a hundred pounds. Two bales made a horseload. These bales were stored on scaffolds to protect them from hungry wolves and bears.

Walden and his men had such good luck on this first organized hunt into the Southwest in 1761 they stayed away for eighteen months. In their journeys they covered much of the wild region between Long Island on the Holston and Cumberland Gap, the country later traversed by the Wilderness Road. They crossed and recrossed many times the well-defined southern portion of the Warrior's Path. They named many ridges and streams. Walden himself is remembered by Walden's Ridge and at least two Wallins Creeks.[1] Newman's Ridge was named for Walter Newman, a member of the party. Walden's men perhaps changed Walker's "Beargrass River" to "Powell River," because of the frequency with which they came upon "A. Powell," carved by Walker's companion on beech trees along the stream in the exploration of 1750. It is also likely that they changed the name of "Cave Gap" to "Cumberland Gap" to conform to the name by which the mountains were now being called.

Walden went on his next long hunt in 1763. With approximately the same group of men, he followed the old path through the Cumberland Gap and trapped on the headwaters of the Cumberland River and the streams in the hills of southeastern Kentucky. Notable among these was Stinking Creek, a tributary of the Cumberland, often mentioned in the annals of the Wilderness Road. According to legend, it was so named because of the odor of the decaying carcasses and offal of game which the hunters left along its banks. The men extended their hunt to the Rockcastle country and reached westward until the land began to flatten out. They came upon a large orchard of sweetly blooming crab-apple trees at some great springs. The spot, still known

as Crab Orchard, became a significant point on the Wilderness Road.

The news of Walden's profitable hunts stimulated other men on the border. The fur trade was attractive. Men who loved the chase organized long hunts after their crops were in. Walden was probably on a trip of his own when one of the largest groups of these Long Hunters, gathered near Fort Chiswell early in June 1769 and took to the western trails. Most of the men were from the New River frontier, Rockbridge County, Virginia, and the Yadkin country in North Carolina. Among the leaders were Kasper Mansker, Uriah Stone, Richard Skaggs, and Abram and Isaac Bledsoe, whose names became fixed upon the western country. They followed Walden's trail down Powell Valley to Cumberland Gap, and the Warriors' Path to Flat Lick in Kentucky. Here they veered west along the Cumberland River until it led them into the Tennessee country. They established their central camp in Sumner County, Tennessee, and discovered Bledsoe's Lick and Mansker's Lick, afterward notable in the history of the settlement of Nashville.

The following year another large company left from Fort Chiswell, including many of those who had been on previous hunts. They took Walden's trail through Cumberland Gap and hunted extensively on Green River and in the Barrens, a large denuded area burned off by the Indians, on the border of the future states of Kentucky and Tennessee.

During this hunt James Knox, of Augusta County, Virginia, and some companions left the main group to make an excursion northward. In their rambles on Rockcastle River, where game proved scarce, they met Captain Dick, a Cherokee chief, whom they had met before at the lead mines near Fort Chiswell. The friendly chief explained that they would find plenty of game over on "his river," indicating the direction for them to take. But he cautioned them with significant emphasis to kill only what they needed and go home. Knox accepted the chief's advice, went west to the head of the stream described and called it Dick's River, in honor of his Indian friend.[2] He was exploring a ter-

ritory through which he would help to build the Wilderness Road.

Early in May 1769 Daniel Boone and five companions appeared at Cumberland Gap, bound for the Kentucky hunting grounds. Walden and many other Long Hunters had preceded him at the pass in the Cumberlands, but the trail would lead Boone to a greater destiny than all the rest. Thin-lipped, wide-mouthed and dark-haired, the slender, medium-sized backwoodsman from the headwaters of the Yadkin was nearing middle age, and his career had not been remarkable. Since his marriage to black-eyed Rebecca Bryan in the Great Valley of Virginia, he had joined in the migration south, helped to repel Indian raids on the border, settled on the Yadkin and hunted over wide areas in the Holston and Tennessee valleys. Once he went to Florida to take up land but he did not like the country. At forty, he was getting along in years and had accumulated very little for Rebecca and his growing family. A skilled woodsman, he was expert at stalking game and knew most of the good hunting grounds in western North Carolina and East Tennessee.

This trip of Boone to Kentucky was not his first. Two years before he had crossed the valley between the Blue Ridge and Alleghenies and wandered through the mountains drained by the Big Sandy, but he did not get beyond the hills. He had heard of fat lands of bluegrass on unexplored rivers which flowed into the Ohio, and of the game which ranged the rich region. Disappointed in his Big Sandy excursion, he made up his mind he would try again to reach this paradise about which he had learned.

His opportunity came when an old friend called at his cabin on the Yadkin in the spring of 1769. John Finley, of Pennsylvania, was peddling household wares in the settlement. The two old cronies had not seen each other since they soldiered with Braddock. They exchanged information. Finley sketched briefly what he had done since they separated. He had been a trader among the western Indians and in 1754 spent some months with

THE BLOCK HOUSE

Built by Captain John Anderson in 1777 in Carter's Valley six miles east of Moccasin Gap in Virginia. It was the starting point for companies of emigrants entering the wilderness en route to Kentucky.

DORTON'S FORT

Still standing near Nickelsville in Scott County, Virginia, it was built by Robert Killgore in 1790 and was typical of the early small forts along the Wilderness Road.

BEAN'S STATION TAVERN IN EAST TENNESSEE

Built in 1813, it typified the better inns on the Wilderness Road. Here Henry Clay, Andrew Jackson, James K. Polk, and other ante-bellum leaders often stopped on their way to Washington. Removed by the TVA in 1941 to be re-

the Shawnee in Kentucky at Es-kip-pa-ki-thi-ki, the present site of Winchester.³ He had tough luck there. The Indians turned upon him and his fellow traders, took all their goods and kept him a captive for a while. Finally he secured his release, returned to Pennsylvania and began peddling in the white settlements. He had now worked his way south into the Carolinas.

Boone was interested in what Finley had to say of Kentucky. He plied his friend with questions. A persuasive raconteur, Finley pictured the inviting beauties of the meadowland and its inexhaustible supply of game. Boone's gray eyes brightened. He proposed that they make a long hunt there. Finley was willing and at once they began preparations. Boone persuaded his brother-in-law John Stuart to go along, and employed Joseph Holden, James Mooney and William Cooley to accompany them as camp helpers. They cleaned and repaired their rifles, sharpened their flints and filled their packs. It would be a long journey.

Daniel and his companions and pack animals left home on May 1, 1769. His parting from his somber-eyed Rebecca was not marred by any misgivings. Rebecca and the children would get along while he was away. James, eleven now, could shoot and trap like a man and he would bring in fat coons, wild turkeys, and an occasional bear or deer to provide good steaks for the table. The garden was full of new vegetables, corn was ready for the first hoeing, and it would not be long until the summer crop was made. If Daniel had good luck on his hunt, his bag of skins and furs would help to supply the family's needs when he got back.

"There's a big gap in the mountain range which the Indians use," Finley explained to Boone, as they discussed the best way to Kentucky, the immediate route only vague in his mind. He had heard the Indians talk of the ancient place. Boone was in familiar territory in southwest Virginia and knew the trail which led to the pass. Perhaps he told Finley of the time he and some companions had been disturbed by wolves in their camp at the site of Abingdon, to which they gave the name of Wolf Hills.

Perhaps he recalled the tree in East Tennessee on which he inscribed the fact that he had killed a bear in 1760.

Through Moccasin Gap and across the Clinch, over Walden's Ridge, Powell Mountain and into the valley, the riders picked their way. They came upon a dark escarpment which rose with forbidding ruggedness. This huge wall only a few miles on their right was the Cumberland barrier a thousand to fifteen hundred feet above Powell Valley. The precipitous slopes gleamed gray in the sun, and it was no surprise to the travelers that the trail should turn southwest along the base of the rugged cliffs, through canebrakes, meadows and rolling timbered lands.

Suddenly the hunters came upon a settlement. Having left the last signs of habitation in the Holston country nearly a hundred miles away, they were astonished to find at this advanced point about twenty men busily erecting cabins, clearing land and planting corn. The leader was Joseph Martin from Albemarle County, Virginia, who had arrived a few weeks before. He had won a race with a rival band of settlers to take up land for Dr. Thomas Walker who had sponsored the enterprise.[4]

Martin had sent out scouts in all directions to learn the lay of the land, and hunt deer, bear and buffalo. They had scaled the mountain wall at a high notch where huge cliffs gleamed white and menacing, had gone over into "the Brush" back of the wall where Walden and his men thrashed about for game several years before. Others had followed the trail through the big pass twenty-five miles beyond into the marshes of Yellow Creek basin.

Leaving Martin and his men to their task of building a settlement, which for many years would be a convenient stopping point on the Wilderness Road before the final entry into Kentucky, Boone and his companions hastened on—down the valley through thickets and timber, across streams and over small hills, till they came upon the break in the mountain which Walker had found nineteen years before. On their right was the sheer face of a precipice which loomed fifteen hundred feet above them. On the left was the smaller rounded peak where the wall took up again. The dip was like a "V," and winding up to this lower

depression was the old Indian road, twisting through masses of underbrush and over boulders and ledges.

In the saddle of the depression, the men crossed the divide between the Tennessee and Cumberland Rivers. It was early summer. The breezes rustled in newly leafed trees. Immediately beyond the crest on the Kentucky side a spring broke out beside the trail and lost itself in thick tangles of laurel and rhododendron. The trail led down into a ravine where oak, elm, pine, poplar and chestnut trees brightened the slopes. At the northern base, the path leveled out in a jungle of high grass, canebrakes and animal wallows, and followed the lazy, crooked stream of Yellow Creek,[5] so called because of its yellowish cast from the sulphurous content of its waters washing over soft-coal outcroppings.

Boone and his men followed the Indian road down the creek to the Cumberland River ford and eight miles farther to Flat Lick where Indians often camped and made salt. Here Boone turned left from the Indian path and continued along a route blazed by Walden and other hunters. When they reached the Rockcastle country where the Hunters' Trail turned westward, Boone and Finley left the trail and headed due north into a broken region. They came out of the mountains in the neighborhood of Big Hill and for the first time looked upon the beautiful levels of Kentucky. They made a camp on Red Lick Fork of Station Creek, south of the Kentucky River, and at once began to range the region. Boone in describing it later said:

> We found every where abundance of wild beasts of all sorts, through this vast forest. The buffaloes were more frequent than I had seen cattle in the settlements, browsing on the leaves of the cane, or cropping the herbage on those extensive plains, fearless, because ignorant, of the violence of man. Sometimes we saw hundreds in a drove, and the numbers about the salt springs were amazing.

In the busy weeks which followed, Finley made a trip to the last Shawnee settlement in Kentucky at Es-kip-pa-ki-thi-ki and saw the abandoned huts and ruins. Later, the hunters clashed

with the Indians and lost their furs and skins. Boone and Stuart were away on a hunt along the Kentucky River. They were captured by an Indian hunting party, but managed to escape after seven days. When they got back to their old camp, they found it plundered and Finley and the camp helpers gone home. Boone and Stuart were not to be easily frightened out of the country. They continued to trap and hunt for several weeks, and one day they were joined by Squire Boone, Daniel's brother, and Alexander Neeley, who had become alarmed at their long absence and came to look for them. With this reinforcement, they trapped through the winter into the spring season.

Finally Stuart was slain by the Indians while hunting alone; Neeley became homesick and returned to the settlements. The two Boone brothers were left to themselves. Supplies ran out, and Squire went back to North Carolina with a load of furs to get new horses and ammunition. Daniel, alone in the wilderness without bread, salt or sugar, or a horse or dog, ranged the country. He went as far north as the Ohio and was impressed with its size and beauty. He camped along its banks, went to the Falls, inspected the fertile valleys of the Kentucky and Licking and dreamed of the day when the country would be filled with homes and farms.

Boone was rejoined by Squire at their old camp on July 27, 1770, but the site was too well known to the Indians. The Boones left it and turned south toward the Cumberland. Along the stream draining the southern portion of Kentucky, they hunted, trapped and reconnoitered, gave names to different waters and steadily added to their stock of skins and furs. Thus they passed the winter of 1770-1771.

Spring came and Daniel felt lonely one day. He killed a deer and lay on his back on the hide in the dense forest. Looking idly up through the leaves he forgot discretion and burst into song, oblivious to the soft sound of moccasins coming to him. Suddenly the green limbs of his bower parted. A long flintlock rifle, a bearded head and buckskin fringed shirt appeared. Daniel looked into the grinning face of Kasper Mansker. The Long Hunter

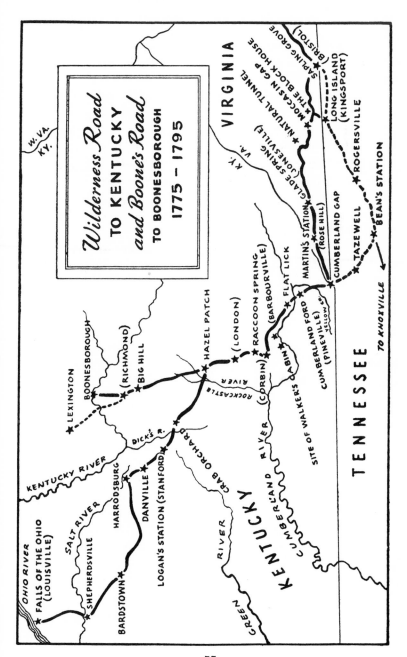

Wilderness Road
TO KENTUCKY
and Boone's Road
TO BOONESBOROUGH
1775 - 1795

W. VA.
KY.

VIRGINIA

VA. KY.

SAPLING GROVE (BRISTOL)
MOCCASIN GAP
THE BLOCK HOUSE
NATURAL TUNNEL
GLADE SPRING (JONESVILLE)
LONG ISLAND (KINGSPORT)
ROGERSVILLE
MARTIN'S STATION
(ROSE HILL)
CUMBERLAND GAP
TAZEWELL
BEAN'S STATION

LEXINGTON
BOONESBOROUGH
(RICHMOND)
BIG HILL
HAZEL PATCH
(LONDON)
RACCOON SPRING
(BARBOURVILLE)
FLAT LICK
CUMBERLAND FORD (PINEVILLE) YELLOW C.
SITE OF WALKER'S CABIN
(CORBIN)
ROCKCASTLE RIVER

TO KNOXVILLE

TENNESSEE

KENTUCKY RIVER
DICK'S R.
CRAB ORCHARD
HARRODSBURG
DANVILLE (STANFORD)
LOGAN'S STATION (STANFORD)

OHIO RIVER
FALLS OF THE OHIO (LOUISVILLE)
SALT RIVER
SHEPHERDSVILLE
BARDSTOWN

KENTUCKY

CUMBERLAND RIVER

GREEN RIVER

was camped in the neighborhood. He had heard Boone's discordant voice, thought it a new kind of Indian decoy and had slipped stealthily through the forest to investigate.

In March 1771 Daniel and Squire packed up their skins and started at last on their homeward journey. For nearly two years Daniel had been away. He had learned to know Kentucky better than any other man. He determined to bring his family out to this "second paradise" as soon as he could. Contentedly, Daniel and Squire jogged along the old trail, their horses loaded down with heavy packs of valuable furs. They passed through Cumberland Gap and reached Powell Valley where they met Alexander Neeley, their old companion. He had lost his way, used all his ammunition and had had nothing to eat but a stray dog he had killed. They shared supplies with him and continued on their way.

At their next night's camp six or eight Cherokee visited the two hunters, disarmed them, took their horses, skins and supplies and ordered them to leave the country.

Thus Daniel returned to Rebecca with nothing to show for his absence of two years, except the load of furs Squire had previously brought back, and his own enthusiasm for the land which was beckoning him to new adventures.

Determined to move to Kentucky as soon as he could arrange it, he sold his farm and moved into the Holston Valley. He hunted and roamed around the new settlements on the Watauga and the Holston for two years, and made the acquaintance of Captain William Russell, a leader among the frontiersmen on the Clinch. Boone's stories of the land beyond the Cumberland excited his new friends. With little difficulty he interested Captain Russell and several families in moving to Kentucky.

In September 1773 a party of forty persons started on the western journey from an outpost on the Clinch, with Boone and his family and some neighbors from the Yadkin leading the way. Captain Russell and another company followed some miles behind, hurrying to catch up with the forward party. Camping not far east of Cumberland Gap, Boone sent back his son James,

now seventeen, to pilot Russell's party to the forward camp so that all might be united for the trip through the dangerous hills. James found Russell, gave directions how to join his father and hurried forward again. With him came Captain Russell's son Henry, his own age, Isaac Crabtree, two Mendinghall brothers, a hired man, and two Negro slaves, Adam and Charles, belonging to Russell. Darkness overtook the young men and their companions about three miles from Boone's camp, although they did not know they were so near. They crossed a creek and finding a level spot near by decided to make camp. They built a fire, ate supper and spread out their blankets to sleep.

The men noticed that the wolves howled close to camp. It was a common occurrence, but this time they seemed closer than usual. Apparently no one suspected the reason. Not used to such nocturnal terrors, the Mendinghall brothers shivered in fear. Crabtree guffawed at the cringing brothers, twitted them about their cowardice and remarked that when they got to Kentucky they would hear buffalo bellowing from treetops.

Dawn broke through the heavy trees. Dark forms rose suddenly from all sides and sprang upon the sleepers. A flurry of arrows showered the camp. Young Russell was shot through the hips and James Boone was pierced with darts. Savages brandished tomahawks, slaying the Mendinghall brothers and the hired man. Negro Charles was taken prisoner. Crabtree fled into the woods and Negro Adam escaped to a pile of driftwood in the near-by creek.

Cowering in his hiding place, Adam heard the cries of the wounded boys as they were cut and slashed by their torturers. He could recognize the voice of young Boone pleading with the chief to spare him. The youth had evidently recognized the leader as Big Jim, a Shawnee who had once visited at the Boone cabin. For some time the torture continued, the Indians knifing and slashing the bodies of the boys. Their fingernails were torn out and the palms of their hands were lacerated in their futile efforts to ward off the blows. Finally Adam heard James beseech the Indians to end their work quickly.

At last their fiendish task was over. The savages gathered up the plunder and disappeared. They took Charles forty miles into the mountains. When two warriors quarreled over who should own him, a chief settled the argument by splitting the Negro's head open with a tomahawk.

After the Indians had gone, Adam came out if his hiding place. He set off to find the Russell camp, got lost and wandered eight days before he was found. Crabtree, in the meantime, carried the news back to the Russell party and a runner was sent ahead to inform Boone. Russell hurried to the scene, prepared graves for the mangled bodies, then followed the trail of the raiders. After several miles he abandoned the chase as futile.

At the plundered camp the two parties united sorrowfully to bury these first victims in the effort to settle Kentucky. Rebecca provided a clean linen sheet to wrap around the body of her son. The graves were filled. Dirt was packed down hard and stones were piled on top to protect the bodies from ravenous wolves.[6]

The party held a consultation. Should they go on or turn back? Perhaps the Indians whom they thought at peace were again on the warpath. Perhaps there were other bands roving along the trail ahead. Only Boone wanted to proceed. Determined and stoic, he hated to admit defeat. Perhaps it was his own good judgment which caused him to give up; perhaps it was the reproachful eyes of grief-stricken Rebecca. He yielded and they returned to the Holston settlements. Daniel and his broken family were given shelter in a cabin of Captain David Gass near a newly established station on Clinch River, the present site of Castlewood, Virginia. His time for claiming the Kentucky paradise was not yet.

1 The creeks are located in Lee County, Virginia, and Harlan County, Kentucky. Walden's name is variously spelled Walden, Walding, Wallins. Walden's relatives and descendants are legion in East Tennessee. Like Boone, Walden later moved to Missouri where he died.

2 The river is now erroneously spelled "Dix River," the form adopted in recent years.

3 This was the last permanent settlement of any Indian tribe in Kentucky. The Shawnee shortly after moved to their Scioto towns.

4 Martin found the Cherokee hostile and abandoned the settlement after crops

were made. No further attempt was made to revive the settlement until the early spring of 1775, before Boone and Henderson started for Kentucky. See *post*, p. 101.

5 This was first named Flat Creek by Dr. Thomas Walker in 1750, and it retained that name for a number of years. When "Yellow Creek" was adopted by the pioneers or hunters is not known, but it was probably not later than 1775.

6 Before he finally settled in Kentucky in 1775, the grief-stricken Boone made a hurried trip to visit the grave of his son.

Chapter 6

Trouble on the Holston

A RED-HEADED, long-jawed Scotch-Irishman, Arthur Campbell, was disturbed by the murder of the Boone and Russell lads in the fall of 1773. It looked like trouble for the Holston settlers. He reported the affair to the Augusta County authorities and hastened to investigate. Major in the Augusta County militia, he was responsible for the safety of the settlers who had crossed New River into the Holston Valley after the barriers to westward expansion had been removed by the treaties in 1768 of Hard Labor, South Carolina, and Fort Stanwix, New York. The first to penetrate deep into the Valley, Arthur Campbell lived sixty miles west of Ingles Ferry, on the Middle Fork of the Holston, in a commodious frontier house called "Royal Oak." He was the accepted border leader to defend the Byrd military road from Ingles Ferry to Long Island.

Campbell suspected the Cherokee of assaulting Boone's expedition. The chieftains disavowed any responsibility and maintained that they had been friendly and long-suffering with the whites, but Campbell knew that settlements had advanced to pinch them. Block after block of land had been surrendered to the colonists. Already many clusters of cabins dotted the forests around Royal Oak. To the west a group of Scotch-Irish settlers had made a clearing near Wolf Hills twenty-eight miles away. Beyond them twelve miles Captain Evan Shelby had located. South of Long Island the settlers had founded in 1772 what was known as the Watauga Association for self-defense and also

82

for self-government—the first independent state of native Americans. Many Regulators, backwoodsmen who had revolted against the tidewater authorities in North Carolina had joined the group. Two young men, James Robertson and John Sevier, both waited to assume local leadership in case of emergency.

Any uprising of the Cherokee would involve all these settlements. The time had come to test Campbell's ability to avoid an open break. The volatile Scotch-Irishman knew Indians. At fifteen, he had served with a company of Rangers in the French and Indian War. Assigned to Dickerson's Fort on Cowpasture River in present Bath County, he had been caught in a plum tree by an attacking band of Wyandotte, wounded in the knee and captured. For three years he lived among the Indians in the Lake Erie region, going with them on many hunts and traversing much of the present territory of Ohio, Indiana, Illinois and Michigan. During a trip to Detroit, he escaped, traveled alone more than two hundred miles in the wilderness to a British outpost and gave valuable information on the plans and strength of the northern Indians.[1] When he returned home after the French and Indian War he attended Walnut Hill Academy at Lexington, Virginia, married his cousin Margaret Campbell, and moved to Royal Oak.

To prevent irritation among the Cherokee which might lead to war, Campbell accepted their disclaimer of responsibility in the Boone affair, but he noticed that the Indians were sullen and resentful, so he kept a close watch on developments. An incident in the spring of 1774 touched off new trouble. Isaac Crabtree who had escaped in the Boone massacre vowed to kill any redskin he could find and went on a one-man war against the southern Indians. At a big racing match between the Cherokee and Wataugans, Crabtree shot an innocent warrior observing the sport. The enraged Cherokee demanded Crabtree's punishment and hotheads in the tribe threatened reprisals. The Virginia governor offered a reward for Crabtree's arrest but the settlers ignored him.

Fearful of the consequences, Campbell reported the situation

to Colonel Preston, sheriff and county lieutenant of Augusta, and stated that it would be easier to find two hundred volunteers to protect Crabtree than to secure ten to bring him to justice. Campbell urged that a friendly letter be sent to the Cherokee chief, Oconostota, to appease the Indians.

Preston at once sent Colonel William Christian, his deputy at Dunkard's Bottom near Ingles Ferry, to confer with Campbell and inspect the defenses along the "Great Road" as it was then called. Christian found the settlers thoroughly alarmed. He and Campbell talked together. The Cherokee nation was on the southwestern flank of the settlement, but the Shawnee might attack from the north. The Road from Ingles Ferry to Campbell's home at Royal Oak was dangerously exposed. Settlements along the parallel Clinch River north of the Holston Valley would serve as a buffer to the segment of the Road west of Campbell's to Wolf Hills.[2] Beyond that point the line of settlements to the Watauga dangled dangerously deep in Cherokee territory. The two militia officers sent detachments to all exposed places in their territory. They ordered scouts to the mountain passes from Moccasin Gap to the headwaters of the Big Sandy. Then they waited, alert and ready.

Campbell put a lot of faith in aged and friendly Attakullaculla, the Little Carpenter, who shared the rulership of the Cherokee with Chief Oconostota. Campbell reported to Preston the Indians wanted to avoid a war with the whites, unless Crabtree made some new affront. He added significantly that the Cherokee supply of powder had been seriously damaged by being stored in a damp cave. But Campbell was much concerned lest the emissaries of the Cherokee recently sent to a Grand Council with the Shawnee might return in a warlike mood.

Wild rumors from the Watauga a few days later sent Campbell into a panic. He dashed off a report to Preston that the dreaded hour had come. The Cherokee, he said, had at last begun hostilities. Two trusted peace envoys from Watauga, James Robertson and Robert Faulin, had been murdered along with some white traders. Undoubtedly the people on the fron-

tier would meet the same fate if not quickly succored. Campbell implored Preston to help him defend the inhabitants lest all the settlers on the Great Road flee before the enemy.

But Campbell's alarm was premature. He soon learned the rumors were false. Instead of being murdered, Robertson and Faulin had been successful in making peace with the Cherokee. Still fearful of Crabtree's activities, Campbell in reporting to Preston again paid his respects to that worthy, saying that he "is become a very insolent person; but I believe his timidity, on dangerous attempts, will mostly get the better of his ferocity."[3]

Campbell permitted his militiamen to go home. Then he received stirring news. Lord Dunmore, lieutenant governor of Virginia, had ordered out the militia along the Shenandoah and Holston Valleys. Here was real service for Campbell at Royal Oak. He knew that the Shawnee, Mingo, Ottawa and Delaware tribes north of the Ohio were beating the drums of war. He had suspected that they might combine with the Cherokee to push back the entire frontier. He realized now that the northern Indians, under Chief Cornstalk, intended to go ahead without their southern allies.

Lord Dunmore's order was plain. He did not intend to wait for the war to come to Virginia. Instead he planned taking personal command of the lower Shenandoah troops. Colonel Andrew Lewis, of Staunton, was to mobilize the militia in the western counties, march them down the Kanawha to Point Pleasant on the Ohio, build a fort there, and unite with Dunmore for a combined assault upon the northern Indians. Major Campbell was not to go on the expedition. He was ordered to organize the home guards at scattered outposts on the Clinch and around the edge of the settled area on the Holston and Watauga. Jealous subordinates made his home-guard duty unpleasant but he had the satisfaction of knowing that the border was being guarded.

Campbell had a group of unexpected callers at Royal Oak on August 3, 1774. Captain James Harrod, of Pennsylvania, and thirty deeply tanned frontiersmen with the tang of the wilderness still upon them suddenly showed up from the West. Harrod

told Campbell that while he and his men were building a settlement at a big spring on the headwaters of Salt River in central Kentucky Daniel Boone and Michael Stoner had visited them and told them the northern Indians were on the warpath. Boone and Stoner had been sent into Kentucky by the Virginia authorities to warn all surveyors and prospective settlers of the impending danger. Harrod and his men had reluctantly abandoned their settlement and hurried out of Kentucky through Cumberland Gap. When they learned of the Lewis expedition, they wanted to join the Virginians.

Campbell gave Harrod a letter of recommendation to Colonel Preston and sent him and twenty-two of his men forward. A few days later Boone appeared, hot for action after his 800-mile journey in sixty-two days. Campbell recommended him highly to Preston, saying he was a popular officer. But the old hunter was retained on the Clinch as captain of a company of rangers to guard against raids on the border.

These were not long in coming. Major Campbell was roused out of bed at midnight, September 25, 1774, by a messenger announcing that raiders had struck in force the day before at two widely separated points on the Holston. Two Negroes had been captured at Moore's Fort below Castlewood and made to run the gantlet, and a considerable number of horses and cattle had been stolen in the neighborhood. Forty miles south on Reedy Creek, in a fringe of the Watauga settlement, the wilderness home of John Roberts had been attacked, the father and mother and three children scalped and one lad taken prisoner. Campbell hurried a letter to Colonel Preston at five o'clock in the morning, telling of the outrages and of the general alarm sweeping the frontier. He said he was taking measures to meet the threat and that Captain William Cocke was off to North Carolina to get recruits in that quarter.

Campbell learned that one little Roberts boy was found scalped but alive in the woods, the back of his head cut open with a tomahawk. The lad was able to talk intelligently and give details of the massacre. Campbell had him brought to Royal

Oak and employed an attendant to care for him. Since no doctor was available, he rounded up some medicines and applied them himself. He was greatly moved by the little boy's losing struggle to live. The lad remained rational to the end, and continued to lament he had not been able to "fight enough to save his mammy."

As more news came to Campbell each day, he learned that the raiding Indians were hovering around the rim of the settlements, striking at points where the defenses were weak. The four small forts on the Clinch from Maiden Springs to Fort Blackmore, a few miles northeast of Moccasin Gap, were manned only by skeleton forces because all available men were marching with Lewis to Point Pleasant. Campbell dispatched some rangers to Shelby's Fort at Sapling Grove, and to Fort Blackmore. Fearful of an attack upon his own home, he stationed some men at Royal Oak.

The Indians struck again at Moore's Fort on the Clinch September 29, killing and scalping John Duncan. From a dozen different points, news was rushed to Campbell of savages lurking in the wilderness, and of stock being killed and stolen. Campbell kept bombarding Preston with pleas for more powder and lead, saying that he had to send out men with only enough powder for two or three shots each. On one occasion a company had gone out without any ammunition. His great concern was the wild exodus of the settlers from the danger zone. In one letter he said: "Since I began this letter I am mortified with the sight of a family flying by."

The raiders struck again at two separate points on October 6, 1774. They captured a Negro woman near Shelby's Fort and tortured her in an effort to get her to tell the number of men and guns in the stockade. She managed to escape and reported that one of the men appeared whiter than the rest and could speak good English. A number of horses and cattle in the neighborhood were also killed, scattered or taken. About the same time another party attacked Fort Blackmore, killed one man and took six horses. They had sneaked up on the fort along the

bank of the river out of sight of the stockade. Boone and Captain Daniel Smith rushed down from Castlewood with thirty men, but the savages were gone when they arrived.

The identity of the raiders was in doubt. Some believed they were renegade Cherokee. But Campbell discovered that the big man whom the colored woman had seen was Chief Logan, a bloodthirsty Mingo who was wreaking his vengeance upon the southern whites because of the treacherous murder of his family on Yellow Creek in Ohio, April 20, 1774. Logan mistakenly believed Captain Michael Cresap responsible for the unprovoked and unjustifiable murder. Instead of joining the main body of Indians under Chief Cornstalk marching to attack Lewis at Point Pleasant, Logan was glutting his revenge in an independent raid on the Holston and the Clinch, scalping, burning, stealing and ravaging.

Campbell's first intimation that Logan was doing the mischief came in a letter belatedly brought to him from the scene of the massacre of the Roberts family on Reedy Creek. The note, addressed to Captain Cresap, was crudely written and signed by "Captain John." In it, the chief berated Cresap for killing his people and said that he must kill, too. Campbell passed the letter on to Colonel Preston.

Campbell and his neighbors breathed easier when Logan, having fully satiated his thirst for blood, withdrew into the northern mountains as swiftly and silently as he had come. The Holston men now waited impatiently for news of the army marching to the Ohio. Colonel Preston was the first to be informed of the battle of Point Pleasant, October 10, 1774. His old friend, Captain William Ingles, of Ingles Ferry, in charge of the commissary department for the expedition, wrote him immediately after the battle, giving the details. Colonel Lewis, bivouacking at Point Pleasant with two divisions of about 600 men awaiting instructions from Lord Dunmore at the mouth of the Hockhocking, had been attacked by a force of about 800 warriors under Chief Cornstalk. With heavy losses on both sides, the Indians had been forced to withdraw.

Without making any effort to join Lewis, Lord Dunmore marched directly toward the Indian towns. Within a few days Cornstalk sued for peace. At the meeting of the chiefs with Dunmore only Logan was not present. He had just returned from his bloody raid on the Holston and refused to meet Dunmore. To the governor's emissary he gave his famous message of revenge and defiance which has often been quoted as one of the finest examples of Indian oratory:

I appeal to any white man to say if ever he entered Logan's cabin hungry and he gave him not meat; if ever he came cold and naked and he clothed him not? During the course of the last long and bloody war, Logan remained idle in his camp, an advocate for peace. Such was my love for the whites that my countrymen pointed as I passed and said: "Logan is the friend of the white man!" ... Colonel Cresap, the last spring, in cold blood and unprovoked, murdered all the relations of Logan, not even sparing my women and children. There runs not a drop of my blood in the veins of any living creature. This called on me for revenge. I have sought it. I have killed many. I have fully glutted my vengeance.

For my country, I rejoice at the beams of peace; but do not harbor a thought that mine is the joy of fear. Logan never felt fear. He will not turn on his heel to save his life. Who is there to mourn for Logan? Not one![4]

Far away on the Holston, Arthur Campbell could testify to Logan's glut of vengeance. He rejoiced that the offended chief was at last satisfied and would not return to the Holston. With the menace to the frontier temporarily removed, he turned to a happier diversion. He watched the parade of men, women and children passing his door with their faces to the sunset, instead of flying in terror eastward along the road. From the front porch of Royal Oak, he would witness for thirty years the endless caravans moving along the Great Road. Ambitious and acquisitive, but an ardent and courageous patriot, he would develop a greed for land and power and become a prolific letter writer

and important political leader. Like Ingles at the New River Ferry, he was one of the most interesting personalities on the Virginia stretch of the Wilderness Road.[5]

1 Draper MSS. 10DD42.

2 Thwaites and Kellogg, *Documentary History of Dunsmore's Wars* (Madison, 1905), pp. 75-78. The comprehensive volume contains important documents in the Draper Collection relative to Dunmore's War.

3 *Ibid.*, p. 73.

4 Branty Mayer, *Tah-gah-jute; or Logan and Cresap* (Albany, 1867), pp. 122-123.

5 Campbell lived at Royal Oak until about 1805 when he moved to a 600-acre tract he had previously patented on the Wilderness Road in Yellow Creek Valley in Kentucky. He died there August 8, 1811, and was buried in a plot called "Gideon's Tenements" near his home. His forgotten grave was discovered in 1890 by workmen building a street for the new town of Middlesboro, Kentucky.

Part 2

PATH OF
EMPIRE

Chapter 7

Big Deal and Little Road

Six creaking wagons slowly rumbled down the Great Road past Major Arthur Campbell's broad veranda at Royal Oak in late January 1775. They were heavily laden with merchandise—sacks of corn, flour, salt and casks of rum; bundles of bearskins, duffle, booting, green Durant, Dutch blankets, silver housing and ribbons; a vast assortment of trinkets of all kinds, shirt metal brooches and wrist bands to catch the feminine eye; a sizable supply of guns, powder and lead. The goods might well have stocked a half-dozen frontier stores.

A great destiny rode in those wagons.

Colonel Richard Henderson was on his way to the Cherokee nation to buy an empire with the goods. Riding proudly at the head of the caravan, he cut an imposing figure. Big and tall, with high forehead, projecting chin and square-set jaw, he had the judicial poise and dignity he had learned to assume as a Superior Court judge of North Carolina. Accustomed to dominate every situation in which he took part, he issued commands with proud authority and kept his wagons rolling toward Watauga. With him was his friend and partner, Captain Nathaniel Hart. Watchful guards and attendants marched beside the wagons.

Staying close to the wagons was a frail, dried-up Indian chief, with two large scores across each cheek, his ears, beaded with silver, hanging down almost to his shoulders. Attakullacula, the Little Carpenter, had a particular interest in the cargo and kept

93

a sharp lookout to see that nothing happened to it. He and a keen-eyed squaw had helped to select the merchandise when the wagons were being loaded at Cross Creek, North Carolina. He wanted to be sure his people would get value received for the lands they had agreed to sell to Henderson and Hart.

Henderson's bold scheme to buy a large area of land from the Cherokee had been long in the making. For years he had watched the grandiose colonization plans of land speculators. He knew how the Ohio and Loyal Land Companies were making money out of western lands for many prominent colonial leaders in Virginia and the Carolinas. These operators usually had the blessing of generous colonial governments and had secured their vast grants with the permission of the Crown. Henderson sought the same end by different means.

He was a good lawyer and knew all the legal quirks. When his judgeship in North Carolina ended in 1773, he studied the legal questions concerning the disputed territory west of the mountains, weighed the claims of the English crown, analyzed the charter rights of Virginia and North Carolina and became conversant with the claims of the Cherokee as recognized by the treaties of Hard Labor and Lochaber. He decided the Cherokee were the rightful owners of the Kentucky land reaching from their nation to the Ohio River and could deal directly with private individuals if they desired.

The audacious Henderson divulged his conclusions to some prominent North Carolina associates and they thought well of them. Accordingly they formed the Transylvania Company "to rent or purchase a certain Territory lying on the west side of the mountains of the Mississippi from the Indian tribes now in possession thereof." Partners with him were three Hart brothers, Nathaniel, Thomas and David, and John Luttrell, James Hogg, Leonard M. Bullock and William Johnston. Others were to be brought in later.

Henderson and Nathaniel Hart had immediately set out for the Cherokee country in the autumn of 1774 to see what kind of bargain they could make. With Dunmore's War at a close,

they enlisted the services of Daniel Boone, an old acquaintance, to help them in their negotiations.¹ Boone knew most of the Cherokee headmen. But more important, he knew the Kentucky land from firsthand observation and wanted to make his home there. He was quick to accept Henderson's offer to become his agent and adviser.

The North Carolinians had found the Cherokee willing to sell to the Transylvania Company the land lying between the Cumberland and Kentucky Rivers. The chiefs agreed to take ten thousand pounds' worth of serviceable goods as a fair remuneration, and they chose their beloved chieftain, Attakullaculla, to go back with Henderson and Hart to North Carolina to select the merchandise. That detail accomplished, Henderson, Hart and the Little Carpenter were escorting the wagons of goods to the Cherokee to close the deal. To get to Watauga, they had come out of the North Carolina country into the Virginia Valley at Flower Gap, and down into the Great Road of the Holston.

Henderson and Hart arrived with their wagons in the Watauga settlement early in February. They stored their goods in cabins until time to consummate the treaty. Attakullaculla went on to his town on the Little Tennessee and called the tribesmen to come in for a big talk with the traders.

The great conclave was held at Sycamore Shoals, an ancient treaty ground of the Cherokee on the southern bank of the Watauga River, fifteen miles southeast of Long Island on the Holston. Here, a short distance below where the rayon plants of Elizabethton, Tennessee, would later stand, is a little valley close by the "broken waters" of the Watauga.²

Henderson and his associates, soon joined by Boone from the Clinch, waited at Watauga for the Indians to arrive. They watched the various bands of Cherokee trail into the valley—chieftains, warriors, squaws, old men and papooses. The women set up lodges and built campfires. The little valley was soon covered with more than a thousand Indians, lolling about on the grass and under the sycamores, listening to the river as it broke

and chattered over the shoals. Occasionally they crowded around the cabins for a peek at the precious goods.

Mingled with the Indians were many of the Watauga leaders and their families, whom Henderson had employed to provide food. The countryside was scoured for beeves, flour, corn meal and game to feed the hungry guests and keep them in friendly mood. Henderson and the settlers were careful to withhold the distribution of rum until the trading talks were over. Too much rum might spoil the big deal.

Henderson greeted the various chiefs as they arrived with their warriors and smoked and chatted with them. To the emperor, Oconostota, chief ruler with Attakullaculla, he was especially cordial, because the Indian, with bluff face pitted with smallpox, was anxious for the trade to go through. Another chief, Savanooka, the Raven, nephew and counselor of Oconostota, was a stout, dark, dignified fellow. Onistositah, or the Corn Tassel, had a heavy-set body and a flat inflated face. Willanaughwa, the Great Eagle, was a leader on whom Oconostota depended a great deal in his deliberations. Young Dragging-canoe, son of Attakullaculla, held somewhat aloof and did not have his father's conciliatory attitude toward the white men.

At last the various councils of the Cherokee were all repre-sented, and the time had come for treaty making. Colonel Henderson opened the negotiations by inquiring if the Kentucky land which he sought was actually owned by the Cherokee—a needless formality to give a guise of legality to the affair. The chiefs withdrew for a solemn powwow among themselves. Next day they reported their conclusions. Without question they owned the land, they said. The claims of the Six Nations were spurious because they had never conquered the Cherokee. The Shawnee had long ago been driven out of the country and had no rights there.

Then Colonel Henderson explained that he would like to buy the block of land west of the mountains between the Cumberland and Kentucky Rivers. Chief Attakullaculla arose with great dignity to respond. He began by saying that he was an old man,

who had presided as chief in every council and been president of the nation for more than half a century. He went on to say that he had formerly served as agent to the King of England on business of first importance to the Cherokee nation; had crossed the big water and been received with great distinction by the Great White Father; had the honor of dining with His Majesty and the nobility; had the utmost respect paid him by the great men of the white people, and had accomplished his mission with success; that from long standing in the highest dignities of his nation, he claimed the confidence and good faith of all in defending and supporting the rightful claims of his people to the Bloody Grounds, then in treaty to be sold to the white people. He would recommend the proposed sale.

Other chiefs followed the Little Carpenter, all agreeing to accept Colonel Henderson's proposition. Then the son of the Little Carpenter, young Dragging-canoe, rose to his feet. He was disappointed that his great father and the other headmen should consider selling at any price the fair hunting land of his people. He explained the once flourishing state of his country and mentioned the steady encroachment of the white people upon his retiring and expiring nation. As paraphrased by the interpreter, he said:

Whole nations have melted away like balls of snow before the sun. The whites have passed the mountains and settled upon Cherokee lands, and now wish to have their usurpation sanctioned by the confirmation of a treaty. New cessions will be required, and the small remnant of my people will be compelled to seek a new retreat in some far distant wilderness. There they will be permitted to stay only a short while, until they again behold the advancing banners of the same greedy host. When the whites are unable to point out any farther retreat for the miserable Cherokees, they will proclaim the extinction of the whole race. Should we not therefore run all risks, and incur all consequences, rather than submit to further laceration of our country? Such treaties

may be all right for men too old to hunt or fight. As for me, I have my young warriors about me. We will have our lands.

The impassioned speech of Dragging-canoe threw the council into an uproar. Henderson was dismayed. He adjourned the session to feast the Indians again and to permit individual lobbying among the older chiefs. The leaders argued the question among themselves, brought the minor chiefs around to their viewpoint and agreed to accept Henderson's offer. Dragging-canoe alone held out sullenly.

The deed of conveyance was prepared, read aloud and translated by interpreters. It was signed March 17, 1775, by Oconostota, Attakullaculla and Savanooka acting in behalf of all the Cherokee tribes. The parchment specified that "for and in consideration of two thousand pounds of lawful money of Great Britain" (this was in addition to the goods estimated to make up the balance of the £10,000 price agreed upon), there be granted, bargained and sold to Henderson and his associates "all that tract, territory or parcel of land" lying south of the Ohio River between the Cumberland and Kentucky Rivers, an area estimated to contain 20,000,000 acres. It embraced also the lands drained by tributaries of the Cumberland, thus including a large territory in the present state of Tennessee.

Henderson felt good over his deal, but was not through trading. He announced to the Indians: "I have yet more goods, arms and ammunition, that you have not yet seen. There is land between where we now stand and Kaintuckee. I do not like to walk over the land of my brothers, and want to buy from them a road to Kaintuckee."

For Dragging-canoe this was only further evidence of the insatiable greed of the whites. He had kept glumly silent during the final negotiations and signing of the deed, but this new proposal brought him to his feet again. He stamped angrily and, pointing to Kentucky, said: "We have given you this, why do you ask more?" Then in haughty grandeur he strode from the

council, never to return to take part in another treaty with the hated whites.

But Henderson prevailed in his second purchase. By what has been known as the "path deed," he secured a wide strip of land extending from Long Island on the Holston to Cumberland Gap where the Cumberland River watershed begins—a right of way from Watauga to his newly bought empire.

The trading over, Henderson joined in a felicitating feast. Pipes of peace passed around and rum was given out in discreet quantities. But dividing a houseful of goods among more than a thousand Indians spread the rewards thin, and there was considerable disappointment. One brave who got a shirt for his portion complained he could kill more deer in one day on the land sold than it took to buy a shirt.

Colonel Henderson, gratified with his success, perhaps pondered the prophetic warning made by Dragging-canoe to Daniel Boone when the first agreement was reached: "You have bought a fair land, but there is a cloud hanging over it. You will find its settlement dark and bloody." The day would come when he would recall it. The Indians broke camp for their return to their towns, and Henderson hurried preparations to depart for Kentucky. He must be on his way to make good his claim in the West.

Daniel Boone had a more important job than helping in the negotiations. He had been employed to cut a path to Kentucky. As soon as Henderson was sure of his treaty, Boone went to Long Island to assemble a crew of road cutters. He and Henderson had already agreed that the first settlement should be made at the mouth of Otter Creek on the Kentucky River, the northern extremity of the Henderson boundary. (Boone had hunted all over that area and knew the land.) A settlement and fort on the Kentucky would serve as a bulwark against any invasion of protesting Shawnee and northern Indians.

Boone gathered thirty armed and mounted axmen at Long Island and with the authority of Henderson promised each of

them a tract of land for their services. He himself was to get a bounty of 2,000 acres. His company was made up of trained woodsmen, most of whom he knew personally. He could rely on his brother Squire, his son-in-law William Hays, the faithful old scout and Long Hunter Michael Stoner, and one of his hunting associates in Kentucky, Benjamin Cutbirth. Then there were his friends and companions in the Dunmore's War troubles, Captain David Gass and Captain William Bush. Another stalwart was Colonel Richard Callaway, a neighbor on the Yadkin. Callaway was an ambitious fellow with big ideas of his own. He had a Negro woman cook who would be useful too around the camp.

Boone was much pleased with a contingent of eight men from Rutherford County, North Carolina, whom Henderson had sent from Sycamore Shoals before Boone was ready to leave. Captain William Twetty, the leader, was an aggressive woodsman of fine physique. In his company were Samuel Coburn, James Bridges, Thomas Johnson, John Hart, William Hicks, James Peeke and a Negro servant. A handy young man with an observant eye was Felix Walker, going along for the adventure.[3]

Boone led his trail blazers out of Long Island, March 10, 1775. His destination was more than two hundred miles away. He could not expect to do much in building a passable road through an unsettled wilderness. Much of the way he would follow Indian, hunter or buffalo trails, but occasionally he would need to make a short cut by chopping out underbrush, removing logs and blazing a path in the trackless woods.

Boone's route from Long Island, at the end of the Great Road down the Holston, led directly to Moccasin Gap, the gateway to the mountainous area of southwest Virginia. Here he came upon the old trail of the Indians and hunters. He went up Little Moccasin Creek valley to a low divide and over to Troublesome Creek. Wandering down Troublesome almost due west, he crossed Clinch River where Speer's Ferry was later established. On the west side of the Clinch, he went up the river to a ford on Stock Creek, following its meanderings for

several miles to the great physical freak known as Natural Tunnel. Turning left at this hill, he crossed over Horton's Summit and went down into the valley of the North Fork of the Clinch to Little Flat Lick.

Here Boone and his men came upon an important stopping place, now identified as the site of the Duffield schoolhouse. Boone led his men over Powell Mountain at Kane's Gap and into a valley near the head of Wallins Creek, where Walden and his hunters had ranged several years before. They continued down the narrow valley to the point where the town of Stickleyville was later built, and crossed over Wallins Ridge to Powell River, and thence to Glade Spring, where Jonesville is now located. Two miles west of Glade Spring they passed another interesting underground channel, smaller but similar to the Natural Tunnel on Stock Creek. They were now deep in Powell Valley, with the long white wall of the Cumberland Mountains rising before them. Ranging down the valley in a southwestward direction for twenty miles they came to Martin's Station, the present site of Rose Hill.

Here Boone and his axmen found Captain Joseph Martin for the second time busily engaged in rebuilding the settlement he had abandoned shortly after Boone's first visit there in the summer of 1769. Driven out by hostile Cherokee that year, Martin had not returned until the early part of 1775 to begin again where he left off.

Boone and his men stopped at Martin's long enough to explain their mission and announce that Colonel Henderson would come along soon on his way to settle Kentucky. They checked their needs, secured some additional supplies and pushed off down the valley for Cumberland Gap, twenty-five miles away. They had little to do on this part of their journey. The trail had been long used by Indians, hunters and buffalo, so it needed no chopping or widening.

After Boone's axmen passed through the portals of Cumberland Gap, they had comparatively good going along the Warriors' Path. The trail through heavy canebrakes in the Yellow Creek

basin immediately northwest of the pass had been tramped down by the hoofs of countless buffalo. Minor trails led off to springs and licks, but the main route continued down the creek for twelve miles to Cumberland River and crossed at the ancient ford. The woodsmen passed over the river to the north side and followed the trail for eight miles to Big Flat Lick. Here Boone left the main Indian road and turned to the left on the route of the hunters he had followed in 1769.

In this broken, hilly region the axmen began to work in earnest. They were going almost due north in a thick woodland of scrubby trees, underbrush, rhododendron and laurel. The first important stream they crossed was Stinking Creek where Walden and his men had trapped so successfully in 1763. Veering northwest they crossed Little and Big Richland Creeks, then Lynn Camp Creek, and headed for Raccoon Spring on the Hunters' Trail so named because Boone had once trapped a raccoon there. Perhaps they camped at this important spring which became a favorite stopping point for the countless travelers moving to Kentucky in the migration years.

The road makers continued north, hewing out a path across Laurel River. In the broken upland they encountered much dead underbrush. The way led to a big patch of hazel bushes covering several acres of ground, on a creek which ran westward. Here the hunting trail turned down Hazel Patch Creek into the regions where the Skaggs brothers, Knox and other Long Hunters had ranged. But Boone and his men headed due north, cutting a new path in the unbroken underbrush which took them to an upper crossing of Rockcastle River. The country now began to open up and they chopped their way through big stretches of cane. They were soon to be out of the mountains.

At last the axmen came to Big Hill, and suddenly arriving at a wide gap in the last range of mountains on the dividing line between the present counties of Laurel and Madison, they caught their first vista of the plains of Kentucky. It was an ample reward for the weary road cutters. Enthralled by the view of vast plains spreading before them, covered with clover in full bloom,

they felt that truly a paradise was at hand. They were approaching a land where game abounded and turkeys scratched and strutted in almost one continuous flock.

The men were at last through the mountain wilderness. Following a buffalo trace through thick cane and reed, they proceeded for two more days across broad and inviting lands. On March 24 they camped for the night in a gently rolling forest about three miles south of the present city of Richmond, Kentucky. They were now only fifteen miles from their goal on the Kentucky River, where they expected to build their settlement.

Relieved because their labors were so nearly over, Boone and his men slept heavily that night, oblivious of dangers. About an hour before day a heavy volley of balls poured down on the sprawling sleepers. From the darkness a band of Shawnee dashed into the circle swinging tomahawks. The surprise was complete. The aroused men scattered wildly into the woods. Half asleep, Squire Boone seized his jacket instead of his powder horn and shot pouch and crawled away with his useless rifle until he found Daniel. Captain Twetty was shot through both knees and could not run. Two warriors sprang forward to scalp him. His bulldog lunged at the leader, knocking him down. The second brave dispatched the dog with his tomahawk, and the diversion saved the captain's scalp. Negro Sam was hit in the first volley, leaped to his feet and fell back dead into the smoldering campfire. Walker was badly wounded in the hip but managed to crawl to a hiding place in the bushes.

Boone rallied his scattered men in the darkness, drove off the Indians and posted guards until daylight. Then he attended the two wounded men and took stock of the situation. Some horses were gone, but the baggage and camp supplies were saved. It was impossible to proceed so he put his men to cutting logs for a temporary fort. He selected a spot of elevated ground a short distance away and threw up log barricades in the form of a square, six or seven feet high. In this improvised and open-topped shelter he placed the wounded men and ministered to their needs.

Captain Twetty died the second or third day during the enforced delay. He was buried within the barricade by the side of his Negro servant. Walker remained in a critical condition, but under Boone's careful nursing and application of ointments made from herbs he began to improve.

Boone sent hunters to scout the surrounding territory for Indians and to get provisions. They came upon a son of Samuel Tate wandering in the woods. The boy said that his father's camp had been fired upon the night before and two men killed. These unexpected campers in the region belonged to a company headed by Captain James Harrod who had come down the Ohio River a few weeks before to return to their settlement on Salt River. Boone and his brother went to the Tate camp and found the scalped bodies. He sent word to the fugitives in the region to meet him at the mouth of Otter Creek so that all might protect themselves against the Indians.

With Walker still unable to be moved, Boone sent Henderson a report of his situation on April 1. After reciting an account of the attack, he said:

> My advise to you, sir, is to come or send as soon as possible. Your company is desired greatly, for the people are very uneasy, but are willing to stay and venture their lives with you, and now is the time to flusterate their [the Indians] intentions and keep the country, whilst we are in it. If we give way to them now, it will ever be the case.

Twelve days later Boone considered it safe to remove Walker. Walker was carried on a litter between two horses to the Kentucky River, about a mile below the mouth of Otter Creek. On entering the plain, the men came upon a herd of two or three hundred buffalo. The animals ran off in every direction, with a large number of calves playing and skipping around their mothers.

Boone looked over the site chosen for the Transylvania settlement and was satisfied. It looked as he had remembered it. The

SKETCH OF FORT AT FALLS OF THE OHIO
Fort erected on Corn Island by George Rogers Clark in 1778 at the Falls of the Ohio, later the site of Louisville, Kentucky. This was the outpost on the Kentucky frontier where the Wilderness Road ended at the Ohio River.

SYCAMORE SHOALS

Site of historic meetings near Elizabethton, Tennessee, taken in September 1941 during a period of extreme drought.

Kentucky River rolled peacefully westward through a bower of elms and sycamores. On the south bank a level valley with plentiful springs provided ample room for a town. Boone and his men immediately set to work to build a stockade for Henderson and his colonizers when they came.

Colonel Henderson left the treaty grounds at Sycamore Shoals on March 20, 1775. He spent two or three days in the Watauga area making final arrangements. Two of his associates, John Luttrell and Nathaniel Hart, had gone on ahead but he expected to catch up with them soon. He put Captain William Cocke in charge of the supply wagons. On March 24 he joined his two partners at the home of Captain Anthony Bledsoe who lived in the neighborhood, and the next day he tarried at Samuel Calloway's, near Long Island, making last preparations for his journey.

Henderson was leaving for his new country without the official sanction of Virginia and North Carolina authorities. Word had already been sent to Governor Dunmore of Virginia about the colonization scheme. On March 10, 1775, Colonel William Preston reported: "A great Number of Hands are employed in cutting a Waggon Road through Mockeson & Cumberland Gaps to the Kentucky which they expect to compleat before planting time; & . . . at least 500 people are preparing to go out this Spring from Carolina besides great Numbers from Virga. to Settle there."

Lord Dunmore acted promptly and decisively. On March 21 he issued a proclamation against "the unwarrantable and illegal designs of the said Henderson and his abettors," whom he described as "disorderly persons," and sent a vigorous protest to Attakullaculla and the other Cherokee chiefs, claiming they had no right to make a private trade with the North Carolinian. Colonel George Washington, dealer in western lands, looking on with concern, wrote Preston: "There is something in that affair which I neither understand, nor like, and I wish I may not have cause to dislike it worse as the mystery unfolds." Governor Martin of North Carolina was more vehement. He called Hen-

derson a "famous invader," and his association "an infamous Company of land Pyrates." British agents hastened to broadcast orders for Henderson's arrest.

Unconcerned by this storm in official circles, Henderson rode out from Long Island at the head of a cavalcade of about thirty horsemen on March 28, 1775. In the group were two of his brothers, Nathaniel and Samuel. Packhorses and wagons carried supplies of food, ammunition, seed corn, vegetable seed, household and farming implements. Domestic stock trailed along; cattle were to be eaten if wild game could not be secured for food.

Henderson followed the trail blazed by Boone's men. He arrived at Martin's Station in Powell Valley on March 30, 1775, and found Captain Joseph Martin much interested in the Kentucky plans. Henderson explained to Martin that his purchase of the "path" to Kentucky included the boundary in Powell Valley where the treaty was enacted. He then appointed Martin agent and entrytaker for the Transylvania Company. To a brother of the captain, Brice Martin, Henderson made the first conveyance of land on behalf of his company. He wrote it out on the back of the first page of his journal:[4]

> April 3, 1775, Mr. Bryce Martin enters with me for 500 acres of land lying on the first creek after crossing Cumberland Gap northward from powels valey going toward Canetuckey river. RICHARD HENDERSON.

Henderson lingered at Martin's Station five days, waiting for Captain Cocke's wagons to come from Long Island. Martin told him that it would be impossible to take wagons farther along the trace cut by Boone. Reluctantly Henderson arranged to shift his supplies to packhorses and build a shed to take care of the wagons until some future time when he could take them through. The wagons came at last. Cocke had a trying experience to relate. He had been forced to take the vehicles apart at times and carry them in pieces over the rugged hills.

While Henderson delayed at Martin's Station five men came in from Prince William County, Virginia. The leader was William Calk, a black-haired, blue-eyed, jolly Welshman with a quaint sense of humor. His companions were Abraham Hanks, Philip Drake, Enoch Smith and Robert Whitridge. They had not expected to meet Henderson but they quickly volunteered to join him in his Kentucky venture.

The whole company now numbered from forty to fifty people. The group had been augmented also by Benjamin Logan and William Gillespie and their Negro servants who had started for Kentucky from the neighborhood of Wolf Hills and had attached themselves to Henderson's company for convenience and protection in traveling.

April 5, 1775, dawned brightly. The various groups set out for Cumberland Gap. Their progress was slow because horses strayed and hunters got lost. On April 7 Henderson camped within five miles of Cumberland Gap. Here he received Boone's letter describing his trouble with the Indians. The men read it with consternation. Captain Nathaniel Hart, Henderson's partner, did not like the look of things and determined to return to the Valley "to make corn for the Canetucky people." A week or two later his courage revived and Hart rejoined the march to Kentucky.

Discouraged but not deterred, Henderson took time out to write his partners in North Carolina about the situation:

> You observe from Mr. Boone's letter the absolute necessity of our not losing one moment, therefore don't be surprised at not receiving a particular account of our journey with the several little misfortunes and cross accidents. . . . We are still one hundred and thirty or one hundred and forty miles from our journey's end. We are all in high spirits, and on thorns to fly to Boone's assistance, and join him in defense of so fine and valuable a country.

Calk told of the next step forward on April 8: "We all pact up & Started Crost Cumberland gap about one oclock this day we

Met a grat maney peopel turnd Back for fear of the indians but our Company goes on Still with good courage." Henderson recorded the incident: "Met about 40 persons returned from the Cantuckey on account of the late murders by the Indians. Could prevail on one only to return. Several Virginians who were with us returned home." His North Carolinians were made of sterner stuff!

The party camped the next night in the low marshes of Yellow Creek, a few miles north of Cumberland Gap. Sunday they waited until the beef cattle came up, eating only a little snack until night. That night they slept on the south bank of Cumberland River at the ford, and they spent Monday in camp on account of rain. Some of the men hunted during the day and found Indian signs.

During this halt at Cumberland Ford, Henderson decided he must somehow send word to Boone that he was on his way with supplies and reinforcements. He was increasingly concerned since he had met nearly a hundred refugees in four days. He afterward reported to the proprietors of his company:

> The general panic that had seized the men we were continually meeting, was contagious; it ran like wild fire; and, notwithstanding every effort against its progress, it was presently discovered in our own camp; some hesitated and stole back, privately; others saw the necessity of returning to convince their friends that they were still alive, in too strong a light to be resisted.

Henderson knew that most of the men were not from Boone's woodsmen, but from independent parties who had gone out in the early spring to clear up land and build cabins. But the returning men talked earnestly about the danger ahead and their tales were completely demoralizing.

In the midst of Henderson's despair, Captain William Cocke volunteered to go on ahead with a letter to Boone. Henderson with tears in his eyes accepted Cocke's brave offer and promised him ten thousand acres as a reward. He outfitted Captain Cocke

with a Queen Anne's musket, plenty of ammunition, a tomahawk, a large "cutto knife," a Dutch blanket, a quantity of jerked beef and a "tolerably good horse." The captain carried with him, besides his own apprehensions, a considerable burden of Henderson's uneasiness.

Henderson and his company resumed their journey the following day, made twenty miles and found Richland Creek bank full of water from the rains. Calk and his group had their own special troubles:

> We Cross Cumberland River & travel Down it about 10 miles through Some turrabel Cainbrakes as we went down abrams mair Ran into the River with Her load & Swam over he followd her & got on her & made her Swim Back agin . . . we take up camp near Richland Creek they Kill a Beef Mr. Drake Bakes Bread with out Washing his hands.

Despite another rainy morning, Richland Creek was crossed the next day, with more trouble in Calk's party. "We toat our packs over on a tree & swim our horses over & there We meet another Companey going Back they tell Such News ABram & Drake is afraid to go aney further." The next day breaking fair, the party continued without Hanks and Drake and came to Laurel River. Here again they had to unload the horses, float the packs over on a log and swim the horses. One horse ran into the river before being unpacked, and lost his load. While in camp north of Laurel River a dozen frightened men stumbled into camp. They were fleeing the country and urged Henderson's men to do likewise.

The demoralized party proceeded and Calk noted that they came to a "plais Cald the Bressh." This was Hazel Patch, where Boone's blazed trail led northward away from the Hunters' Path going westward—the future course of the Wilderness Road toward the Falls of the Ohio. At this point Benjamin Logan and William Gillespie with their slaves parted from Henderson, and turned toward the west.

After crossing Rockcastle River, Henderson met the McAfee

brothers, Samuel, Robert, William and James, coming out of Kentucky with about eighteen companions. He tried to persuade them to join him in his colonization scheme. James McAfee did not like the proposal and told his brothers that Henderson's claim of ownership of the land was not valid. However, Robert, Samuel and William felt a new courage in the increased number of the united companies and decided to join the Transylvanians.

Henderson's spirit ran high the next day when he met Michael Stoner and three men sent out by Boone, with welcome news and a good supply of beef. He noted in his diary with satisfaction: "Camp't that night in the eye of the rich land." He recorded, on April 20, with a warm glow in a heart burdened heavily during his arduous trip: "Arrived at Fort Boone on the mouth of Otter Creek, Cantukey River where we were saluted by a running fire of about 25 Guns, all that was then at Fort—— The men appeared in high spirits and much rejoiced on our arrival."

Colonel Henderson immediately took command. He revised Boone's defense plans, started a new stockade on an elevated piece of ground 200 yards from the first makeshift fort, built a magazine, opened a store and established a land office. He arranged drawings for home sites, adjusted complaints, sent out surveyors and encouraged the men to put in crops and plant vegetable gardens. He talked with visitors from Harrod's settlement on Salt River, explained his terms of disposing of the Kentucky lands and prepared to set up a proprietary government. In recognition of Boone's help, he named the capital Boonesborough.

Messengers were sent to the new settlements of Harrodsburg, Boiling Spring and Logan's Station (St. Asaph), asking that representatives be chosen to assemble at Boonesborough for the purpose of adopting a constitution for the new colony. Henderson knew he had to face opposition to his claim of ownership in Kentucky. But the response to his invitation was immediate, and on May 24, 1775, the first assembly of the "Colony of Transylvania" was held under a huge elm in the bottom near the

fort. Henderson opened the convention with a pompous address.

In rounded phrases and a flourish of oratory, he told the assembled throng: "You, perhaps, are fixing the palladium, or placing the first corner-stone of an edifice, the height and magnificence of whose superstructure is now in the womb of futurity and can become great and glorious in proportion to the excellence of its foundation." He called for the establishment of courts and tribunals, that the new colony might be ruled with justice and freedom for its citizens. Laws were to be enacted by the settlers but the right of veto was reserved for the proprietors of Transylvania.

Committees were appointed, bills drafted, read and passed. Courts were established, and laws were enacted to regulate the militia, preserve game and provide for writs of attachment. Fees for clerks and sheriffs were named, and penalties were provided for profane swearing and Sabbath breaking. There were also laws for the punishment of criminals, for improving the breed of horses and for preserving the range. Thus Transylvania became a duly organized governmental unit.

On the last day of the proceedings, Colonel Henderson took part in a formality which typified his love of ceremony. Standing under the great elm, John Farrar, the attorney employed by the Indians, handed him a piece of the turf cut from the soil beneath them. While they both held it, Farrar declared his delivery of seisin and possession of the land, according to the terms of the title deed, which Henderson displayed. The immediate reading of the deed completed a legal requirement long obsolete. Then the convention adjourned, the delegates went back to their homes, and Colonel Henderson retired to his office, a proud and happy man.

However, other strong-willed pioneers with conflicting dreams for western development were pouring into Kentucky over Boone's road. These men were to figure largely in shaping the destiny of Transylvania.

1 Authorities do not agree when Boone entered the employ of Henderson. Dr. Archibald Henderson, of the University of North Carolina, descendant of the

Transylvanian, in his *Conquest of the Old Southwest* (New York, 1920), pp. 108-109, claims Boone was spotting land for Henderson on his hunts as early as 1763, citing the Tennessee historians, Haywood and Ramsey. Because he was in the nature of a secret agent, Boone was reported to have said nothing of their relationship. Nathan Boone, son of the old hunter, stated that his father made no trip to Rockcastle in 1764, when he was reported to have met Walden, Blevins and Skaggs and told them he was working for Henderson, as Haywood claimed. Dr. Lyman C. Draper who made the most exhaustive study of Boone's career while records were still available did not find any evidence that Boone was actually employed by Henderson until 1774-1775. (Draper MSS., 6-S-38).

2 This historic spot is now marked by a monument memorializing the formation of the Watauga Association, the Henderson Treaty and the rally of the Overhill patriots who marched to King's Mountain to defeat Ferguson.

3 Walker subsequently became a member of Congress from the Buncombe district of North Carolina. While in Congress, he rose to make a speech during a debate, saying he wanted to "speak a word for Buncombe." His remark led to the expression "that's all buncombe." He removed to Missouri and before his death wrote an account of his trip with Boone in 1775. It was published in *DeBow's Review*, XVI, New Series, II, 1854, 150-155.

4 Original in the Draper Papers, Wisconsin State Historical Society.

5 Lewis H. Kilpatrick, ed., "The Journal of William Calk, Kentucky Pioneer," in the *Mississippi Valley Historical Review*, VII, No. 4, March, 1921, 363-377. (Original owned by Calk family, Mount Sterling, Kentucky.)

Chapter 8

Kentucky Frontier in the Revolution

BENJAMIN LOGAN turned aside from Boone's Road in the big thicket of hazel bushes, April 15, 1775, leaving Henderson and his company to continue their way to Boone's camp on the Kentucky River. Logan followed a dim trace which became the final segment of the Wilderness Road. The trail hacked out by Boone and his men a few weeks before led eighty-two miles farther north to Boonesborough. Logan's path wove along an obscure trail to Harrodsburg and the Falls of the Ohio. The intersection of the trails in the thick brush came to be known as Hazel Patch, an important junction of the two prongs of the Wilderness Road, eight miles north of today's London, Kentucky.

Logan and his companion, William Gillespie, had not listened to Henderson's pleas to continue to the Transylvania settlement. They intended to explore the Dick's River country for a location of their own. The trail they were taking was already known as Skaggs Trace. It was named for three Irish brothers, Henry, Charles and Richard Skaggs, Long Hunters who had spent much time in the region.

The big handsome frontiersman on his way to pick a likely spot for a plantation was already a prosperous farmer on the Holston. Since his fourteenth year, when his Scotch-Irish father, David Logan, died in Augusta County, Virginia, Benjamin Logan had been on his own. In 1764 he had fought as a sergeant in Colonel Bouquet's expedition. After that campaign he took to

113

the Great Road with the first group of Scotch-Irish settling at Wolf Hills. Here he prospered by raising corn, wheat and hemp. He missed the battle of Point Pleasant while Holston men were beating back the rampaging Shawnee in 1774, because he was attached to Lord Dunmore's army as a lieutenant. In that campaign he became acquainted with George Rogers Clark. The two men began a friendship and association lasting as long as they lived. In 1774 Logan had married pretty Anne Montgomery, several years his junior.

Logan and Gillespie kept a sharp lookout for good land as they rode along the trail, but the hills continued rugged, the forest thick and scraggly, the soil thin and sandy. They crossed meandering Skaggs Creek several times and passed over Brushy Ridge to the headwaters of Dick's River. Then they came to a country of open, inviting and rolling valleys. Thirty-two miles from Hazel Patch, they noticed a big orchard of wild crab apple where hunters had often camped at the big springs. It was a delightful spot and the crabs were beginning to bloom. They lingered for some time in the neighborhood which later was developed into the settlement of Crab Orchard.

Logan, his companion and their slaves followed the main trail west several miles. He noted that the land became increasingly fertile. A stream in his path wound through a valley skirted on one side by rugged cliffs and on the other by immense expanses of bluegrass, young cane and pea vines. Along the stream a buffalo path led to a magnificent group of springs. On a rounded knoll overlooking the biggest spring where buffaloes laved and cooled themselves, Logan pitched his camp May 1, 1775. Here he decided to build a home. The town of Stanford was afterward to grow up on this spot.

The season was well advanced. Logan, Gillespie and their Negro servants turned feverishly to the task of cutting trees, building a log house on the hill above the springs and clearing fields for corn and vegetables. Chopping and digging, planting and hunting, they worked hard from sunup until sundown, and the homestead soon took on the marks of permanency. Logan

had come to stay. But he and Gillespie did not long remain alone. Other travelers from Virginia rode in over the trail from Hazel Patch and eagerly joined the workers. No one worried about good land. It stretched out in every direction, fertile and inviting.

Within a short time the settlement was called St. Asaph. Legend has it that among the first visitors at Logan's camp was a devout Welshman who suggested that since May 1, the day of Logan's arrival, was the anniversary of the canonization of Asaph, a monk in the monastery on the River Elwy in North Wales, it would be appropriate to name the settlement for the saint. Logan, who liked the Psalms written by Asaph, readily assented to the suggestion, but it was Logan's name, and not the name of the saint, by which the settlement became generally known until Stanford was laid out.[1]

As new arrivals came over the trail, St. Asaph developed into a busy place. At first Boonesborough drew most of the adventurers following Henderson from North Carolina and Virginia, but many took Logan's path to his settlement. Still others did not stop but continued to Harrodsburg, twenty-two miles westward. Usually those coming down the Ohio River disembarked at Limestone and took the trail southward to Boonesborough, or ranged across the country from the mouth of the Kentucky River or the Falls of the Ohio to Harrodsburg. Logan's settlement, the most southern of the three outposts rising in Kentucky in 1775, caught the adventurers following the westward trail from Hazel Patch.

This new settlement was sufficiently important to be included in Henderson's call for representatives to go to Boonesborough in May 1775 in order to form the proprietary government of Transylvania. John Todd, John Floyd, Alexander Spotswood Dandridge and Samuel Wood were chosen as delegates to represent St. Asaph. Logan did not go to Boonesborough for the proceedings because he was too busy putting in his crops and had little regard for Henderson's claim of ownership.

The settlers of St. Asaph, Harrodsburg and Boonesborough

visited frequently during the first restless summer. The connecting trails became well-worn. The route from Hazel Patch to Logan's Station was extended to Harrodsburg and then to the Falls of the Ohio. Cabins began to spring up along the paths through the wilderness paradise. James Knox, stopping briefly with his old friend and Holston acquaintance on his way to the Falls, laid out some good tracts on Beargrass Creek and put in a crop of corn. By the end of 1775 the future course of the Wilderness Road from its intersection with Boone's Road at Hazel Patch was permanently fixed, and the western branch quickly rivaled the northern prong leading to Boonesborough.

Although no sinister red shadow lurked near the settlements during the summer of 1775, Logan and his men took precautions against possible surprise attacks. A stockade was erected around the cluster of cabins on the knoll above the springs. Blockhouses were built at each of the four corners, with upper stories protruding over the lower and fitted with portholes. The blockhouses were connected by tall, heavy posts sharpened at the top and set close together deep in the ground to form a continuous wall. The only opening into the enclosure was a heavily constructed gate.

When the stockade neared completion and the crops of corn were well along, Logan went back to the Holston. During his absence, his wife had given birth to a son, David. He brought out the rest of his slaves, cattle and farm stock, and a number of families willing to brave the winter in the new country. After he gathered his crops, he again set out for Virginia to be with his wife and little David until the winter was over.

On March 8, 1776, Logan and his little family arrived at St. Asaph, this time to stay permanently. The settlement was teeming. Fields were extended, bigger crops were planted, and more families joined his station. The woods rang with the sound of axes, the crash of falling trees and the reports of hunters' guns. The soil was good, the forest was peaceful. The Kentucky wilderness was yielding to the conquest of the pioneer.

But it was not long until ominous news trickled into the busy

settlements. Far to the north Governor Henry Hamilton, loyal servant of the British King, was already enlisting Indian allies for an invasion of the Kentucky frontier. With a rebellion against the Crown seething along the Atlantic seacoast, he realized the danger of a deep penetration of settlers west of the mountains. If the colonists should gain a strong foothold on the extended western frontier he could not give much military aid from the rear in quelling the incipient revolt.

The Shawnee, Wyandotte and other northern tribes quickly accepted Hamilton's overtures. They resented the encroachment of the whites on lands they considered their own despite the acquiescence of the Southern Cherokee to the Kentucky settlements. Before the grievances of the Eastern colonists took defiant form in the Declaration of Independence, Hamilton's Indian allies had prepared to strike at the Kentuckians.

During the summer and fall of 1776 the Kentuckians saw frequent Indian signs around their stockades. Furtive forms darted through the forest. It was evident that savage spies were appraising the strength of the settlements in preparation for concerted attacks. The frontiersmen pushed their log defenses and kept their women and children close within the forts. For them it was the grim necessity of holding on to the fine lands they had taken. They could not yet realize the importance of their relationship to the impending struggle for national independence.

Since St. Asaph was the smaller of the three important posts in Kentucky, Logan removed his wife and son and the other women and children to the protection of the stronger fort of Harrodsburg, but he and his men remained to harvest their crops. He went over to Harrodsburg frequently during the winter and was with his wife when their second son was born, December 8, 1776. The boy, named William, the second male child to be born in Kentucky, was to become a distinguished jurist and statesman.

In 1777, year of the "bloody sevens," the full ferocity of the northern Indians was loosed upon the frontier. First, occasional small bands forayed across the Ohio and attacked the more

exposed straggling settlements to test their strength. Then in April they fell upon Boonesborough in force. For three days and nights more than a hundred Indians poured a heavy fire upon the post. Discouraged by their failure to make a quick conquest, they withdrew into the forest. Harrodsburg was next. On May 6 savages appeared in the edge of the clearing and exchanged shots with the defenders. The Indians lurked about the settlement for several days and again disappeared.

Logan, at St. Asaph, had only fifteen riflemen to defend thirty women and children who had returned from Harrodsburg. He put the fort under martial law and permitted no one to leave except with an adequate guard. On the morning of May 20 Mrs. Logan, Mrs. William Whitley and a Negro woman went out to milk the cows, accompanied by four guards. While the women were filling their pails with milk, a sudden fusillade burst from the thick canebrake where Indians had crept silently during the night. William Hudson was shot in the head and died instantly. Burr Harrison fell helpless. John Kennedy, hit by four bullets, staggered bleeding into the fort. James Craig and the women dashed toward the gate. Mrs. Whitley lost her hat—a borrowed one. She stopped, picked it up, then followed the women through the gate to safety.

Logan placed his men at the portholes and they fired at the Indians whenever they saw them. The savages kept themselves well hidden in the canebrake but it was estimated the attacking force numbered fifty or sixty warriors. Desultory shots smacked against the log fort all day but no one was hurt.

In the late afternoon, one of Logan's men peered through a porthole toward the spot where the body of Harrison lay. Harrison appeared to move. The astonished rifleman reported what he saw and Logan raised his head above the stockade walls and shouted: "If you are alive move your foot." Logan detected a slight movement of the prone figure in the tall grass, and yelled again: "Lay still, don't be discouraged, I will have you in at the risk of my life."

Logan asked for volunteers to go with him to bring in the

wounded man. One husky fellow begged off by saying he was a weakly man. Another said he was sorry for Harrison but that the skin was closer than the shirt. Finally one young man, John Martin, declared: "I can only die once, and I am as ready now as I ever will be."

Logan took a bag of wool for protection and held it in front of him as he slipped out of the gate in a stooping posture and edged toward the fallen man. Martin followed at his heels. Harrison saw the rescuers coming. He rose up halfway as though to come toward them. Martin, thinking the man could help himself, fled back into the fort. Logan dashed ahead, took the wounded man in his strong arms, and staggered back to the gate as bullets whizzed about him. One struck in the edge of the gate as he stumbled through with his burden. He immediately treated Harrison's wounds, but the man died within a few days. Two days later, during a lull, Logan ran out of the fort a second time and brought in the mangled body of Hudson to be buried in the stockade.[2]

Long, dread days passed at the fort while the Indians continued their siege, apparently intent upon forcing a surrender by starvation. Logan kept the men at their posts, and the women molded bullets from the scanty supply of lead. At last it became evident that the fort could not hold out without more ammunition and supplies. Logan called the men together and announced he would go to the Holston settlements for help. In the dead of night he slipped out of the gate and disappeared.

Ten days later Logan was back with all the ammunition he could carry and the joyful news that his friends on the Holston were recruiting a company to come to their relief. Worn and tired from his swift and dangerous mission, he did not give the details of his trip through the wilderness. He explained only that he shunned the usually traveled path and cut through trackless forests, heavy canebrakes, across streams and over mountains, in order to avoid prowling enemy bands.

Not long after Logan's return, six men ventured out of the garrison to get some corn from the fields, to supplement their

dwindling food. The Indians fired upon the party, killing Ambrose Gristham and wounding James Menifee and Samuel Ingram. A savage ran to Gristham's body and pinned a paper upon it. When Logan was given the paper he found it was a proclamation by Sir Guy Carleton, British commander in chief in Canada, addressed to Kentuckians in general and Logan by name, stating that if Logan would surrender his arms and embrace the cause of the King he would be given a commission in the British Army, and that every settler joining His Majesty's service would be rewarded with two hundred acres of land at the close of the war. Logan kept the contents secret, fearing that if the inhabitants knew of its promise some might desert.

It was a happy day at Logan's fort when two companies of Holston militiamen under Colonel John Bowman, grandson of the "Old Baron," Joist Hite, trooped in the latter part of August 1777. The savages immediately lifted the siege and disappeared. They had no heart to fight the wild "Long Knives." Bowman left a good-sized garrison with Logan, hurried on to Harrodsburg and rushed a large contingent to Boonesborough.

With the savage menace lifted for the time being, the settlers who had been cooped up all summer and unable to attend their crops, swarmed out of the stockades and took in their meager harvests. Logan set out again for the Holston and brought back a train of pack horses loaded with supplies. This timely assistance from less disturbed and more fortunate communities enabled the frail settlements in Kentucky to survive the winter of 1777-1778.

Grim times faced Logan's Station and the other Kentucky settlements as 1778 turned into summer. The Indians around the Lake country were growing more and more restless again. Daniel Boone and a number of companions were captured early in the year while making salt at Blue Licks. Boone was taken to an Ohio town of the Shawnee and adopted by Chief Blackfish. He accompanied some chieftains to Detroit where he temporized with British inquisitors and evaded direct questions about the

strength of the Kentucky settlements. When he returned to Ohio, he learned the Indians were planning a strong expedition into Kentucky. He managed to escape and to return to Boonesborough. He told of the Indian plans and led a force of scouts back into the Indian country for more information.

After his return Boonesborough was invested by a large body of Indians. The settlers pretended to negotiate for surrender. They procrastinated openly and in secret prepared their defenses. At last the assault began. Caught in the siege were fifteen men from St. Asaph sent earlier to reinforce the post. For three weeks the attacks were successfully beaten off and an attempt at mining the fort was frustrated. Finally the Indians withdrew, some to return to their Ohio towns, others to visit the Cherokee, and one band to strike at Logan's Station.

Logan was warned of the approaching savages by William Patton, a man from his station who had been spying around Boonesborough for several days. Patton came rushing in with a wild tale. He said he had watched the besiegers of Boonesborough from a high hill. On the night of the final assault, he said, the Indians charged forward with firebrands and war whoops. He was certain the stockade had fallen because he heard the screams of women and children being massacred. He fled from the scene without waiting to see more.

Logan's garrison was weakened by the absence of the fifteen men caught at Boonesborough, but he was certain he could withstand a long siege. Previously he had dug a ditch from the fort to the spring and covered it over, so that water could be brought through the tunnel. He ordered the men and women to bring in a big supply of roasting ears and pumpkins from the fields and to fill the vessels with water. He conferred with Daniel Trabue,[3] his commissary man, about the food stores, and decided to bring in the cattle pastured two miles from the station.

Logan first instructed six or eight men to go for the cattle, but on second thought he decided to go alone. He said: "I am afraid for you to go. . . . I will hunt the cattle and the Indians alone, and will keep in the cane the whole way." Mounted on

his favorite white horse and keeping under cover he made his way toward the pasture. Near the place where the cattle were grazing, eight or ten Indians fired at him. He was hit in the chest and his arm was broken. Taking the thumb of his helpless arm in his teeth he made a dash for the fort. The Indians pursued him so closely one seized the tail of his horse. But his swift mount soon outdistanced the pursuers and charged safely in through the open gate of the fort, his sleek white hide streaked with the blood of his wounded master.

Bleeding profusely, Logan was put to bed. Benjamin Pettit, an amateur surgeon, dressed his wounds with slippery elm bark. From his pallet Logan issued orders. His first thought was for reinforcements from his friends on the Holston. He called John Martin, the young man who had volunteered to help him rescue Harrison the year before, and told him to take a letter to the Holston settlements. He impressed Martin with the seriousness of the situation and expressed every confidence that the Holston men would come to his defense as they had done before.

Next Logan called in Trabue and outlined the dangers and the need for courage. Whatever happens, he said, the fort must hold. "I am certain if we can keep the fort for fifteen or twenty days, men will come from Holston and help us. It is certain that if the Indians take the fort they will kill me and all the sick and wounded, and perhaps will not spare any. Try to encourage the men and boys in your houses." Then, one by one, each man in the fort was brought before Logan for the same admonition.

During the night the Indians made their first appearance. They stole a horse tied near the fort but sentries fired at the dusky forms and drove them away. The next morning some cattle were seen running wildly about with arrows sticking in their backs. They kept looking back as though they were being pursued. Some of the belled stock had been killed for the bells. The settlers did not dare to open the fort gate.

Long, anxious and fearful hours passed as the occupants of Logan's Station waited for the Indians. Trabue went about the fort observing the defenses and carrying out the orders of the

wounded captain. Some of the people were frantic with fear. Women walked about inside the stockade seeming not to know what they were doing, expecting the tension to break and bravely hoping for the best. The men stuck to their posts at the portholes, relieving each other at regular intervals.

On the second day after Logan was wounded, observers from the side of the stockade toward Boonesborough saw some furtive figures creeping along the trail in Indian file. Immediately the cry went up, "The Indians are coming." The women joined with the men in rushing to the walls to look out, and some screamed: "Lord have mercy on us! Yonder they come!"

But before the approaching figures got within firing distance, one woman shouted: "It is our boys!" The gate was flung open, and the men who had been sent to Boonesborough were welcomed with tears of joy. The dread about their fate since Patton had brought his account of the siege now broke into a celebration of rejoicing. Someone ran into Logan's room with the news, and he smiled for the first time since he had been wounded.

For three weeks the settlers waited for an attack. Lurking Indians killed some cattle but did nothing else. Then one day a hundred men arrived from Holston in response to Martin's alarm. The settlers welcomed them with fat buffalo, bear meat and new corn. The Holston men were fretting for a war upon the Indians. Their officers went to Boonesborough and Harrodsburg for a war council, but it was decided the season was too late for a campaign. In a week or two the Holston men went back across the mountains.

Hardly had Logan recovered from his wounds before he was asked to sit in a court-martial to try Daniel Boone. The renowned backwoodsman was charged with treacherously leading the Indians to the saltmakers' camp at Blue Licks; with compelling his fellow workers to surrender; with sponsoring the unnecessary reconnoitering expedition into the Shawnee country before the siege of Boonesborough; with being willing to take the officers of Boonesborough to the Indian camp to make peace out of sight of the fort; and with being in favor with the British. The charges

were preferred by Colonel Richard Callaway, a onetime friend of Boone's. His son had married the old woodsman's daughter. The court sat in Logan's Station and Logan himself seems to have believed that there was some foundation for the accusations.

Boone appeared before his accusers and gave his version of the events. He had a good reason for everything he had done. Despite the representations made by the jealous and suspicious Callaway, Boone was cleared of the charges and was soon promoted to the rank of major. Trabue, present at the trial, reported that Callaway and Logan appeared to be disappointed by the acquittal, but that the verdict was accepted as just. After the trial Boone took the Wilderness Road for North Carolina to find Rebecca and his children, who had left the country months before and gone east with the belief that he was dead.

The raids of the northern Indians on the Kentucky border had become almost seasonal and Logan determined in 1779 to invade their Ohio towns to forestall another attack. He and John Bowman at Harrodsburg were both colonels in the Virginia militia. Together they gathered 300 men from the Holston and the Kentucky settlements and assaulted Chillicothe, principal town of the intractable Shawnee. The expedition was only in part successful but the Indians were discouraged from crossing the Ohio that season.

Logan took part in another punitive expedition in 1780. That year 300 Indians under the command of Colonel Henry Bird of the British Regulars swept down upon the Kentucky settlements, killing, robbing and plundering. Logan collected a regiment of riflemen from his station and Boonesborough and joined George Rogers Clark who, for two years, had held the Northwest Territory against both British and Indians. They crossed the Ohio, struck Chillicothe, razed several towns, scattered the Indians and destroyed their corn crops.

A year later, in 1781, Cornwallis surrendered but the Revolutionary War did not end in the West. On August 19, 1782,

the Kentucky settlers were defeated badly at Blue Licks. Impetuous militia commanders from Harrodsburg, Lexington and Boonesborough had not waited for the help of 150 men under Logan who were marching rapidly to join them. They pursued a band of northern raiders across the Kentucky River and rode into an ambush. Cut to pieces they lost eighty-seven militiamen, and a large number were wounded. Among those who fell were Colonels John Todd and Stephen Trigg and a son of Daniel Boone. Logan arrived with his fresh troops in time to bury the dead in this "last battle of the Revolution."

Grief-stricken at the loss of so many of his friends and neighbors, Logan hurried back to the Falls of the Ohio to confer with Clark about retaliatory measures. The two commanders gathered the shattered forces in the settlements and again raided the Shawnee country, laying waste more villages and crops.

Logan returned from the campaign worn and hardened by his arduous service against the Indians during the bloody years. At his station on the Wilderness Road he had helped to keep open the supply line for Clark's conquests in the Northwest. Although far removed from the strategic fighting of Washington's armies he had rallied the western frontiersmen in beating off the hordes of Hamilton's Indian allies who were stabbing at the backs of the harassed colonists in the East. But his work was not done. With the burden of the Revolution lifted from the frontier, new duties and new demands absorbed his time. He turned to the vexing political problems which had so seriously divided and plagued the early settlers.

During the turbulent Revolutionary War period Logan had risen to leadership while Kentuckians had quarreled over the conflicting authority claimed by Colonel Richard Henderson and the State of Virginia. The North Carolinian, who had parted with Logan at Hazel Patch, April 15, 1775, to found Boonesborough, had immediately encountered domestic as well as foreign difficulties. Logan had stood aloof and nonco-operative despite his willingness to send representatives from his station to sit in the first legislative assembly of Transylvania at Boones-

borough. But after the first meeting he had ignored the ambitious proprietor and had calmly gone about his own business.

A conflict was inevitable. When word had reached the new settlements that Virginia officials opposed Henderson's claims, the independent settlers resisted his authority. But it was not the suave and nonprovocative Logan who was to prove Henderson's nemesis. Another leader and spokesman for the discontented frontiersmen was at hand.

1 "Logan of Old Lincoln," (MS by Dr. Will N. Craig, Stanford, Kentucky).

2 Bayless Hardin, ed., "Whitley Papers" (Vol. 9—Draper MSS—Kentucky Papers), in *The Register of the Kentucky State Historical Society*, Vol. 36, No. 116, July, 1938, 202-203; John A. M'Clung, *Sketches of Western Adventure* (Dayton, O., 1847), pp. 109-112; Thomas Marshall Green, *Historic Families of Kentucky* (Cincinnati, 1889), pp. 127-129.

3 An excellent account of life at Logan's Station during this period is given in the reminiscences of Daniel Trabue in Lillie DuPuy VanCuiin Harper, ed., *Colonial Men and Times* (Philadelphia, 1916), pp. 34-39.

Chapter 9

Clark's Supply Line of Conquest

T HE revolt which shattered Henderson's dreams of a proprietary empire centered in Harrodsburg, twenty-two miles west of Logan's Station. George Rogers Clark, a young Virginia surveyor, spearheaded the opposition. The red-haired, eagle-eyed youth first came into the West in 1772 and then spent each summer with surveying crews along the Ohio as far down as the Falls. After brief service with Lord Dunmore in the war with the Shawnee in 1774, he was back in Kentucky by the time Boone and Henderson started Boonesborough. He was not on hand during the proceedings when the Transylvania colony was established because he was busy surveying Leestown near the present site of Frankfort.

Clark occasionally visited Harrodsburg during the summer of 1775 and quickly caught the temper of its citizens. James Harrod and his men were spreading out from their settlement, at first tolerantly accepting Henderson, but at last boldly defying his pretensions. Hundreds of independent settlers were pouring into Kentucky over Boone's Road and down the Ohio, taking up land without regard to the North Carolinian's claims to ownership. Despite this growing opposition, Henderson and his agents disposed of a half million acres of land within six months, and Boonesborough flourished as the capital of Transylvania.

Clark did not say much at first as he watched the conflict of interests. He went back to Virginia for the winter of 1775-1776,

heard the denunciations of Henderson by the authorities and decided that it was time to bring the issue to a head. He returned to Kentucky in the spring of 1776 and counseled with the settlers at Harrodsburg. He told them they should make an official protest to the Virginia Assembly.

This the Harrodsburg men did at once with vigor.[1] Sending a petition to the Virginia Convention at Williamsburg, signed by James Harrod, Abraham Hite, Jr., grandson of old Joist Hite in the Lower Shenandoah, and eighty-six other settlers, they declared they were adventurers who had come to Kentucky because of the good reports of their friends who had explored it, and were greatly alarmed at the conduct of the men who styled themselves proprietors. The petitioners stated that the price of land had been arbitrarily increased from thirty to fifty shillings for each hundred acres and that further demands might be made because of the "insatiable avarice" of the proprietors. They urged the Virginia Convention to take measures at once to restore peace and harmony to their divided settlement.

This petition was mild in tone compared with the indignation of the next communication.[2] Clark was not present when it was drafted, but he had urged that a general meeting be held of all the independent settlers at Harrodsburg on June 6, 1776, in order that more positive action might be taken. Still busy surveying, he left the preliminaries to Harrod, Hite and John Gabriel Jones, a promising young attorney. This time a new revolutionary spirit was injected into the proceedings. To the people's resentment of Henderson was added their hatred of the growing oppression of the British crown. Although far removed from the scenes of stormy debate along the Atlantic seacoast, the Kentuckians took their stand with the patriots in the old settlements. Calling themselves "a Respectable Body of Prime Rifle Men," they declared they were ready to join the revolt and would be willing to bear their share of the cost.

But the Harrodsburg patriots also brought up their old grievance against Henderson, the real purpose of their convention. They again voiced their complaint in strong terms and de-

manded representation in the Virginia Assembly. They announced that they had selected George Rogers Clark and John Gabriel Jones as delegates from the district on "the western waters of Fincastle (on Kentucke)." Fearing savage raids on their settlements, they urged the appointment of magistrates so that the laws of the colony of Virginia would protect them.

Clark arrived at Harrodsburg as the deliberations ended and learned that he had been chosen with Jones to carry the protest in person to Williamsburg. The two set out at once along the Wilderness Road. This was Clark's first trip across the mountains. His previous journeys to Kentucky had been down the Ohio.

The young men found their journey easy at first.[3] With fresh horses and a good trail from Harrodsburg to Logan's Station, and then along Skaggs Trace, they made fast time. But on the third day Jones's horse gave out and had to be abandoned in the woods. The men put their packs on Clark's horse and took turns riding. Heavy rains set in and for three or four days they were soaked to the skin, and they dared not make a fire to dry their clothes for fear of Indians. They soon developed what hunters called "scalded feet." With intense suffering they plodded along.

By taking turns at hobbling and riding, the two men at last passed through Cumberland Gap and came to an abandoned and partly burned station eight miles west of Martin's Station. Clark cheered his disconsolate partner by saying that they would surely find help at Martin's. To avoid the main road where they might be seen by Indians, they took to the woods and attempted to ride their horse double. Failing in that, they returned to the dangerous open path again, for they could not walk in the woods with blistered feet. They heard guns discharged frequently in the forest and were convinced that hostile savages were about.

When they reached Martin's Station, they found it was deserted, and they saw some recent Indian tracks about the cabins. "Our situation now appeared to be deplo[rable]," Clark commented. "The nearest Inhabetants we now knew to be sixty miles not able to Travel our selves and Indeans appeared to be

in full possession of the Cuntrey that we ware in we sat a few [minutes] Viewing Each other. I found myself Reduced to perfect desperation."

Jones turned to Clark and despairingly asked what they should do. Clark told him it was impossible to make the settlements; they could not hide in the mountains in this bad weather—they might perish. There was only one alternative: fortify a cabin and burn down the stockade. With a barrel of water, corn from a crib near by, and meat from a hog running in the lot, they might withstand a siege for several days, perhaps until relief came.· In eight or ten days another party would be along from Harrodsburg on its way to Virginia. In the meantime they could make "an oil and ouse" of oak bark to cure their feet.

Jones agreed, drew his sword and started after the pig. He hoped to kill it without making any noise. Clark inspected the cabins. He selected a small one detached from the rest. It was locked. He climbed to the roof and threw down the logs off the chimney until it was low enough for him to drop inside. Then he cut the lock on the door and opened it.

Jones, who was better able to walk, filled a keg with water, collected some wood, brought in some corn and the carcass of the hog. They barred the door and cut some portholes. On the table they laid their rifle, saber, two braces of pistols and ammunition. In case of attack, it was agreed that Clark was to do the firing and Jones the loading, unless there should be "the appearance of a storm."

With these preparations completed, they cooked some provisions and dressed their sore and aching feet with an oak-bark brew. Night came. They unbarred the door and looked out cautiously. They heard the faint tinkle of a horse bell. Convinced that Indians were creeping upon them, Clark whispered instructions to his companion as they waited in the gathering darkness. Suddenly they discovered the approaching forms of white men. They flung open the door, placed themselves in full view and hallooed loudly. The visitors were from the Clinch settlements returning for some things they had left behind when

the station was abandoned a few days before. Seeing the smoke from the cabin the men judged Indians were present, and they were surrounding it for a surprise attack.

Given fresh horses the next morning, Clark and Jones accompanied their new friends to an outpost on the Clinch where they remained several days to permit their feet to get well. When they could travel, they took the road again, pushed on through southwest Virginia, crossed New River at Ingles Ferry and got to Fincastle. Here they learned that the Virginia legislature had adjourned. The two men debated what to do until it met again, then separated, Jones to return to the Holston settlements to take part in an expedition against the Cherokees, and Clark to proceed to the home of Governor Patrick Henry in Hanover County.

Henry was ill when the young envoy arrived, but he listened with keen interest to Clark's story of what was happening in the West. The patriot who had spoken defiant words against King George III in the cause of liberty was impressed by this forthright young man fresh out of the wilderness, and he readily promised to aid the Kentuckians in their dilemma. He was not only anxious to take them into Virginia's sphere but was ready to respond to Clark's request for five hundred pounds of powder from the state's meager stores of ammunition. Patrick Henry gave Clark a letter to be presented to the Virginia Executive Council at Williamsburg.

Clark hurried on to appear before the Council, but found the members reluctant to grant the powder. They had enough troubles at home: a war with Great Britain was under way; the treasury was empty; men and supplies were needed at home. But more important from a legal standpoint, there was no official recognition of the settlements in distant Kentucky, and to grant them supplies would recognize the obligation to give them future protection. They said Clark could have his powder but only as a personal loan.

Clark, adroit and persuasive, determined not to be trapped into a compromise which left Kentucky dangling in uncertainty. He

refused to accept the powder with the conditions imposed, and pointed out that if Virginia claimed the western country under her charter rights, she should be willing to protect it. In his argument he made the statement which has often been repeated as an axiom: "If a Cuntrey was not worth protecting it was not worth Claiming." He warned the Council that their refusal of his terms would drive the Kentuckians to seek protection elsewhere. The Council capitulated; Clark got his powder on his own terms.

At the Virginia Assembly a few weeks later, Clark and Jones were on hand to carry out their instructions from the Harrodsburg convention. They presented their credentials but were at first refused seats, because Fincastle County was represented by Colonel Arthur Campbell. The long-jawed master of Royal Oak was jealous of his authority and strenuously opposed the proposal of the western delegates. Also present as a busy lobbyist was Colonel Henderson, trying desperately to get recognition of his claim to the land he had purchased from the Cherokee. But Clark and Jones at last secured the official sanction they sought, and the legislature passed an act on December 6, 1776, establishing the County of Kentucky out of the western part of Fincastle.

Henderson was not successful and his personal empire was doomed. Later he was partially compensated for his expenses and trouble by a consolation grant of 200,000 acres at the mouth of Green River on the Ohio where Henderson, Kentucky, perpetuates his name. Likewise, North Carolina gave his company 200,000 acres near the junction of the Clinch and Powell Rivers, in compensation for the "path deed" for the land through which Boone's Road ran from Long Island to Cumberland Gap. Henderson also participated in the development of Big French Lick on the Cumberland where the capital of Tennessee was later established.

Clark and Jones returned through Fort Pitt, in order to pick up the powder which had been ordered placed there for the use of Kentucky. They had trouble running it down the Ohio through the hostile Indian country and were forced to secrete

it in various places not far from Limestone. Jones led a party from Harrodsburg to get it, but he and three others were slain in an Indian ambush. It is easy to imagine with what sorrow Clark recorded this tragedy on Christmas Day, 1776, when he began his brief diary of Kentucky's tragic era.

The year 1777 opened with growing dangers for the frail, ill-equipped and undermanned settlements on the Kentucky frontier. Governor Henry Hamilton, the British lieutenant governor of the northwestern region who had established his headquarters at Detroit, began to enlist the Shawnee, Wyandotte and other tribes on the side of the British. War talks spread from camp to camp, and vengeance was declared against the settlers west of Fort Pitt and along the Wilderness Road. Hamilton seized on this natural enmity of the Indians for the advancing whites to loose a savage scourge upon the long western front from Fort Pitt to the Falls of the Ohio. The helpless and scattered settlers fled into their hastily constructed stockades at Boonesborough, Harrodsburg and Logan's Station.

Clark looked beyond the immediate problem of meeting Indian attacks. He began to consider how the widely scattered outposts in the West could be utilized in the colonial fight for the country's freedom. Kentucky lay across the path of the British and Indians moving down from the Northwest upon the rear of the Virginians. Not only must this frontier be held, but the interminable reaches of the Illinois country with its plains, prairies, lakes and streams should be conquered, and the nest of Detroit where Hamilton was hatching his nefarious schemes destroyed.

Clark was then only twenty-five, with little military experience. His concept of the strategy to be followed was daring. Why wait until Hamilton and his legions came down in force to strike Kentucky? It would be far better to take the attack to Hamilton. On April 21, 1777, he sent two men, Ben Linn and Samuel Moore, as his personal spies to Kaskaskia, a French town under British rule on the Mississippi in the heart of the western country. Clark wanted to find out the strength of that place and to learn about the movements of Hamilton's forces at Vincennes

and Detroit. The men returned to Harrodsburg, June 22, and reported confidentially. Clark immediately wrote Governor Henry and suggested he be given authority to raise some men and take possession of the Illinois country by next April. If this were not done, it would be necessary within twelve months to march an army against the Indians on the Wabash which would cost ten times as much and not be of half the service.

Clark was too far from Williamsburg to get quick co-opera-tion. The summer passed, troubles in Kentucky increased, and Clark fretted over his inaction. At last he resolved to go to see Governor Henry again. He joined a company of men at Har-rodsburg and Logan's Station who were escorting a number of families through the danger zone to the Holston settlements—in all seventy-six men with their women and children.

The large company moved slowly, making only a few miles each day. They traveled in rain much of the way until they got to Laurel River. Here they were delayed for three days by the high water and bad weather. They lost the cattle that they de-pended on for food. They met fifty half-starved men and two families under Captain Watkins on their way to Boonesborough.

On October 11 Clark's company reached Cumberland Ford and killed two buffalo. They found abundant Indian signs in the neighborhood and proceeded cautiously along the old trail through Cumberland Gap. They crossed the pass as the sun went down and spent the night at a camp site on the edge of Powell Valley. In spite of a late start they were able to reach Martin's Station the next night.

The caravan continued along Boone's Road until they reached the Clinch. Here they left the Road, turned up the river and bivouacked at Rye Cove. They passed Blackmore's Fort and Moore's Fort near the present site of Castlewood, and stopped at Royal Oak, where they were once again on the Wilderness Road. Clark stayed all night with Arthur Campbell, now a colonel in the militia.

Restive over his delay, Clark left the slow-moving caravan at

Royal Oak and hurried on to Williamsburg. He did not imme-
diately divulge his plans but took time to settle his militia
accounts, buy new clothes and consult some of the Virginia
leaders. He was gratified to hear that Burgoyne had surrendered
to the colonists in far-off New York. When he went to Gover-
nor Henry with his proposal for an expedition into the North-
west, he received a sympathetic hearing.

Henry discussed Clark's plans privately with Thomas Jeffer-
son, George Wythe and George Mason. All agreed that the
expedition should be undertaken. Realizing the need for secrecy,
they did not reveal to the Virginia Assembly the real purpose
back of the plan. They secured approval only for dispatching
five hundred Virginia militia into the West for the defense of
the Kentucky frontier. Clark, however, was secretly authorized
to lead his forces into the Illinois country for an attack upon
Kaskaskia.

His army for the expedition finally dwindled to a skeleton of
four companies of volunteers, to be recruited in Virginia, on
the Holston and in the Kentucky settlements. Each man was
promised 300 acres of land in the conquered territory. Most
of the recruits went by way of Fort Pitt to the Falls of the Ohio,
but some marched from the Holston settlements over the Wilder-
ness Road. A few others enlisted at the Kentucky stations.

Clark selected a seven-acre island, later known as Corn Island,
in the Ohio above the Falls for his rendezvous in the spring of
1778. Here at the western terminus of the left prong of the
Wilderness Road, Clark gathered his men, built a stout garrison
and instituted rigid military discipline. Thirteen families whom
he had reluctantly permitted to come with him, he put to clearing
the island and planting it in corn. Until he was ready to start on
his expedition, he kept his mission a secret. When he at last
revealed his true designs, it was only by force and intimidation
that he was able to keep many of the men on the island. Some
deserters led by a lieutenant swam the river to the Kentucky
shore and fled toward Harrodsburg. At last in the early morning

of June 24, 1778, while the sun was in eclipse, Clark and 175
men rode the treacherous rapids and went on to capture the out-
posts of Kaskaskia and Cahokia.

At Kaskaskia Clark needed instructions from his chief, Gover-
nor Patrick Henry, more than a thousand miles away at Wil-
liamsburg. Busy consolidating his victories and making peace
with various Indian tribes, he was without authority to handle
the civil affairs of the district he had conquered and was without
funds and sufficient men to march upon Vincennes. He sent a
report to Governor Henry by Captain John Montgomery and
his young cousin Lieutenant John Rogers, telling of his capture
of Kaskaskia and Cahokia. They had taken with them De
Rocheblave, the former commander of Kaskaskia. But as the
summer of 1778 wore on, Clark needed to communicate with
Henry again.

Clark found in William Myers, a young and unmarried Ken-
tuckian, the training and qualities needed for the long overland
journey to Williamsburg. Myers had been among the eighty-
two men at Harrodsburg who signed the protest petition of
1776, and had impressed Clark by his conduct on the Kaskaskia
expedition. Clark gave Myers his letters to Henry and sent him
on his way. The young man went to the Falls of the Ohio and
then took the Wilderness Road on his long journey to the Vir-
ginia capital.

Four months passed before Clark saw his messenger again. On
February 27, 1779, two days after Clark marched his ragged
band through ice-filled waters to take Vincennes, Myers turned
up on the boat *Willing*, which arrived belatedly on its slow voy-
age up the swollen Wabash. The young envoy brought mes-
sages from Henry. Clark broke the seals. He was in a happy
frame of mind. His victory at Vincennes had been complete and
Lord Henry Hamilton, "the Hair Buyer," was safely in his cus-
tody. He would have a pleasant report to make to his Governor
at Williamsburg.

Henry covered a lot of things in his instructions to Clark. He
explained that the Virginia legislature had acted promptly in

COLONEL JOHN LOGAN'S ACCOUNT BOOK

Recorded the first expenditures on the Wilderness Road in 1792. Colonel Logan was a brother of General Benjamin Logan. Sample page shows partial list of subscribers to the Wilderness Road improvement fund.

THE BLUEGRASS REGION OF LINCOLN COUNTY, KENTUCKY

Modern view looking north from Hall's Gap toward Logan's Station (Stanford) and Crab Orchard through which the Wilderness Road passed.

providing for the civil control of the conquered Illinois country. Colonel John Montgomery had been appointed county lieutenant of Illinois in charge of civil affairs. He would supply Clark with funds for his further conquests. Patrick Henry assured Clark that he would be given wide latitude in his operations.

Clark was interested in a private letter which Henry did not want to get into the official files.[4] The governor inquired about the fine horses of Spanish blood that he had heard were in the Illinois country. He wrote with a measure of insistence:

> Get for me upon receipt of this Eight of the best Mares you can purchase large as you can get, & not old Don't loose a moment in agreeing for the Mares, for vast Numbers of people are about to go out after them from here. . . . Send them to Colo Wm Christians, by some good men coming in.

Henry repeated his request in a message later in which he inquired about the various Indian tribes in the Illinois: "Send off the express to me with this Intelligence quickly as possible. Buy a Stallion on my Account for him to ride in. He may ride the Stallion & lead a Mare . . . let the Messenger take good Care of them."

Clark prepared letters for Myers to take back to Williamsburg with his report of the Vincennes affair. With modesty and restraint, he briefly covered the expedition in his letter and stated that he would send along the journal he had kept and let it speak for itself. Then he turned to the governor's request for a stallion and some good mares. He regretted that he had to disappoint his Virginia friend.

> There being no such horses here as you request me to get. . . . The common breed in this country is triffling as they are adulterated. The finest Stallion by far that is in the country, I purchased some time ago, and rode him on this Expedition, and resolved to make you a Compliment of him, but to my mortification I find it impossible to get him across the drown'd lands of the Wabash as it is near three leagues across at present.

On March 13, 1779, Clark ordered Myers to return through the wilderness without any stallion for the governor of Virginia. Myers had Clark's letter of authority, expressing confidence in him and urging haste:

> As the Letters you have at present contain matters of great consequence and require a quick passage to Williamsburg, This is to impower You to press for the Service any thing you may stand in need of. If you cannot get it by fair means, you are to use force of Arms. I request you to lose no time as you prize the interest of your Country. I wish you success.

Less than a month later Captain James Patton, in charge of a little garrison at the Falls of the Ohio, gave Clark bad news. Myers had been murdered by Huron Indians in an ambush on Beargrass Creek, four miles out from the Falls. Myers had reported at the garrison on April 4, 1779, after making a dangerous journey down the Wabash and up the Ohio in a frail canoe with three other men. Patton furnished him a horse, and Myers immediately set out for his journey along the Wilderness Road, in company with John Moore. They had scarcely passed from the protection of the garrison before they were attacked by Indians. Myers was slain and Moore taken prisoner. Patton reported that he found the body of Myers fully clothed but that his packet of letters was missing. He hunted through the woods and discovered a number of personal letters, some opened, and others torn into bits. He could not locate Clark's journal detailing his Vincennes expedition.

Clark read the account of his messenger's murder with mingled sorrow and worry. The death of his faithful envoy touched him deeply; his letters and journal might reveal important information to the enemy. Fortunately he had not written Henry too freely.

Clark's prize catch at Vincennes was Lord Henry Hamilton. Kentuckians looked upon the Detroit commandant as an infamous "Hair Buyer" who had caused all their troubles. He was

erroneously reputed to have paid the Indians large rewards for white scalps. Clark told Hamilton about this feeling when he was ready to send him and his staff on the long journey to Williamsburg where the Virginia authorities would deal with them. The British Lord might meet with violence at the hands of the enraged Kentuckians, though Clark gave orders to the guards to treat the prisoners with consideration and protect them against all dangers.

Hamilton did not look forward with any enthusiasm to the journey. Before him was a trip of 360 miles by water down the Wabash and up the Ohio to the Falls, and 840 miles by land over the Wilderness Road to Williamsburg. It was a gloomy prospect.

The party consisted of about twenty-seven prisoners and twenty-three guards. They set out seven days before Clark's messenger was ready to start with his important communications. Their trip on the rivers in a crowded boat was miserable. They arrived at the Falls on March 30, 1779, where Hamilton and his fellow prisoners were herded into a log cabin. Here the nervous commandant had his first experience with the frontiersmen. The men in the fort fired off their guns all day around his cabin. He was careful not to show himself and he set down in a journal his experiences and apprehensions.[5]

Hamilton's party and the guards left the Falls on April 1. Only two horses were provided, and each man had to carry his own pack. Hamilton had a portmanteau and a small box in which he carried a few papers. His secret documents he kept in an inner pocket of his waistcoat. A kindly woman at the Falls provided some bread and Hamilton gave her his quilt in appreciation of the unexpected friendliness.

The prisoners trudged from twelve to fifteen miles a day along the trail to Harrodsburg. They reached that town at dusk on April 6. Hamilton observed in his journal:

Tis called a fort and consists of about 20 houses forming an irregular square with a very copious spring within the enclosure. At the time of our arrival they were in lively ap-

prehension of attacks from the savages and no doubt these poor inhabitants are worthy of pity. Their cattle were brought into the fort every night, horses as well as cows. They could not go for firewood or to plow without their arms. Yet in spite of this state of constant alarm a considerable quantity of land has been cleared. . . .

Our diet here was Indian corn and milk for breakfast & supper, Indian bread and bear's flesh for dinner, yet we were hungry & thirsty. We were delayed here much against our will, thinking we held our lives by a very precarious tenure, for the people on our first coming looked upon us as little better than savages, which was excusable, considering how we had been reported, and besides that they had suffered very severely from the inroads of those people. One man in particular had last year lost his son and had 14 of his horses & mares carried off, yet this man was reconciled upon having a true state of facts, and Colonel Bowman acted as a person above prejudice by rendering every service in his power.

At Harrodsburg Hamilton and the more important prisoners were provided with horses brought from Logan's Station. Colonel Bowman let Hamilton have one of his own. They arrived at Logan's in the late afternoon of April 19. Hamilton commented:

It is an oblong square formed by houses making a double street, at the angles were stockaded bastions. The situation is romantic among wooded hills. A stream of fine water passes at the foot of the hills which turns a small grist mill. They had been frequently alarmed & harassed by the Indians. Captain Logan, the person commanding here had his arm broken by a buckshot in a skirmish with them. . . . The people here were not exceedingly well disposed to us and we were accosted by the females especially in pretty coarse terms. But the Captain and his wife . . . were very civil and tractable.

The prisoners and the guards stopped at Whitley's Station and bought a small ox, three bags of corn and some dried meat

to serve as food for the fourteen days they estimated it would take to pass through the wilderness to the settlements on the Holston. Turning into Skaggs Trace, they headed for the mountains. Hamilton counted forty crossings of Skaggs Creek. He observed:

> The difficulty of marching through such a country as this is not readily imagined by a European. The Canes grow very close together, to the height of 25 feet and from the thickness of a quill to that of one's waist. As they are very strong and supple the rider must be constantly on the watch to guard his face from them as they fly back with great force. The leaves and young shoots are a fodder horses are exceedingly fond of and are eternally turning to right & left to take a bite. The soil where they grow is rich and deep so you plod thro in a narrow track like a cowpath, while the musketoes are not idle.

Hamilton was impressed with the wild beauty of the Rockcastle River region where the trees were high and the water clear and bright. While the fatigued horses were being towed across the rapid stream by their wearied and hungry leaders, he made a hasty pen sketch of the scene. They reached Hazel Patch at nightfall April 22 and camped. Here they were joined by Colonel Richard Callaway. He came down Boone's Road from Boonesborough to take charge of the prisoners. Hamilton did not think much of him:

> The Colo[l] made new arrangements, new dispositions, talked of grand division maneuvers, and made a great display of military abilities, posting a number of sentries & fatiguing our poor Devils . . . who willingly would have trusted their prisoners in this desert, not one of whom could have made use of his liberty without guide, provision and shoes being furnished them. It rained all night, which did not set our disciplinarian in a favorable light.

On the morning of April 23 Lord Hamilton and his British comrades remembered their country's patron, St. George. Not

having a supply of spirits they drank their toasts in Hazel Patch water. "We were very hearty in our wishes for the honor and success of the patron's countrymen, and though the water was very good, did not exceed the bounds of moderation in our potations."

The party proceeded on the trail, slippery and difficult from the rains, until they crossed Stinking Creek. At Flat Lick, where the warpath of the Shawnee came into Boone's Road, Hamilton inspected the salt lick much frequented by buffalo, and commented:

> Several of the trees here bear the marks of the exploits of the Savages, who have certain figures and characters by which they can express their numbers, their route, what prisoners they have made, and how many killed. They commonly raise the bark and with their Tomahawks & knives carve first and then with vermillion color their design.

Hamilton reported no particular incident in crossing Cumberland River and Cumberland Gap into Powell Valley until the party arrived at a point two miles east of the present town of Jonesville. He was impressed with an unusual spring where they camped.

> A very copious stream of fine water breaks out of the ground in a beautyfull valley well cloathed with clover, skirted with rising grounds ornamented with a variety of timber trees, evergreens & shrubs. At about 250 yards from its source it passes under a rocky ledge which serves for a bridge, being about sixty feet wide at top and covered with trees. The road passes over this natural Bridge, which is hollowed into several arched cavities, some of a considerable dimension. This pretty stream and peaceful scene would have engaged me a considerable time but I had no allowance and just took two light sketches on cards. . . . I went to see the cave from which the creek (as 'tis improperly called) issues. It is arched over naturally and the covering is really very smooth and even. A tall man may stand upright in it

and walk 70 yards, a breach in the top taking in light suffi-
cient. I thought it singular enough to take a view of it.

The Hamilton party traveled slowly over the southwest Vir-
ginia portion of Boone's Road. It took them three days to go
from Glade Spring to Moccasin Gap. Sleet and hail added to
their discomfort, and in crossing Clinch River some of the men
were nearly drowned. Hamilton got across in a small canoe. He
had a new trouble. "I felt the gout flying about me and as it
would have been dreadful to have been sick while in such a
country, I dismounted & walked the whole day in moccasins
which dissipated the humor and enabled me to keep up."

Passing through Moccasin Gap into the open country of the
Holston, Hamilton felt a little better. He was grateful when
they came to the home of Mr. Madison[6] who received them with
unexpected cordiality and friendliness. Remembering his dis-
comforts in the wilderness, Hamilton observed:

> The sight of a pretty cultivated farm, well cropped with
> a large garden orchard & convenient buildings set off by
> the lofty & rugged mountains we had just passed, formed
> a pleasing contrast to our late situation. The cheerful con-
> versation of a very agreeable old man, with a plentyful meal
> (what we had long been strangers to), rest after our fatigue,
> and a very clean bed to conclude were real luxuries, to peo-
> ple who had not lain in sheets for 7 months.

Moving up the Valley to the home of Major Anthony Bled-
soe,[7] near Sapling Grove, they were again treated to good
beds. But here Hamilton had apprehensions.

> We were told the country people had designed to assem-
> ble & knock us on the head. Tho we considered this
> was only meant to prevent our having any conversation with
> them, we thought it advisable to stay within. We break-
> fasted at Colonel Shelby's plantation, where we were very
> frankly entertained. The Farm is in extraordinary good
> order and condition. We were shown a black stallion, one

of the finest creatures of his sort I ever saw.... We slept at a Captain Thompson's whose riches could not keep penury out of doors. We did not get our dinner 'till 11 at night and thus made us see economy in no favorable light.

Hamilton and his guards turned in for an overnight stay, May 5, with Colonel Arthur Campbell at Royal Oak, but this time his own men almost caused trouble. "Our Host was very civil to us, but from the difficulty of procuring provisions in this part of the Country, some of the prisoners who were pressed with hunger and fatigue broke out into very injurious language and even threatened to be revenged at a future day for the little attention payd to their necessities." On May 8 they passed Fort Chiswell where the people again were ugly and hostile.

At Ingles Ferry Hamilton and his men were received so hospitably by Colonel William Ingles, his wife and children, that they remained a full day. Hamilton found three lovely daughters and a son, filling the vacancy in the heart of their graying mother since the tragedy of Draper's Meadows. Warmed by their hospitality, he recorded in his journal:

> A beautiful Girl, his daughter, sat at the head of the table and did the honors with such an ease and gracefull simplicity as quite charmed us. The scenery about this home was romantic to a degree. The river was beautiful, the hills well wooded, the low grounds well improved & well stocked.... Mrs. Ingles in her early years had been carryed off with another young Woman by the Savages and tho carried away into the Shawnee country had made her escape with her female friend & ... tho exposed to unspeakable hardships, and having nothing to subsist on but wild fruits, found her way back in safety from a distance of 200 miles. However, terror and distress had left so deep an impression on her mind that she appeared absorbed in a deep melancholy, and left the arrangement of household concerns & the reception of strangers to her lovely daughters.

Lord Hamilton's party turned out of the Wilderness Road in Roanoke Valley, to cross the Blue Ridge into Bedford County.

When they got to the James River, they rested their weary bodies by taking to canoes. At Richmond Hamilton was put in irons, much to the hurt of his soldierly pride, for the sixty-mile journey on horseback to Williamsburg.

> The fatigues of the march having heated my blood to a violent degree I had several large boils on my legs, my handcuffs were too tight but were eased at a Smiths shop on the road thus sometimes riding and sometimes walking we arrived ... at Williamsburgh. ... We were conducted to the Palace where we remain'd about half an hour in the Street at the Governors door, in wet cloaths, weary, hungry, and thirsty, but had not even a cup of water offered to us—During this time a considerable Mob gather'd about us, which accompanied us to jail—On our arrival there we were put into a cell, not ten feet square where we found five criminals.[8]

The weary, footsore and disconsolate nobleman reached his destination, June 17, 1779, nearly four months after his surrender to Clark. The trials of his overland journey were soon forgotten in the greater humiliation he suffered in the narrow dungeon of the Williamsburg jail. He protested to Thomas Jefferson, who had recently succeeded Henry as governor, vigorously at first but at last plaintively, until he was paroled. When he got to London his cup of woe was full. In his official report, July 6, 1781, he recounted his ill-starred service in a land where he complained the rules of honorable warfare did not prevail.

In the early summer of 1783, Hamilton's conqueror, George Rogers Clark, was also gloomily fretting and chafing as he rode along the Wilderness Road. Not as a proud hero going to receive the plaudits of a grateful people, but as a harassed, penniless man he was on his way to the capital to defend his record as commander of the Western Department. The Revolutionary War was over; Virginia was ceding to Congress the empire of new lands he had wrested from the British in the Northwest; and he was turning in his commission as brigadier general, with-

out a penny of pay for his six years of service, or reimbursement of funds he had advanced and obligations he had made in financing his campaigns. By a hundred different friends and acquaintances, he was plagued and hounded for payment of debts he had incurred in behalf of his country. The remnants of his regiment were in a deplorable state, many of his men not having received a shoe, stocking or hat in two years, and none of them any pay. To top it all, he himself was hopelessly deep in debt.

These burdens weighed heavily upon Clark as he picked his way over the trail he had twice taken when his star was rising. At last he arrived at Richmond. The Virginia capital had moved here in 1779. Clark penned a note to Governor Benjamin Harrison, a magnificent example of pathetic restraint:

> Nothing but necessity could Induce me to make the following Request of your Excellency, Which is to grant me a small sum on Acct, as I can assure you Sr. that I am Exceedingly distress'd for the want of necessary cloathing &c and dont know of any channell thro which I could procure any—Except that of the executive, The State I believe will fall considerably in my debt. . . .

Clark was speaking of what he believed the audit of his accounts would show. A horseload of papers had been sent to Richmond dealing with the tangled maze of his operations in the West, and Clark was following to make his personal report and plead for the payment of others who had advanced aid. Turning from his own pressing needs, he wrote again to the governor:

> It is with pain Equal to the misfortunes that cause it that I daily View persons in this City and Reflect on others absent that have Reduced themselves to a state of Indigence by supporting the Credit of the state to the westward with a zeal that I at that time thought actuated the breast of Every friend to his Country. . . . Altho I have sufferd Every dis-

advantage that a person could Experience for seven years anxiety and fatigue, subject to the Clamours [of] Every Vilinous principal perticularly the Enemies of this state I could bear it with greater fortitude was I to be the only sufferer and the Creditors of the state alluded to paid.

Clark got the empty thanks of the council for his services, and Governor Harrison gave him a letter on July 2, 1783, relieving him of his command in the West because a general officer was no longer needed there. Since the governor had been unjust in previous censures, his honeyed words may have tasted bitter to Clark:

Before I take leave of you I feel myself called on in the most forcible Manner to return you my Thanks and those of my Council for the very great and singular services you have rendered your Country, in wresting so great and valuable a Teritory out of the Hands of the British Enemy, repelling the attacks of their Savage Allies and carrying on successful war in the Heart of their Country.[9]

These thanks, two swords and land warrants valued at a little more than £3,300, were Clark's immediate reward for his services in winning the Old Northwest. Twenty years after his death his estate was allowed $30,000 in settlement of the "debt" his country owed him. Clark returned to the Falls of the Ohio in 1783, a young man of thirty-one, to live out a brooding, decaying life. "When Virginia needed a sword, I found her one. Now I need bread," he told the representative of the governor of Virginia who came to him with the second honorary sword in his old age.[10]

1 "Petition of the Transylvanians to the Virginia Convention" in George W. Ranck, *Boonesborough* (Filson Club Publication, No. 16, Louisville, 1901), pp. 241-244.

2 "Petition of 'the Committee of West Fincastle' to the Convention of Virginia (Harrodsburg, June 20, 1776)" in Ranck, *Boonesborough*, pp. 244, 247.

3 "Clark's Memoir, 1773-1779," in James A. James, ed., *George Rogers Clark Papers, 1771-1781, Collections of the Illinois State Historical Library* (Springfield, Illinois: 1912), VIII, 208-302.

4 *Ibid.,* pp. 75-77, 88, 303-304.

5 "The Journal of Lord Henry Hamilton," in Harvard Library. The quotations are from a photostat copy in the Filson Club, Louisville, Kentucky.

6 This was perhaps Captain Thomas Madison who was one of the commanders in the battle of Long Island Flats with the Cherokee, July 20, 1776.

7 Major Anthony Bledsoe, of Culpeper County, Virginia, was a prominent man in the Holston settlements. He later moved to Cumberland and settled at Bledsoe's Lick, and was killed by Indians or white enemies in 1788.

8 "Hamilton's Report" in James, ed., *George Rogers Clark Papers, 1771-1781,* p. 197.

9 James, ed., *George Rogers Clark Papers, 1781-1784, Collections of the Illinois State Historical Library* (Springfield, 1926), XIX, 245-246.

10 Temple Bodley, *George Rogers Clark* (Boston, 1926), p. 372.

Chapter 10

Trials of the Hard Winter

COLONEL WILLIAM FLEMING, enfeebled veteran of the battle of Point Pleasant, did not know what he was getting into when he went out to Kentucky in the fall of 1779 as the chairman of a commission to settle Kentucky's land troubles. Had he known he might have turned the appointment down. Living on his fine estate of Belmont, where the Great Road passed through the town of Christiansburg in Augusta County, he had slowly recuperated from his severe wound received when he led his column against Cornstalk's warriors. His own affairs had taken all his time, and he had felt no urge to join in the mad rush down the Wilderness Road for the great meadows beyond the mountains. He left that to younger and more virile men.

Now the Virginia Assembly needed someone to untangle the land grants in Kentucky County. Since Harrod, Boone and Logan had established their settlements, hundreds of people had poured into the West seeking homesites. Despite the Indian wars, the frontier was sprinkled with settlements, surveys, clearings and cabins, with many overlapping claims. Official surveyors allotted lands for veterans of the French and Indian War according to Virginia law. The Transylvania Company sold hundreds of thousands of acres without regard to Virginia's requirements. Hundreds of land-hungry squatters settled on any good tracts which caught their fancy, built cabins and made clearings. Everyone was busy with his personal affairs or fight-

ing the northern Indians. No one paid much attention to his neighbors unless their interests conflicted. To correct this condition, the Virginia Assembly passed an act in 1779 which established a method by which all claims, regardless of kind, might be validated, and named a land commission to administer it.

Fleming, state senator from Augusta County, headed this commission. He was an old Scotch physician who had been a surgeon on Washington's staff in the French and Indian War and later a member of the Committee of Safety during the Revolution. With him were Colonel Stephen Trigg, Edmund Lyne and James Barbour. Fleming did not want the job. He was getting old and did not feel well enough to endure the hard travel and strain of public hearings to adjudicate claims. But the old man was a patriot. He would do what he could in the grim days when every Virginian was needed.

Colonel Fleming bundled up his things and rode off into the West in late September 1779 for his first trip over the Wilderness Road. He agreed to meet his fellow commissioners at Logan's Station where they would begin their work. A meticulous public servant, he kept a journal of his experiences,[1] as he had done in his campaign with Colonel Lewis in Dunmore's War. The commissioners held their first court at Logan's Station October 13, moved on to Harrodsburg a week later and shifted to the Falls of the Ohio on November 16. They reached Boonesborough December 18 and went to Bryant's Station January 3, 1780. They spent the entire winter of 1779-1780 shuttling back and forth between these and other newly established stations served by the Wilderness Road. They heard and adjudicated 1,328 claims involving 1,334,050 acres of land. When Fleming came out of Kentucky in May 1780, he was a sick and weary old man loaded with heavy records which affected the fortunes of thousands of people in the far wilderness.

It was with relief that Colonel Fleming delivered his papers to the Virginia authorities, but he would never forget the rigors and hardships he endured while in Kentucky. He reached the frontier three years before the disaster at Blue Licks. Logan's Station

was still scarred by the summer siege and Logan himself was across the Ohio wreaking vengeance on the red men. A retaliatory attack from the Indians was possible but the thing that impressed Fleming was the terrible weather he endured. The thin line of settlers trickling over the Wilderness Road was about extinguished. For more than three months the frontier settlements were frozen in so completely that there was little activity except the struggle to survive.

As Colonel Fleming moved from place to place to hold his hearings he became increasingly concerned about the welfare of the people. At Boonesborough on Christmas Day he was convinced that the cold was the most severe he had ever experienced in America. The Kentucky River was frozen to a depth of two feet, and the people who endured the hardships of the journey through the wilderness were now all down with colds.

At Logan's Station on March 20, 1780, Fleming recapitulated some details of the prolonged sub-zero weather.

> **The** effects of the severe winter was now sensibly felt, the earth for so long a time being covered with snow and the water entirely froze, the Cane almost all kiled, the Hogs that were in the Country suffered greatly, being frozen to death, in their beds, the deer likewise not being able to get either water or food, were found dead in great numbers, tirkies dropt dead off their roosts and even the Buffalos died starved to death, the vast increase of people, near three thousand that came into this Country with the prodigious losses they had in their cattle and horses, on their Journey, and the severity of the winter after they got here killing such numbers, all contributed to raise the necessaries of life to a most extravagant price.

During the inflationary period of Virginia currency, corn was bringing from $100 to $150 a bushel, salt $500 a bushel, and meat was so scarce it could hardly be obtained at any price. The settlers were forced to eat the horses and cattle frozen to death

in the fields. More than 500 cattle perished while being brought in over the Wilderness Road.

All sections of Kentucky were paralyzed from the middle of November to the latter part of February. Most of the smaller streams froze solid in their beds. Snow and ice continued through the winter, and not a drop of rain fell. Water for drinking, cooking and washing was obtained by melting the snow and ice. In the forests maple trees cracked like pistols and burst open as the sap froze. Through the nights the sleep of the settlers was broken by the frantic struggles of buffalo and other animals. All wild life was almost exterminated.

Many families caught in the severe weather on their way to Kentucky perished beside the road. Colonel Fleming learned of a Davis family who stopped to camp on a creek near Rock-castle River. The travelers were marooned by rising water. Davis attempted to swim to another camp for help. The ice-filled current swept him downstream. During the night the mother and children froze to death in their fireless camp.

Emigrants who succeeded in getting through to Kentucky suffered so greatly from exposure that many sickened and died after they arrived. On February 6, 1780, Colonel Fleming noted the deaths of many at Harrodsburg who were seized with pains in their head, back and breast. Even those not exposed on the road became ill. Frostbitten toes, hands and faces were common.

Being a physician, Colonel Fleming was particularly critical of the sanitary conditions around the forts. Of Harrodsburg he wrote:

> The Spring at this place is below the Fort and fed by ponds above the Fort so that the whole dirt and filth . . . putrified flesh, dead dogs, horse, cow, hog excrements and human odour all wash into the spring which with the Ashes and sweepings of filthy Cabbins, the dirtiness of the people, steeping skins to dress and washing every sort of dirty rags and cloths in the spring perfectly poisons the water and makes the most filthy nauseous potation of the water imaginable.

Boonesborough with its thirty houses was almost as bad. Visiting the Falls of the Ohio before the hard winter set in, Fleming found the cabins built in low, marshy lands. "A great many of the inhabitants complained of the fever and ague and many of the children were dying."

But Colonel Fleming did not confine his observations to the distresses of the people. He made a discriminating appraisal of the country's resources and the customs and pursuits of the settlers around the outposts of the Wilderness Road. On his first trip to the Falls, he stopped at Bullitt's Lick on Salt River, near where the town of Shepherdsville stands now on the western leg of the road. He was especially interested in the salt industry there. Salt kettles had been brought down the Ohio from Virginia and were used in distilling the water from the springs. "The Earth is excavated for twelve or fo[u]rteen feet over an area of many acres. By digging from thence to any depth of feet, water boils up . . . they have a trough that holds very near 1000 Gallons which they empty thrise in the 24 hours . . . they have 25 kittles belonging to the Commonwealth which they keep constantly boiling and filling." By successive boilings and emptyings the water was reduced to grains of salt. About 3,000 gallons yielded four bushels.

Around Harrodsburg and the station begun by Colonel Joseph Bowman on Cane Run, Colonel Fleming noted: "The people were mostly imployed in making sugar by boiling up the juice of the Sugar tree which is a species of the Maple . . . the trees are cut in sloping two or three inches so that the hole or box may hold half a pint." A reed or quill is put in the hole through which the sap ran into vessels. "The juice is boiled down till it acquires a consistance like syrup and sweetness resembling Honey." Colonel Fleming learned that the time for tapping trees was in the spring or fall. "The trees bleed the best," he said, "when the buds swell on the tree."

The resourcefulness of the settlers in adapting themselves to pioneer conditions impressed the observant colonel. Buffalos were still numerous because of the limitless feeding grounds

of cane, pea vine and bluegrass. The noble animal not only supplied meat for the settlers, but his skin made a desirable coarse, spongy leather; the heavy, woolly hair was spun and woven into yarn and cloth; the horns were made into combs; and the sinews of the spine produced excellent fiddlestrings and a tough thread for sewing moccasins and leather goods. The hump was the sweetest part of the animal, and the marrow from the bones was a rich delicacy.

The lowly nettle which grew in abundance in the pastures had its uses, although it interfered with the grazing of the cattle and horses because it stung their noses. Fleming observed that the people everywhere were bruised from pulling nettles which had been rotted like hemp by the frost and melting snow. "The nettles growing very tall and strong, when broke and spun makes a strong thread when wove makes a strong coarse cloth, but harsher than hemp." The fibers were often mixed with buffalo hair to produce a more wearable and endurable cloth.

Colonel Fleming investigated the terrain of the country he was parceling out to the settlers and observed that the risings, sinkings and levels of the rolling land were formed by limestone rock which underlay the soil. The richest soil was usually covered with black walnut, cherry and honey locust. During the freshet season springs burst out of the ground. Under the main layer of limestone were inexhaustible streams which came to the surface in huge springs sufficient to supply large groups of settlers. It was at these points most of the settlements were located. Along the streams and rivers fertile bottom lands were covered with heavy cane and tall grass and the rolling terrain was cut deep by the rivers flowing into the Ohio. Even in the winter season Colonel Fleming was impressed with the "paradise land" so eagerly sought by thousands.

Colonel Fleming spent most of his time in the hearings held at Logan's Station, Harrodsburg, Boonesborough and Fort Nelson, established by Colonel Clark at the Falls. But so rapidly had the settlers come into Kentucky since 1775 that many smaller settlements stood close to the principal stations. From Harrods-

burg Colonel Robert Patterson went north of the Kentucky
River to begin the future city of Lexington. From Logan's
William Whitley built a station five miles west of the "crab or-
chard." From Fort Nelson at the Falls, three settlements were es-
tablished, Lynn's Station on Beargrass Creek ten miles above the
Falls, Brashear's on Lloyd's Fork, and Sullivan's five miles from
the Falls. At Bullitt's Lick on Salt River a group of cabins
sheltered workers at the salt springs. Thus Colonel Fleming found
a string of settlements extending along the Wilderness Road
from its terminus at the Falls to Whitley's Station not many
miles from the point where the road entered the mountain
wilderness.

When the spring of 1780 opened, Colonel Fleming's work
was nearly done and he was anxious to return home. The
rigors of the winter had been too much for him. Frequently ill,
he carried on his duties when he should have been resting. His
most serious illness occurred in March while he was staying at
Harrodsburg. The settlers' malady caught up with him at last.
In order to relieve a severe pain in his head and chest he "got bled
12 oz." He reported his blood to be "solid like liver and black
as tarr," but as the pain increased he was bled again until "24 oz.
was in the basin" and he felt giddy. The ends of his fingers were
deadly white; he had the "appearance of a corpse"; and a noise
"like the rustling of waters" was constantly in his ears. During
his illness he lived on "poor dried Buffalo bull beef cured in
smaok without salt" and boiled in water. His only other food
was "Indian hoe cake which made my breakfast and the same
for dinner." In spite of his feebleness he continued to hold
sessions of the Land Court, but was often propped up on the
bench.

Weary from his labors and spent with illness, Colonel Fleming
started back along the Wilderness Road for his home early in
May 1780. A party of twenty men had gone ahead. He caught
up with them on a small stream flowing into Dick's River near
English's Station, a new settlement recently begun three miles
east of Crab Orchard.

Fleming and his party followed a new road to Skaggs Creek and joined another group of fifteen men. They crossed Rockcastle River and encamped on Raccoon Creek three miles from its mouth. Here they saw the graves of the Davis family who had perished in the cold in December. They observed the huge rock which sits like a castle on the ridge by Rockcastle River. It is from this immense boulder, still plainly discernible from Highway 25 a few miles south of Livingston, Kentucky, that the river and county are named.

After passing Hazel Patch where the Boonesborough road came into the trail the party continued to Raccoon Spring, seven miles south of the present town of London. Here they camped a half mile from the place where two men had been killed and a Negro taken by the Indians a short time before.

In the neighborhood of Cumberland Ford, Fleming and his fellow travelers met three white men and a Negro—the survivors of a party of twelve men from Lexington ambushed five miles ahead. In silent marching order, Fleming and his men rode on to the scene. They found the bodies of John and Robert Davis of Amherst lying scalped and mangled on the road. Two war clubs lay by the bodies, and on one of them was the figure of a lizard, which Colonel Fleming believed belonged to Chief Spring Lizard of the Chickamauga. The travelers buried the bodies and continued their journey across Cumberland Gap and camped near Walker's Creek in Powell Valley.

Joined by another man from the scattered Lexington party, Fleming continued up the valley and camped eight miles beyond Martin's Station, then he followed the main road to the Holston settlements, passed Glade Spring, present site of Jonesville, Virginia. Two more men from the defeated Lexington party caught up with Fleming after he had crossed Wallins Ridge. On May 19 Fleming noted in his journal:

> We ... passed a verry bad and Slippery hill as bad as any
> of the Mountains passed Flats Lick where the road comes
> in from the Rye Cove, the road down Stock Creek verry

bad and long, crossed Clinch which was rising so deep some of the horses were swimming in the midle of the River a swarm of Flies settled on my horses head and set him a plunging however I got safe over. We halted when we got over the River, then crossed several steep hills, stoney road and Miry places a fresh Indian Tract was discovered, which brought our company into a little Order encamped two miles from Moccasin.

After passing Moccasin Gap and the newly established Block House[2] of Colonel John Anderson at the entrance into the wilderness, Fleming's party reached the open country of the Holston Valley and began to break up for their separate destinations. Fleming rested a day before resuming his journey up the Great Road. On the night of May 22 the weary colonel found lodging in the hospitable home of the stout old Scotch-Irish preacher, the Reverend Charles Cummings, at Wolf Hills. Five days later he arrived at his home at Belmont after an absence of nine months.

Fleming's work did not solve all the problems arising from the confused land policies of Virginia but it was the first important move for an orderly development. With the Revolutionary War running toward a victorious close, his service to Virginia during the hard winter helped to prepare the way for the rush westward in the next decade.

Another Scotsman did an important job for Virginia in 1780 and 1781, soon after the land commissioners came out of Kentucky. His work helped to ease the trials of the settlers picking their way through the jungles over Boone's slender path. Captain John Kinkead, of Clinch Valley, headed a crew of woodcutters employed by Virginia to clear the road to Kentucky.

The Virginia Assembly had been stirred to do something about the road by Colonel Richard Callaway and Major James Harrod, delegates to the legislature from Kentucky County in 1779. Both pleaded for improvement of the road to Kentucky. Not a lick had been struck on it since Boone had cut it out as a private path

for Henderson and his colonizers. Virginia had left her sprawling stepchild in the far wilderness without a good connecting road with the mother colony. In fact, she had done little for the Kentucky district except to supply meager funds for Clark's conquests and provide for the establishment of militia at the frontier outposts.

Callaway and Harrod got action on their road project. At their insistence the Virginia Assembly passed an act in October 1779 for the improvement of the old Boone path. The preamble of the act recited that great numbers of people were settling upon the waters of the Ohio and that great advantage would result from a free and easy communication with them. It was therefore ordered that commissioners be appointed to explore the country on both sides of the Cumberland Mountains to trace out and mark the most convenient road between the settlements, and to improve it for the passage of travelers with packhorses. The commissioners were to work with all possible dispatch in their task and report at the next session of the assembly the practicability and cost of making the trail into a good wagon road.

Callaway and Colonel Evan Shelby, of Sapling Grove, were first named as the commissioners. Both of these appointments were considered admirable, because Callaway was at the extreme northern prong of the road at Boonesborough, and Shelby lived at the point where it left the Holston Valley and entered the wilderness. But Callaway did not have an opportunity to carry out his duties. He returned to Kentucky after the close of the legislative session and began to build a ferry across the Kentucky River at his home town. While cutting timber for his boat at Canoe Ridge, a short distance from Boonesborough, March 8, 1780, he was fired upon by Indians and instantly killed.

The road-building job was given to Captain Kinkead when Shelby was disqualified because it was found he was living in North Carolina. Kinkead did little work in the summer of 1780. The Holston and Watauga settlements were upset by partisan rangers—Tories and British Regimentals—and Kinkead was one of the "back country" rebels who fought at King's

Mountain, October 7, 1780. Returning from that campaign, he devoted the following months to his road work and on December 1, 1781, made his report that the job was done and asked that he be paid for his services.

Captain Kinkead did not change the route to Kentucky located by Boone. He followed the winding path from Moccasin Gap to Cumberland Gap, and into Kentucky to Hazel Patch, where the road forked for Logan's Station and Boonesborough. From that point the paths leading from the jumble of hills into the open Bluegrass country were worn down by constant use. He did little more than make the trail wider, remove obstructions and trim out overhanging limbs. The lack of proper tools, man power and funds permitted him only to improve the pack-horse trail through the rugged terrain.

But the Wilderness Road had at last become a public thoroughfare officially adopted by Virginia.

1 "Colonel William Fleming's Journal of Travels in Kentucky, 1779-1780," in Newton D. Mereness, ed., *Travels in the American Colonies* (New York, 1916), pp. 317-655.

2 The Block House was erected in 1777 by Colonel John Anderson, who was born in Augusta County, Virginia, and moved to the head of Carter's Valley shortly after the beginning of the Watauga and Carter's Valley settlements. This Block House for ten years after the Revolution was the chief point for settlers to assemble for protection before entering the wilderness. It is often mentioned in diaries of travelers. James Nourse, Jr., who made a trip to Kentucky in the hard winter of 1779-80, described it as a "log house with the upper part built wider than the under." Dr. William Allen Pusey in *The Wilderness Road to Kentucky* (New York, 1921), states the Block House marked the beginning of the real Wilderness Road. Anderson lived there until his death, October 13, 1817. It remained in the ownership of the family until it burned in September 1876. A two-story frame house is now on the site.

Chapter II

Claiming the Paradise Land

A LONG wagon train rolled into Fort Chiswell one pleasant day in October 1781, when the southwest Virginia hills were tinted with a thousand shades of gold and crimson. The drivers brought their wagons to a halt in the clearing around the frontier post on the Great Road, and began to unload women and children. Riders tied their horses to near-by trees, and servants and slaves put up tents and prepared meals at camp-fires. The slopes were covered with more than five hundred people, talking, laughing and singing as they busied themselves in making camp. It was a welcome rest after a day's journey from Ingles Ferry on New River.

The leader of this large throng of travelers went among the family groups, made inquiries about their welfare and exchanged pleasantries. He was clearly much beloved and respected by the people, despite his unprepossessing looks. He was about forty years old, slight in figure, stoop-shouldered, and with black, curly hair and deep, burning eyes.

The Reverend Lewis Craig and the entire congregation of the Upper Spotsylvania Baptist Church were on their way to Kentucky[1] in spite of Indians, Tories, hard winters and the Revolution. For three weeks they had been on the road from their homes in Spotsylvania County. They had passed through the plantations and villages of eastern Virginia toward the misty peaks of the towering Blue Ridge wall, over the divide at

160

Buford's Gap, and they were now upon the Great Road leading out of the Valley of Virginia into the west. Singing gospel hymns, holding nightly religious services and listening to fervent exhortations from Craig and other ministers in the company, they kept moving westward, a gay, congenial party bound for the "promised land" of far-off Kentucky.

This mass uprooting of a church organization for transplanting six hundred miles away into a frontier land of danger and hardship was inspired by the spirit and magnetism of Craig, pastor of the church for eleven years. As information came to him of the wild and riotous life of the settlers pouring into Kentucky, he felt a call to carry the gospel into the wilderness. With the characteristic zeal of Christian ministers seeking new fields to evangelize, he decided that Kentucky needed him.

Craig was especially fitted for such a mission. One of the early dissenters of the established forms of worship in Virginia, he had tongue-lashed the restrictions and formalism of the episcopacy and had protested vigorously against paying taxes for the support of a state church. Twice he had been thrown into jail because of his nonconformity. Singing with his companions while being taken to jail and preaching through the bars to all who would listen, he had defied the courts. Freed at last because of the rising tide of religious freedom brought about by such eloquent advocates as Patrick Henry, he had become the pastor of the Upper Spotsylvania Church, which prospered under his leadership.

When Craig had appeared before his congregation in early September 1781 and announced his intention of going to Kentucky as a missionary, hundreds of his members crowded around him at the close of the service and insisted on going with him. This spontaneous outburst was not wholly because of their love and loyalty for their pastor and desire to be with him wherever he went. They had heard many extravagant tales about the second Canaan beyond the mountains in the Bluegrass of Kentucky and had seen many of their neighbors pull up stakes and take the westward road. They longed to go, too. Their decision was an

evidence of the restless spirit sweeping all the older settlements in the East.

When the news got around in Spotsylvania County that Craig and most of his church members were moving to Kentucky, many neighbors and friends not connected with his church also asked permission to go along. Craig welcomed them all and set a date for the departure. The whole countryside turned out for a farewell meeting. The families who were to make the journey brought their wagons, household furnishings, provisions and farm stock for the rendezvous. All day long, visiting ministers preached parting sermons. Finally Craig delivered his own farewell message. The vast company camped in the church grove, and early the next morning, at the sound of the bugle, the wagons wheeled into line for the long journey.

Among the other preachers in the company were Joseph Bledsoe, later to be the father of Senator Jesse Bledsoe of Kentucky; Joseph Craig, brother of the leader, who once "laid down in the road" when he was arrested for preaching without a license; William Cave, a relative of the Craigs; and Simeon Walton, former pastor of the Nottaway Church. These men like Craig looked to Kentucky as a great field for their religious labors. Young Captain William Ellis, son of a patriotic sire who had also been jailed for nonconformist preaching, was in charge of the armed guards and arranged the wagon train.

The travelers had good roads and pleasant weather until they reached Fort Chiswell, a central gathering point on the Great Road for families and small companies moving into the West. Here a militia company was stationed for the defense of the frontier, and a store, tavern and other conveniences were maintained for the accommodation of the traffic. A minor road came across Flower Gap from North Carolina and joined the Great Road, and travelers out of the Great Valley in Virginia united with those coming from the Carolinas. The fort was a busy center. Final preparations were made here for the long journey ahead.

Much to their disappointment, Craig and his followers learned

at Fort Chiswell that they would have to abandon their wagons and transfer their belongings to packhorses. True, they could take the wagons for another hundred miles along the good road to Boone's Trace, but here at the fort they could sell or trade all the things that they could not take the rest of the way. The keepers of the store and tavern and the settlers in the neighborhood all carried on a big business in heavy household goods, food and supplies.

It was a crushing blow for Craig and his people to give up their wagons so early in their journey. The women and children hated to leave the luxury of wheels for a hard and uncertain horseback ride. But it could not be helped. Huge baskets and bundles of clothing, bed furnishings and household articles were prepared and lashed upon packhorses. Children were crowded on top, or rode in front and behind their mothers and relatives. The men and older boys who did not have mounts trudged along on foot. Thus accoutered, the company strung out on the road to the dark wilderness with its unknown terrors.

Slowly the pack train proceeded by easy stages to Black's Fort at Wolf Hills. Here Craig got disturbing information. He learned that Colonel Arthur Campbell, lieutenant of the newly formed County of Washington, had been busy all spring and summer trying to stop the Cherokee outrages on the road from the Block House to Cumberland Gap. Campbell had marched with a company of 150 volunteers into the Cherokee country and destroyed three towns, killed twenty Indians and rescued about fifteen captives, mostly children. Captain Joseph Martin, at Long Island, had also taken sixty-five men on a nineteen-day expedition against the Indian towns below Cumberland Gap to the mouth of Powell River and dispersed a body of savages who had been molesting the Road. But Craig was told that the ravages had not stopped, and that it would not be safe to cross the wilderness at this time. He reluctantly decided to halt, hoping the delay would not last until winter—a bad time for traveling.

Craig and his men built temporary huts, molded bullets, repaired packsaddles, made moccasins and mended their worn

clothing. Their livestock was kept in good condition on the extensive pastures around the settlement. Craig also labored at his religious work. A group of Baptists from Orange County, Virginia, on their way to Kentucky had temporarily halted at Wolf Hills. He helped to organize them into a church of their own. He preached, prayed, exhorted and baptized at frequent gatherings, and kept the spirit of his people bright.

A high moment came during their stay at Wolf Hills. They learned that Washington had captured Cornwallis at Yorktown! The war for independence had turned in favor of the colonists. The Spotsylvanians joined in the celebration at the fort, shooting off guns and holding a mammoth service of thanksgiving and prayer. At last, word came that the Indians on the Road had gone back to their towns for the winter. Members of the congregation made hurried preparations to be on their way.

Early in November at the sound of the horn from the armed guards, Craig and his company broke camp and marched forward. Down the long road in a single file three miles long the company proceeded slowly, with a vanguard of horsemen alert for danger. They passed the Block House and entered the wilderness at Moccasin Gap where Boone's Trace began. In the Clinch River country they crossed marshes and sloughs, those on foot suffering from scalded feet, neuralgia and rheumatism. Women became weary from long hours on horseback. The children fretted. In camp at night, pickets stood guard and Negroes watched the horses. Craig held religious services and often recited the story of the Israelites in the wilderness seeking the land of Canaan. His strong and resonant voice echoed from the surrounding crags as he exhorted and prayed for strength for his own wandering pilgrims.

Drenching rains which turned to sleet and snow swelled the Clinch and Powell Rivers. The packhorses had to be unloaded, and rafts ferried over the women, children and supplies. The slippery trace became a quagmire in which the horses sloshed and struggled. The men, boys and slaves, on foot, labored in knee-deep mud, their moccasins ruined and their feet torn and

bleeding. The supply of hard biscuits laid in at Wolf Hills became moldy and the company subsisted on beef from their dwindling herd of cattle and the wild meat procured by the hunters.

The straggling caravan traveled three weeks over Boone's Road from Moccasin Gap to Cumberland Gap. They reached the gateway in the Cumberland range in December. A north wind sucked through the pass, driving hard snow into their faces. There were no more pleasant camps and religious meetings! Preceded by armed men bundled in heavy coats, the column pushed ahead as rapidly as possible. Babies whimpered in their baskets, little girls cuddled up in their wraps, older boys struggled over boulders on foot, and mothers were sober and tight-lipped as they clucked their horses forward.

Into Yellow Creek Valley, terrifying in the winter gloom, the long train disappeared. Through mudholes, big sloughs and canebrake marshes, the company toiled until they reached the ford of Cumberland River. The stream was high and full of floating ice. There was no time for delay. The women and children rode across on the horses and the men and boys waded waist-deep in the icy waters. Once across they pushed on ahead, their wet clothes freezing stiff in the bitter wind. Thus the slow-moving company sloshed on, across Stinking Creek, Richland Creek and Big and Little Laurel Rivers. At Hazel Patch, they turned westward on Skaggs Trace, fought off a stray band of Indians and came out of the Rockcastle country.

The weather moderated when the company was within a day's journey of Crab Orchard. The travelers broke into song as the column wound out of the wilderness, and happy slaves snatched children from their cramped positions in baskets and carried them on their strong shoulders. The company trailed into English's Station east of Crab Orchard, happy that they were near their journey's end. Another day brought them to Logan's Station where they were received with rifle salutes from all the settlers. Broken families were reunited and old neighbors and acquaintances embraced one another. The newcomers were

feted and entertained before blazing log fires. Long into the night the frontier post echoed with laughter and song.

Craig did not linger at Logan's Station. He sent out scouts to hunt a good location for his church. Their Canaan was found on Gilbert's Creek, a tributary of Dick's River, two and a half miles from the present site of Lancaster, in Garrard County, Kentucky. Here his people cleared the land, built a stockade and erected cabins. On the second Sunday in December 1781 in an open grove he held the first organized service of the transplanted church. The records were unpacked and the church roll and minute book brought out. Using the worn Bible he had carried through the wilderness, he preached to his followers and offered a prayer of thanksgiving for their safe arrival in the new land. They were welcomed by the Reverend William Marshall, the "loud thunder-gust" preacher of the Shenandoah who had come to Kentucky the year before.

In a few weeks a log house of worship was built on a rounded knoll a half mile from the clearing, and the Upper Spotsylvania Church became officially Gilbert's Creek Church, the third Baptist organization to be formed in Kentucky. It was preceded only a few months by the Severn's Valley Church near Elizabethtown, in Hardin County, organized June 18, 1781, and the Cedar Creek Church, five miles from Bardstown, in Nelson County, begun July 4, 1781.

The next year Craig moved to Squire Boone's Station on Clear Creek near the future site of Shelbyville. This weakened his old church on Gilbert's Creek, but it was soon strengthened by a new contingent from Spotsylvania County, led by the Reverend William Waller. Also in September 1783 the people from Orange County, Virginia, who had been organized by Craig into a church at Wolf Hills arrived to swell the rolls of the church.

The migration of Craig's company was the forerunner of other large companies moving into the West on the Wilderness Road after the close of the Revolution. Still only a horse trail, it was crowded with endless caravans of homeseekers.

Although Craig's removal to the West was missionary in spirit,

his followers came with many motives. The poor and the land-
less, the redemptioners and the persecuted, rich planters and
lords of the manor all were on the march to build new estates.
Speculators greedily seized large boundaries for exploitation.
Rough, unlettered frontiersmen with shabby household plunder
mingled with courtly gentlemen and their entourages of slaves
and servants. Some were fleeing from debts, troubles with the
law and the hard existence in the mountains along the trail
where they had eddied for a time. Some ventured out of
curiosity. Some joined hopeful neighbors who believed in the
pot of gold at the end of the rainbow.

Quite a contrast to the booming-voiced Craig, who could ex-
hort and pray until men trembled, was Colonel James Knox who
piloted a large party through the wilderness in the fall of 1784.[2]
Knox was a Scotch-Irishman who came to America when he was
fourteen. He grew up in Augusta County, Virginia, became a
noted Long Hunter, scouted for Colonel Lewis in the war with
the Shawnee in 1774 and paid court to pretty Anne Montgomery
before her marriage to Benjamin Logan.[3] He followed Logan
into Kentucky in 1775 and took up lands near the Falls of the
Ohio. During the Revolution he organized a company of fron-
tier riflemen and served with General Daniel Morgan's rifle
corps.

Knox returned from the Revolution to look after his affairs
in Kentucky and shuttled back and forth on the Wilderness
Road between his old stamping ground on the Holston and his
western holdings. He never made a trip without joining a
party of travelers, either going in or out, and often acted as the
officer in command.

In October 1784 Knox had charge of a large number of
families who gathered at Staunton in Grace Valley to pre-
pare for the long journey. On the preceding Sunday the
Augustans attended church to hear a farewell sermon by the Rev-
erend James Waddell, famous "Blind Preacher" of the frontier

and pastor of the united congregations of Staunton and Tinkling Spring churches. The frail, broken, white-haired preacher with sightless eyes spoke such moving words of blessing and benediction that the entire congregation wept.

The Augusta party outfitted themselves with a train of packhorses to carry their farming and cooking utensils, beds and bedding, wearing apparel and provisions. Pieces of light furniture were strapped upon the backs of the animals. Their packsaddles were fitted with thongs with which to tie on the bundles, and in some cases two creels of hickory withes in the fashion of a crate, one on each side, were balanced across a horse. In these large baskets were placed the bedclothing, tents and other supplies, and tucked inside each was a child with its head sticking out. Cows were taken along to furnish milk for the children, the surplus being carried in canteens during the day. The Trimble family had in their belongings two Bibles, a half-dozen Testaments, the Catechism, the Confession of Faith of the Presbyterian Church, and the Psalms of David. Each man and boy carried a rifle and shot pouch and most of the women were armed with pistols.

The party was increased by other small groups as it trailed down the Great Road leading to Long Island. By the time it reached the Holston settlements the number had increased to 300. Instead of striking northwest into the wilderness from the Block House to follow Boone's Road to Cumberland Gap, the party took a recently opened path through Carter's Valley on the Holston to the newly established Bean's Station, fifty miles directly west of Long Island.

At Bean's Station Colonel Knox took command of the company for the trip through the wilderness. They were joined by nearly two hundred more people, most of them from North Carolina. Colonel Knox selected the armed men who had no family obligations and divided them into advance and rear guards, each party to alternate daily in position. He placed the families, women and children, and the long line of packhorses between

BOONESBOROUGH MONUMENT

At the site of the fort on the south side of Kentucky River where Boone's Road of 1775 ended. Boonesborough disappeared as a settlement soon after 1810.

HAZEL PATCH MARKER

Located eight miles north of London, Laurel County, Kentucky, where Boone's Road to Boonesborough and Skagg's Trace to Crab Orchard forked.

Courtesy, Norfolk & Western Railway

THE NEW RIVER VALLEY

Modern scene several miles north of Ingles Ferry, where the Wilderness Road crossed into the Holston Valley. It

these armed groups. As they could proceed only in single file, the line extended for nearly two miles along the trail.

Three miles out from Bean's Station, the party came to Clinch Mountain. They moved slowly up the steep sides, and many of the packhorses were unable to make the precipitous ascent. The rear guard discovered signs of Indians and sent frantic word ahead to Colonel Knox. He dispatched the advance guard to Clinch River, six miles away, to reconnoiter above and below the crossing with instructions to wait there until the arrival of the main company. He ordered the women to advance slowly, and turned back to bring up the straggling packhorses.

The advance guard headed by Captain James Trimble reached the river and found it greatly swollen by recent rains. Realizing that it was impossible to cross at the usual ford, Captain Trimble took his men to a big bend above the ford and crossed over. Because he believed that Colonel Knox would be in the advance party of the women, Trimble did not leave a guide at the main ford. When Mrs. Trimble arrived, on her horse with little William at her back and baby Allen in her arms, she saw some of the guards on the other side. She supposed they had crossed at that place and immediately plunged into the river with Mrs. William Erwin following her. Captain Trimble, sensing their danger, shouted to them not to attempt it but his voice was drowned by the rushing waters.

The horses of the two women were soon swimming in the current, and Mrs. Erwin's horse was washed against a ledge of rocks. With great difficulty the animal struggled to get a footing and managed to clamber back up the bank. A huge wallet thrown across her horse in which two Negro children were carried was washed off into the current. A man coming up at the time plunged into the stream and managed to save the children and the bags.

Mrs. Trimble's horse continued to struggle against the current, with his head turned toward the opposite shore. Firmly grasping the bridle and mane with her right hand, clinging to her baby with the left and calling to William behind her to hold fast, she

urged her swimming horse forward and at last managed to reach the opposite bank. Frightened and anxious, the men lifted her and her children from the exhausted horse. She sank to the ground, uttering a broken prayer, completely spent.

Colonel Knox arrived soon after Mrs. Trimble reached the shore. Knowing the ford well, he supervised the transportation of the party one by one without further incident and gave orders for the company to fix tents for an overnight stay. The encampment was formed in military order with sentinels posted, and the tired and exhausted women slept unmolested through the night.

Next morning dawned with rain threatening. Eight horsemen rode past in a hurry to be on their way. Knox warned them that Indians might kill them and that they should attach themselves to his party; but the men clattered off and were soon out of sight. Breaking camp, the long column again got under way. Knox put Mrs. Trimble in the lead of the women's division but he cautioned her good-humoredly not to try the power of her horse in another stream.

Before the company had proceeded many miles they came upon the mangled remains of the eight horsemen who had passed their camp at the river. The bodies had been stripped, tomahawked and scalped by Indians and torn and eaten by wolves. Knox paused to bury the remains and, fearful of an ambush ahead, decided to camp for the night. He formed the company in a hollow square with the horses in the center, and piled up the baggage to make breastworks. He posted guards in a wide circle some distance from the tents and wagons.

The travelers' sleep was disturbed during the night by the excessive howling of wolves and the hooting of owls. Since Indians were known to be in the neighborhood, it was believed that much of the terrifying noise was made by the savages. But there was no attack, and the company marched on the next day. Colonel Knox doubled the front guard and sent scouts ahead to reconnoiter the narrow defiles where ambushes might be laid. Scouts reported abundant signs of Indians and an occasional

stray savage in the forest. Slowly and cautiously the company proceeded, with everyone alert. They stopped early to camp. During the night one sentinel fired upon a lurking form in the shadows. Blood found on the leaves the next morning indicated his aim was true.

Because of the danger of attack at Cumberland Gap, Colonel Knox sent Captain Trimble with fifty men to examine the precipices about the mountain. Another group of ten was sent to Cumberland Ford to see if the way was clear that far. The advance spies, though discovering frequent signs, reported that apparently no large body of Indians was ahead of them. Feeling a little easier, Knox led his long caravan through the pass and down into the canebrakes of Yellow Creek.

Danger from Indians was not the only worry for Knox as he patiently piloted his company along Boone's old trace. Measles broke out in an epidemic, and scarcely a family escaped. He frequently rode up and down the long line, reassuring the anxious mothers, encouraging the whimpering children, and promising that it would not be long now until they were safe out of the wilderness.

Knox did not relax his vigilance when the danger of Indian attacks seemed to have passed. After crossing Cumberland River, he made camp, felled timbers for breastworks and posted guards. Advancing only a few miles each day, he repeated this procedure every night until Stinking Creek, Big and Little Laurel and Rock-castle Rivers were crossed. On November 1 he arrived safely in Crab Orchard with his charges.

Here Knox took his leave with a farewell speech to the company. He complimented them upon their patience and endurance and referred to the care and consideration given to the weak and ailing. Particularly impressed by the courage of the women, he spoke again of the exploit of Mrs. Trimble, saying that her horsemanship and self-possession in the hour of danger was equal to any heroine of ancient or modern times. He declared he had never commanded a group he esteemed more highly nor parted with more reluctantly. In closing he said: "I hope you

will find in this new country happy homes, and long may you enjoy its blessings and abundance!"

Captain Allen, in behalf of the company, expressed the good wishes of all for their leader's success and happiness. The stalwart old hunter and soldier was greatly moved. Tears traced down his cheeks as he turned to depart. His new friends would spread over the Kentucky land to varying destinies. Most of them he would never see again. He could not know that little William Trimble, the three-year-old tot who had clung to his mother when she struggled through the waters of the Clinch, would become a distinguished soldier in the War of 1812, and that Allen, the cuddling, bright-eyed baby whom she clasped to her bosom, would be a future governor of Ohio.

[1] George W. Ranck, *The Travelling Church* (1910); MS of Dr. Thomas D. Clark, Lexington, Ky., on "The Travelling Church"; Lewis N. Thompson, *Lewis Craig, the Pioneer Baptist Preacher* (Louisville, Ky., 1910); J. H. Spencer, *A History of Kentucky Baptists* (1886), Vols. I and II; James B. Taylor, *Lives of Virginia Baptist Ministers* (Richmond, Va., 1837),

Chapter 12

Guardian of the Road

ANOTHER Indian raid on the Wilderness Road! A man carried this news to Colonel William Whitley at Sportsman Hill. The colonel was usually the first to be informed of these raids and the first to respond. He would buckle on his pistols, take down his long rifle, mount his favorite horse and lash off to the trouble spot, bellowing for his men to follow him. The steel-eyed, long-nosed Irishman in his bedappled red brick mansion at the edge of the wilderness became a terror to the savages who menaced the emigrants streaming into Kentucky over the Wilderness Road.

The runner who brought the alarm on this October day in 1784 did not find the colonel at home. He gave the news to Mrs. Whitley instead. A party had been attacked at the head of Skaggs Creek on the road, astonishingly close to the settlements, a number killed and some women and children taken prisoner. The mistress of Sportsman Hill had the coolness of her husband in time of danger. Just as deliberately as she had recovered her borrowed hat when she was attacked at Logan's Station she now seized a horn, let out a blast to bring the men from the fields and sent a servant off to get the colonel. By the time he arrived, she had twenty-one riflemen ready to go with him.

Whitley and his men hurried along the trail to the scene.[1] They found six scalped and mangled bodies and paused only long enough to bury them. Picking up the trail of the savages, they tracked them through the forest. After a day and night of hard

riding the pursuers came upon the Indians in camp, sporting about in clothes taken from their white victims. One big warrior strutted in a pair of stolen boots. Whitley and his men overwhelmed the unsuspecting merrymakers, killed two in the first fire and scattered the rest into the woods. They rescued a Mrs. McClure and a Negro woman.

Mrs. McClure told Whitley that when her husband's camp had been assaulted in the night he had made no effort to save his family and had fled into the woods. She and her four children managed to slip away in the shadows. As she crouched in her hiding place, her baby began to cry. She tried to hush it, but the Indians discovered her, killed and scalped the three older children and took her and the baby to their camp.

The Indians had broken camp the next morning. They had mounted Mrs. McClure on a wild horse which threw her off. Then they tied her on and as the unmanageable horse plunged through the forest she was scratched and torn by the limbs and bushes. When the Indians halted, they forced her to cook for them in sight of the fresh scalps of her children stretched on hoops to dry.

Whitley was so incensed at McClure's cowardly desertion of his family he told Mrs. McClure she should never live with him again. He took the woman and baby back to Sportsman Hill, where, in spite of his advice, she reunited with her husband.

Knowing that the raiders perhaps still lingered in the forest, Whitley was not surprised to get word a few days later that another white party had been wiped out two miles south of Raccoon Spring. He rounded up fifty armed men and rode south of Skaggs Trace on a hunters' trail into the Tennessee country that he might cut the Indians off before they withdrew to the Chickamauga towns. He came to a fresh trail which the Indians appeared to have followed and soon overtook the savages, who, dressed in the stolen clothes of their victims, were passing in single file through a heavy canebrake.

Whitley halted before being discovered by the unsuspecting Indians. He sent ten men to ride around to the right of their

column, while he and ten others rode to the left. He dismounted the remainder with instructions to press forward at his signal for attack. Before Whitley could encircle the enemy the savage in the rear of the file gave the alarm. The Indians leaped from their horses and scattered into the cane. Whitley's men opened fire and deployed for individual pursuit. Whitley said: "After I got out a piece I saw two Indians and ran them about 200 paces. I lit from my horse within twenty yards, shot at them and they both fell. One recovered and ran into the cane. I did not get him but learned later . . . he died of his wounds."

In the final roundup, Whitley recovered twenty-eight stolen horses, a large amount of stolen goods, fifty dollars in cash, and eight scalps of the murdered party. No white captives were found. All apparently had been slain.

These raids were no new thing to Whitley. For years the bloody Chickamauga had been striking at the slender life line threading through the wilderness to the Kentucky settlements. Usually these renegade and irreconcilable Cherokee from the towns on the Lower Tennessee would hide for weeks in ambushes along the Road between Cumberland Gap and Crab Orchard. They would not attack large groups like those piloted by Craig and Knox, but their full vengeance fell upon helpless travelers too weak to fight back. The Cherokee had been particularly active during the summer and fall of 1784, and travelers who got safely through would often come upon the scenes of massacre—mangled bodies and plundered camps. More than a hundred men, women and children were murdered on the Road during that season.[2]

Colonel Whitley was proud of Sportsman Hill by the side of the Road, even though its construction cut heavily into the fine lands he had taken up near Walnut Flat when he followed Logan into the country in 1775. He sold off two tracts to pay for the masonry and wood carving in his brick mansion, and sacrificed another big slice to pay the liquor bill of his workmen. But he was pleased with his handiwork, because there was nothing like

it in all the settlements of crude log cabins and stockades on the frontier.

The big brick house loomed spaciously on a hill between Crab Orchard and Logan's Station. The solid red walls were broken with rows of lighter colored brick to form a diamond-shaped pattern. In the long wall over the front entrance, Whitley inserted his initials "W. W." in white brick, and for a proper recognition of his wife Esther, he wove "E. W." in the opposite wall.

To protect the occupants of the house from being fired upon from the ground Whitley built the windows high. He brought the glass from eastern markets by packhorses over the Wilderness Road. In the mantel over the huge fireplace he carved a row of dollar marks to denote the new money of the young Republic, and built thirteen steps in the stairway leading to the second floor to represent the original states. On each banister in the stair was carved the head of an eagle with an olive branch in its mouth. At the landing on the third floor, he constructed a secret panel to a hiding place for the women and children in case of attack. Not neglecting plans for the entertainment of his friends, he made the entire third floor into a ballroom.

Whitley set the pace for his fellow frontiersmen in building the first brick house in Kentucky while Indians were still ferociously contesting the bloody ground. In the intervals between chases after marauding Indians at home and scout trips for Logan, Clark and Bowman across the Ohio, he tended his broad acres in the rolling country along the Wilderness Road. He enjoyed entertaining sportsmen with lavish prodigality. His race track on a rounded knob near his home was the first of its kind in Kentucky. He leveled off the top of the hill so that spectators in the center could have an unobstructed view. Violently anti-British, he ran races counterclockwise because it was the English custom to run them clockwise.

But time and again Whitley's domestic activities were rudely broken by news of Indian massacres on the Wilderness Road. The red raiders soon learned that a man who lived in the "big

governor's house" would scourge them relentlessly. After a few forays around the outskirts of the settlements in the Crab Orchard country, they confined their attacks along the Road to the deep stretches of the wilderness. Whitley was away when the "McNitt Defeat" occurred in the fall of 1786, one of the major disasters on the Road in the dangerous decade following the Revolutionary War. The old fighter was much provoked because there was no pursuit of the desperadoes. Later in giving an account of the tragedy, he significantly explained: "I was then in Virginia & they were not followed."

Whitley got the details of the massacre on his return. On the night of October 3, 1786, a company of about thirty people on their way to Kentucky camped at a spring in what was later the Levi Jackson Wilderness Road State Park, near London, Kentucky. The leaders were the prominent McNitt, Ford and Barnes families and their servants from Botetourt and Rockbridge Counties in Virginia. During the night a band of Chickamauga fell upon the camp, killed and scalped twenty-one persons, took five women prisoners and carried away all the horses, cattle and household belongings. The Indians destroyed everything they could not take with them, tore up pillows and bed ticks and scattered the feathers over the ground.[3]

According to tradition, a woman hid in a hollow tree and gave birth to a child during the night. She and the child were found the next day and were taken to the Kentucky settlements where she was reunited with her husband who had escaped. Another father who got away could not forget his small son who was one of the victims. The lad had remonstrated with him before leaving his Virginia home, saying he did not want to go to Kentucky, because he felt sure he would be killed by Indians.

Whitley was stirred by a new violence which broke out in the early spring of 1793. An outlaw band led by Chief Red Bird Bowles lay in the mountain fastnesses along the Wilderness Road and watched for unprotected traveling parties. On March 21, 1793, Thomas Ross, the first mail carrier over the postal route

established in the fall of 1792, was following his route from the Holston to Danville, Kentucky. Accompanying him were Joseph Brown and Colonel Jacob Friley. Brown was a young man who had been captured by the Chickamauga and had lived with them for a year. When the riders reached Little Laurel they were fired upon but not injured. They splashed across the river and rode hard to get away. About a quarter of a mile from the river they ran into a large ambush. Ross was instantly killed, and Brown and Friley wounded, one in the shoulder and the other in the arm. The next morning a passing party found the postrider's horse without a bridle or saddle and the mailbags missing.

Captain John Wilkinson and thirteen militiamen from Whitley's Station went to the scene. Ross's body had been cut into pieces and hung in the bushes. They gathered up the remains and buried them by the side of the road.

Whitley acted quickly five days later, March 26, 1793, when he received word of another massacre, five miles south of Hazel Patch. Heading a company of rangers, he hurried into the wilderness and learned the details of the ambush of a party led by James McFarland, consisting of nine men, two women and eight children. The Indians had attacked them while they were riding along the road. The men leaped from their horses and in close formation returned the fire for fifteen minutes. Then the marauders closed in and killed or took prisoners all in the party except four.

Whitley tracked the Indians to their camp, scattered them, rescued a little girl and recovered much of the stolen plunder.

After Chief Red Bird Bowles and his ravaging warriors had been driven out of the wilderness by Whitley and his men, the road was again safe for a few months. But with the opening of spring in 1794 the Chickamauga were once more on the warpath, this time led by Chief Doublehead, a terrifying scourge to the white settlers for more than a decade. With a hundred warriors he lurked along the trail and swooped out upon helpless travelers. On March 11, 1794, his outlaws ambushed a party on

Richland Creek, killed two Baptist preachers, the Reverend Martin Haggard and the Reverend Thomas Shelton, and two ministers of the Dunkard Order. Another company came along the next day and buried them.

Chafing at Sportsman Hill, Whitley decided that the time had come to put an end to these troubles on the Road. He was tired of picking up each week his issue of the *Kentucky Gazette*, published in Lexington, and seeing boxed on the front page announcements of dates for the departure of parties through the wilderness. Invariably the editor urged the men to come fully armed. Ever since the *Gazette* had begun its publication in 1787, almost every issue had carried these private notices, attesting to the weakness of the militia and official authority in dealing with the danger on the Wilderness Road. The time had come to protect travelers to and from Kentucky.

Kentucky was a state now and Whitley's old friend Isaac Shelby was governor, but he did little to correct the situation. Whitley did not think much of the effectiveness of the three small companies of militia Shelby had stationed on the Road under the authorization of the federal government. These companies of about twenty men each were commanded by Lieutenant Robert Modrel, stationed on Laurel River; Lieutenant Walter Middleton, on Turkey Creek; and Lieutenant Joel Collins, on Richland Creek. They patroled the Road from Crab Orchard to Cumberland Gap, but in spite of their vigilance Whitley felt the militia did nothing but "bury the dead."

To Whitley all this was mere dillydallying. He decided that the best plan to end the outrages was to destroy the vipers in their den. Renegade Cherokee, Creek and Chickasaw had violated the peace treaties of the principal tribes. More than three hundred warriors were known to be at Nickajack and Running Water, two towns hidden in the mountains south of the Tennessee River about twenty miles below the present city of Chattanooga. The red pirates preyed upon the river traffic, roamed in thieving and murdering bands on the Tennessee and Kentucky frontiers and lurked along the Wilderness Road.

Whitley proposed an expedition against the Indians at Nicka-jacks similar to the expedition Logan had led against the Shawnee. He knew that the Cumberland settlements, where Nashville would stand, had suffered at the hands of these Indians. He explained his plans to General James Robertson, commander of the Mero (Cumberland) district. Robertson approved Whitley's plan, but the federal authorities objected to any direct action that might upset the delicate relationship with the peaceful tribes. Whitley and the outraged settlers on the Road took the matter into their own hands. Rallying to the old colonel's call, a hundred volunteers accompanied him on the unauthorized expedition.

Whitley was at first put in command of the united forces, numbering about five hundred and fifty men, but in order to give a semblance of legality to the campaign, Major James Ore, at the head of a force of militia for the Southwest Territory, became the official commander. Joseph Brown, now recovered from his wounds received when the postrider was killed, joined as a guide. Having lived with these Indians, he knew the secret paths to the towns.

Whitley and Ore marched their forces to the Tennessee River opposite the hiding place of the Chickamauga. Under cover of night they ferried across the river on rafts made with bundles of dry cane. They used four "bull boats" of steer hide to carry their ammunition. Whitley was personally accoutered for a war of extermination. He carried on his horse a swivel gun, which he could wheel and fire in any direction. Effecting a complete surprise, the frontiersmen fell upon the towns of Nickajack and Running Water, burned them, killed fifty-two warriors, captured nineteen squaws and children. Their own loss was only one man killed and a few wounded.

Triumphantly Colonel Whitley with his swivel gun led his men back to their Kentucky homes. Feeling that the campaign had been justified by the circumstances, he sent a memorial to the Kentucky legislature asking pay for the services of his volunteers. He recited the reason for his unauthorized action and spoke

bitterly of the federal government's failure to give sufficient protection to the frontier.

It is a truth demonstrable from indubitable testimony that the Associate Savages resident at the Nickajack Town & its vicinity for 18 years previous to my excursion committed more spoilations on the . . . frontier Inhabitants—and perpetrated more murders on the Wilderness Road and elsewhere than the rest of the Savage Enemies combined.[4]

With a touch of pride he said that since his expedition the depredations on the Road had ended.

The gallant old fighter was unsuccessful in getting pay for his men, but he rewarded them with a big barbecue at Sportsman Hill. Long tables on the lawn were heaped with meats, vegetables and fruits. In the center two roasted shoats lay on platters with big Irish potatoes in their mouths and sweet potatoes under their tails. With roars of laughter at the colonel's bizarre humor the men rolled and tumbled about in their merriment.

The Indians at last defeated and the Wilderness Road comparatively safe, Colonel Whitley reveled in gaiety on his estate. Sportsman Hill became a welcome hostelry on the Wilderness Road. Here friends gathered for dances, horse races and hunts. The colonel would display his long rifle, always loaded with an extra charge of powder and two balls. His big powder horn, holding two pounds of powder, was a special attraction. On it he had carved the rhyme:

> Wm. Whitley I am your horn
> The truth I love, a Lie I scorn
> Fill me with the best of powder
> I'll make your Rifle crack the louder
> See how the dread terrific Ball
> Make Indians bleed and Tories fall.
> You with power I'll supply
> For to defend your Liberty.

Whitley often remarked to friends that he wanted to die in the defense of his country. In his many close skirmishes with Indians, he had never been taken prisoner and was never wounded except once when the tip of his big nose was clipped off by a bullet. Whether he was serious in wanting his end to come in combat, or whether it was a presentiment, he at last had his opportunity.

At the age of sixty-four, the old warrior enlisted as a private in the War of 1812. He was assigned to a regiment commanded by Colonel Richard M. Johnson. The night before the battle of the Thames the old warrior talked with a neighbor about the impending clash with the British and Indians. Whitley told his friend that he had a feeling he would not survive. If anything should happen to him, he said, he wanted his scalp taken back to Esther at Sportsman Hill.

Next day the troops marched along the Thames toward the enemy. Whitley, wearing his cocked hat, spied an Indian across the river. He shot the savage, swam the river and proudly returned with the scalp. A few hours later he was one of twenty men in the "Forlorn Hope" led by Colonel Johnson, who rode toward the Indian lines in a swamp to draw their fire. The remaining troops were to rush forward when the rifles of the enemy were empty. The savages met the advancing men with a heavy fire, Colonel Johnson was severely wounded, and his mare staggered and fell to her knees, pierced by fifteen bullets. Whitley and eighteen others were dropped upon the field, killed or wounded. For thirty minutes the battle raged with terrible slaughter on both sides. Then the brave Tecumseh fell, and the Indians withdrew.

Did Whitley kill Tecumseh? The question is still debated by historians. Colonel Johnson rode to political fame on the questionable honor. Some eyewitnesses averred it belonged to David King. But there were others just as positive that it was the last act of Colonel Whitley. His long rifle is exhibited by his decendants as the gun which killed the Shawnee chieftain.

Whitley's scalp was not brought back to his beloved Esther,

in the house on the Road which he had defended so valiantly. Instead, he was buried where he fell, wrapped in his blanket.

[1] Much of the information about the raids on the Wilderness Road is taken from Bayless Hardin, ed., "Whitley Papers," published in *The Register of Kentucky State Historical Society*, Vol. 36, No. 116, July 1938, 190-209.

[2] See "Tours into Kentucky and the Northwest Territory" by the Reverend James Smith of Powhatan County, Virginia, 1783-1795-1797, in *Ohio Archaeological and Historical Quarterly*, Vol. XVI, July 1907, 348-401. Smith in the journal of his trip in 1783 described Cumberland Gap: "This is a very noted place on account of the great number of people who have here unfortunately fallen a prey to savage cruelty or barbarity. The mountain in the gap is neither very steep nor high, but the almost inaccessible cliffs on either side the road render it a place peculiar for doing mischief."

[3] Pewter plates, identified as belonging to the McNitt party, were discovered by a man some years ago while plowing in a field on the site of the tragedy. These are now preserved in Kentucky's Levi Jackson Wilderness State Park, and a marker has been erected at the scene of the "Last Supper." The graves of the victims are located in the park in an inclosure surrounded by a stone wall. These graves are the only ones preserved between Crab Orchard and Cumberland Gap of the hundreds killed along the road during the migration years.

[4] Shelby Manuscripts, Filson Club, Louisville, Kentucky.

Chapter 13

Pack Trail to Wagon Road

GOVERNOR ISAAC SHELBY had many things on his mind when he took office as Kentucky's first chief executive, June 4, 1792. One thing was very much on his mind. The old trail linking the new commonwealth with the Eastern states needed to be improved. He had traveled it many times from his father's home at Sapling Grove on the Holston to his estate at Travellers Rest a few miles south of Danville, Kentucky. He knew every crook and turn in it and had seen it gorged with travelers streaming into the West.

Although more than 70,000 people had poured into Kentucky over the old trail, down the Ohio, Shelby knew this was but the beginning. Each year brought an increasing number of settlers to claim the great meadows. Word-of-mouth praise of the fertile land had taken substantial form in John Filson's book, *The Discovery, Settlement, and Present State of Kentucky*, published in 1784. This little book with its important map of the country, its autobiography of Daniel Boone and its logged account of the Road from Philadelphia to the Falls of the Ohio, a distance of 826 miles, was the most popular guidebook of the decade. Worn and thumbed by the countless travelers pushing into the West, it was eagerly scanned around the campfire. Filson's valedictory in addressing the future inhabitants of Kentucky was especially luring:

184

In your country, like the land of promise, flowing with milk and honey, a land of brooks of water, of fountains and depths, that spring out of valleys and hills, a land of wheat and barley, and all kinds of fruits, you shall eat bread without scarceness, and not lack any thing in it; where you are neither chilled with the cold of Capricorn nor scorched with the burning heat of Cancer; the mildness of your air is so great that you neither feel the effects of infectious fogs nor pestilential vapours. Thus, your country [is] favoured with the smiles of heaven. . . .

Shelby, prospering on his own fat farm near Danville, had seen many people enjoying the riches which Filson pictured. Kentucky surely had a destiny now that it had become an independent state and the Road which served it must be made into a major artery of travel.

But how could he do it when his state did not have a dime for public improvements? He turned to some of his friends and neighbors around Danville and Stanford and passed the hat for a road fund. He pledged a contribution of three pounds himself, not much for the wealthy landlord of Travellers Rest, but it was a start. Robert Breckinridge, Jacob Froman, Thomas Kennedy and James Parberry matched his gift, and 116 others subscribed amounts, the lowest a mite of three shillings. Colonel William Whitley, resourceful and practical, contributed bacon for the workmen.

Judge Harry Innes and Colonel Levi Todd were named treasurers of the fund, and Colonel John Logan, brother of Benjamin Logan, and Colonel James Knox were commissioned to direct and supervise the work. Logan, representative of Lincoln County in the Virginia legislature in 1790 who had done a little previous work on the Road, kept the account book.[1] Knox recruited the workmen.

For twenty-two days Logan and Knox worked their crews on the Road between Crab Orchard and Cumberland Gap, trimming, widening and cutting a shorter route. The improvement

was not much, but the gash through the wilderness was fresh and clean and looked more like a road.

A strange visitor called on Governor Shelby September 1, 1793. He planned to test the improvements on the Road. André Michaux, a distinguished French botanist, was the secret agent of Citizen Genêt, minister of the French Republic. Through Michaux, Genêt sought to enlist Kentucky leaders in his intrigue to take the Mississippi from the Spanish. Michaux dined with the governor, inspected his farms and visited the hills called Knob Licks. Michaux was more of a scientist than a diplomat, and was apparently more interested in what was growing in Kentucky soil than in political intrigue.

After conferring with Shelby and other Kentuckians in Louisville, Lexington and Danville, Michaux took the new road through the wilderness in icy, inclement weather for his return to Philadelphia. Worn out when he got to the Holston settlements, he commented in his journal on its bad condition. But his weariness was compensated by the discovery of a rare fern, *Lygodium palmatum*, near Stinking Creek. Despite the ice mantling the ground, the fern was not at all injured,[2] he said.

After Logan and Knox finished their work Shelby next improved the mail service. Heretofore communication facilities for Kentucky had been dependent on private enterprise. Letters and messages were carried as an accommodation by individuals on business trips. John Bradford, publisher of the *Kentucky Gazette*, had employed riders to deliver his papers to the distant districts in the state, and maintained a letter box for the convenience of his patrons. But when the federal government established a general postal service in 1789, Kentuckians were quick to demand its extension into the West.

Their efforts were rewarded soon after Shelby became governor. The postal route connected Bean's Station in Tennessee with Danville, through Cumberland Gap, and postriders were employed for regular trips. The service began about August 20, 1792, and Thomas Barbee of Danville was made the first postmaster. A little later a route was established down the Ohio to

serve communities in the northern part of the state. But difficulties of travel made the service on the Road unsatisfactory. Citizens complained, and Bradford in his *Gazette* constantly pouted about the slowness and lateness of the mails from the East.

Finally the Wilderness Road mail service was discontinued. Then Shelby took a hand. Writing to Edmund Randolph, Secretary of State, March 14, 1795, he said:

> I consider it as my duty to state to the President of the United States the great inconvenience to which this State has been subjected by changing the route of the post from the Wilderness Road to the Ohio. From the time that the line of posts was extended to this country, to that when the alteration was made, the mail was received here with great regularity and punctuality; but since that alteration we have been almost entirely deprived of the benefit of the post, only two mails have been received here since some time in December last.

Shelby pointed out that Kentucky had much intercourse with the southern states, and that it was imperative that the service be re-established over the southern route. He recommended the use of both routes, stating that the double line would be of great service to the people and should be self-supporting in a short time.

The governor's plea was heeded and service was resumed. Then it was the turn of the Ohio River route to be abandoned during the winters. Kentuckians plagued the department with protests. One irate citizen wrote the Postmaster General that mail was being received only twice a year. In order to give the governor additional service for official communications, the legislature passed an act authorizing him to employ special "expresses" to carry important dispatches when regular service was not available.

The connection with the East by mail service was a great boon to the Kentucky people and post riders became popular heroes. When they arrived with their bags of mail at the frontier

post offices, they were greeted by crowds of loungers about the taverns and bars. The informal news they brought was as eagerly sought as the official mail. Warmed by the treat at every bar, they would discourse at length on their experiences on the Road and on all the happenings back in the old settlements.

Toward the close of his administration, Governor Shelby sponsored the first major improvement and relocation of the Wilderness Road. In November 1795 he approved a legislative act which declared that it was essential to the interest of the commonwealth to build a good wagon road to Virginia. It was ordered that three men of integrity and responsibility be appointed as commissioners, vested with full powers to open a wagon road, to begin in the neighborhood of the Crab Orchard and to terminate on the top of Cumberland Mountain in the Gap. The commissioners were to have complete discretion in locating the road and the power to employ the hands, guides, surveyors, chainmen and markers necessary to do the work in the cheapest and most effective manner.

The act further provided that the road was to afford safe and easy passage of wagons and carriages carrying one ton weight and, except where digging or bridging was necessary, to be at least thirty feet wide. Two thousand pounds were appropriated for the work. The road when completed was to be considered as established and could not be changed, altered or obstructed by private individuals, or by the court of any county, without the consent of the legislature.

Empowered by this act, Governor Shelby looked about for good men to appoint as commissioners. Announcements were made in the *Kentucky Gazette*. The news reached Daniel Boone, living in a cabin belonging to his son on Brushy Fork, in present Nicholas County, not far from Blue Licks. Old Daniel was sixty-two years old, and twenty-one years had passed since he blazed the first path through the wilderness. He had seen Kentucky change from a virgin wilderness to a prosperous state with more than a hundred thousand people. Beaten and buffeted

by the winds of fortune, the old scout, hunter, soldier, surveyor
and legislator had become penniless and landless. All his labors
had gone to profit others. Moody and taciturn, he had come
back into Kentucky after a few years in West Virginia, hoping
that at last his fortunes might turn for the better.

Boone pondered the road Governor Shelby was planning to
build big enough for wagons. He remembered his own experi-
ence cutting a trace in 1775, and with some bitterness recalled
he had never been paid for his work. Here was an opportunity
to recoup his old losses. Two thousand pounds was a lot of
money to Boone. He took a goose-quill pen and scrawled a
letter to his old friend whom he had known on the Holston.
Shelby would remember him, of course. He had traded with
Shelby's father at the Sapling Grove store, and they had been
together at Boonesborough in its first days. Surely the governor
would be considerate for old times' sake. So Boone wrote to
"his Excelancy:"

feburey the 11th 1796

Sir

after my Best Respts to your Excelancy and family I wish
to inform you that I have sum intention of undertaking this
New Rode that is to be Cut through the Wilderness and I
think My Self intiteled to the ofer of the Bisness as I first
Marked out that Rode in March 1775 and never Re'd any-
thing for my trubel and Sepose I am No Statesman I am a
Woodsman and think My Self as Capable of Marking and
Cutting that Rode as any other man. Sir if you think with
Me I would thank you to wright mee a Line By the post the
first oportuneaty and he Will Lodge it at Mr. John Miler
son hinkston fork as I wish to know Where and When it is
to Laat So that I may atend at the time.

I am Deer Sir your very omble Sarvent.

DANIEL BOONE

To his Excelancy governor Shelby

Governor Shelby had probably decided who should get "the
Bisness" when he got Boone's letter. He appointed Colonel

James Knox and Colonel Joseph Crockett to make the improvements. These men were among the most colorful figures in pioneer Kentucky. Knox had worked with Colonel John Logan four years before in disbursing the funds privately subscribed to clear out the Road to Cumberland Gap. Crockett was a Holston man who had fought with General Daniel Morgan's riflemen and with George Rogers Clark in the Northwest. A towering figure, six feet three inches tall, he always wore a long, blue cutaway coat with brass buttons, knee breeches, black silk stockings and heavy silver shoe buttons.

Knox and Crockett spent the summer of 1796 carrying out the instructions of Governor Shelby. To them two thousand pounds was a small sum to build a wagon road from Crab Orchard to Cumberland Gap, a distance of nearly a hundred miles. Their surveyors had changed the route at many places. From Crab Orchard to Hazel Patch the route now veered north of the old Skaggs Trace and passed through the present towns of Brodhead, Mount Vernon, and Livingston. At Hazel Patch it crossed the creek five miles below the original fork of the traces of Boone and Skaggs, and did not touch Boone's Road until it came to the present city of London. From this intersection it did not reach Boone's route again until they got to Flat Lick, where the Warriors' Path led to the north. From Flat Lick to Cumberland Gap it followed the well-worn, century-old trail of the Indians.[3]

With this improvement and relocation, the Wilderness Road assumed an identity separate from that of Boone's Road from Flat Lick to the Kentucky settlements. The old pioneers' path was never used again except by surveyors as a means of identification in plotting land. The new road for the first time became officially the "Wilderness Road," as it was already being called by the early travelers. Likewise, the continuation of Boone's Road from Hazel Patch to the central Kentucky settlements was abandoned. In compliance with an act of the legislature, March 1, 1797, Joseph Crockett built a new road from Milford, then the seat of Madison County, reaching south into the wilderness for an intersection with the new Wilderness Road at the present

site of Pittsburg, in Laurel County. Old Hazel Patch was no
longer the "forks of the road" in the heart of the wilderness, and
the new crossing several miles down the creek took the name.

Crockett and Knox published an announcement of the road's
completion in the *Kentucky Gazette*, October 15, 1796, which
the editor John Bradford spread across all four columns of the
front page in display type.

> THE WILDERNESS ROAD from Cumberland Gap to
> the settlements in Kentucky is now compleated. Waggons
> loaded with a ton weight, may pass with ease, with four good
> horses,—Travellers will find no difficulty in procuring such
> necessaries as they stand in need of on the road; and the
> abundant crop now growing in Kentucky, will afford the
> emigrants a certainty of being supplied with every necessary
> of life on the most convenient terms.
>
> <div align="right">Joseph Crockett
James Knox
Commissioners</div>
>
> (The printers in the various states are requested to re-publish
> this notice.)

Shelby and his fellow Kentuckians were delighted that at last
the old packhorse trail had been modernized into a wagon road.
Only one group of men watched its improvement with concern.
These were the professional packhorse men who made it a busi-
ness to hire out to settlers or merchants for transporting supplies
through the wilderness. Tradition says they strenuously objected
to making the road wide enough for wagons. They claimed it
would put them out of business and seriously handicap horse
breeding in Kentucky. They were the first martyrs in the
development of transportation.

December 22, 1796, was court day in Stanford, Kentucky. A
man named Moses Austin rode into town fresh from the Wilder-
ness Road. He owned lead mines on New River a few miles

above Ingles Ferry and had come over the Road on his way to investigate the new lead region near Ste. Genevieve in upper Louisiana. With his son, Stephen Austin, he was destined to found a colony in Texas.

Former Governor Isaac Shelby invited Austin to dine with him at Travellers Rest and they had a good talk before Austin continued on his way. Austin was a man of wealth and prominence in southwestern Virginia. He had observed carefully the country through which he had passed and was ready to tell what he had seen. The Wilderness Road had not yet been improved into a real thoroughfare but there were sufficient houses along the way for a traveler to lodge under a roof every night. Austin considered that the Road needed bridges more than anything else. Wagons could get through, he said, but years of work would be required to make the Road "tolerable."[4]

Shelby had been so busy with his state duties he had not been along the road for some time. He was, therefore, interested in Austin's observations. Austin left the lead mines on December 8, 1796, and had been two weeks on the way. In company with James Bell, he had good traveling until he reached the Block House of Colonel John Anderson at the entrance to the wilderness where Boone's trace began. Leaving the Block House, he and Lee rode thirty-four miles along the Boone path through southwest Virginia and stopped at the home of Benedict Yancy at the head of Powell Valley. The Yancys refused to take them in, but after much protestation Austin and his companion were permitted to sleep on the floor in their blankets.

In snow and rain the next day Austin and Lee continued down the valley, passed through the new village of Jonesville, seat of Lee County, a small town of about ten houses and two stores, and stopped to stay all night with a Mr. Ewing. The Ewings gave the travelers the welcome they had not received at the Yancys' and furnished them with everything they needed and a good piece of beef to take with them. They made Cumberland Gap the next day and stopped at a tavern kept by a Mrs. Davis at the foot of the mountain on the north side where the city of

Middlesboro is now located. Austin was curiously impressed with his hostess:

> We took our leave of Mrs Davis, who I must take the liberty to say may be Justly call Capn Molly of Cumberland Mountain, for she Fully Commands this passage to the New World. She soon took the freedom to tell me she was a Come by chance her mother she knew little of and her Father less. as to herself she said pleasure was the onely thing she had in View; and that She had her Ideas of life and its injoyments.

Austin estimated the distance from Cumberland Gap to the tavern of Richard Ballinger on Cumberland River, the site of present-day Barbourville, to be thirty-seven miles. The accommodations here he found good considering the newness of the place, but the horses had to be hitched to trees in the extreme cold and fed on cane. The next day's journey of thirty miles brought them to a small hut on Little Rockcastle where the accommodations were abominably bad. The cabin was about twelve feet square, and in a night distressingly cold, seventeen people, including women and children, were crowded into it. A more filthy place Austin could not imagine.

The next night the two men got to Crab Orchard, where they lodged with a Mr. Davis. There was nothing agreeable about it. But Austin was impressed with Crab Orchard, long of note as the grand gateway into Kentucky. The ninety miles from Cumberland Gap were through a country still sparsely settled. He felt that in time the wilderness might be sufficiently settled to furnish travelers with comfortable accommodations but that it would never be a desirable country. He counted eighteen families settled along the road, all of whom appeared to be little removed from savages in their manners or morals.

Austin noted that the tide of migration had not abated. He was distressed to find on the Road many families traveling in ice and snow, crossing rivers and creeks, without shoes or stockings

and with hardly enough clothes to cover their nakedness, and with no money or provisions except what the wilderness afforded. He was moved by their pathetic faith in what they would find at the end of their journey:

> Ask these Pilgrims what they expect when they git to Kentuckey and the Answer is Land. have you any. No, but I expect I can git it. have you any thing to pay for land, No. did you Ever see the Country. No but Every Body says its good land. can any thing be more Absurd than the Conduct of man, here is hundreds Travelling hundreds of Miles, they Know not for what Nor Whither, except its to Kentucky, passing land almost as good and easy obtain.d, the Proprietors of which would gladly give on any terms, but it will not do its not Kentuckey, its not the Promis.d land, . . . and when arriv.d at this Heaven in Idea what do they find? a goodly land I will allow but to them forbiden Land. exausted and worn down with distress and disappointment they are at last Oblig.d to become hewers of wood and Drawers of water.

Austin was disappointed with the seat of Lincoln County where he had met Shelby. "Little can be said in favor of the Town of Stanford. it Contins about 20 House of Loggs excep a Brick and Stone House, has Three small Stores, a Tan Yard and Four Taverns." However, he noted that the land was good and there were some large improvements.

Austin looked about Governor Shelby's Travellers Rest and observed that he had a large and well improved farm, and a plain but neat stone house. His host showed evidences of considerable wealth and was kind enough to give him a letter of introduction to a man at Frankfort whom he wanted to see. Austin left Travellers Rest to continue his journey. He visited Danville, Harrodsburg, Frankfort and Louisville on his way to upper Louisiana.

Shelby may have felt that Austin was too critical of the improvements made on the road and the settlements along the route.

His guest had been living in a developed section of Virginia and was not acquainted with frontier life. Big advances had been made in Kentucky since the Revolution, and Austin could not make proper comparisons. The new wagon road, though inadequate, was an important step forward for the commonwealth rising in the West.

1 This handmade account book is preserved in the archives of the Filson Club, Louisville, Kentucky.

' 2 "Journal of André Michaux," in Reuben Gold Thwaites, ed., *Early Western Travels, 1748-1846* (Cleveland, 32 vols, 1904-1907), III, 45. Michaux logged his journey in December 1793 over the Wilderness Road as follows (pp. 51-52): "From Danville to Lincoln 12 miles; from Lincoln to Crab Orchard, 10; from Crab Orchard to Langford Station, 10; from Langford to Modrell Station, 28; from Modrell to Middleton Station, 28; Middleton to Cumberland Gap, 24; Cumberland to Davisses Station, 2; Davisses to Houlston, 27; Houlston to Hawkins Court house, 22; Hawkins to Amis, 3; Amis to North Fork of Houlston, 25; North fork to Carolina fork, 31; . . . Fork to Abington . . . , 15; from Abington to . . . With Courthouse, [60]; from With Court house to Peper ferry, 33." (The Pepper Ferry was several miles above the main crossing of New River at Ingles Ferry.)

3 Russell Dyche, "Sesquicentennial of the Wilderness Road," in *The Register of the Kentucky State Historical Society*, Vol. 44, No. 147, April, 1946, and accompanying map. This excellent description of the routes of the Wilderness Road and Boone's path is based on the research of local historians in the wilderness area through which the roads passed. The data are in slight variance from those given in the excellent book of Dr. Pusey, *Wilderness Road to Kentucky*.

4 George P. Garrison, ed., "A Memorandum of M. Austin's Journey" in *American Historical Review*, V, No. 3, April 1900, 523-527.

Chapter 14

"Worst on the Whole Continent"

JOHN FARRIS, SR., keeper of a little tavern in Rockcastle County, had a most agreeable guest the night of December 12, 1797. A well-dressed young man traveling alone stopped for accommodations and Farris discovered he was Thomas Langford, whom he had known as a boy in Mecklenburg County, Virginia. Langford was crossing the wilderness on his way to Frankfort where he was to meet a friend, David Irby.[1] Farris and Langford spent a pleasant evening talking about mutual acquaintances in the old settlements.

Farris had done well since he moved to this spot on the Road after Whitley cleaned out the Chickamauga. Living in a log house south of the forks of the Road at Hazel Patch, he found profit and sociability boarding strange travelers. His son William and Jane, his son's wife, helped to run the place and take care of the trade. In 1797 their little hostelry was one of the nicest places to stay in the "desert" between Crab Orchard and Cumberland Gap. Only Ballinger's at the big bend of Cumberland River was better.

Farris never turned away anybody who applied for accommodations, no matter how poor he was or how he looked. That was the code of the wilderness. On the frontier, the latchstring was always out, and one caller was as good as another. When travelers rode up to a house, hallooed and asked to stay all night, they were usually greeted with a cheery order, "Get down and rest your saddle." The first arrivals got the spare shuck or straw

bed. Latecomers had to sleep on the floor. But that was better than lying on the ground with feet toward the campfire.

While the Farris family and their jovial guest breakfasted the next morning, two men and three women rode up and dismounted. All were heavily tanned and swarthy-looking. They appeared to be in their late twenties or early thirties. The leader was big and rawboned, with black, curly hair and dark, deep-set eyes under a low hairy brow. The other man was smaller, with red, curly hair and a weasel-like face. Both were slouchily dressed in shabby coats, breeches and leggings. The women were dirty and poorly dressed and all three showed signs of advanced pregnancy. Two of them were apparently the consorts of the big man, and the third, smaller and more demure, was attached to the little man.

Farris invited the ill-kept strangers to help themselves to breakfast. They replied that they had no money. Langford generously offered to pay for their fare. Jane hustled up some more food, and they ate as if starved. Keeping up a line of light talk, Langford took frequent nips at his bottle and asked Jane to fill it for him out of the Farris supply. When he opened a pocketbook to pay his bill he displayed a number of gold coins. The strangers eyed him silently.

Langford, learning that the travelers were headed in his direction, invited them to go along with him. They would be company for one another and the wilderness was lonely, even though it was no longer dangerous. Breakfast over, Langford saddled his horse and put on his packs. He remarked good-humoredly to Jane that the contents of his saddlebags were worth £500. The guests departed, and Farris and Jane watched them ride out of sight on the road to Crab Orchard.

A few days later Farris got disturbing news. Some cattlemen driving a herd from the Kentucky bluegrass pasture lands to Virginia stopped at his tavern. They told him that the cattle had become frightened and plunged off the road into a thicket near Rockcastle River. While rounding up the stray cattle, one of the drovers had come upon a man's badly mangled body, hidden

behind a log with brush and leaves piled over it. They had sent word of the murder back to Stanford, county seat of Lincoln, and the unidentified body had been buried near the Road.

From the drover's description Farris felt sure that the murdered man was his young friend, Thomas Langford. He went to Stanford, got the details of the coroner's inquest and met David Irby, who had in the meanwhile heard of the murder. He and Irby, accompanied by a man who helped bury the body, went to the spot, exhumed it and positively identified the gay-hearted Langford. His clothes, bags and horse had all been taken.

Since Farris and his daughter-in-law were the only ones who had seen the two strange men and their women, he told what he knew to the Lincoln County authorities. Captain Joseph Ballenger, a prominent Stanford merchant known as "Devil Joe," organized a posse to go in search of the suspects. He trailed them to Carpenter's Station, a few miles southwest of Stanford, the present site of Hustonville. There on Christmas Day, 1797, he found the strangers resting quietly on a log. He and his men rushed them quickly. Resistance or escape was impossible. The prisoners were lodged in the Stanford jail.

The accused men said they were brothers, Micajah and Wiley Roberts, and that their wives were two sisters, Susanna and Sally Roberts. The third woman was Betsy Walker. Farris, his daughter-in-law, Irby, Ballenger and Thomas Welsh, a member of the pursuing party, testified at the hearing. The court decreed that the prisoners should be tried in the Danville district court for the murder of Langford and remanded them to the Danville jail.

Farris and Jane were soon to learn that they had entertained at their house two of the craftiest and most vicious criminals on the frontier. The strangers were Big and Little Harpe, sons of a Tory father in North Carolina, who had located two years before in the Beaver Dam section west of Knoxville. Here they met their women and terrorized the country by horse thieving, robbery and murder.

Travelers brought Farris news of other murders on the Wilder-

ness Road which apparently had been committed by the Harpes. A pack peddler by the name of Peyton had been tomahawked near Cumberland Ford, his bundle of goods torn open, ransacked and scattered. The bodies of two men from Maryland, named Paca and Bates, were found on the road near Barbourville, stripped of their clothes. Farris and Jane shivered as they thought what might have happened at their little tavern that morning when they had taken in the strangers who had apparently committed four murders on their leisurely trip through the wilderness.

Farris was glad to learn that the Danville jailer had taken extra precautions to prevent the possible escape of his prisoners. The log jail had walls nine inches thick, but the jailer bought two horselocks to chain the men's feet to the ground and put another strong lock on the door. He repaired the jail and employed two men to keep a watch on the prisoners at all times.

The criminals took things calmly. Big Harpe, the bullish, curly-haired dark man, joked with the jailer and offered to take on any two men in a fair fist fight, provided he be set free if he bested them. The jailer had other worries. On the night of February 7 he hustled in a midwife to deliver Betsy Walker of a baby boy. On the night of March 6 he repeated the performance for Susanna Harpe, who gave birth to a daughter. Keeping an account of his expenses, he turned in charges for the midwife and the purchase of some hyson tea, sugar and ginger for the care of the new mothers.

The jailer's precautions against the escape of his charges were fruitless. On the night of March 16, 1798, the two unchained desperadoes overpowered their guards, took their guns, cut a big hole through the side of the jail and disappeared into the darkness. The two mothers stayed behind with their babies, and Sally Harpe waited her turn. On April 9, the jailer again furnished a midwife and some more tea, sugar and whisky for the birth of a baby girl.

As occasional news reached Farris after the escape of the ruffians, he shuddered anew over the robberies, murders and

savage butcheries by which the "terrible Harpes" were traced in the wildest man hunt in Kentucky history. For a time they took refuge in Cave-in-Rock, the retreat for outlaws and river pirates on the Ohio.

After a succession of trials and legal maneuvering, the women had been released from the Danville jail. Impressed with the professed repentance of the mothers, sympathetic citizens around Danville took up a collection of money, gave them clothes and fitted them out with an old mare to go back to their homes in East Tennessee. They accepted the gifts with apparent appreciation, bundled up their babies and took the Wilderness Road. After passing Crab Orchard, they turned south on a dim trail toward Green River, swapped their mare for a boat and paddled down the river to its junction with the Ohio, then on seventy miles farther to Cave-in-Rock.

Sally, wife of Little Harpe, soon discovered the brutal depravity of her brother-in-law. The babies were encumbrances on the movements of the outlaws, who usually took their wives with them. One day in a moment of rage Big Harpe snatched Betsy's little girl from her and brained it against a tree. But retribution was not long in coming. Big Harpe was cornered and shot. His head was cut off and mounted on top of a trimmed sapling in Hopkins County, Kentucky. The skull remained there for years, and that lonely spot is still known as "Harpe's Head." Little Harpe, continuing his career of crime in the Mississippi territory, was finally caught and executed.

The new border terror at last removed, Farris and thousands of others living along lonely trails felt safe again.

The little wayside house of Farris on the Wilderness Road continued to accommodate visitors as Kentucky grew to ninth place in population among the states of the Union. The traffic along the newly made wagon road swelled in volume annually. Farris, from his vantage point south of the forks of the Road, saw the undivided stream flow by. His tavern was full nearly every night.

Photograph by Harry H. Catching

RACCOON SPRING AND MARKER
Three miles east of Lilly, Laurel County, Kentucky, an important camping spot on Boone's Road. It was by-passed in 1796 by the new location of the Wilderness Road.

Photograph by J. Winston Coleman, Jr.

CASTLE ROCK

As seen from Highway No. 25 four miles south of Livingston, Kentucky. It was from this rock that Rockcastle River and County were named.

Of all the guests Farris entertained, none was better known and more distinguished on the frontier than Bishop Francis Asbury, the great Methodist preacher who toured on horseback for over forty years the vast stretches of the new nation from the Atlantic seacoast to the Mississippi River.[2] During his ministry in America, he crossed the Alleghenies sixty times, ordained more than 3,000 preachers, preached more than 17,000 sermons, and traveled on horseback at least 275,000 miles.

On Columbus Day, October 12, 1803, the bishop and two companions came out of Madison County, Kentucky, where they had attended a Methodist Conference and put up at the Farris tavern. Having ridden in rain all day they were dripping wet. They welcomed the warm fire which Farris had blazing in his big fireplace, steamed out their clothes, ate a hearty supper and chatted congenially with their host.

The bishop was a tall, spare man with penetrating eyes and long, flowing white hair. He wore a plain frock coat and a low-crowned, broad-brimmed hat which gave him a severe clerical appearance. All his personal belongings he carried in his saddle-bags. He had been elected the first bishop in America in 1784, after he came to this country as a disciple of John Wesley. He never married. He insisted on journeying to the four corners of his continental parish. He made his first trip into Kentucky in 1793 over the Wilderness Road to organize a Kentucky Conference, and he had been back many times to look after his flock. During the dangerous years on the Road he traveled with a company of guards. He had never been fired upon by Indians or by bandits, like the terrible Harpes, but the suffering he endured found eloquent expression in the daily journal he kept.

On this wet night in October, Asbury had a particular complaint to make to Farris. The night before he had stayed with a man named Woods just south of Big Hill where the Rockcastle country began. His host's house was unfinished, and the bishop got little rest. The place was crowded with masons, carpenters, riflemen and whisky topers who kept him awake all night. Besides there were swarms of gnats, and bats flew in and out.

Bishop Asbury called the place a "purgatory," and was somewhat resentful that Woods should have charged him and his companions $2.50.

Ever interested in the spiritual welfare of the frontier people, the bishop talked with Farris about the great increase in population along the Wilderness Road. Before Whitley's Nickajack campaign only Woods Station at Hazel Patch had been located between Cumberland Gap and the outlying stations in the vicinity of Crab Orchard. The temporary militia stations of Modrel, Middleton and Collins had been abandoned in 1795 with the ending of the Indian menace, but families had quickly moved in and put up their cabins. Now after eight years the Road through the wilderness was becoming dotted with homes. Travelers could stop at taverns every night.

Why not start a Wilderness Circuit for these people? Asbury pondered the point in his reverie and remarked that it was high time to begin. Then, as was his custom, he prayed with Farris and the other guests in the tavern and retired for the night.

Two days later the weary bishop passed out of the wilderness into Powell Valley. He took time to recapitulate in his journal some of his impressions. "What a road we have passed!" he wrote.

Certainly the worst on the whole continent even in the best weather; yet bad as it was there were four or five hundred crossing the rude hills whilst we were. . . . A man who is well mounted will scorn to complain of the roads, when he sees men, women, and children, almost naked, paddling barefoot and bare-legged along or labouring up the rocky hills, whilst those who are best off have only a horse for two or three children to ride at once. If these adventurers have little or nothing to eat, it is not an extraordinary circumstance, and not uncommon, to encamp in the wet woods after night; in the mountains it does not rain, but pours.

The bishop had a common tie with these poor travelers.

I too have my sufferings, perhaps peculiar to myself; pain and temptation, the one of the body, the other of the spirit. No room to retire to, that in which you sit common to all, crowded with women and children, the fire occupied by cooking, much and long loved solitude not to be found unless you choose to run out into the rain in the woods. . . . The people it must be confessed are amongst the kindest in the world. But kindness will not make a crowded log cabin, twelve feet by ten, agreeable; without, cold and rain, and within, six adults and as many children, one of which is all motion.

Then, as if to mention the climax of his humiliation, he wrote:

I found amongst my other trials I have taken the itch; and, considering the filthy houses and filthy beds I have met with, in coming from the Kentucky conference, it is perhaps strange that I have not caught it twenty times. I do not see that there is any security against it but by sleeping in a brimstone shirt.

The terrible Harpes and Bishop Asbury passed out of the life of John Farris, and he was left to wrestle with "the worst road on the whole continent." Running his tavern and looking after his little farm, he observed the efforts of state officials to improve the life line cutting through the wilderness. Governor James Garrard succeeded Shelby, and took measures for the maintenance and further development of the Road. On March 1, 1797, the legislature appropriated five hundred pounds to be spent on it. Again Colonel Crockett was named special commissioner, this time to build a turnpike, with a tollgate at some convenient point so that income might be added to the appropriation. After an investigation Crockett decided to place the tollgate at Cumberland Ford. Robert Craig was appointed tollgate keeper to serve for seven years. Should he fail to perform his duties faithfully, he would have to pay a penalty of £3,000.

The rates set for the tollgate were 9 pence for all persons; 9

pence for a horse, mule or mare; 3 shillings for a carriage with two wheels; 6 shillings for a carriage with four wheels; and 3 pence for each head of meat cattle going eastward. Postriders, expresses, women and children under ten years were allowed to pass free.

Craig was supposed to keep the Road in good order for wheel carriages and where necessary to build bridges and causeways across unfordable streams. He was to be paid for his services out of the tolls. Commissioners were appointed to supervise and direct the repairs, and no changes in the route were to be made except to avoid hills or other bad places. In 1802 Craig was given a flat salary of $200 per year and the toll rates were reduced.

Farris observed that the toll business was immediately profitable. The Ohio River route was now well developed, but the Cumberland Gap way to the West was still more popular. Moreover, the eastbound traffic was now almost equal to that going west. Commerce had supplanted exploration and settlement. Craig, busy at Cumberland Ford, collected the toll and poured it back into the road improvement fund.

The tollgate idea worked so well that Virginia authorities established a gate in the saddle of Cumberland Gap in 1805. This spot where the tip of Virginia reaches down in a sharp wedge to corner with Tennessee and Kentucky was a strategic location. Travelers from Kentucky on their way to East Tennessee passed over only a few yards of Virginia soil. Kentuckians were irate. They considered that paying toll was little short of robbery. The governor of Kentucky protested to the Virginia governor against the discriminatory tribute. But the Virginians stood their ground and for a time kept an armed guard at the gate to compel the payment of toll. It was only after the Kentucky legislature memorialized the Virginia legislature in a vigorous denunciation that the offending tollgate was moved farther east on the Virginia segment of the road.

The Cumberland Ford tollgate and others later put up at appropriate points were not the only schemes to extract money from the traffic flowing east and west. Added to the wagons

and carriages and the lone riders still using packhorses were long lines of livestock moving eastward. Cattle had multiplied in the western canebrakes. As beef for eastern markets they had become a principal source of income for the farmers in central Kentucky. Cattle, horses, mules, hogs and sheep found a ready sale in Maryland, Virginia and the Carolinas. The old Road through Cumberland Gap was the main outlet. To accommodate the drovers during the marketing season, many others like Farris built big corrals for the overnight care of the livestock. The meager farms in the wilderness could sell all they raised to the passing drovers.

A Virginia visitor in Kentucky in 1825, greatly impressed with this business, regarded the income from the tolls as totally inadequate for the maintenance of the Road. He said it was intolerable in most seasons of the year. Although poles had been placed in the worst bogs and sloughs to give it a bed, long stretches were still almost impassable.

This visitor described the development of the hog business in Kentucky. Kentuckians customarily bought hogs in the spring season in Ohio and Indiana, he said, brought them to their own farms and turned them into the clover. As the season progressed, the hogs were turned out in the rye and oats, and finally into cornfields where they were fattened for market. When they were at last ready, they were driven over the road in droves of five hundred or more. Virginians joked about the Kentuckians' economical method of providing feed for their hogs. "On my journey I fell in with a drove of steers on their way to the Southern market; in their rear were driven as many shoats which gather their wastings. If Kentuckians are extravagant in some ways they are saving in others."[3]

Farris watched the development of another phase of the livestock business. In the endless caravans passing by his door handsome stallions pranced into Kentucky from the best stables in Virginia and the Southeast to improve the thoroughbred racing stock in the state. Almost every number of the *Kentucky Gazette* which Farris read contained advertisements that boasted

of their qualities. Among the lauded stallions that came in by the Wilderness Road were Castor, Darius, Nero, Flimnap, Don Carlos, Slider, Laburnum, Arabian, Pilgarlick and Godolphin.

Henry Clay, while busy defending clients and proclaiming his doctrine of the "American system" and "internal improvements," imported Hereford cattle from England and added them to his herd of Shorthorns. He introduced Merino sheep and red and belted hogs. He imported jacks from Spain to improve the quality of mules, attended cattle and horse shows and never failed to promote the interest of the livestock growers. Many of his blooded animals came to Kentucky over the Wilderness Road.

So great did the reputation of Kentucky horses become that fanciers came from the eastern states and foreign countries to see and buy them. Representatives of Russia purchased some fine stallions. They took them out over the Wilderness Road for shipment from Charleston. When they neared the saddle of Cumberland Gap for the crossing into Virginia and Tennessee, one of the best stallions broke away from his leader and ran up the north side of the mountain. The men pursued him to the top of the Pinnacle. Cornered at the edge of the 1400-foot precipice, the frightened horse plunged over to a ledge several hundred feet below.

Like Farris, James Renfro was a man who profited greatly from the livestock traffic. Soon after 1800 he had settled on land purchased from Isaac Shelby, south of the Cumberland Ford. Renfro maintained a public tavern in the brick house Shelby had built,[4] kept passing livestock in a near-by corral and operated the ferry and tollgate after Craig's term expired.

On November 14, 1822, when Kentucky was having financial troubles, Renfro wrote to the *Kentucky Gazette:*

> At this time there have passed this place, 45,421 live hogs for the market . . . worth 7 dollars each, which . . . amounts to 317,947 dollars. Also 5,446 horses and mules, at an average of 80 dollars each, makes 435,680 dollars. Only 236 stall-fed

steers . . . worth 40 dollars each, makes 9,440. Two or three thousand hogs, I hear, are on the road to be added to the above list . . . making in all, 777,067 in good money. I trust the time is not very distant when Kentucky will restore her credit and there will be no more relief measures prayed for, nor stop laws passed; which have so much disgraced one of the most prolific and rich states in the union, whose sons are bold and enterprising, beyond any, I believe in the world.

For 1825 Renfro reported that the value of livestock which passed south through his gate for southern markets was $905,892 and consisted of 4,019 horses, 1,019 mules, 63,036 hogs and 1,393 cattle. By 1828 he proudly reported that the value had passed the million mark, the total being $1,167,302, for 3,412 horses, 3,288 mules, 97,455 hogs, 2,141 sheep and 1,525 stall-fed beef cattle.

Farris, Renfro and other prominent leaders in the fast settling wilderness during the first quarter of the nineteenth century kept up a constant agitation for the improvement of the Wilderness Road. They hounded the legislature with appeals and usually got action. Scarcely a session of the legislature passed without some consideration of the Road's maintenance and management. The Kentucky statutes were filled with acts relating to bridges, ferries, repairs, improvements, regulation of tolls and methods of maintenance. Never satisfactory to the long-suffering travelers who passed over it, "the Wilderness Turnpike," as it was now called, continued a subject of debate, complaint and agitation.

1 Otto A. Rothert, *The Outlaws of Cave-in-Rock* (Cleveland, 1924;) Robert M. Coates, *The Outlaw Years* (New York, 1930).

2 *The Journal of the Rev. Francis Asbury,* Vols. I, II, III (New York, 1821).

3 *Letters on the Condition of Kentucky in 1825* (New York, 1916). (Reprinted from the *Richmond* [Virginia] *Enquirer* and edited by Earl G. Swem).

4 This brick house at Cumberland Ford built for Shelby was the first in the wilderness. It stood until the Civil War when it was torn down and, according to tradition, hauled to Cumberland Gap by the Federal Forces under General George W. Morgan to be used in constructing military buildings. Shelby never lived at Cumberland Ford but owned property there for a number of years and was for a short time a partner in operating the ferry later taken over by Renfro. Renfro and a boy companion were killed by lightning July 29, 1835, while searching for Swift's silver mine.

Chapter 15

End of an Era

MAJOR ROBERT P. BAKER was an engineer. Everybody said he was a good engineer. Governor James T. Morehead believed he was a good engineer. So everybody applauded when the governor appointed Baker chief engineer of the Bureau of Internal Improvements which the legislature had authorized in 1835.

Baker got his job when Kentucky was waxing rich and "internal improvements" had become a national shibboleth. It had been sixty years since Boone, Harrod and Logan built their first towns in the wilderness. Their land of promise was yielding its abundance. Towns flourished, industries thrived, and big farms spread over the Bluegrass region. Kentucky was no longer the frontier. The advancing line of conquest had circled into the far reaches of the Northwest. Only one thing lagged. The network of turnpike roads in Kentucky had not kept pace with progress, and the rivers draining the fertile valleys needed to be integrated into a transportation system.

For more than twenty years, every governor had beaten the drums of internal improvements. Turnpike companies were chartered to build and improve the roads. Canal companies were projected and river dredging schemes advanced. But little had been done except to build a canal around the Falls of the Ohio. Federal aid was out of the question. President Jackson had effectively killed that by his vigorous veto of the proposal to participate in the building of the Maysville-Lexington turnpike. Such

208

jobs, he had said, were for the states and local communities unless they were necessary for national defense. His stand had much to do in further alienating his political support in the state where Clay was the fair-haired idol of the people.

But at last Kentucky had a program. The Bureau of Internal Improvements had been authorized with an appropriation of $1,000,000 from a hopeful legislature, and a good chief engineer had been chosen to put transportation facilities in order.

Baker had the enthusiastic support of Governor Morehead, the legislature and the people. Everybody predicted big things and looked for happy days. Editorial comments were lyrical. One writer said:

> Who can predict the aspect Kentucky will present when her streams become permanently navigable, and when all her roads through the interior become commodious channels of trade? The day is fast approaching when the difficulties of transportation will live in tradition only, and be listened to with incredulity by the rising generation.

It was a big order for Baker, but he did not falter. He studied his maps and reviewed the possibilities. The state had already spent $125,000 on Green and Barren Rivers. Kentucky River had hardly been touched. Then there were the Cumberland, Rockcastle, Salt, Licking, and Big and Little Sandy. All these streams must be integrated with the network of turnpikes lining the state. But where was he to start?

Baker immediately eliminated the roads from his plans. The system of tolls established in 1797 on the Wilderness Road had been extended to other roads, and the net income applied to their improvement. Bridges and ferries had been constructed, and the roads widened and straightened. Although the income had never been sufficient to keep in step with the increasing transportation demands, at least the roads were being supported. Baker therefore turned from the highway to the streams; the Kentucky River was the place to start. It served the central

Bluegrass region, and its tributaries reached into the mountains not far from the Wilderness Road.

The energetic engineer made an extended field trip during the summer months of 1835. He went up the Kentucky River and charted its three prongs. He ranged the southeastern Kentucky mountains and mapped the water gaps and valleys. He crossed over from the South Fork of the Kentucky to Goose Creek at Manchester, where important saltworks were going full blast. He observed the lay of the land and turned west to Cumberland River at the big bend at Barbourville.

Here on the old road now being called the "State Road," "the Kentucky Road" and "the Wilderness Turnpike," he watched wagons rumble past in long lines, with an occasional big Conestoga drawn by a six-horse team; droves of horses, mules, cattle and hogs on the way to the eastern markets; the stage-coaches loaded with mail and passengers, creaking and rolling through bogs and chuckholes. He realized the Road's inadequacy to carry the traffic of a commonwealth bloated with riches.

Baker talked with James Love and other prominent leaders at Barbourville. They discussed the old Road and its possibilities. Naturally they were interested in this outlet for Kentucky because the passing thousands had brought big business to their doors. But competition was cutting in. The Ohio River and the newly built National Road were swinging traffic away from this longer and more mountainous connection with the East. Would the Wilderness Road lose its importance as a channel of commerce and become only a local service road?

Baker and the Barbourville leaders pondered the question. Baker had an idea. Perhaps water was the answer. He took leave of his worried friends and rode along to Cumberland Ford. The noble stream enchanted him. He continued up Yellow Creek, noting its size and the swiftness of its flow. Could this little stream lazily winding out of the huge basin immediately north of Cumberland Gap be put to practical use?

Then he came to the Cumberland wall looming three thousand feet high, the divide between the Cumberland and the

Tennessee systems. He circled up the dizzy road worn deep in the ledges and boulders by forty years of wagon traffic. In the Gap where the wall was cut with a thousand-foot gateway, he looked south into Powell Valley. He wound around the south side of the bold precipice of the Pinnacle and was entranced by the stream which gushed out of the face of the mountain. He estimated the flow. In 1750 Dr. Thomas Walker had said it was sufficient to turn a mill. Baker found not only a gristmill in operation but also a sawmill and an iron forge. The stream, tumbling in foaming cascades to the foot of the mountain for its junction with Powell River five miles away, could be an important link in the visionary chain he was building.

Baker had reached the end of his investigation and was satisfied. The high loop of the Wilderness Road over Cumberland Gap could be remedied. He made a calculation of the altitude of the Cave Spring on the south side, and the headwaters of Yellow Creek north of the divide, and toyed with the engineering problem of connecting them. He went back to Frankfort to work up his notes.

When the legislature met in January 1836, Baker was ready with his report. The chief engineer covered a good many things relative to the plans and operations of the Bureau of Internal Improvements since he had taken charge. One idea he expanded at great length. He recommended the building of a waterway connecting Kentucky with the Atlantic Ocean! If Kentuckians were thinking big things in those days, their chief engineer could top them all.

To Baker the waterway was perfectly feasible. He outlined it briefly:

The route I propose to follow would lead from the Ohio up the Kentucky River by locks and dams to the three forks of the Kentucky; then up the South Fork and Goose Creek to the salt works; thence by a canal into the Cumberland River at Cumberland Ford; thence four miles in Cumberland River to the mouth of Yellow Creek; thence by a canal in

the bed of Yellow Creek to Cumberland Gap; thence through Cumberland Gap by a tunnel and by canal from thence into Powell's River, five miles below; down that river successively into the Clinch and Tennessee, and up the Hiwassee by locks and dams; from the Hiwassee continue the improvements by a canal to the navigable waters of the Savannah at the head of steamboat navigation on that river.[1]

It was just as simple as that. Baker mentioned the advantages:

The canal would outflank the whole chain of the Appalachian mountains on the Southwest, and in the course of its extent would cross the various notable rivers, Coosa, Chattahoochee, Oconee, etc., which taking their rise in the chain of the Appalachians flow into the Gulf of Mexico and the Atlantic Ocean between the cities of New Orleans and Charleston. Thus throwing open to commerce of the countries bordering on the Ohio a choice among numerous and greedy markets presented by the vast extent of cotton country along the coast of the United States; independently of the facilities it would offer for reaching the northern cities or European ports through the ports of Savannah and Charleston.

Baker tossed this recommendation to the legislators to give them time to think about it. They argued over it, and some were skeptical. Apparently the canal in a tunnel through Cumberland Mountain worried them a little. How could ships of commerce sail through the heart of a big mountain? For the benefit of the doubters, Baker went into more detail on this point in a supplemental report:

The result of my reconnaissance satisfied me of the reasonable practicability of connecting the Cumberland and Powell's Rivers by a canal, made to pass by a tunnel through the mountain at Cumberland Gap. The length of the tunnel which would perforate the mountain would not . . . exceed 700 to 800 yards. For supplying the water for this summit level, a source believed to be superabundant is presented by a

fountain which issues from the southern brow of the mountain, several hundred feet above the plane of the canal. The face of the mountain at the point where this water issues is a vertical ledge of rocks of probably 1500 feet in height, and the water pours out of an aperture in the face of the rocks, several hundred feet above the base. . . . The great depth of the sources of this water below the surface of the earth gives it a uniform flow during the whole year. At a few hundred yards from its source, the water . . . is collected into one channel and forms a considerable stream which flows down a valley . . . to Powell's River. . . . The distance over the ridge at Cumberland Gap, following the road by zigzag windings along the steep acclivities is about a mile and a quarter.

Then he described Yellow Creek on the north side of the mountain, saying it would be no problem at all to build locks on its headwaters, so that the stream could be lifted into the canal through the tunnel in the mountain to connect with the Cave Spring.

Baker had the cost all figured out. The project included 256 miles of canals and 669 miles of slack water, and the total cost would be $8,518,503, or an average of $9,209 a mile. He took notice of those visionary individuals who had begun to think about railroads. The cost of canalization would be so much lower than building a railroad that it would be economy to construct the canal system. However, if a railroad were advisable, the same route was open to it. He would leave the final decision to the legislature.

The ambitious lawmakers at Frankfort debated at some length. They were sympathetic with the plan to build an auxiliary for the overtaxed and inadequate Wilderness Road. But the railroad advocates talked loudly of the future of steam in transportation and threw cold water on Baker's water baby. Baker saw his proposition tabled without action.

He was deeply disappointed. His engineering ability was not appreciated. He resigned March 23, 1836, left his report to

gather dust in buried archives and took his talents to other fields.

With the abandonment of Baker's waterway proposal, the railroad promoters came to the front. Henry Clay and John C. Calhoun led the movement. They made pleas for federal assistance in building a line to connect the interior towns west of the Alleghenies with the coastal cities in the Southeast. A convention was held in Knoxville, July 4, 1836, to discuss the project. A company was formed and a charter secured with a capitalization of $6,000,000. The proposed line was to reach down from Cincinnati to Lexington, then across the divide at Cumberland Gap, curve down to Knoxville, and then go up the French Broad to the Carolinas and finally to Charleston.

A follow-up meeting was held in Lexington, August 27, 1838. At a barbecue and festival attended by 3,000 people, Henry Clay, John J. Crittenden, Richard M. Johnson and Thomas Metcalfe extolled the railroad project. Eloquent Robert Y. Hayne represented South Carolina. In reporting the meeting, the *Kentucky Gazette* said: "The almost unanimous sentiment appeared to be enthusiastically in favor of the great work which is to strengthen the bonds of Union between the South and West and to make Kentucky what the God of creation designed—the finest portion of the habitable globe."

But the promoters, like Baker, had their disappointment. A ruinous financial policy in Washington had brought a panic, and all types of internal improvements had to be restricted or abandoned altogether. Sensing the rising opposition to extravagant expenditures, the Kentucky Whigs abandoned their grand plans for railroads, canals and road building. The Democrats exulted over the discomfiture of the Whigs. One partisan writer twitted: "They built locks and dams on two rivers, and made patches of turnpike roads here and there in the state, and then sank down exhausted with the mighty effort. Since then they have been engaged in the laudable work of devising ways and means of paying the state debt, created on the memorable occasion."

The failure of Baker and the railroad promoters to build an

auxiliary transportation system to the Southeast left the Wilderness Road still wheezing and groaning under its heavy load.

Unlike Baker, Senator John J. Crittenden was not dreaming of waterways as he rode into Yellow Creek Valley five years later. On his way to attend a tri-state Whig rally at Cumberland Gap, he was wondering how many votes he could round up in the mountains for Harrison and Tyler. The Whig leaders in Kentucky, Tennessee and Virginia had arranged for the meeting to be held September 10 and 11, 1840, the anniversary of Perry's victory. They had been publicizing the rally for weeks. Partisan writers thought there could be no more appropriate place for such a gathering than the historic gateway into the West.

Crittenden, junior senator from Kentucky, was to be the chief speaker on the two-day program.[2] His senior colleague, Henry Clay, the distinguished standard-bearer for the party in 1832, could not be present because he was scheduled to speak in Nashville, the home town of his arch-enemy, Andrew Jackson. General William Henry Harrison, the Whig nominee, had been invited to defend himself against the charges of calumny and cowardice, but he had gone to Dayton, Ohio, for a similar meeting. It was left to Crittenden, General Leslie Combs, of Lexington, and Congressman John White, of Richmond, to be the principal representatives of Kentucky in the tri-state convention.

As Crittenden rode along the old Road to Cumberland Gap, he was impressed with the changes which had taken place since his father had moved to Kentucky in 1788. Instead of a dark unsettled wilderness in the rugged hills, he was finding along the worn-out Road countless cabins, occasional substantial homes, and little cultivated patches hanging on hillsides or reaching back into narrow coves. The settlers in the migration days who had chosen to stop in the wilderness rather than pass on to the richer bluegrass meadows were of the same sturdy stock that had peopled central and western Kentucky. They had stopped because a wagon broke down, some member of the family had got sick and was not able to go on, or the forest had lured them

aside because of good hunting. The main migratory stream swept by and they remained in little eddies in dark hollows and narrow valleys. Here they scratched out a living on thin soil, hunted a great deal, got out timber and floated it downstream to big sawmills, and were content with their lot.

Crittenden was struck with the English, Scotch-Irish and Huguenot names which revealed the ancestry of these people. Around Barbourville were the Eves, Loves, Woodsons and Ballingers. Spreading up and down the river from Cumberland Ford and over into isolated pockets were the Renfros, Ashers, Hendersons, Partins, Cawoods, Howards and Ballous. In the Yellow Creek Valley were the Colsons, Turners, Raines, Bledsoes and Tacketts. To name them was to be reminded of the Virginia and Carolina settlements which furnished the men and women who had built the great Kentucky commonwealth. But in their isolation and restriction they had not prospered as had their more fortunate neighbors who continued to central Kentucky. A distinct type of civilization was developing in the mountains, but the spirit of liberty still flamed high. Crittenden was in complete accord with the writer in the *Cincinnati Gazette*, of August 29, 1840, who said in announcing the Cumberland Gap rally: "Give the mountaineers of Tennessee, Kentucky, and Virginia light and they will strike a blow for liberty that shall be felt throughout the land."

He arrived at the Kentucky camp ground at the base of the mountain north of Cumberland Gap late in the afternoon of September 9. He found more than a thousand mountaineers already assembled for the meeting. All day long they had been arriving in wagons, carriages, carryalls, on horseback and on foot. They hitched their horses, mules and oxen in the grove, set up tents or arranged to sleep in the wagons. Men, women and children out for a good time joined in songs, swapped stories, exchanged railleries and took part in friendly sports. They had banjos and fiddles, fifes and drums, pistols, rifles and shotguns, flags and banners, barrels of hard cider, coonskin caps and miniature log cabins. Party workers whipped up a martial spirit

in their campaign for "Tippecanoe and Tyler, too," and denounced "Old Van Buren," the chief rawhead and bloody bones of the "Locofocos." The mountaineers took their politics seriously.

Crittenden learned that a similar camp had been made in the little valley south of Cumberland Gap where the natives of southwest Virginia and East Tennessee were gathering. Many had come long distances, and the crowds in the two camps swelled to several thousand before the end of the day. After a night of festivity and celebration, a fifteen-pound cannon mounted on the Pinnacle boomed a signal for the campers to get ready for the program.

With banners waving and fifes tootling, the people from the two camps marched up on both sides of the mountain to a little hollow on the Kentucky side of the pass where a speaker's stand was erected. Here the converging celebrants swarmed into a natural amphitheater large enough to accommodate 10,000 people. One huge banner, 30 by 40 feet, dominated many bobbing signs. It bore the inscription: "KENTUCKY-VIRGINIA-TENNESSEE; Harrison and Tyler; One More Fire and the Day is Ours." Another blazoned the single word "Liberty," and one mounted on the Pinnacle bore the words "Tip and Ty." Back of the speaker's stand was a banner showing pictures of three sisters in a loving embrace—the three states.

Everybody shared the florid enthusiasm of a reporter.

Imagination can scarcely conceive of a place where the beautiful and the sublime are more harmoniously blended. ... It was to such a spot that the Friends of Liberty directed their steps as a fit temple in which to make their vows of devotion to their country. ... The character of the people was in keeping with the boldness of the scenery. It has been well said that "Liberty has her home in the mountains," and to no better guardianship could she be entrusted than to those fearless and independent men who dwell therein.

Crittenden chatted with the leaders on the speaker's platform

who had charge of the program. His old friend Congressman John White, of Richmond, was chosen president. Two vice-presidents were named for each of the states: Martin Beaty and Frank Ballinger, of Kentucky; Alfred W. Taylor and William Lowry, of Tennessee; and John Campbell and John D. Sharp, of Virginia. The three secretaries were Silas Woodson, of Kentucky, Thomas W. Humes, of Tennessee, and Connally F. Trigg, of Virginia. All these men had taken a prominent part in the campaign and most of them were well known to the mountain people who had turned out for the speechmaking.

Crittenden was the only United States senator present and the most distinguished personality in the group. His was the principal address. He drew himself to his full height. His black eyes kindled his homely face. His loose, mobile lips covered irregular defective teeth, but his oratorical fire transformed him as he warmed to his subject. For two hours he discussed the principles of government, the origin and rise of political parties, the recent tendencies toward corruption and autocracy. He denounced what he termed the imperialism of Jackson and lambasted the Van Buren administration. He declared that the hope of the nation depended on the election of Harrison and Tyler.

Crittenden was followed by Congressman John Bell, of Nashville. Weak and ill after his long journey, he broke down in the middle of his speech. General Leslie Combs followed, defending Harrison against the usual charges of cowardice and bungling in his military campaigns; he read a long list of the nominee's exploits. The speaking went far beyond the noon hour, but at last the first day's session was adjourned. The people returned to their happy celebrations, to wait for the final session.

The second meeting of the convention was opened by Wyndham Robertson, of Virginia, former governor and prominent Whig of that state, who continued the denunciation of the Van Buren administration. Next John Bell finished the speech he was unable to conclude the day before. After a number of other lesser figures had their say, Crittenden closed with a plea for

united support of the Whig ticket. Appropriate resolutions were passed and the convention adjourned.

Crittenden exchanged farewells with his political comrades and turned back on the Wilderness Road. He could not know that the oratory which echoed from the beetling crags of Cumberland Gap in 1840 marked the end of an era. Harrison's election and death ended the internal improvements the mountaineers wanted. The old Road lost much of its importance until it was changed into a trail of bloody conflict two decades later.

1 *Kentucky House Journal,* 1835-1836, Appendix, pp. 87-88; *Kentucky State Journal,* 1835-1836, Appendix, pp. 17-18; *Kentucky House Journal,* 1836-1837, Appendix, pp. 7, 27; *Ibid.,* 1837-1838, Appendix, pp. 191-204.

2 For full accounts of this meeting, see *Kentucky Gazette,* Frankfort, Sept. 22, 1840; *Knoxville Register and Weekly Times,* Knoxville, Sept. 16, 1840; *The Argus,* Knoxville, Tenn., Sept. 16, 1840. See "Rally of 'Friends of Liberty' " by Robert L. Kincaid in *Lincoln Herald,* Harrogate, Tennessee, Vol. 48, No. 1, February, 1946, 30-38, for extensive account.

Part 3

TRAIL OF
BLASTED HOPES

Chapter 16

Delayed Thrust

Two secret agents of President Lincoln talked long into the night in a hotel room in Cincinnati July 23, 1861. They had met by prearrangement. One had just arrived from Washington where he had seen the routed, bleeding remnants of McDowell's army streaming back to the capital after the disaster of Bull Run. The other had been in Kentucky for more than a month trying to hold the wavering state in line.

The gentleman fresh from Washington was Samuel Powhatan Carter, lieutenant in the United States Navy, who had been called from duty in Brazilian waters for a special mission to his native Tennessee. The other was William Nelson, also a Navy lieutenant, who had been detached from gunboat duty to provide secret arms for loyal home guards in Kentucky.

The two men contrasted sharply in appearance and personality. Carter was forty-two, a handsome, blue-eyed, well-built man with a neatly trimmed beard. Calm and deliberate in his manner, he showed no trace of his Indian heritage which reached back to King Powhatan whose name he had adopted by choice. His great-grandfather was Colonel John Carter, one of the original members of the Watauga Association. His grandfather was Colonel Landon Carter, a King's Mountain man, for whom Carter County, Tennessee, was named. His grandmother, Elizabeth Maclin Carter, had been honored by having the county seat, Elizabethton, named for her.

Nelson was thirty-six, a massive, full-faced man of three hun-

dred pounds with a large head and heavy, curly black hair. He was a native of Maysville, Kentucky, the son of a prominent physician, and through his mother was related to the illustrious Southern family, the Doniphans. He was explosive and dominating, but with nerves of steel.

Though Southerners, Carter and Nelson were loyal to the Union as a matter of course. Others might be torn by inner conflict trying to decide which way they should go; these men did not hesitate. They both owed allegiance to the flag for which they had fought in the Mexican War. Although Carter had been out of the country during the critical time, he had kept in close touch with events at home. He was much disturbed over the maneuvering of Governor Isham Harris to take Tennessee into the Confederacy. Writing from Buenos Aires on Washington's birthday, 1861, to William G. Brownlow, editor of the *Knoxville Whig*, he had expressed his concern:

> When I read in the papers that there are many who speak of our Union as an "accursed thing" I feel as though it were all a dream or else the people are surely mad. . . . I would have Tennessee remain firm & unshaken in her adherence to the Constitution & the Union, even if she has to stand alone among all the slave holding states. . . . Have the people of Tennessee counted the cost of a Civil War? To it, foreign invasion is but child's play—burning villages, cities zealously guarded; trampled harvests; smoking farm houses, & country people wandering in distraction or perishing from disease & starvation on the road side; all business paralyzed & the whole country filled with the woes which are the ashes of Military glory. . . . Are Tennesseans prepared for this? Let them be wise and stand by the Union & if fight they must let them battle in behalf of the Constitution.[1]

Nelson had made known his position in a characteristic way. On special duty in Washington during the latter days of the Buchanan administration, he was importuned by his old friend and fellow Kentuckian, Vice-President John C. Breckinridge,

to go with the South. He haughtily refused and was given orders to proceed to China that he might be out of the country. He scornfully tore up the orders and went at once to Lincoln to assure him of his loyalty.[2]

Now that their country was plunged into the conflict which Carter had foreseen and the first battle at Bull Run portended a long struggle, the two men sat in their hotel room and talked with heavy hearts. They knew that the flames of war would spread into their own states. Kentucky was still trying to maintain a position of neutrality, but the Kentucky State Guard under Simon Bolivar Buckner was undependable. Governor Beriah Magoffin was carrying water on both shoulders, and pro-Southern elements in the Bluegrass were boldly advocating secession. However, Nelson had arranged with Lincoln's old friend, Joshua Fry Speed, for the secret distribution of "Lincoln guns" to the loyal home guards, and Union leaders were confident the Legislature could be held in line.

Carter and Nelson bent over a map to check the boundary lines separating the North from the South and to determine a course of action. It was difficult to find a dividing line. The border commonwealths stretching from Maryland to Kansas were embroiled in conflicting sentiments, and a perplexed and slow-moving administration in Washington was floundering in doubtful procedures. But the shock of the first battle of Bull Run necessitated immediate aggressive action. The administration felt that two military movements in the West were important. The western rivers must be controlled, and the loyal mountain area of East Tennessee and western North Carolina must be maintained. The immediate assignment of Carter and Nelson was concerned with the latter objective.

The strategy was clear. On the map was a slender line indicating a road from central Kentucky through Cumberland Gap into eastern Tennessee and southwest Virginia. The old Wilderness Road would serve for the shortest and most direct thrust into the midriff of the Confederacy, severing the railroad in the Holston Valley that connected Virginia with the West, and

dividing the South into detached segments which would be easily conquered.

Carter and Nelson agreed on their plans. Nelson would recruit an army in Kentucky for the march into East Tennessee, and Carter would hurry to his native Tennessee and build a similar army. Their combined forces would sweep the Wilderness Road from central Kentucky to the Holston and prepare for the march of larger armies into the South. The two men separated for their assignments: Nelson to proceed at once to Danville to start a recruiting station on the farm of Dick Robinson, near by, and Carter to hurry to his home in Carter County.

Carter felt he would have no difficulty carrying out his part of the mission. He had been informed that East Tennessee was in open revolt against the middle and western parts of the state in acting to take the state out of the Union. Unexpected support for the Union cause had come from Senator Andrew Johnson, a Democrat who had campaigned for John C. Breckinridge in the 1860 presidential election. On December 18, 1860, Johnson had risen in the Senate to voice his adherence to the Union in a dramatic address which stirred a discouraged North and rallied the Unionists of the South. He was ably supported by two Whig congressmen of East Tennessee, Horace Maynard and Thomas A. R. Nelson. The Reverend William G. Brownlow, despite his previous conviction that slavery was right, was unceasingly vehement in denunciation of secession. The majority of the 300,000 East Tennesseans were clearly pro-Union, and to recruit a sizable force among them should be easy.

As Carter passed through central Kentucky on his way south, he noted the growing tenseness in that stronghold of slavery. It made him wonder what the state's ultimate decision would be. But when he reached the mountain section, he found a change of atmosphere. In a region where there were no large land-holders and few slaves, the vexing question of abolition was of no importance. But the Union was another matter. The mountain people had heard that their country's flag had been fired

upon at Fort Sumter and an overwhelming majority were ready to fly to arms.

When Carter reached London, Kentucky, on August 1, he met his younger brother James. James had been to Washington to confer with President Lincoln, Secretary of War Cameron, Senator Johnson and Congressman Maynard. When he returned to Carter County in East Tennessee for preliminary recruiting duty, he found conditions much worse. He realized that his brother would not be safe in the danger zone. He left his home by a little-traveled route and hurried into Kentucky to warn him.

James brought late news. Jefferson Davis had acted quickly to quell the revolt in East Tennessee against the Confederacy. Felix K. Zollicoffer had been commissioned brigadier general in the Confederate Army and placed in charge of the Southern forces there. A successful newspaperman in Nashville and a former Whig congressman, Zollicoffer was well known in Knoxville where he had been a printer in his youth. By force of arms and sympathetic treatment, the Confederate authorities believed he could nullify the martial spirit Johnson, Maynard, Nelson and Brownlow were whipping up among the Unionists.

The East Tennesseans had protested when Governor Harris formed a military alliance with the rebelling cotton states, in defiance of an overwhelming mandate in February against secession. In a forced plebiscite in June, Middle and West Tennessee voted to join the Confederacy, but East Tennesseans would not go along with the majority. They held a convention in Greeneville and proposed the formation of a new state. Revolt was seething in every hamlet in the mountains. Then Zollicoffer moved in, distributed 10,000 hurriedly mobilized troops at strategic points and closed Cumberland Gap and Big Creek Gap on the north. The East Tennesseans were walled off from outside help.

James, explaining this situation to his brother, told him it was impossible to set up a recruiting station within Tennessee. Since Sam was in the military service of the United States, he would be promptly taken prisoner. There was only one alternative:

Set up a station in Kentucky north of Cumberland Gap to receive the loyalists who would cross the border to him.

The two Carters went back to Barbourville, Kentucky. Here deep in the mountains, forty miles north of the enemy-occupied gateway at Cumberland Gap, they established "Camp Andy Johnson," in honor of the Democratic senator from Greeneville, Tennessee, and began to receive stragglers from across the Tennessee line. All during August hundreds slipped through little known and unprotected gaps by night and found their way to Samuel Carter. Worn, tired, hungry, they brought squirrel rifles, old pistols, knives, axes, hatchets and shot pouches. All were worried about their families and anxious to go back to their relief.

By the end of August more than a thousand East Tennessee men had assembled at Camp Andy Johnson. A motley, untrained and undisciplined aggregation, they talked through each day and long into the night about their desire to free their families from the terrors of the Confederate occupation. Carter had no food, no arms or uniforms to furnish them. However, he organized the First and Second Regiments of Tennessee Volunteers, U. S. A., arranged for officers to be chosen from the ranks, and hurried to his friend Nelson for supplies and assistance at Camp Dick Robinson near Danville. The two talked things over and decided that Carter should withdraw his men from their advanced outpost on the Wilderness Road and join Nelson's forces for training and equipment.

Governor Magoffin protested to President Lincoln against the recruiting camps in Kentucky, but the state's neutrality was soon to be more decisively broken. General Leonidas Polk, who had cast aside his clerical robes to take the sword of the Confederacy, moved into Hickman, Kentucky, on September 5, and General Ulysses S. Grant countered by crossing the Ohio to Paducah. Jefferson Davis wired General Zollicoffer on September 7: "The neutrality of Kentucky has been broken by the occupation of Paducah. Take the arms. Return the answer."[3]

On September 9 Zollicoffer ordered three regiments stationed

at Cumberland Gap to march into Kentucky. With banners waving, the Confederates pushed down the corkscrew Kentucky road into Yellow Creek Valley, and had their first brush with home guards commanded by Colonel John C. Colson, a preacher-merchant of the Valley. Most of Colson's men were Union in sentiment although the home guards understood little of the issues. One said: "We are going to whup both sides." Valiantly they brought out their hog rifles and shotguns to repel the Southern invaders, but they were quickly brushed aside. Colson was taken into custody.

Within two days Zollicoffer placed troops on the three Log Mountains and established a post at Cumberland Ford which he named "Camp Buckner," in recognition of a popular Kentuckian, Simon Bolivar Buckner who had just resigned as head of the state guard to take command of a Confederate force across the Kentucky border at Camp Boone, near Clarksville, Tennessee.

From Camp Buckner Zollicoffer sent an advance force of 500 men to Barbourville and cleaned out the remnants of the home guards and the late arrivals around Carter's deserted camp. He sent a contingent to the Goose Creek saltworks near Manchester, seized a big supply of salt and started wagons back to Tennessee laden with that precious commodity.

The Kentuckians and Tennesseans drilling at Camp Dick Robinson under Carter and Nelson were indignant because they could not be on hand to oppose the advance of the Confederates along the Wilderness Road, but they felt that they would be ready to strike back before long. A stolid but determined Virginian, General George H. Thomas, arrived to take command. Carter was commissioned a brigadier general in charge of the Tennessee regiments. Nelson, with a similar commission, was transferred to duties in northeast Kentucky.

The first important brush between the opposing forces on the Wilderness Road occurred at Camp Wildcat, October 21, 1861, where the road forked in the Rockcastle hills. Strong Confederate troops attacked advance units of the Union Army. Kentuckians under Colonel Theophilus T. Garrard, of Clay County, bore

the brunt of the assault, but they were soon reinforced by three regiments under General A. Schoepff and by Carter's First and Second Tennessee Regiments. Losses were light on both sides. The Confederates withdrew, and Carter's brigade chased them south as far as Cumberland Ford. Moving back to London, Carter waited impatiently for orders to resume the march to Cumberland Gap. General Thomas advanced the main forces from Camp Dick Robinson to Crab Orchard to support a quick offensive on the Gap.

Zollicoffer drew in his lines under this threat and began to fortify Cumberland Gap more strongly. He placed General William Churchwell in command of the garrison and brought in heavy guns. To prepare for the approaching winter, a string of log huts was hurriedly put up along the mountainside near Gap Creek. "It is the roughest place in the world," wrote a soldier to his wife, "but we are going to stick the mountain full of cannon to prevent the Lincolnites from crossing."[5]

Trouble in Zollicoffer's rear fretted him more than the troops of Carter and Thomas poised at the edge of the Kentucky wilderness. The unrest in East Tennessee was getting out of hand. Frantic messages from alarmed Southern sympathizers urged President Davis to protect the vital East Tennessee and Virginia Railroad running through the Holston Valley. Landon C. Haynes, a leading secessionist, telegraphed that the expected invasion of the Unionists from Kentucky would be disastrous: "The flames of rebellion will flash throughout East Tennessee, the railroad will be destroyed, the bridges burned, and other calamities not necessary to mention will follow."

That this was no idle fear was soon demonstrated. An underground movement in East Tennessee had been active for months, with the special objective of destroying the railroad bridges in the Holston Valley. Brownlow had boldly advocated this in the *Knoxville Whig* as early as May 25, 1861. A group of loyalists in a convention at Greeneville displayed considerable wrath because the railroad was daily carrying Confederate troops and supplies to eastern Virginia. The Reverend William Blount Car-

ter, brother of the general, was a leader in the movement. Late in September 1861 he arrived at his brother's headquarters in London. When the plan to destroy the bridges was revealed to General Thomas, he passed it on to the War Department. Washington authorities approved it promptly and sent $1,000 to enlist bridge-burning forces.

On the night of November 8, 1861, clandestine crews of Unionists struck at widely separated points, beat off the Confederate guards and succeeded in burning two bridges south of Chattanooga, one between that city and Knoxville, and two between Knoxville and Bristol. This created wild alarm among the Confederates, who made a quick roundup of suspects. Nine men were hanged, while scores of suspects went into hiding or escaped to the Union lines. Brownlow was arrested, but nothing to connect him directly with the incident was established.

The strategy of Carter and Thomas had been to march immediately upon Cumberland Gap as soon as the bridges were destroyed, but an unexpected command from headquarters stopped them. General William T. Sherman had been sent to Kentucky to succeed General Robert Anderson. He found Thomas stationed at Crab Orchard and Carter chafing at the advance post of London. When he surveyed the Kentucky situation, he grew alarmed because of the widely separated Union forces and the apparently overwhelming Confederate power strung along the whole border from Cumberland Gap to the Mississippi. He wanted more men and more supplies. He refused to let Thomas and Carter advance along the Wilderness Road and began to bombard Washington with demands for larger forces. This kept up for six weeks. By that time dismayed authorities removed him from command. Sherman wrote his brother that he contemplated suicide and General Don Carlos Buell was put in charge.

One of General Buell's first orders showed he shared Sherman's fears. He directed the withdrawal of Thomas from Crab Orchard to Danville, and Carter's Tennesseans from London to a point north of the Kentucky River. This order to Carter

exploded like a bombshell among his men. Andrew Johnson, visiting the troops at the time, was so shocked he retired to his quarters in despair. The men threw themselves on the ground. Many wept. They cursed their commanders and vowed they would not march a single step in a dishonorable and cowardly retreat. Hundreds trailed off in the woods on squirrel hunts. Whole units refused to obey.[6]

When Carter reported the situation to Buell, the commanding general revoked the order and permitted the brigade to remain at London on reconnoitering duty. As a mild censure to his men for their conduct, Carter issued a statement to bolster their morale.

> Soldiers: You love your homes, your families & your native E. Tenn. All are worthy of your love; but in memory of the past, in view of the future, so conduct yourselves that the loved ones at home shall not have cause to blush at your acts, or the land which looks to you to aid in her deliverance be covered with the shame of the misconduct of her sons. Your wives, your daughters, and your sisters are daily giving proof of the most exalted patriotism & most unwavering loyalty. . . . Were you to return to them stained with dishonor, think how their true and noble hearts would bleed & what shame you would bring upon their heads which are worthy of being crowned with all honor. . . . In the future, let me only have cause for praising you & May this be the last time, I shall have reason for uttering a word of censure.[7]

Impatient at the further delays, Carter kept up a correspondence with General Thomas, pleading for quick action. He reported that recruits were still arriving daily from East Tennessee, and that he had no arms with which to equip them. These refugees brought distressing news of conditions at home. On November 24, 1861, Carter reported: "The condition of affairs in East Tennessee is sad beyond description, and if the loyal people who love and cling to the government are not soon

COLONEL WILLIAM WHITLEY

THE FIRST BRICK HOUSE IN KENTUCKY

Home of Colonel William Whitley built in 1782, five miles west of Crab Orchard on the Wilderness Road

relieved they will be lost." His brother William, who had escaped after the bridge-burning episode, wrote him that the whole country suffered under a reign of despotism.

The Union men are longing and praying for the hour when they can break their fetters. The loyalty of our people increases with the oppression they have to bear. Men and women weep for joy when I merely hint to them that the day of our deliverance is at hand.

All the pleas of Carter and Thomas to Buell were ineffectual. Buell felt that an immediate thrust at Cumberland Gap could not succeed, even though McClellan in Washington, yielding to political pressure, was prodding him. Finally Lincoln took a hand. When Congressman Maynard called on the President with two urgent letters from General Carter, he endorsed them to McClellan with the curt note: "Please read and consider." On December 3, 1861, he went a step farther in his annual message to Congress:

I deem it of importance that the loyal regions of East Tennessee and western North Carolina should be connected with Kentucky, and other faithful parts of the Union, by railroad. I therefore recommend, as a military measure, that Congress provide for the construction of such road, as speedily as possible.

But Congress was slow-moving and doubtful. No action was taken.

Maynard and Johnson went to see the President again on December 1 and secured a positive promise that an advance movement would be made immediately. They wrote Buell of their interview and urged him to proceed at once. Maynard followed with a hot letter of his own:

You are still farther away from East Tennessee than when I left you nearly six weeks ago. . . . I feel a sense of

personal degradation from my connection with it. . . . My heart bleeds for those Tennessee troops. I learn they have not been paid and are without cavalry or artillery at London and are not permitted to do what is their daily longing—go to the relief of their friends at home. With . . . the measles and blue-grass and nakedness and hunger and poverty and home-sickness the poor fellows have had a bitter experience since they left their homes to serve a Government which as yet has hardly given a word of kindly recognition. . . . My assurances to them have failed so often, that I should be ashamed to look them in the face.

He ended with a tribute to General Carter, stating he was like a father to his men.

The unmovable Buell still temporized. For another six weeks he was belabored by Johnson and Maynard and needled by hesitant orders from McClellan. Lincoln telegraphed a query: Had arms gone forward to East Tennessee? Buell responded that it was not possible to send them without a protecting force much larger than he had at his command, and that in his judgment the movement was unwise. This brought from Lincoln one of his characteristic and understanding letters:

Your dispatch of yesterday . . . disappoints and distresses me. . . . My distress is that our friends in East Tennessee are being hanged and driven to despair, and even now I fear, are thinking of taking rebel arms for the sake of personal protection. . . . My despatch, to which yours is an answer, was sent with the knowledge of Senator Johnson and Representative Maynard of East Tennessee, and they will be upon me to know the answer, which I cannot safely show them. They would despair—possibly resign to go and save their families somehow, or die with them.

I do not intend this to be an order in any sense, but merely, as intimated before, to show you the grounds of my anxiety.

Precious weeks during the winter of 1861-1862 were thus whittled away without any decisive action to carry out the

strategy which Nelson and Carter felt was easy and feasible when they had taken over their recruiting duties in Kentucky and Tennessee. The Wilderness Road lay idle and silent, with impatient armies wintering at each end. Only once—on January 19, 1862—did considerable forces come to a major engagement. At Mill Springs, north of the Cumberland River near Somerset, a battle was fought in which General Zollicoffer was killed and his troops defeated. Carter's men had the satisfaction of arriving in time to help turn the tide.

The East Tennesseans did not long rejoice over this victory. because Buell would not follow up the advantage. Now thoroughly convinced that an expedition through Cumberland Gap would be a dangerous undertaking, he set his foot down against it once more in a letter to McClellan on February 1, 1862. The mountain country, he said, was stripped of forage. An army thrust into Tennessee along the Wilderness Road could not be serviced. Three divisions would be required to maintain any immediate advantages gained. Buell believed a better entry was up the Tennessee and Cumberland Rivers. But in a gesture of sympathy for impatient Carter, he allowed the Wataugan to move his brigade toward Cumberland Gap on a reconnaissance mission and to remain in control of the Road, while the main Union forces were withdrawn for the river campaigns.

Dull and uneventful months passed for Carter and his men, fretting and fuming on the Wilderness Road north of the gateway. Their principal activity was foraging for food in the Kentucky hills and working on the Road to permit supply wagons to be brought from the depots at Nicholasville and Crab Orchard. Details of ragged soldiers cut logs and carried stone to fill chuckholes in the sloughs and marshes, and widened difficult stretches. This was irksome for men who had enlisted to fight. They grumbled and complained in their work camps along the road from London to Cumberland Ford.

Added to their physical woes was increasing anxiety for their families at home. Stragglers and bands of refugees piloted by trained scouts continued to cross the hidden passes in the moun-

tain wall, bringing news of persecutions in East Tennessee. Young men were being rounded up by Confederates as conscripts. Barns were stripped, homes pilfered, horses taken, and livestock slaughtered. Hotheaded mobs took advantage of the prevailing violence, and outlaws and bushwhackers unattached to either side killed and robbed.

The Tennesseans stationed along the Wilderness Road were at least a threat to the Confederates stationed at Cumberland Gap. The post became a dangerously exposed advanced sector of the long line after the Union conquest of Fort Henry and Fort Donelson, and the occupation of Nashville. General Churchwell turned the command of the Gap garrison over to Colonel J. E. Rains and went to Knoxville as provost marshal for East Tennessee. Rains worried about Carter's men. He reported early in February that his force of two regiments of infantry, one battalion of cavalry and one company of artillery was in danger. Reinforcements of two regiments and six heavy pieces of artillery bolstered his defense.

Carter sent frequent scouting parties to the gates of Cumberland Gap, which spurred Rains in his preparations for an expected major attack. On March 21 Carter himself led a considerable force across Cumberland Ford into Yellow Creek Valley, where the gray lines at the mountain pass were plainly visible. His light artillery exchanged shots with the enemy, but little damage was done. After the tantalizing threat he withdrew until Buell could provide reinforcements for a stronger attacking force. The thrust through Cumberland Gap to sever the vital rail line serving the Confederacy, which he and Nelson had so eagerly planned, was stayed by the dead hand of inaction.

1 Carter Family Manuscripts, in possession of Mrs. J. Frank Seiler, Elizabethton, Tennessee.

2 *Sketch of the Life of William Nelson* (author unknown; Cincinnati, n. d.), p. 6.

3 For the official documents concerning the effort of the Unionists under Carter and Thomas to march upon East Tennessee during the fall of 1861, see *The War of the Rebellion: a compilation of the Official Records* (Washington, D. C.), Series II, I, 823-931.

4 Interview by author, August 25, 1938, with John Spencer King, a Home Guard serving under Col. John C. Colson.

5 Letter of Dr. U. G. Owens to his wife, Oct. 8, 1861. Owned by Prof. Owen, R. Hughes, Memphis State College.

6 Interview by author, April 6, 1940, with Andrew Jackson Snow, one of 360 men who arrived at Camp Dick Robinson from East Tennessee in August 1861 and was a private in Company A, Second Tennessee U. S. Volunteers.

7 Carter Family Manuscripts, General Brigade Order, No. 4-5, Nov. 17, 1861, in possession of Mrs. J. Frank Seiler, Elizabethton, Tennessee.

Chapter 17

Advance and Retreat

A FORMER West Pointer and new major general, George W. Morgan, of Mount Vernon, Ohio, drove in a buggy, April 11, 1862, to General Carter's brigade headquarters at Cumberland Ford. He had been called from civilian life to take command of the recently organized Seventh Division of the Army of the Ohio for the long delayed advance along the Wilderness Road toward Cumberland Gap. The nucleus of his division was to be Carter's orphan brigade, and he hurried forward over the old Road to take command.

When Morgan arrived at the Wataugan's headquarters, he found a disreputable-looking outfit. Many of the men were afflicted with scurvy; all were poorly clothed and armed. Some of the companies were less than fifty percent effective. Recent refugees from East Tennessee had been formed into the Third and Fourth Tennessee Regiments, commanded by L. C. Houk, of Anderson County, Tennessee, and Colonel Robert Johnson, of Greeneville, son of Senator Johnson. These new men were raw and undisciplined, and their principal occupation since their enlistment had been to work on the road in the neighborhood of their camps at Flat Lick.

Morgan informed Carter that reinforcements were on the way. Four brigades had been authorized for the expedition. In addition to Carter's Tennesseans were troop units from Kentucky, Ohio, Indiana, Michigan and Wisconsin. The brigade commanders were the brigadier generals, Samuel P. Carter, James G. Spears

238

and Absalom Baird, all Tennesseans, and Colonel John Fitzroy de Courcy, an Irish soldier of fortune who had been given a command of Ohio troops. The full force would number about eight thousand men. While Morgan and Carter planned their strategy for the investment of Cumberland Gap, the new regiments trailed into Cumberland Ford from central Kentucky.

With Carter and De Courcy, Morgan immediately made a reconnaissance of the great pass and studied the land. Convinced that a direct assault from the north would be met with stiff resistance and perhaps repulsed, he decided to make a flank movement through Rogers and Big Creek Gaps, two passes eighteen and thirty-five miles west of Cumberland Gap on the dividing wall. By crossing through these passes into lower Powell Valley, he could swing his army into the rear of the Confederates, cut them off from the scattered outposts of East Tennessee and the southwestern part of Virginia and possibly force a surrender by siege if not by assault.

The route chosen for the flank movement was through a jumble of hills and mountains along local roads where few wagons had ever passed. It penetrated a sparsely settled wilderness known to the natives as "South America" and "Germany." Before Powell Valley could be reached, the backbone of the Cumberlands rose more than a thousand feet above the broken hill land, and Rogers Gap was a mere notch through which a horse trail led. Farther west, Big Creek Gap was a sharp water pass but it was reached by a longer and equally difficult road which ran from Cumberland Ford along the eastern base of Pine Mountain.

The Confederate works at Cumberland Gap could be plainly seen from a peak on the third Log Mountain three miles south of Cumberland Ford. Here at the Moss house, General Morgan stopped his advancing units and masked a force as though to make a frontal assault. Under cover of darkness he sent the separate brigades by a hidden road to the right, leading up Clear Creek along the eastern base of Pine Mountain. The brigades of Carter and Spears were dispatched ahead with instructions to

take still another right fork at Lambdin's house for the longer route to Big Creek Gap.

De Courcy was next with his brigade. At Lambdin's he took the shorter left fork leading through the almost trackless country of "South America" and "Germany" for the nearer crossing of the Cumberlands at Rogers Gap. He was followed by the artillery, consisting of twenty Parrott guns, weighing 8,000 pounds each, and a train of 120 wagons. Baird's brigade brought up the rear. The divided columns of the four brigades were to be united in Powell Valley at the southern base of Rogers Gap after they had crossed the western wall of the Cumberland range.

The movement began on June 6. The troops traveled slowly over narrow and little used paths. Fatigue parties cleared and widened the roads for the artillery and wagons. When the steep slopes of Cumberland Mountain were reached, the artillery was dragged upward by a dozen teams of mules to each gun, hundreds of men assisting with ropes, chains and blocks and tackle. An artillery officer said that some of his men who had been on an overland trip to California during the gold rush complained that their former experience was nothing compared with the difficulties they encountered in dragging their guns and wagons up the long precipitous ascent of seven miles to the crest at Rogers Gap.

The advance brigade of De Courcy was the first to cross over. Behind him were the toiling line of heavy guns and wagons, and Baird's sweating, puffing and complaining infantrymen strung out for more than five miles. De Courcy sent a small contingent of Union cavalry to take possession of a narrow gap two miles east of his crossing place, where they shooed off some Confederate guards. Surprised by this sudden appearance of the enemy, the Confederates hurried to report to the garrison at Cumberland Gap that the Yankees were coming in force.

While this movement across the mountain was under way, General Morgan, still at the forks of the road at Lambdin's, was overtaken by a courier with a message from General Buell. Buell

reported things were not going well at Chattanooga. General Kirby Smith at Knoxville would surely trap Morgan and perhaps invade Kentucky. It was imperative that the Seventh Division fall back to the Cumberland River to oppose this expected advance of the Confederates. Morgan read the dispatch with dismay and immediately sent word to his brigade commanders to turn around and come back.

The Tennesseans, at last in sight of their homeland, received the order with consternation and bitterness. To retreat seemed madness to them, but orders were orders and the reverse movement began.

For twenty-four hours the long lines of infantry, artillery and wagon trains struggled back across the mountains. All the units had reached the northern base of the mountain when an excited soldier of the First Tennessee came running to De Courcy. He said that he had trudged along the mountain crest to Cumberland Gap the night before and had looked down at the enemy works there. He noted a considerable commotion which appeared to be preparations for evacuation.

De Courcy halted his brigade and hurried the information to General Morgan. Meanwhile the commanding general had received another message from Buell, countermanding the previous order to retreat and permitting Morgan to use his own judgment.

Morgan at once stopped the countermarch and turned the soldiers back to their task of crossing Cumberland Mountain for the third time in forty-eight hours. In spite of their exhaustion, they greeted the new order with cheers and once more resumed the backbreaking struggle. On the morning of June 14 all units had reached their rendezvous at the base of Rogers Gap in Powell Valley. Carter and Spears were the last to arrive from their long swing through Big Creek Gap and up the Valley. Their men were utterly worn out. They had met some resistance at the gap and had escaped being trapped by a detachment of Kirby Smith's men after a loyal woman made a long daring ride through the night to warn them.

At one o'clock on the morning of June 17 Morgan's united force moved up Powell Valley toward Cumberland Gap. At breakfast time they had reached the Thomas farm, which had been abandoned by a Confederate outpost during the night. Pushing on rapidly, the troops came upon Cumberland Gap about noon and found it evacuated and in smoking ruins. The last unit of the evacuating force under Colonel Rains had hurried south along the road to Tazewell, escaping the Federal forces on the Powell Valley road. The main body was well on the way to safety in the Clinch Mountains.

By two o'clock Morgan was in complete possession of the abandoned fortress. The national colors were unfurled on the top of the Pinnacle and a salute was fired by each brigade from that lofty eminence. Morgan jubilantly reported to Washington: "The Gap is ours, and without the loss of a single life."

The tired Tennesseans in the Carter and Spears brigades were not content to linger at the pass. Now that they were on their native soil once more and in sight of their home counties, their first thought was to chase the fleeing Confederates down the Tazewell road. Morgan granted permission, and Carter swung his men into column. Although spent from the arduous marches of the preceding days, they made a forced march and reached Tazewell in the late afternoon. But Rains and his men were already out of danger at Clinch River. The pursuers reluctantly returned to Cumberland Gap.

The Confederate works at the pass had been left a shambles in the hasty withdrawal. Five hundred standing tents were cut into slits. Flour, meal, rice and beans were strewn over the hillside. Five of the largest guns had been spiked, and one long "sixty-four" had been pitched over the brow of the Pinnacle to a ledge two hundred feet below the crest. Tons of shot and shell were buried in ravines and scattered about the works.[1]

Morgan in his report to the War Department stated he could have taken the fortress from the front but that two-thirds of his attacking forces might have been left bleaching on the mountainside. Secretary Stanton wired the congratulations and thanks of

President Lincoln, and Buell from Huntsville, Alabama, belatedly added his commendation.

For hundreds of East Tennesseans it was reunion time with their loved ones, who came across the hills to visit the soldiers at the garrison. A correspondent of the *Cincinnati Gazette* reported:

> No sight was ever more gratifying to me than the meeting of these refugees (men who had been run off by the Secesh more than a year before) and their friends and relations. Men, old and young, would greet them with those feelings of welcome that can only be felt by an oppressed people amid storms of anarchy and rebellion. Woman . . . in the unction of her patriotism, forgetting the presence of strangers would utter the wildest exclamations of joy; and if of kin to our honored guides, would throw their arms around them and find relief in their only solace in joy and trouble—tears![2]

Recruits were brought in by "Red Fox" Daniel Ellis, Jacob Myers, William McLane and others who became famous as pilots for the refugees during the war.[3] On June 24 Morgan reported to Secretary Stanton that citizens of Virginia, Tennessee and Kentucky were coming in by the score to take the oath of allegiance. Within three weeks, more than 800 new recruits were added to his forces, and on one occasion 600 from a secret assembly point in East Tennessee arrived at one time, many of them in rags and barefooted.

Morgan planned now to extend his campaign into East Tennessee and take possession of the railroad between Knoxville and Bristol. However, his request for additional troops was not granted. For ninety days he devoted his efforts to building up enough supplies to last 20,000 men for six months. He repaired the old wórn-out Road leading from the Gap to the Bluegrass, and hundreds of wagons daily creaked over it carrying 4,000 stands of arms, kept during the winter at Nicholasville and Crab Orchard.

Early in July a correspondent of the *Cincinnati Gazette* rode in a wagon over the Road from Lexington to Cumberland Gap and gave Morgan a report on its condition. He recited some of his observations for *Gazette* readers:

> The road from Lexington to the Gap is remarkable for possessing all the qualities of all the roads in the world! From Lexington to the foot of the mountains—about forty miles—it is a well graded, thoroughly macadamized, beautiful pike. Before reaching the Big Hill, the mountains loom up in the distance, flanked on the right by the Knobs—known as Joe's Lick, Blue Lick, and Pilot Knob. These spurs of the Cumberland range make a fine picturesque appearance . . . but some of their sides are frowning and precipitous. . . . Hills, at an angle of forty-five degrees, covered with loose and permanent rocks, rise before us for a full hour, then another to descend. "Sink holes" yawn deep enough to bury a small mule, and pits of marl, filled with old rails, out of which unfortunate teams had again and again been lifted, and then left open for others to "stall" and flounder in.
>
> Yet, during our five days' journey, we met at least 500 Government wagons and not less than 3,000 mules. Over this horrible road these miserable animals and these wretched wagons are constantly carrying forage, provisions, and ammunition to supply the wants of our brave and faithful soldiers. Dead animals and broken wagons are unsightly monuments of a bad policy. When Congress refused aid to construct a railroad through Kentucky to East Tennessee, it ought certainly to have made an appropriation sufficiently large to have made and kept in repair during the war a good wagon road.[4]

An experienced army engineer, Lieutenant W. P. Craighill, was sent from Washington to strengthen the defenses at the pass. Batteries were placed on Three States Peak and along the mountainsides facing the south. Troops were deployed at the roads approaching from Virginia and Tennessee. Regiments bivouacked in Yellow Creek Valley. Heavy guards were sta-

tioned at Baptist Gap two miles west of the main pass, and on the road back of the Pinnacle leading to Harlan County, Kentucky. The long gun of the Confederates which had been tumbled over the face of the Pinnacle was snaked around the brow of the cliff and dragged once more to the crest where its muzzle was pointed southward to command the approaches from Powell Valley. It was affectionately called "Long Tom." Occasional shots at daring Confederate vedettes lurking in the fringe of woodland beyond Poor Valley Ridge sent them scurrying into the bushes.

The summer days lengthened into August 1862. Morgan fretted over his failure to get reinforcements for a general advance into East Tennessee. He felt that the occupation of the pass which General Bragg had termed the gateway to the heart of the Confederacy was proving ineffectual. The Tennesseans were clamoring for a vigorous advance; the Kentuckians, more than a fourth of the division, were spoiling for a good fight; and the volunteers from Ohio, Indiana, Wisconsin and Michigan were anxious to get on with the war. Their fiery demand that East Tennessee be swept of every Confederate flamed high. But the War Department was more concerned with General Buell's larger operations around Nashville, where he was sparring with Bragg. The neglected and isolated division at Cumberland Gap was left stranded while Kirby Smith and Bragg planned the invasion of Kentucky.

The chance for Morgan's stroke at the vital East Tennessee railroad evaporated when Smith at Knoxville and Bragg at Chattanooga began their co-ordinated march into Kentucky. Stopped in front by General Stevenson's army hovering at the edge of Powell Valley, Morgan could not prevent Smith's army of 25,000 from filtering through Big Creek Gap and Rogers Gap in a flank movement which put the Confederates in his rear on the Wilderness Road. His 10,000 men were hopelessly surrounded by August 10, when the Confederates took Cumberland Ford and congregated in force at Barbourville.

Before communications with the outside were completely cut,

Morgan sent hopeful messages to Washington saying he was able to withstand a long siege. He did not give his true condition, because he expected the enemy to intercept some of his dispatches and thereby be deceived. However, his last direct telegram to Stanton on August 10 indicated that he had supplies to last only three weeks, and that already his men were reduced to half rations. On that night General John Hunt Morgan's cavalry swooped into Cumberland Ford and cut the telegraph line.

Smith tarried a few days at Barbourville while he debated whether to turn upon Morgan and demolish him, or continue his march to Lexington. Feeling sure that the little Union army was completely trapped, he sent a demand for surrender. Morgan curtly replied: "If you want this fortress, come and take it." Knowing that Morgan was effectively cut off and escape was impossible, Smith hurried along the Wilderness Road toward the Bluegrass, routed a force of green troops under Generals Manson and Nelson at Richmond[5] and marched triumphantly into Lexington. Stevenson moved up closer to the Gap from the south and decided to starve the garrison into surrender.

For nearly two months the men at Cumberland Gap were completely lost to the outside world except for a few communications carried by couriers to the North. Half rations were soon reduced to quarter rations. Then came lean and stringy meat from starving mules. At last there was no bread, rice, flour or potatoes. Corn, fodder and hay were exhausted. Carcasses of starved artillery horses were dragged outside the lines, and the stench of decaying bodies reminded the men of their fate if relief did not come soon.

Rumors and speculations were rife. Word came that General Lew Wallace had reached London with a big army, and the Indianians cheered. Next came the news that Colonel James A. Garfield was on the way and the Ohio men celebrated. Once it was bruited that barrel-bellied William Nelson was bringing relief, and it was the turn for the Kentuckians to rejoice. All these rumors proved false. The men waited, hungry and de-

spondent. The specter of starvation cast its shadow across the pass. All knew that something must be done quickly if they were to be saved.

Morgan learned that the main body of the Confederate troops under Smith had moved up the Wilderness Road to Big Hill and Richmond, driving untrained Federal troops before them. He decided upon a last effort to get food. He sent De Courcy's brigade and the Seventh Michigan battery over the one clear road from Cumberland Ford to Manchester with a train of a hundred wagons to forage in isolated and mountainous Clay County. Each man drew three biscuits to serve for five days' rations. The foragers passed Cumberland Ford without incident and marched up Straight Creek into the Goose Creek region. Instead of finding provisions to send back to their comrades at Cumberland Gap, the foragers were themselves reduced to sour apples and nubbins. Papaws were stripped from the bushes, and in a little while even that wild food was gone. De Courcy sent word to Morgan that he could expect no supplies from the barren hills of Clay County.

On September 12 when the Cumberland Gap men had been without bread for six days, the quartermaster reported that there was no more forage for the remaining mules and horses. He advised that they be driven north. The wagons would have to be destroyed, the artillery abandoned, and the men surrendered to Stevenson who had moved into the outer defenses on the south. Morgan called together his brigade commanders, Carter, Spears and Baird, and explained the situation. Immediate evacuation was the only alternative to surrender, but it seemed impossible. The staff officers called in Captain Sidney S. Lyon, a former surveyor of Kentucky who knew the immediate territory and all the minor roads leading across eastern Kentucky to Ohio.

Captain Lyon stated that there was but one practicable line of retreat—along the ancient Warriors' Path to the Ohio. It lay through a wilderness destitute of supplies and sometimes without water for thirty miles during dry weather. The route led through Clay County where De Courcy was already being harassed by

John Morgan's cavalry, and northward along little-used mountain roads to Greenup, Kentucky, on the Ohio River. Perhaps a bold, swift march in that direction might evade Smith's army in central Kentucky and General Humphrey Marshall's in southwest Virginia.

Morgan's staff unanimously decided to attempt the retreat. After consulting his engineers and artillery officers Morgan decided that the heavy siege guns must be abandoned. Only the wagons and lighter artillery could be taken. With all food gone, the men would have to live off the country. The roads and trails penetrating the mountains would have to be widened for the wagons and artillery. The prospect for a two-hundred-mile march under such difficulties was not inviting.

Morgan sent an advance unit to gather what supplies they could. He dispatched another group to Mount Sterling with similar instructions, expecting them to be captured and thus confuse the enemy as to his actual route. He then prepared to evacuate and destroy the fortifications. The big guns were all spiked, their trunnions cut off, and the cores wedged with shot and spike. Those on the Pinnacle were pushed off the cliff. The Confederate gun "Long Tom" for the second time was sent hurtling over the big precipice. Extra wagons, ambulances, camp kettles and mess pans were destroyed. The roads winding through the fortifications and along the mountainside were mined.

On September 16 Morgan issued General Order No. 64, his last at Cumberland Gap, giving details for the evacuation. The wagon trains and a portion of the artillery started early the next night with an infantry escort. Generals Carter, Spears and Baird with their brigades of East Tennesseans followed at 11:00 P.M. Into the darkness of Yellow Creek Valley, with their faces away from the land which they had enlisted to protect, the Tennesseans marched with heavy hearts.

The last duty of the evacuation was entrusted to a Kentuckian, Lieutenant Colonel George W. Gallup, of the Fourteenth Kentucky Regiment, who had been provost marshal of the post. With a small detachment of picked men, he stayed behind to

destroy the works. Five men were placed at each of the mines, ready for the signal to set the fuses. Early in the evening Gallup went the rounds to check the preparations. Reporting at Baird's headquarters, he found General Morgan sitting on his horse, watching the retreating columns as they disappeared into the darkness beyond the campfires. They exchanged salutes. General Morgan said: "Colonel, you have a highly important duty to perform. This ammunition and these stores must not fall into the hands of the enemy. I hope you will not be captured. Farewell!" He wheeled his horse and cantered off into the gloom.

The night wore on. The fires flickered and died. A gentle rain began to fall, and heavy clouds lowered over the mountains. The mines were not to be sprung until two o'clock, in order to give the main army a chance to get well into Yellow Creek Valley. At last Colonel Gallup ordered all of his men to go, except those necessary to light the fuses.

At the time set Gallup gave the order to apply fagots to the buildings. The flames began to roll up, casting a red glow over the mountains. Then he ordered the fuses lighted that led to the dumps. He waited but there was no explosion. He rushed to the point where the main fuse was laid, seized a brand from one of the buildings, applied the torch and lingered to be sure the powder train had caught. Then he leaped upon his horse and dashed down the Kentucky road. He had barely reached a safe distance when the first explosion blasted huge rocks in every direction. By then the conflagration of the various buildings was well under way. The precipices reddened in the glow. The black gorge grew as bright as noonday. Gallup waited for the greater explosion. Here are his own words:

Every fissure and opening in the cliffs around me, was visible. The trees and rocks upon their sides, at any time picturesque and interesting, were now grand in their beauty. . . . But suddenly the scene changed. The large magazine, with its rich stores of powder and fixed ammunition, exploded. The explosion shook the mountains like a toy in

the hands of a monster. The air was filled with dense smoke, so that I could scarcely breathe. Huge masses of rock, cartridge-boxes, barrels of powder, and other materials, were blown to an indescribable height, and went whirling through the air in wild confusion, falling, in some instances, more than a mile from the exploding magazine. A moment after, the burning roof of a building, a hundred and eighty feet long, used as a store-house on the mountain, fell in, and set fire to the shells stored there.

Pursuit by General Stevenson's men was delayed for eighteen hours because of the danger from shells bursting in the debris which littered the fortifications. The Confederates tarried at a safe distance until three o'clock of the afternoon of September 18, before they moved in. Roadways were blocked by huge boulders. Before they could be cleared, the retreating army was safe in the Kentucky wilderness.

Gallup's men who brought up the rear of the retreating column reached Cumberland Ford in the early morning of September 19. They threw barriers across the narrow road where Cumberland River cuts through Pine Mountain and destroyed the swinging bridges. By the end of the day the two separate columns had gathered for a brief respite near the old saltworks at Manchester, where De Courcy's brigade was lingering. Here new dispositions were made and engineers went ahead to cut out trails wide enough for the wagons and artillery.

Dividing his forces into two columns after a day's rest, Morgan gave the order for the plunge into the unfamiliar country of eastern Kentucky. Taking the general route of the Warriors' Path, they would proceed to Proctor on the South Fork of the Kentucky River in Owsley County as the first objective. When the men got under way a unit of General John Hunt Morgan's Confederate cavalry dashed out upon their rear column. The Tennesseans under Spears wheeled to meet the horsemen and after a brief skirmish forced the attackers to fall back.

The Confederate Morgan, beaten off in the rear, divined the

route taken by the retreating Unionists and swiftly circled the slow-moving and laboring army to reach its front. He webbed the narrow roads with masses of trees and other obstacles, and kept up a running fire in front, on the flanks and in the rear. Time and again there were swift clashes.

The Union army plodded slowly on with more than half of the soldiers at times wielding axes to cut out barricades and widen the path for the wagons and artillery. Finally West Liberty was reached, and the two columns joined again. Here General George Morgan expected to meet Humphrey Marshall who had been sent through Pound Gap with 3,000 Confederates to waylay him, or a contingent from Kirby Smith's army from central Kentucky to cut him off. Instead, he found the little town quiet and deserted. The converging lines of Smith and Humphrey Marshall had not been properly correlated. The Union army passed through them safely and headed for the next objective—Grayson, a little town in Carter County, twenty-five miles from Greenup on the Ohio River.

From September 15 to October 1 only thirty miles were made by the wearied Union columns. The country was dry and barren; the roads were little more than trails; and the Confederate Morgan again placed his horsemen directly in front, firing upon advance units, barricading the roads and dashing out of ambushes to harry and annoy.

Still the struggling army toiled on. On the night of October 1 it moved into Grayson as Morgan's riders cantered out. It was the last they were to see of the bold Confederate raider's gallant horsemen.

After the men left Manchester, little semblance of military organization could be kept. The soldiers strung out along the roads for miles—every man for himself. Each had to subsist on what he could gather by the way. Hard corn was snatched from the fields and gritted for bread or parched in the grain. Pumpkins were cut open and baked. Acorns, nuts and edible roots were hunted and chewed. Water was hard to find. The streams had dried to pools of stagnant water.

In the rest intervals fires were lighted to cook what little food had been gathered. A squad of soldiers would often use a campfire left burning by a preceding group. Mountain hogs, called "razorbacks" or "elm peelers," were shot in the clearings. Once when a soldier was drawing a bead on a hog he had spied in the woods, General Carter came along. The soldier expected a reprimand; it had been ordered that no stock of the natives should be killed except when purchased from the owner. The general said to the soldier with a twinkle in his eye: "Don't kill anything for waste." The soldier understood, but waited until the general was out of sight before he got his hog.

A group of soldiers passing a farmhouse raided a stand of thirty beehives. The stings of the insects were forgotten as the hungry men devoured the rich combs of honey.

To grit corn along the march the men curved a tin plate over a smooth pole or rail and punched it full of holes with a bayonet. Sometimes they used a piece of old stovepipe, or a sheet of tin nailed over a board. Almost every individual, squad or group was equipped with such a miniature mill.[7]

Officers as well as common soldiers suffered from the lack of food. General Morgan went one day with nothing to eat but an ear of parched corn. Another day his entire staff had only twelve potatoes. Ten women, wives and daughters of the officers, traveling with the army, shared the hardship. The general noticed a woman sitting on a log, pale and worn. Asked if she were ill, she replied, "Oh, no; I have eaten but once in forty-eight hours."

Unseasonable heat added to the suffering. Clouds of dust fogged the hot air and filled the eyes and ears of the marching men. On they tramped, begrimed and footsore. Shoes were worn out and thrown away. Padding along on swollen bare feet, the men joked with each other on how hard they could kick the rocks. The packs with which they had started were thrown away, and the roadside was strewn with blankets, mess kits and trappings. Everybody talked about how far it was to the Ohio.

Joyous were the cries of the weary and famished when they

finally beheld the cool, inviting waters of the river at Greenup on October 2. The shouts passed down the columns. Unshaven and dusty, staggering with fatigue, the men wept as they looked across the beautiful river to the northern shore where they might have rest and food. The band of the Thirty-third Indiana Regiment blared out a triumphant tune, "Ain't You Glad You Are out of the Wilderness," as they were ferried across the river.

Ohio citizens poured out to welcome the stragglers. Church bells rang. Food in abundance was brought in by the citizens, and all were soon feasting on roast beef, boiled ham, baked turkey, chicken, bread, cakes and pies. Supplies of new uniforms were rushed to the various camps of the division. Within a few days the hardships and suffering of the 200-mile retreat through a barren land were forgotten.

General Morgan's report stated proudly how he had saved the Seventh Division of the Army of the Ohio. During his occupancy of Cumberland Gap he had captured 542 Confederate officers and soldiers, with a loss in his own ranks of only eighty. Not a gun taken from Cumberland Gap had been lost, and only the wagons broken down or tumbled over cliffs had been left behind. He claimed part of the credit for stopping Bragg and Smith at Perryville, October 8, 1862, maintaining that he had delayed Smith long enough to prevent a junction of the Confederate armies.

But censure was coming. He had to face the humiliation of a military inquiry as to why it was necessary to evacuate Cumberland Gap.

While Morgan and his men were recuperating in hospitable Ohio, the disconsolate Bragg and Smith dragged their own armies out of Kentucky after the battle of Perryville. The Federals had showed unexpected strength, and Kentuckians had not rallied to the Confederacy as expected. The only line of retreat open to the gray army was the Wilderness Road.

On October 13 the discouraged Confederates took to it, with

Bragg in the lead. Smith followed with Colonel Joe Wheeler's cavalry protecting the rear. The wagon train, loaded with supplies gathered in the Bluegrass, moved out of Lexington to join the troops at the junction of the roads in Rockcastle County. At Big Hill where the mountains began, the Road wound up the slopes of a steep escarpment, and thousands of foot soldiers stopped to push the wagons through the mire and over stony declivities. Hundreds of horses fell dead in their tracks, many wagons broke down, and the road was strewn with debris for miles. Many of the supplies were lost before the long train got through the mountains.

Bragg appeared to have easier going with the vanguard, but Smith had trouble all the way. Anxious for his hungry men, he sent messages ahead to have supplies concentrated at Cumberland Gap. When he reached the pass on October 22, he dispatched another message to Bragg, now safe at Knoxville. His men had suffered everything on the march except actual starvation, at least 10,000 of his troops were scattered through the country trying to find something to eat, and yet Bragg had instructed him to leave 3,000 men at the Gap and hurry with the rest to Kingston, Tennessee. Smith complained that immediate operations were impossible; his men were worn down from exposure and want of food, and they were in sore need of shoes, clothing and blankets. By the time the two armies reached Knoxville, it was estimated that 15,000 men required medical attention.

Colonel Wheeler was the last of the retreating Confederates to arrive at the Gap. His cavalry had been engaged in an almost continuous running fight with the Federal troops of General T. L. Crittenden who pursued him as far as London. On October 23 Wheeler issued a message to his men, resting at the Gap from their arduous Kentucky campaign. He praised them for valor in more than twenty pitched battles and a hundred skirmishes fought within two months. They rode out of the pass on the morning of October 24, 1862.

1 Col. B. F. Stevenson, *Letters from the Army* (Cincinnati, 1884) , p. 85.

2 *Cincinnati Gazette,* July 23, 1862.

3 See *Thrilling Adventures of Daniel Ellis* (New York, 1867) , for an account of the activities of these East Tennessee Union scouts and pilots.

4 *Cincinnati Gazette,* July 23, 1862, article by "Granite."

5 In this battle, August 30, 1862, the Confederate General Kirby Smith routed about 7,000 Union men under Generals Manson and Nelson, most of them new and unseasoned troops from Indiana and Kentucky, who had been rushed forward to repel the advancing Confederates. Nelson arrived on the field south of Richmond after the rout began and showed great courage in attempting to rally the fleeing men, even striking some of the officers with the flat of his sword. He was severely wounded but managed to escape. In a quarrel with General Jeff C. Davis, September 29, 1862, in the Galt House, Louisville, Kentucky, he was shot to death in the presence of a number of friends, including Senator John J. Crittenden.

6 J. T. Headley, *The Great Rebellion* (Hartford, Connecticut, 1866) , II, 109-110.

7 *Cincinnati Gazette,* Oct. 9, 1862.

Chapter 18

Carter's Raid on Boone's Road

A T THE end of a hard ride up the northern slopes of Cumber-land Mountain, December 28, 1862, General Samuel P. Carter halted his panting horse on the crest in Crank's Gap, thirty-five miles northeast of Cumberland Gap. The sun was dipping behind the western hills, and a frosty wind whistled through the sharp notch in the mountain wall. Carter looked wistfully across upper Powell Valley and beyond to the pile of hills and mountains purpling in the evening shadows. Leading through the expanse of valleys and ridges into the beautiful Watauga and Holston country was the century-old Road of Daniel Boone and the pioneers.

Carter was at last ready to take that Road.

After more than twelve anxious months trying to reach his torn and troubled country under the domination of Confederate armies, Carter was back again with 980 Union cavalrymen ready to strike at vital bridges on the East Tennessee and Virginia Railroad. Pausing with him on the mountain were his brother, Colonel James P. T. Carter, Colonel Theophilus T. Garrard and other staff officers. Coming up from the Kentucky side were the first of the long line of horsemen struggling along a barely visible trail. The officers were discussing their plan of action as darkness settled upon the wilderness.

It had been three months since Carter had led his Tennessee brigade out of Cumberland Gap in Morgan's ignominious evacuation. Events had moved swiftly since that time, and Buell had

been supplanted by Rosecrans as commander in the West. The Union forces had been concentrated at Nashville and the stage was being set for the battle of Stone's River. Carter would not be with his brigade in that battle. The detached service in which he was now engaged was more in accord with his desires. Destruction of Confederate depots in East Tennessee and of bridges on the railroad which carried troops and supplies to the enemy were his objectives. For weeks he had been working on details. On Christmas Day the cavalry units assigned for his use were assembled at the Goose Creek saltworks. They consisted of eight companies of the Second Michigan, Seventh Ohio and Ninth Pennsylvania Cavalry. Originally Carter had been promised a force of 3,000 men, but when the final dispositions were made, he had only these 980.[1]

On December 26 the horsemen filed out of their bivouac at the saltworks and proceeded to Manchester where the accompanying wagons were unloaded and turned back, and the supplies transferred to pack mules. The weather was bitter cold as the caravan strung out across Red Bird Mountain, through the little village of Mount Pleasant, the seat of Harlan County, and up Martin's Creek toward the looming barrier of Cumberland Mountain. Here the mules were unloaded and also turned back.

Each man carried a hundred rounds of ammunition, one extra shoe and spare nails for his horse. Two axes and some shoeing tools were provided for each company. Only light cooking utensils were carried, and rations were reduced to the minimum. Their raid would take them nearly two hundred miles into the enemy country; they must be lightly accoutered for swift traveling. Preparations were made with the greatest secrecy. The men were kept in ignorance of their mission until they had cut loose from their wagon and mule trains.

Crank's Gap was the only unoccupied pass in the Cumberland wall between Cumberland Gap and Pound Gap through which the riders could go without being discovered. Confederates were swarming around the western passes at Cumberland Gap and Big Creek Gap, and Powell Valley was known

to be well guarded. Humphrey Marshall from his headquarters at Abingdon had spread his forces along the railroad and the valleys bordering the barrier mountain at the Kentucky line. When they left Crank's Gap, the Union men would be in hostile territory.

Carter and his staff waited on the mountaintop while the main body of men assembled for final instructions. He gave orders that they should keep in close formation as they rode down in single file, and that there should be no talking. If they should encounter any inquisitive natives, they were to pretend they belonged to Nixon's Georgia Cavalry and Maclin's Tennessee and to account for their Federal uniforms by saying that they were returning from a big raid into Kentucky where they had captured a supply of new Yankee uniforms.

Night had fallen when Carter and his guides led off the little trail into the recesses below Crank's Gap. It took four hours for the column to reach the bottom of the mountain, but dawn had not broken when they skirted east of Jonesville by six miles and came into the Virginia segment of the Wilderness Road. Like ghostly couriers they leveled out into a gallop on the widening Road, crossed Powell Valley and forded the river. Walden's Ridge was topped by daylight, where a two-hour rest was taken, coffee made, meat toasted and horses fed.

In the saddle again in broad daylight the men made swift progress over Powell Mountain and through the narrow valleys. Natives eyed the galloping horses in wonder and without alarm. Only a few stray Confederates were encountered. At one o'clock the raiders reached Pattonsville. Here, unknown to them, the first message of warning was sent to Marshall at Abingdon. Sunset found the riders at Clinch River where they halted for an hour at a mill. Into the saddle again, they sped through the night in the dark regions of Purchase Ridge, over Copper Ridge and on to Estillville, now Gate City, backtracking on Boone's old trail.

At Estillville the men learned that an enemy force was hiding at Moccasin Gap on the alert since the alarm sent from Pattons-

ville. Scouts were sent ahead to flush the enemy, and by the time the main body came along the small Confederate force had fled. By eight o'clock on the morning of December 30, they had reached Blountsville, only a few miles west of Bristol. Their objectives were near at hand.

Carter halted to permit stragglers to come up, and to divide his forces for their separate tasks. He hurried a detachment of Michigan men to Union, now Bluff City, where a 600-foot railroad bridge spanned the south fork of the Holston. It was guarded by three companies of Confederates under Major B. G. McDowell. So complete was the surprise that the major and his staff and garrison of 200 men were captured, and the long bridge of green timbers was totally wrecked. Not wanting to be encumbered with prisoners, the Union officers immediately paroled the surprised Confederates. Some of the prisoners had been serving the Southern cause against their will. These fellows showed happy relief and vowed they would not take up arms again.

Carter sent another detachment to the bridge over the Watauga at Carter's Station, ten miles west of Union. Captain Love, commanding the Sixty-second North Carolina, C.S.A., was racing along on an engine and tender with a telegraph corps to investigate the rumor that a Federal force was in the country. He and his crew were captured, the telegraph lines cut, and two companies of guards at the bridge were attacked and driven into the woods. The 300-foot bridge was burned, the depot wrecked, a large store of arms and ammunition destroyed, and the locomotive and tender were run into the river among the broken and flaming debris.

It had rained during most of the day. The work was cold and disagreeable, but the operations were completely successful. The prisoners totaled over four hundred men, including one colonel, two captains and two lieutenants.

Carter united his forces after dark and permitted a few hours' rest. He realized that news of the raid was spreading rapidly and that soon he would be faced with a superior force of con-

verging Confederates. At one o'clock on the night of December 31 he gave the order "To the saddle!" The tired and sleepy men sprang to their mounts and galloped back along the road to Kingsport. Here they lingered for three hours, but knowing that pursuit was close at hand, they soon plunged on through the darkness toward Rogersville. Colonel James P. T. Carter, remaining behind at a friendly hotel in Kingsport, was fired upon, and his orderly was wounded.

The raiders skirted Rogersville by eight miles, crossed Clinch River, topped Clinch Mountain at Looney's Gap and reached Powell Valley by daybreak on January 2, after a roundabout march of twenty-four hours. A short rest for breakfast and the men were in the saddle again, heading toward Jonesville along a route infested with bushwhackers looking for them.

General Humphrey Marshall, the obese Confederate commander of southwest Virginia, arrived in Jonesville with a pursuing force at dusk on January 2, in time to see the fleeing heels of Carter's men. Two more companies of Confederate cavalry had galloped up from Cumberland Gap soon enough to fire upon the rear guard of the Union men as they dashed through the town. Marshall could have followed but he feared an ambush in the dark hills and called off the chase.

Safely sheltered in the Cumberland Mountain, Carter led his men back over the trail to Crank's Gap. He got to the crest by eleven o'clock at night and did not halt until the northern base was reached. That last ride from Jonesville in the darkness was the most trying experience of the entire expedition. For five days and seventeen hours the men had been in the saddle, traveling 470 miles with less than thirty-six hours' rest. They reeled in their saddles. The horses stumbled and pitched up the slope. Thirty horses died in the struggle. Many had cast their shoes in the long ride and now hobbled in agony on the frozen ground. The men left the dying horses, broke up their saddles and carried their packs the rest of the way. For hours the stragglers trailed into camp.

North of the ridge and under no further necessity to hurry,

Carter took his men leisurely back to their original rendezvous at Manchester. Here they rested and feasted from their supply wagons. On January 5, 1863, they began to disperse to their original commands.

Carter was showered with congratulatory messages from his superior officers. Rosecrans, feeling better after the bitter battle of Stone's River fought while the raiders were in East Tennessee, warmly commended the expedition and recommended Carter for promotion to major general. Chief of Staff Halleck in Washington called the expedition "without parallel in the history of war." The people of the North who had been accustomed to hear of the bold, spectacular raids of John Hunt Morgan, Nathan Bedford Forrest and J. E. B. Stuart, were heartened to learn that not all the daring was on the Confederate side. Called the "Sailor on Horseback," Carter was acclaimed a hero, the first Federal officer to make use of cavalry on a wide-scale raid.

1 Accounts of the first important cavalry expedition by Federal forces in the Civil War are given in Captain Marshall P. Thatcher's, *A Hundred Battles in the West, St. Louis to Atlanta, 1861-1865, the Second Michigan Cavalry* (Detroit, 1884), pp. 91-111; *War Papers No. 19,* "A Sailor on Horseback," by G. C. Kniffen, Military Order of the Loyal Legion of the United States, Commandery of the District of Columbia, March 7, 1894; Frank Moore, ed., *The Rebellion Record* (New York, 1864), VI, 322-325.

Chapter 19

Bluster versus Bullets

COLONEL JOHN FITZROY DE COURCY fumed in his tent in Crab Orchard on August 20, 1863. He was watching the cavalry division of the Twenty-third Army Corps swing into line. His fellow officer in the Cumberland Gap campaign of 1862, General Samuel P. Carter, was off on a new attempt to conquer East Tennessee. This time an adequate Union army was detailed for the expedition under a new commanding general, the bewhiskered Ambrose E. Burnside. Carter with his cavalry had marched down the Wilderness Road to London, then across the Jellico Mountains to Williamsburg, to enter Tennessee fifty miles west of the Confederate-occupied Cumberland Gap. Three other divisions in the Twenty-third Corps were moving south along parallel roads west of the trail of the pioneers. They were to concentrate at Kingston, Tennessee, and swing eastward to Knoxville and up the Holston Valley toward the Virginia line. To back up this movement, the Ninth Army Corps was being gathered at Camp Nelson, Camp Dick Robinson and other depots in central Kentucky.

De Courcy was irked because he was not to march with the main body of Federal troops. He had been ordered by Burnside, who had joined Carter's division at Crab Orchard, to proceed with an independent brigade along the Wilderness Road for a direct assault upon Cumberland Gap, known to be held by a considerable Confederate force. He was familiar with the territory, having been with General George W. Morgan in the

262

ill-starred invasion the year before, and he felt that the force Burnside had assigned him was totally inadequate for a successful expedition.

De Courcy was a tall, dapper, lean-cheeked Irish nobleman, grandson of Lord Kingsale the 26th. He had taken up fighting as a career when he was sixteen. He came to America at the outbreak of the war and was put in command of the Sixteenth Ohio Volunteers. After his service with Morgan in 1862, he had taken part in the Vicksburg Campaign. He was not moved by any strong patriotic motives, but being of hot Celtic blood he had an affinity for fighting men and a violent dislike for slavery. His military discipline, vitriolic tongue and impressive profanity did not win warmth or affection from his men.

After Carter and Burnside moved out of Crab Orchard, De Courcy called his subordinate officers together and took stock of his assignment. His infantry consisted of the Eighty-sixth Ohio Volunteers, commanded by Colonel Wilson C. Lemert, and the One Hundred and Twenty-ninth Ohio, with Colonel Howard D. John in charge. His artillery was the Twenty-second Ohio battery of only six light Elrod guns, commanded by Captain Harry M. Neil. His cavalry was made up of the Eighth, Ninth and Eleventh Tennessee—recent refugees from East Tennessee with no military training. One of the regiments was commanded by Colonel James P. Brownlow, son of the "Fighting Parson." In all, De Courcy did not have more than 1,700 troops, and they were green, with little or no battle experience.

He explained to his officers that Burnside had told him their job in the general advance was to clear the Wilderness Road from Crab Orchard to Cumberland Gap as a supply line for the main Federal forces to be lodged in East Tennessee. He sneered at the instructions given him. If he followed Burnside's directions, he said, the expedition would fail. His shabby forces could not hope to take Cumberland Gap by direct assault. But, he added, perhaps the job could be done with subterfuge and strategy.

The Irish officer outlined what he had in mind. It was neces-

sary to make his force appear much larger than it actually was, so that he might put up a big bluff for the commander of the Confederate garrison. Two of his officers intervened with some questions. De Courcy shut them up rudely and said it was not for them to question but to obey; he was in supreme command and knew what he was about.

To magnify his force, he ordered that the numbers of the regiments shown on the men's caps be juggled into different combinations. The Eighty-sixth and One Hundred and Twenty-ninth Regiments could be split into an appearance of eight regiments each, and the artillery and cavalry regiments to a lesser degree with their smaller numbers. In all, he could appear to have sixteen full regiments, four times the actual number. He explained that on their march to Cumberland Gap they would have natives in their camps selling pies, cakes and other supplies, and that among these visitors would doubtless be spies who would pass to the enemy information of the numbered regiments in the brigade. No effort would be made, he said, to keep such spies from slipping out of their lines, so that the false information would be sure to get through.

De Courcy moved out of Crab Orchard on August 25. His men had arranged the numbers on their caps according to his directions, but he was not pleased with the support he was receiving from the Ninth Army Corps to which his independent brigade had been attached. He reported to his immediate commanding officer at Lexington that his raw and undrilled troops had only thirty rounds of ammunition, that two of the cavalry regiments had even less and no revolvers, that the battery was poorly equipped with caissons, and that there were not even enough blank cartridges for the shells in the caissons. He had rations for only four days and a small supply of grain and forage for the horses. He urged that supplies be rushed forward to him at London.

His column moved slowly in order to give time for the requested supplies to come up. On August 28 De Courcy camped at Pittman's, three miles north of London. From that point he

CUMBERLAND GAP

Etching by Harry Fenn of the south side of Cumberland Gap as it appeared in 1870, showing the Wilderness Road and military roads built during the Civil War converging at the entrance into Kentucky. From *Picturesque America*, (New York, 1872).

THE ENTRANCE TO KENTUCKY FROM CUMBERLAND GAP

Modern view looking northwest from the eastern portal of the pass. In the foreground is the Wilderness Road leading into Kentucky and to the Yellow Creek basin where Middlesboro, Kentucky, is located.

extended the telegraph line along the old road to Flat Lick, so that he might have quick communication with the Ninth Army Corps in his rear, and with Burnside's marching columns on the parallel roads west of him. He sent word to Lexington headquarters that the road between his camp and Mount Vernon was hilly and fearfully bad, and that operations would be greatly impeded unless it was so improved that wagons could be brought over it quickly. He announced that he would continue his march to the bridge over Laurel River six miles south of London, where he could cover London and protect the road to Williamsburg, which Carter and Burnside had taken a few days before.

No supplies came forward to De Courcy at London. Impatient with waiting, he moved on to Barbourville and Flat Lick. By September 7 he had all his force across Cumberland Ford and spies were out making reconnaisances of the Gap, fourteen miles away. He found evidences of a strong force there, busily engaged in preparing defenses. Incensed over the fact that food and ammunition had not been rushed to him as requested, he sent a dispatch almost every hour to Lexington, wanting to know the reasons for the delay. He learned that no trains with rations or ammunition had passed Crab Orchard, and that the commissary and quartermaster officers there had been drunk for days.

Entirely without bread for his troops, with many of his men ill in the houses along the Road in his rear, and with no surgeons or medicines, he reported that he had only enough ammunition to "bluster with." In a final blistering message to his commander in Lexington before moving on toward Cumberland Gap, he charged that if some other officer should come up, fully equipped, and take the Gap with the help of De Courcy's own intimate knowledge, he would have to explain to his men that they had been prevented from making a successful attack because they had not been properly supplied.

Despite the fact that his men were without food, and had less than thirty rounds of ammunition, De Courcy moved up on the Wilderness Road to where it crossed a spur of the first Log Mountain, five miles north of Cumberland Gap. From that

point the bristling Confederate works were in plain sight of the advancing column of Union troops, and De Courcy knew that field glasses at the Gap were focused on him. He decided to use his second piece of strategy to magnify the appearance of his attacking force. He divided his regiments into sections, separated at proper intervals, and marched them down the road leading off the mountain in plain view of the Confederates. When the foot of the hill was reached, he sent the men back to the top of the hill under cover of the forest and marched them down again for the benefit of the Confederate lookouts. He repeated this circling movement four times.

The soldiers, weary from their march, could see no sense in it. As they climbed each time back up the mountain through the woods, burdened by their heavy packs, they swore at the whimsical perversity of their Irish commander. They had enlisted to fight, not to march around in senseless circles.

After the infantry had completed their confusing maneuver and were hidden at last in the approaches to the fortifications, the three half-manned cavalry regiments of Tennesseans galloped along the dry road. They raised as big a dust as possible to screen the six Elrod guns rushed across the segment of the road visible from the Gap. In the late afternoon of September 7 De Courcy had advanced to the foot of Cumberland Mountain, and some units were established on Dark Ridge. To give a further display of formidable strength, he mounted the six light guns on Dark Ridge, about a mile north of the Gap. He masked the guns by bushes, then withdrew them under cover, brought them back beside their former stand and masked them a second time. He repeated his maneuver until he was sure that the watchful Confederate lookouts would report a long battery of fifty to sixty guns.

De Courcy was proceeding independently of another movement converging upon the Gap in its rear. For several days he had been entirely lost to General Burnside who had marched unopposed into Knoxville on September 4, after General Buckner had evacuated precipitately to London, south of the Tennes-

see River. Burnside's and Carter's troops had been treated to a big celebration by the loyal Union elements while the Southern partisans scurried to cover. Carter was named provost marshal for all of East Tennessee and prepared to clear out the area. Learning that Cumberland Gap was still in the hands of the Confederates, Burnside sent General James M. Shackelford with a brigade of 2,000 mounted men to invest the Gap from the south. Shackelford appeared in the rear of the Gap about the same time De Courcy approached from the north.

Shackelford managed to send a line to De Courcy on the afternoon of September 7, by a messenger who circled the Confederate forces in the pass. He explained he was now in command of the situation, and he directed De Courcy to cut off escape routes for the Confederates, particularly the Harlan road which led northeast from Pinnacle Mountain.

De Courcy replied to Shackelford in a veiled and ambiguous way, stating rather petulantly that he knew what he was doing and implying he was not taking orders. He was anxious to pull the big bluff he had planned so elaborately, and take the Gap singlehanded.

Inside the surrounded Gap garrison was a new Confederate commander, Brigadier General John W. Frazer. He had no relish for the assignment. The fortress had not been entirely restored since General Morgan destroyed it the year before. The timber had been cut from the mountainsides, and the bare, shaggy cliffs were gray and desolate. The roads were still cluttered with broken wagons and debris, and the cabins, depots and buildings were piles of wreckage. A soldier described it as "a lousy old camp."

Frazer was a native of western Tennessee and a graduate of West Point. On frontier duty as captain in the U.S. Army when the war broke out, he resigned to cast his lot with the South. He had been on duty in East Tennessee for several months as the colonel of an Alabama regiment. Then he had been ordered to take the Cumberland Gap command.

When the new commander inspected his troops at the Gap, numbering about 2,500 men, he found that his loyal and seasoned soldiers were in the Sixty-fourth Virginia Regiment, commanded by Colonel Campbell Slemp, and the Fifty-fifth Georgia Regiment, in charge of Major D. S. Printup. The Sixty-second North Carolina, commanded by Lieutenant Colonel William B. Garrett, was insubordinate almost to the point of rebellion. Desertions had reduced its ranks to about 450 men. The colonel was gone, and the captain was under a cloud, accused of distributing disloyal papers. The Sixty-fourth North Carolina was little better. At one time 300 men had walked out in a body, and their colonel and lieutenant colonel had been dismissed for dishonorable conduct.

With this state of affairs among his men and with news filtering through that Federal troops were gathering in Kentucky for an invasion of East Tennessee, Frazer had hurried his defense. He started the erection of a blockhouse for a battery on a peak about a half mile northwest of the pass. Oxen were used to snake timber up the slopes for barricades, but in their poor condition many died in their yokes. Water was scarce in the dry season, and oxen hauled water from the Cave Spring on the face of the Pinnacle to the various detachments. Captain Rush Van Leer, an inventive engineer, attempted to rig up wires on which water could be transported in buckets, but the experiment failed.

The food supply was ample for at least two months, although the near-by valleys had been stripped of forage. The mill below the spring was operated day and night in grinding corn and wheat for the garrison. At the end of August the commissary report had shown more than 2,000 bushels of wheat on hand, from 10,000 to 18,000 pounds of bacon and considerable feed for the horses and mules. The batteries had been strengthened and one 32-pound Parrott gun on top of the Pinnacle swept the approaches from the north. The men were armed with new Enfield rifles recently procured from England.

Caught by the encirclement of the Federal forces so unexpectedly on September 7, Frazer blamed Buckner. On August

30 he had received an order from Buckner to evacuate Cumberland Gap, destroy all supplies and proceed at once to Knoxville because it appeared that Burnside was approaching rapidly with a superior force. Before he could act, he got another message from Buckner saying that Burnside's force was not so strong as at first reported and ordering the Gap to be held at all costs. But within three days Buckner had deserted Knoxville, crossed the Tennessee River at Loudon and destroyed the bridge behind him, without notifying Frazer of his retrograde movement.

In spite of his tight position, Frazer firmly rejected Shackelford's first demand for surrender on September 7. He was stalling for time, hoping he might get reinforcements from southwest Virginia. That night he suffered his first humiliation.

About midnight the quiet of the mountain was broken with a rattle of rifle shots. Frazer rushed from his tent in the narrow pass, now familiarly referred to as the "Saddle of the Gap," to see what the trouble was. He discovered a big blaze bursting from the mountainside near the mill and heard shouts of frightened guards racing madly through the darkness to the inner lines. A detachment of Shackelford's men piloted by Sam Chance, an East Tennessee loyalist, had crept within the circle of guards, set fire to bags of shavings and thrown them inside the mill. Taken by surprise, the guards had become panic-stricken. They shouted that "the whole Yankee army was coming." They fired their guns into the air. Some threw away their uniforms and blankets in precipitate flight. One man was wounded by a shot from his comrade. The mill and a big supply of grain were completely destroyed. In the confusion the Unionists got back to their lines on Poor Valley Ridge without a casualty.

Disgusted by this showing of his mill guards, Frazer was in dudgeon when a demand for forthright surrender came to him from Colonel de Courcy on the morning of the eighth. The bluffing Irishman, with tongue in cheek, had written that he was reluctant to bring about a "cruel loss of life" by an assault.

He assured Frazer that he and his command would be treated with due respect and consideration if they would surrender to him unconditionally. Frazer replied that he had already rejected a similar demand from Shackelford, but, apparently impressed with De Courcy's show of strength, he suggested further parley. On the score that it was customary to know the number demanding surrender, he rather naïvely asked De Courcy just how strong he was.

This was exactly what De Courcy did not want to reveal. He replied: "I should not have the slightest hesitation in stating to you the number of troops under my immediate command, but cannot comply with your request for reasons arising out of considerations other than those connected with your defense of the gap." He explained that it was only because of his feeling of humanity that he had not replied with his artillery to Frazer's scattered shots the day before! But he said his guns would begin their deadly work at noon on the ninth, if the Gap were not surrendered by then. His six light Elrods more than a mile from the Confederate bastions would have indeed been destructive!

De Courcy had edged Lemert's Eighty-sixth Infantry forward from its first position on Dark Ridge to a point on the Harlan road back of Pinnacle Mountain. There they were within sixty rods of a strong outpost of Confederates at "Rocky Fort," where a projection of the mountain pushed the road aside and formed a natural fort for a battery. The Eighty-sixth consisted of about 800 soldiers. De Courcy ordered them to keep their rifles unloaded, so that no trigger-happy men could fire prematurely. The last thing he wanted was to bring on a general engagement which would immediately reveal the weakness of his forces.

Frazer used Captain Rush Van Leer as his emissary to carry his replies to Colonel Lemert, acting for De Courcy. The two officers became quite sociable while the messengers under flags of truce passed back and forth between the headquarters of their commanding officers. Lemert offered Van Leer a drink. The Confederate officer smacked his lips in satisfaction and asked if

more could be secured. Frazer and the other officers at the Gap were also thirsty, he said.

Lemert passed the request to De Courcy. The Irishman, feeling that the mellowing effect of a good drink might be helpful, immediately replied: "Fill them to the ears if you can." Two gallons of good whisky were sent to Frazer in his headquarters while he was pondering his dilemma. Between drinks he debated his decision.

De Courcy's dead line of noon September 9 passed, with Frazer not sufficiently deep in his cups to make up his mind. Within an hour he had a final note from De Courcy: "It is now 12:30 P. M., and I shall not open fire until 2 P. M., unless before that time you shall have struck all your flags and hoisted in their stead white flags in token of surrender." In the meantime the perplexed Confederate had acquired a new worry. General Burnside had just arrived from Knoxville with more reinforcements and had sent a sharp note of his own asking surrender, and telling Frazer to cease communications with Shackelford and De Courcy now that he was in charge. Convinced that his position was hopeless, Frazer ordered the white flags to be put up at three o'clock, and retired to his tent.

For De Courcy and the Eighty-sixth Regiment that was a happy signal. Without waiting for Burnside to move in from his station more than two miles away to make a formal acceptance of the surrender, his men and Lemert's with their still empty guns marched out of their redoubts on the Harlan road and entered the fortified pass singing "The Girl I Left Behind Me." The Confederate troops, lined up on each side for the surrender, looked ominously at the small Federal force and some of them inquired, "Where are the rest of the men?" De Courcy went to Frazer's tent, found the Confederate commander off poise and with snuff smeared over his face. He remarked dryly to an orderly: "The whisky worked."

De Courcy's triumph lasted only an hour. Burnside and his staff rode into the Saddle of the Gap at four o'clock to accept the formal surrender of the confused and disconsolate Frazer,

only to find that the Irishman had already accepted the laurels of victory. And instead of all of the Confederate troops lined up with stacked arms, he discovered that nearly 400, on the Pinnacle and at the outposts, had fled into the forest back of the mountain. Two officers had trailed off with their men, Major B. G. McDowell of the Sixty-second North Carolina Regiment and Colonel Campbell Slemp of the Sixty-fourth Virginia.

It was too much for Burnside. Instead of congratulating De Courcy for the brilliant bluff which had kept the Confederates cooped up on the north side, he put the Irish officer under arrest and sent him to his tent under guard.

Although the proud nobleman was cleared of the charges of insubordination and bungling in a court-martial, he resigned from the Federal service and went back to England. Later he became Lord Kingsale the 31st, with the privilege of appearing before His Majesty with his hat on.

Frazer had his own special calumnies to bear while he brooded in a prison in Fort Warren, Boston Harbor. The Confederate officers who escaped described the surrender as a shame and disgrace and hinted strongly that money had changed hands. Secretary of War Seddon reported to President Davis on the danger threatening the Confederates after the Gap surrender:

> The necessity of concentrating forces to encounter the main attack left East Tennessee, with feeble defense, to rely chiefly on the stronghold that guarded the main pass [Cumberland Gap] of the mountains. Unaccountably and under circumstances which force suspicion of cowardice or treachery, but for the hope of satisfactory explanation from the commander, now a prisoner to the enemy, this almost impregnable post surrendered without a struggle. In consequence East Tennessee came easily into the possession of the enemy.

President Davis, deeply concerned, reviewed the situation in a special message to his Congress.

The country was painfully surprised by the intelligence that the officer in command at Cumberland Gap had surrendered that important pass . . . without firing a shot. . . . The entire garrison, including the commander, being still held prisoners by the enemy I am unable to suggest any explanation of the disaster, which laid open Eastern Tennessee and Southwestern Virginia to hostile operations, and broke the line of communications between the seat of government and Middle Tennessee.

Two years late, the strategy of Carter and Nelson was working out.

1 The intimate details of the strategy of Colonel De Courcy in the capture of Cumberland Gap, September 9, 1863, are taken from the eyewitness accounts given in *The Surrender of Cumberland Gap*, by R. W. McFarland, (Columbus, Ohio, 1898) ; *History of the Eighty-Sixth Regiment Ohio Volunteer Infantry*, by Joseph Nelson Ashburn (Cleveland, Ohio, 1909) . McFarland was a lieutenant colonel in the Eighty-sixth, and Ashburn was a private in Company A. The general facts are given in *The War of the Rebellion: a compilation of the Official Records* (Washington, D. C.) .

Chapter 20

Dead Horses and Broken Wagons

I T WAS late afternoon on January 6, 1864. General U. S. Grant
and a half-dozen companions muffled in heavy coats topped
Powell River Hill four miles south of Cumberland Gap and
came suddenly in sight of the Cumberland wall. Across the
murky horizon ran the long naked backbone of the mountain
with its missing vertebrae, covered with dark splotches of timber
and evergreens like a torn and ragged blanket. A zero wind
swirled through the jagged break in the skyline, whistled across
the valley and bit into the faces of the horsemen.

The stocky hero of Vicksburg pulled his slouchy campaign
hat tighter on his head and sat quietly in his saddle for a moment.
Looking upon the pass for the first time, he was impressed with
its natural invulnerability. The snow and ice and wind reminded
him of a fateful Napoleonic venture he had studied in his West
Point days. He remarked to his companions: "With two brigades
of the Army of the Cumberland I could hold that pass against
the army which Napoleon led to Moscow."[1]

Grant had come from Knoxville to Cumberland Gap to follow
the Wilderness Road to Lexington. With him were his chief
medical adviser and old friend of Galena, Illinois, the gray-headed
Dr. Edward B. Kittoe, his assistant inspector general and engi-
neer Colonel C. B. Comstock, and some local guides. Although
interested in the pass itself, he was thinking more of the road to
Kentucky. He wanted to determine its fitness as a supply line
for the Federal forces Burnside had led into East Tennessee.

The Wilderness Road was important in the strategy Grant had been formulating since he took command of all the armies west of the Alleghenies. Burnside had marched triumphantly into Knoxville without much interference and for a while had control of East Tennessee. But Bragg at Chattanooga detached General James Longstreet with his First Corps of the Army of Northern Virginia and sent him to pin down Burnside at Knoxville. After successfully resisting Longstreet's siege, Burnside had resigned and left the wounded General John G. Foster in command of the Twenty-third and Ninth Army Corps cooped in around Knoxville. Longstreet moved up the Holston Valley, set up headquarters at Russellville, Tennessee, and contemptuously refused to budge from his control of the rich river valleys where Foster's army expected to secure most of its subsistence.

It was this situation which vexed Grant no end as 1864 opened. He found it humiliating for his old West Point friend and former fellow soldier, "Old Pete" Longstreet, to sit undisturbed in the heart of Union territory, daring him to come on and fight. He toyed with the idea of sending Sherman to reinforce Foster. But before he did that, he would take a personal look. Leaving his Nashville headquarters with Kittoe and Comstock the first of January, 1864, he went to Knoxville and spent several days with Foster. Finding the supply situation desperate, he looked to the depots of Kentucky. Why were not supplies coming through in greater quantities? What was the matter with the roads?

Grant's first thought was the Wilderness Road. It was the most direct entry into East Tennessee and should be a serviceable avenue for the maintenance of the forces in the area. But he had another reason, half-formed in his mind. Perhaps the Road could support an army which would not only sweep Longstreet from the region but also drive into the North Carolina mountains to split the strongholds of the Confederacy in the Southeast. The dead-pan West Point strategist was thinking along the same lines Carter and Nelson had considered more than two years before.

With these sober thoughts and deep concern over Long-

street's presence in East Tennessee, Grant approached the Cumberland Gap outposts and was conducted to the Dr. J. H. S. Morison residence in the little vale south of Pinnacle Mountain where Colonel Wilson C. Lemert, the post commander, had his headquarters.[2] Here he spent the night of January 6, 1864, and talked with Lemert and the other local officers about their problems. Lemert had been in charge since the capture September 9, 1863, when De Courcy was removed from the command of the independent brigade. It had been a busy place during the first weeks after Burnside's entry into East Tennessee. More than half of the Ninth Corps had passed that way to Knoxville, and detachments of infantry and cavalry had fanned out for stations on Clinch River and between Bean's Station and Knoxville.

Lemert had plenty of complaints to pass on to Grant. Early in October an epidemic of smallpox had broken out among his men. There had been a number of deaths and hundreds of men were incapacitated for weeks. Food had been a chief concern because little had been brought over the old road from the Kentucky depots. Foraging in the winter months had stripped everything clean in the farming region of Powell Valley. By November starvation loomed for the garrison. Once for a ten-day period the men were reduced to corn on the ear foraged from Virginia, and the unburned meal which they could scrape up from the ruins of the old water mill which Shackelford's troops had destroyed. A soldier described the process: "The screenings we made into a stiff batter without salt and baked into chunks. . . . Some of the boys sent samples home (they said for whet stones)."[3]

Lemert also gave the commanding general some distressing news. The Sixteenth Illinois Cavalry had been used to protect foraging trains in Powell Valley. They had had many brushes with Confederate cavalry operating from outposts on Boone's old Road in Virginia. On January 2 Major C. H. Beers had led a battalion on a foraging expedition up the valley to Jonesville. The Federals camped north of Jonesville, and did not post a

picket on the road to Stickleyville. The enemy was not expected to be out in weather six degrees below zero.

The resourceful Confederate commander in southwest Virginia, General William E. Jones, had been waiting for just such an opportunity. Moving out of his encampment in the Powell Valley hills in the middle of the night, he had caught Beers and his men off guard at daybreak on Sunday morning, the third. A converging column under Colonel A. L. Pridemore galloped in from the east. Completely surrounded and outnumbered, the Union men took refuge on a hill northwest of the town and fought valiantly throughout the day. In the late afternoon the Confederates charged their trapped foe and forced them to surrender. They rounded up Major Beers and 383 men, three pieces of light artillery and twenty-seven six-mule teams.[4] It was a cheerful victory for the Confederates, in spite of the fact that one man froze to death in his saddle and many suffered frozen feet.

Grant was philosophical about the regrettable incident, but was more concerned about Lemert's road information. Lemert said the Wilderness Road was in such bad condition that no wagons had been brought over it for some time, and that only pack mules were being used, reminiscent of pioneer days. This was in spite of the work done by Major William Kraus, of Oxford, Ohio, before the winter set in. He had used 250 men for several weeks on the bad stretches between Cumberland Gap and the forks at Hazel Patch. In addition hundreds of Negroes had been employed on the links connecting the supply depots in central Kentucky.

The commanding general spent the morning of January 7 inspecting the defenses. He found well-manned batteries mounted on the sides of the mountain, and on the twin peaks guarding the pass. A bridge had been built across the Saddle of the Gap to facilitate the movement of guns and ammunition from one wall to the other. Although the garrison was small, Grant felt that it was sufficient to protect the natural gateway as

long as there was no enveloping movement to force its capture as had happened three times already.

After lunch Grant and his party prepared to leave. Standing beside his horse at the Morison home, he looked up at the bleak face of the Pinnacle covered with ice and snow. The flag fluttered from the craggy peak 1,400 feet above and black muzzles of guns peeped out over the ledges. He turned to the soldiers gathered around him and smiled grimly. One of them thought he seemed to say: "Pretty tough going up there."

The general swung into his saddle and with his companions began the corkscrew climb around the face of the Pinnacle. The horses picked their way carefully over the icy sheets. They passed underneath the bridge in the Saddle of the Gap and dropped off on the Kentucky side, to begin their tour of inspection along the Wilderness Road. Through the bottoms of Yellow Creek and across the three Log Mountains the road wound toward Cumberland Ford. Grant found it even worse than Lemert had described it. The frozen ruts were so deep it was impossible to draw wagons through. Every few yards he came upon the carcass of a horse or mule. Broken wagons were strewn along the way. A few days before, a soldier had counted 258 dead animals on the fourteen-mile stretch from Cumberland Gap to Cumberland Ford, and enough broken and abandoned wagons to reach the entire distance if placed end to end.[5]

At Cumberland Ford Grant crossed the river on a flimsy, temporary bridge unsafe to cross on horseback. He had respect for the courage and resourcefulness of wagoners who dared to cross it with heavy loads. His companion told of the experience of Private Robert Appleby who a few weeks before had been driving one of thirty wagons coming from Nicholasville. Appleby found the river swollen and almost out of its banks. About halfway across the bridge the wagon broke through, dragging the rear team of mules with it. The swing chain caught on the bridge, and the second span of mules was suspended in the air. The lead mule braced his feet against the bridge rail and hung on until Appleby struggled forward to cut the hamestring which

loosed the harness and released the mule. Then he cut the swing chain loose, permitting the suspended team to drop into the river. He swung down upon the mules floundering in the water and managed to lead them out. They dragged the drifting wagon after them. He repaired the wagon tongue and continued on his way.

The Union general and his party stopped in Barbourville to spend the night of January 7 in the Ben Eve Hotel. Here a number of local people turned out to see the man who had brought victories to the Union armies in the West. From Knoxville to Cumberland Gap the party had been similarly visited wherever they stopped. The expressions of the mountain people's loyalty were most pleasing to Grant. Sometimes the gray-headed and more distinguished-looking Dr. Kittoe was mistaken for the commanding general, and Grant passed as a subordinate officer. He was amused when he occasionally heard uncomplimentary references to his bedrabbled and travel-worn appearance. The people expected to see a much older man, togged out in smart military trappings.⁶

The next day the party pushed off for the low hills of the Rockcastle country. At Hazel Patch they turned to the right on the road to Lexington. They found the steeps of Big Hill in an appalling condition where the road dropped off the mountain for the levels of Kentucky. Grant did not wonder at the difficulties Bragg's and Smith's wagoners had experienced in the Confederate retreat from Kentucky in the fall of 1862, nor at the complaints he had heard from Federal soldiers who had passed over the Road. The roadbed through the gulches of Big Hill was cut thirty feet deep in places. And here again was the debris of countless broken wagons and long lines of dead horses, mute evidences of struggle and suffering as tragic as any on a battlefield.

Grant was depressed and tired when he rode down to the tavern home of Merritt Jones at the foot of Big Hill where advance runners had arranged for him to stay all night. Jones and his two sons were away in the Confederate Army. Mrs. Jones

was ill, and her daughters prepared the meal for their unwelcome guests. The next morning at breakfast Grant asked to speak to the mother whom he had not seen during his stay. He was escorted to her bedroom.

"I am told your husband and sons are in the South," he said to her, "and I want to say I hope they may return in safety to you. I am sorry to find you sick and hope you may soon be well. I have ordered our bill for the night's lodging to be promptly paid." Grant stamped out, mounted his horse and was on his way.[7]

At Lexington Grant and his party left their horses and took the train for Louisville. By January 13 he was back at his headquarters in Nashville.

Grant's inspection of the Wilderness Road under the worst possible conditions convinced him of its absolute uselessness as a major military highway. It could never be kept open to support a large force in East Tennessee. Certainly he could not drive out Longstreet by a flanking movement from Kentucky. Grant immediately discarded the old Road from any consideration in his plans. For two months he had Thomas divide his supplies with Foster. When Foster was forced to give up his command because of his wounds, Grant put the able and aggressive General James B. McPherson in charge. By that time he had decided it was just as well to let Longstreet stay in the Holston Valley. As long as that Confederate general was detached from Bragg he could do no special harm except to keep McPherson close to Knoxville and subsist upon the sorely distressed Unionists of East Tennessee.

When, early in the spring of 1864, Grant was made general in chief of all the Union Armies, Longstreet obligingly moved out of the Holston—but not until he had looked across the Cumberland Mountains into Kentucky and dreamed his own dreams of conquest. Longstreet had had plenty of time in his comfortable quarters at Russellville, Tennessee, to do some thinking. He wrote Lee and Davis his plans. He wanted to take his army over the mountain passes into Kentucky and do what Bragg and

Smith had failed to accomplish in 1862. He said the plan was entirely feasible, because the passes were poorly manned by Union troops, and Kentucky was sympathetic to the Southern cause and would furnish many recruits for his army. But Lee and Davis had too many troubles in Virginia. They ordered Longstreet to come there. He was badly needed, now that Grant was marshaling his forces for the battles that led to Appomattox.

East Tennessee was left with only a skeleton Federal force. Sherman and Thomas proceeded with their plans to corner the Confederate Army of Tennessee at Atlanta and prepare for the march to the sea, and the fertile valleys of the French Broad, Holston, Clinch and Powell Rivers were at the mercy of bushwhackers. The people, Union and Confederate alike, suffered equally. Until the end the Unionists looked in vain for a big conquering army to march over the Wilderness Road and free their land from the Confederates. The old Road had failed miserably as a major factor in the war in the West. For both the Blue and the Gray, it was only a trail of dead horses, broken wagons, blasted hopes.

1 The legendary account of Jacob Myers, a Unionist of Claiborne County, Tennessee, who was the pilot of Grant's party from Tazewell, Tennessee, to Cumberland Gap.

2 The large frame residence of Dr. J. H. S. Morison immediately south of the pass was not destroyed during the Confederate and Federal occupations of Cumberland Gap, and was used for the headquarters of the commanding officers.

3 Ashburn, *History of the Eighty-Sixth Regiment, Ohio Volunteer Infantry*, p. 69.

4 The subsequent suffering of these captured men is told in John McElroy's *Andersonville, a Story of Rebel Military Prisons* (Toledo, 1879). McElroy was a member of Company L of the Sixteenth Illinois Cavalry.

5 R. W. McFarland, *The Surrender of Cumberland Gap*, (Columbus, 1898), p. 10. This is one of the best accounts of the capture of the pass by General Burnside, and describes in detail the strategy of De Courcy.

6 For Grant's own brief account of his journey over the Wilderness Road, see *Personal Memoirs of U. S. Grant* (New York, 1885), II, 101-102.

7 Oliver P. Temple, *East Tennessee and the Civil War* (Cincinnati, 1899), pp. 516-517, from an account in the Louisville *Courier-Journal*. The Merritt house is still preserved, and is owned and maintained by Berea College as a historic site and tourist attraction.

Part 4

RETURN TO THE WILDERNESS

Chapter 21

"Covered with the Rime of Centuries"

THE store and saloon of Samuel C. Jones built in 1866 under the eastern abutment of the bridge across the Saddle of Cumberland Gap was a makeshift affair, in keeping with the shabby, temporary buildings left by the soldiers when they moved out at the end of the war. The whole place was a desolate shambles after four years of occupation. The mountain was stripped naked of its timber, gashed with trenches and pocked with battery pits, tumbled-down shacks and dumps. The Tennessee road wound up the gulch to meet the Virginia road strung along the lower face of the Pinnacle. At the crest in the gap of the mountain these roads formed the single entry into Kentucky under the old bridge passing within four feet of Jones's place.

Jones prospered from the very beginning. Most of his customers were old acquaintances who liked to stop with him. They were teamsters, stage drivers and cattle and hog men whom he had learned to know during his own career as a livestock dealer. After growing up in southwest Virginia as a saddle and harness maker, he had crossed over into Yellow Creek Valley in the forties and gone into the livestock business. He bought cattle in the mountains and drove them to the Bluegrass for sale. In the fall he gathered mules and hogs along the Road and took them

to the Carolinas for sale to the cotton growers. In this way he came to know nearly everybody on the Road from the Holston settlements to the ends of its two prongs in Louisville and Lexington.

Jones was the father of twelve children. Getting on toward sixty, he weighed 275 pounds, walked with a limp and was no longer able to endure the hard life of a traveling cattleman. He looked for an opportunity to take things easier. He bought 120 acres of land in the Saddle of the Gap, used an abandoned military building for his home, boarded up the abutments of the old bridge and put in a stock of goods and whisky. His new business was much to his liking. Stretched out on the counter, he talked politics with the travelers, got all the latest news along the road and swapped yarns with his customers. He scribbled his charge accounts on the rough walls of his store; whenever they were paid, he crossed them out. Jolly, friendly, and easygoing, he was one of the most popular wayside operators on the Wilderness Road.[1]

In the never-ending traffic which passed back and forth by his door were occasional strangers whom Jones had never seen before. Usually he could spot their business quickly because he knew the characteristic marks of every kind of tradesman. With all the curiosity and inquisitiveness of the native mountaineer he was never long in finding out what they were doing, where they came from and where they were going.

Two men rode up from the Virginia side to his little store one summer day in 1870 who were out of his world. One was an artist and the other was a writer. They wanted to stay around awhile, sketch and take notes. To the corpulent old storekeeper, their names meant nothing. He had never heard of Harry Fenn, artist and magazine illustrator of New York City, lately from England, and Felix Gregory de Fontaine, noted Confederate correspondent from Charleston, South Carolina. He looked the strangers over quizzically, responded to their questions and wondered what interest they could have in the drab old mountain.

But the two visitors had a historical perspective Jones did not

possess. It had been nearly a hundred years since Boone had marked the trail for the settlers to follow. Pioneers had been left in the western fringes of the Appalachians by the big migration. The country was no longer new. The mountaineers had kept much of their forebears' independence of spirit, and they still clung to the once famous Wilderness Road without realizing its great past and the fact that it had become only an insignificant local wagon road, penetrating a thin, hilly land of no consequence in the life of a nation fattening upon inexhaustible natural resources.

It was this historical significance of the old pass and the scenic beauty of the region which appealed to Fenn and De Fontaine. Jones lived too close to it to appreciate this. He could see no beauty in the old mill and iron foundry which Fenn sketched with such zest and interest. Destroyed during the war, it was now being rebuilt by its owner, John G. Newlee, in an effort to recoup his losses. There it was with the ugly scaffolding used in restoring the big stone furnace, and the huge overshot wheel to operate the 500-pound hammer in pounding the iron ingots into shape. Fenn delighted in these quaint features, and sketched them into one of his pictures.

Jones watched the outlines Fenn made of the two portals of the gateway, the bare face of the Pinnacle, the rounded knob of Three States Peak, and the slender lines denoting the roads converging at his store. He was interested by another drawing of Fenn's, looking down from Pinnacle Peak on the pass, showing a jumble of mountains of exaggerated Alpine ruggedness through which the road wound. A covered wagon drawn by three yoke of oxen was placed on the road going into Virginia. Jones was flattered that Fenn would think enough of his establishment under the bridge to sketch a covered wagon and two ox teams passing by his door, with an angular, bearded mountaineer sprawled out on his doorstep.

These pictures, Jones was told, would be put into a book which William Cullen Bryant was editing, to be called *Picturesque America*. He did not then know what the eager journalist,

De Fontaine, would write for the text, but later he would read it with interest. The writer was busy taking notes while Fenn was doing his sketching. Conscious of the place of the old Road in history, the journalist described the mountain region through which it passed from the Holston settlements to central Kentucky. He envisaged the hardships of the early settlers and the dangers they encountered. He jotted down his thoughts:

> Passing through the scenes of bloody ambuscades, legends, and traditions, it would seem almost a part of the romance of the place if now an Indian should suddenly break the reigning silence with a warwhoop, and its dying echoes be answered by the rifle-shot of a pioneer. . . . It is an old, old region, covered with the rime of centuries, and but slightly changed by the progress of events.

His description of Boone's Road through Virginia in 1870 indicated there was still hardship to be endured:

> The approach to the [Cumberland] range from the northeast side, after leaving Abingdon, Virginia, is over a rough, broken country; and the only compensation to the traveller, as he saunters along on horseback, is in the enjoyment of bits of scenery wherein rocks and running streams, mountain-ferries, quaint old-fashioned mills, farm-houses and cabins perched like birds among the clefts of hills, lovely perspectives, wild-flowers and waving grain, and a homely but hospitable people, combine in charming confusion to keep the attention ever on the alert. The road through the gap, winding like a huge ribbon, to take advantage of every foot of rugged soil, up, down, and around the mountains, is but the enlarged war-trail of the ancient Cherokees and other tribes. . . ."[2]

De Fontaine would use Jones, though not name him, as an example of an enterprising mountaineer who made his living on the Road. In describing the establishment under the bridge, he noted that it was similar to others found at five and ten-mile

intervals. Trade with teamsters and the natives constituted the principal part of their business. Skins, hides, tallow, dried apples, peaches, chestnuts, butter, lard, flaxseed, bacon, chickens, eggs, geese, ducks and guineas were collected from the natives and sent off by wagonloads to Baltimore and other Eastern markets, to be exchanged for merchandise needed by the people.

But De Fontaine looked beyond this strictly local business. He foresaw a new day for Jones and the other people in the wilderness.

Whatever may be the peculiarities of the region, social or otherwise, the time cannot be far distant when the whole of this wild tract must yield to the march of improvement, and pour forth the treasures of mineralogical wealth now latent in its soil. Already, a railroad is in process of construction, that is destined to cut the backbone of Kentucky and Tennessee in twain, and open a new avenue of communication between the East and West; while geologists and engineers are "prospecting" among the mines.

He described the iron ore existing in the limestone ledges running along the southern base of Cumberland Mountain for 150 miles, and the apparently inexhaustible deposits of coal in the hills of southeastern Kentucky first discovered by Dr. Thomas Walker in 1750. Since 1854, many thousand bushels of this coal had been dug out by the mountaineers and hauled in wagons through Cumberland Gap to southeastern markets.

The two interesting strangers who exchanged stories with Jones for a day or two and made their sketches and took their notes gathered up their saddlebags, notebooks and easel and disappeared. It was two years before Bryant's book appeared with the story of their visit.

After Fenn and De Fontaine departed, Jones lapsed into his quiet role as unofficial guardian of the historic pass. He looked after his trade, scribbled his charges on the store walls and listened to his customers' tales. Bit by bit the lore of the old

mountain grew in volume as the travelers talked about pioneer days, their experiences during the war and the latest feuds along the Road.

Sometimes a fiddler in the crowd would strike up weird and haunting melodies. A favorite was "Cumberland Gap." To some of them it brought back memories of the tall, lean, left-handed young fiddler, Sam Lambdin, who made it up around the campfires in George Morgan's army. Lambdin had been a Union loyalist living over in Tennessee in the bend of Clinch River called "The Gourd." He quit moonshining to join Carter's volunteers at Barbourville in August 1861. His fellow soldiers were so pleased with his fiddling they had taken up a collection to present him with a special left-handed violin. At Murfrees-boro he had been taken prisoner and his fiddle confiscated. He had contracted a disease in Belle Isle prison and died. But the whining dirge he composed echoed and re-echoed from a thousand hills as a tribute to his memory.

Scarcely a day passed without a customer's asking about "Long Tom," the big "sixty-four" rifled cannon which had twice been pitched off the Pinnacle precipice. Jones explained that the gun had lain for several years near the mouth of the cave on the face of the Pinnacle, above the old mill and iron foundry, and that it had at last been hauled to Powell River and floated on a flatboat to Chattanooga where it was salvaged for its metal.

Jones had some stories about "Long Tom" which he liked to pass on to his visitors. While the Federal Morgan was in command of the Gap, a Confederate regiment had been billeted four miles south at Pump Hollow Spring, near Patterson's Crossroads, to keep an eye on the enemy's movements. One Sunday morning the boys in gray had been called together for a religious service on a little knoll where Pinnacle Peak could be clearly seen. The men were lounging about on the ground, with their guns stacked, some dozing contentedly, while the chaplain, a native preacher attached to the regiment, held forth. After the chaplain had been preaching about three-quarters of an hour, the Confederates saw a puff of smoke spurt from the top of the Pinnacle, and in a

few seconds heard a shell whistle overhead. They scattered in great haste, some of them falling over their stacked guns. The preacher caught his breath in the midst of his exhortation and turned with a disturbed look to his commanding officer.

The colonel said, "Oh, that's all right. It's passed. Go right ahead."

The preacher said, "I was about through anyhow." Without further announcement he delivered a brief benediction and disappeared. He was not seen again until late in the afternoon.

Another story always brought a chuckle to Jones's listeners. After "Long Tom" was thrown from the Pinnacle by Morgan's men in the evacuation of September 1861, the Confederates mounted the gun again at the base of the cliff near the entrance to the Cave. One day some "Yankee spies" were discovered by Confederate lookouts on the crest of the mountain, and the gun crew brought the old gun into position. A member of the crew said:

> We h'isted the gun's muzzle up toward the men, and let her roar, but we didn't h'ist her high enough. The ball struck the face of the Pinnacle. We loaded her ag'in, and h'isted her a little higher. That time the ball went clean over the mountain. The next day we heered we had killed a mule and a goose over on Yaller Creek.

Other stories were bandied about by Jones's customers as they sipped their whisky and took turns at friendly card games. One which Jones himself enjoyed telling concerned a religious gathering on the Pinnacle one Sunday. News of the meeting had spread through the mountains, and thousands of natives assembled at the Gap to hear their preachers raise loud voices against the sins and iniquities of the world. Alex Moore, riding in, hailed Henry King as he passed his home on second Log Mountain.

"What kind of a meeting is it?" asked King.

"They are a-goin' to talk about changing the Bible. If there's any easier way to git to hebbin, I want to know it," Moore replied.

Jones and his neighbors down in Yellow Creek Valley may not have learned of an easier way to get to heaven, but they knew of quick exits from their troubled world without having to go to "public wars." Private wars became frequent along the old Road winding through the Kentucky hills, and embittered clans furnished many new graves in rapidly filling cemeteries.

"The wimmen git to talkin', and the men git to shooting," was the explanation of one of the Turner clan. Often Jones heard the tolling of the big bell in the Jack Turner home in Yellow Creek Valley, calling for the gathering of the Turner kin when new violence had broken out.

Jones himself did not escape being involved. One night two men broke into his store, rolled out a barrel of whisky and hid it in the bushes on the Kentucky side. Jones told R. T. ("Red") Colson and Alfred McTee, two of his Yellow Creek friends, about the robbery. They found the missing barrel. Watching the next night, Colson and McTee discovered Bob and Joe Pearce coming to get the whisky. Alarmed, the Pearce brothers made a quick escape. A few days later one of them, standing by his mother, was shot at the front door of his home. The other was killed as he ran out the back door. It was thought Colson and McTee did the killing, but they were never brought to trial. The theft of Jones's whisky had been avenged.

The innkeeper witnessed a grimmer example of mountain justice which had the full approval of the courts. On the morning of August 12, 1875, he joined some Yellow Creekers on their way to Tazewell, Tennessee, to see the hanging of Ananias Honeycutt. Somebody had robbed and clubbed to death Thomas Ausmus, a prominent Powell Valley farmer of Claiborne County, Tennessee, on January 30, 1874.[3] The body was found lying against a tree in a big timber tract. Circumstantial evidence pointed to Honeycutt, a young farmer and neighbor who had been seen to enter the woods with Ausmus, supposedly to inspect timber. Honeycutt was arrested, tried and convicted, although he steadfastly maintained his innocence. The case was appealed, but the higher courts sustained the sentence, and

the date was set for the execution. It was to be a public hanging, the first on record in the Cumberlands. Thousands of people in the county and surrounding sections went to Tazewell for the proceedings.

By wagon, horseback and on foot, the Yellow Creekers came across Cumberland Gap, picked up the old storekeeper by the side of the road and fell in with Virginians and Tennesseans journeying to the county seat of Claiborne. They found a great crowd gathered in "Academy Hollow" on the road north of the town opposite a two-story brick building used as Tazewell College. In the natural amphitheater a gallows had been built. It consisted of a perpendicular pole set in the ground, on which a heavy crossarm had been nailed. Over the extended bar dangled the rope with its noose.

The gallows was in the center of an enclosure which had been roped off. The gathering spectators vied with one another to find an advantageous viewpoint. The doors and windows of the college building were filled with faces long before the time set for the execution. The hillsides were covered by men, women and children, estimated to number between 5,000 and 6,000. The day was hot, and the impatient, restless crowd fanned and talked while they waited for the show to start.

Shortly before noon, a ripple of excitement ran through the crowd. "They are coming with him!" someone shouted. Everyone stared at the procession of guards, officials and attendants marching up from the jail in the town to the place of execution. Fifty men flanked a two-horse wagon, in which rode the doomed man sitting on his coffin, and two preachers, the Reverend Crutchfield and the Reverend A. J. Greer. Sheriff Mayes and some deputies followed closely. The officers were taking no chances. They had heard a rumor that some Honeycutt sympathizers might attempt to free the prisoner. The procession moved into the enclosure through a lane in the crowd. The wagon stopped underneath the gallows.

Preacher Crutchfield opened the proceedings by reading the Fifteenth Psalm. Then he announced a hymn and according to

custom invited everybody to join in. But the crowd was in no mood for singing. Only a few complied. The Reverend T. P. Ensor, another minister standing close by, was called on to lead in prayer. The prisoner quietly knelt beside his coffin as the mountain preacher invoked divine blessing. When the prayer was closed, Crutchfield opened his Bible and read the text, Hebrews 9:27: "And as it is appointed unto men once to die, but after this the judgment." For more than an hour he waxed warm with the fervor of his sermon, and his booming voice rolled out over the assembled throng like the crack of doom. Not much time was left for Brother Greer, who followed with a sermon of his own on the text Amos 4:12: "Therefore thus will I do unto thee, O Israel: and because I will do this unto thee, prepare to meet thy God, O Israel." It was nearly two o'clock when he finished.

During the long exhortations of the two ministers, the crowd kept their eyes on Honeycutt, sitting silent and immobile on his coffin. He was a strong, handsome fellow of twenty-five, who showed marks of Indian ancestry. The only blemish on his fine physique was a short left foot, which turned up at the toes. It was the telltale print of that short foot at the scene of the crime which had been the most damaging evidence against him.

When the ministers had ended their part in the service, the prisoner was given a chance to speak. He arose by the side of the coffin and spoke in a low voice. He said it was hard to die such a death, but that he had no fear; he had made his peace with his God. He held no enmity against any man and did not want his friends and relatives to grieve for him. He invited all of them to meet him in heaven.

When Honeycutt indicated that he was done, Preacher Greer asked him the question which often had been propounded to him: "Are you guilty or not guilty?"

Everybody leaned forward as a great hush fell upon the throng. Honeycutt's reply was audible only to those close about him: "I've told it time and again, and will not tell it any other way than the one told before." The preacher gave him a white handkerchief, asking him in his dying moments to shift it from

one hand to the other if he were innocent. Then Honeycutt shook hands with those near him, bade them farewell and signaled that he was ready.

Sheriff Mayes stepped upon the wagon, placed a cap over the prisoner's head, adjusted the noose about his neck and pulled the rope taut so that Honeycutt stood almost tiptoe on the coffin. The wagon was cleared of everyone else, and the sheriff clucked to the team. The wagon moved out from under the condemned man at 2:10 P. M.

There were screams from the crowd. A number of women fainted. A wave of sobs and groans ran through the crowd as the body twisted and struggled on the rope. Before it was still, the handkerchief was shifted twice from one hand to the other to attest his innocence. At 2:36 the body was cut down and turned over to waiting relatives.

Tennessee had an impressive way of avenging crime.

Jones and the Yellow Creekers from Kentucky had enough to talk about as they rode homeward, though they did not know of a mysterious stranger who had been in the crowd. Had they known, they would have shown more interest in him, with proper discretion, than in the unfortunate victim dangling at the end of the rope.

A tall, bronzed, well-built man with steel-gray eyes, traveling with a companion, had accidentally fallen in with riders from Kentucky on their way to the execution. He came from "South America," that isolated section of southwest Bell County, where he had been visiting members of the Henderson clan. Some of them were noted moonshiners who often gave refuge to men fleeing from the law. He was on his way to Tazewell, to visit an old acquaintance, Ben Schultz, with whom he had served as a Confederate soldier in the army of General Sterling Price, of Missouri. Learning that Honeycutt was to be executed, he and his companion mingled with the crowd in the hollow. In order to get a good view, he gave a native a five-dollar gold piece for a place in one of the windows of the school building.

The man was Frank James, the famous Missouri outlaw, and

his companion was George Shepard.[4] In 1893, when James was a member of the St. Louis police force, he visited Nashville, Tennessee, to seek information about the death of his chieftain, William Clarke Quantrill, the notorious guerrilla killed in Kentucky at the close of the Civil War. James told some medical students of the visit to Tazewell in 1875 at the time of the Honeycutt hanging, during a quiet interim in his career of crime when he and his brother Jesse were hiding from the Missouri authorities. It had been easy to lose himself for a little while in the forgotten wilderness in Kentucky where men still lived much as they pleased.

1 Interview by author with Robert H. Jones, son of Sam C. Jones, August 13, 1938.

2 William Cullen Bryant, ed., *Picturesque America* (New York: 1872), I, 232-237.

3 *Daily Press and Herald* (Knoxville, Tennessee), August 15, 1875; *Press and Messenger* (Knoxville, Tennessee), August 18, 1875; interviews by author with eyewitnesses.

4 Interview by author with Dr. H. C. Chance, Cumberland Gap, Tennessee, who heard the story from Frank James himself; *Daily News* (Middlesboro, Kentucky), July 11, 1945.

GENERAL GRANT AT CUMBERLAND GAP

The General's party passed through January 7, 1864, on an inspection tour of the Wilderness Road. The condition of the Road in the severe winter weather was so difficult the party at times had to dismount. From a sketch in *Harper's Weekly*.

SCENE FROM BIG HILL IN MADISON COUNTY, KENTUCKY

Showing the Wilderness Road before its relocation and modernization. Near this spot Boone and his companions had their first view of the Bluegrass region in 1769. In the foreground on the left of the Road is the Merritt Jones

Chapter 22

Pickax and Compass

S OMETHING queer was going on in the Cumberlands early in
July 1875. A large company of strangers put up tents at
the Grassy Spring back of Pinnacle Peak at Cumberland
Gap, about a quarter of a mile from the historic old Road looping
over the mountain wall. Each morning they would load up with
packs, pickaxes and instruments, separate into small groups and
go off into the hills in different directions. When they came
back to their camp at night, they would bring in little bags of
rocks, lumps of coal and ore and collections of twigs, leaves,
ferns and flowers. Everything about the region seemed to in-
terest them.

This was a strange thing to the natives who lounged around
Jones's store and saloon in the Saddle of the Gap, or brought their
turns of corn to Newlee's mill below the cave. Wagoners heard
about the strangers and spread the news along the road winding
through the hills. Some natives saw no good in it. One old man
predicted dire consequences. He said that just before the Civil
War somebody had put up tents on the mountain near the same
spot and raised a flag on the summit of the mountain. Then came
the war with its shooting and bloodshed. He was sure these
tents were the omen of another catastrophe.

What did the fellows mean by sighting along queer instru-
ments and stepping off distances through the woods? Why were
they picking up rocks and lumps of coal? What use could they

make of common twigs, leaves, ferns and flowers? For a people who had not kept pace with the march of civilization, such capers were a mystery. Did somebody mean to steal their lands?

It was not long before the leader of the party made himself known and dispelled most of their misgivings. He introduced himself to the old storekeeper as Nathaniel Southgate Shaler, teacher of paleontology in Harvard University, and explained that his tent companions were teachers and students of Harvard doing field work in geology. To clear away any prejudices, he announced that he was from Kentucky and had been captain of a Union battery of Kentuckians during the late war. He had been east for a number of years, had studied at the Lawrence Scientific School and had become a co-worker with Louis Agassiz, the distinguished scientist. Recently, Governor Preston H. Leslie of Kentucky had employed him to spend his summers in a geological survey for the state. He picked Cumberland Gap to start the work because of its unusual geological features, and because private interests had been considering the possibility of a railroad that way.[1]

The natives were interested in railroad talk. They had been hearing vague tales all their lives. Shaler appeared friendly and was easy to talk to. Tall, thin-faced, gray-eyed, and with long, flowing hair slicked back in pompadour style, he was a freakish-looking fellow to the natives, but sociable and they liked him. He and his companions paid Jones with new, shining silver coins for their purchases. In a little while the natural reserve and suspicion of the mountaineers gave way to timid friendliness. They might not understand about the study of rocks and the running of lines through the woods, but these visitors were able to use big words and had a lot of book learning. Perhaps they could bring a railroad to their isolated hills.

Shaler had been one of the first to arrive, after a horseback ride over the Wilderness Road from central Kentucky. He came in on the first of July and picked out the camp site at the Grassy Spring, which he called "Camp Harvard." He was soon joined by Mrs. Shaler and their ten-year-old daughter, a few

other women, and a company of young men. They arrived by wagon with the camp equipment from Morristown, Tennessee, where they had come by train from the East. Newcomers from Ohio, Indiana, Illinois and other Northern states traveled over the old Road from Livingston, Kentucky, ninety miles north, where the L. & N. had pushed its line south toward the mountains. Within a few days there were thirty-two students, most of them recent graduates of Harvard, a half-dozen teachers, and some geologists who were to assist Shaler in the Kentucky survey.

Shaler was permitted by Dr. Charles W. Eliot, president of Harvard University, to combine his survey work with a summer geology school under Harvard auspices. He had a capable faculty, some of whom were later to become famous. In the geology courses he was assisted by Professor J. M. Safford, state geologist of Tennessee, and Professor Kerr, state geologist of North Carolina. Professor Walter Faxon, of Harvard, was instructor in zoology. Shaler's chief assistant in the survey was A. R. Crandall, a Seventh Day Adventist who would not work on Saturday. With Crandall were Lucian Carr, P. N. Moore, W. B. Page, C. J. Norwood, John T. Talbutt and John R. Procter. Procter was camp superintendent.

The students were much interested in Shaler's advance billing of a young fellow soon to arrive who was to give instruction in the flora of the region. None of them had ever heard of David Starr Jordan who had been teaching in Indianapolis, but Shaler said he was a most capable instructor. Jordan arrived on foot, having walked the ninety miles from Livingston. They were somewhat taken aback by the tall young stranger. One of the students wrote:

> Jordan was bare-footed, with a foot as flat as a flounder, and as big as a barn door. His excuse for a shirt was decidedly décolleté, a ten-cent straw hat, gone to seed, trousers much abbreviated and of no describable color. . . . He was about the most dilapidated individual possible, rivalling the mountaineers in appearance.

Jordan got along well with the students from the beginning. They were amused at his account of his journey through the mountain settlements. He was accompanied by John Harper, a student at Purdue. As they passed along the old Road they had occasionally come upon a backwoods baseball game. Usually they had joined it, with Jordan pitching and Harper catching. The curved ball was just then being developed, and Jordan was more skilled than his rustic rivals in pitching a ball which would force a pop fly. His team always won.[2]

Shaler adopted a fixed schedule for the operation of the school. At six o'clock each morning he assembled the students for an hour's lecture. Then they would separate into small groups for specific assignments. After the field trips were over, they gathered again for another lecture and to hear reports on the day's findings. While the students were collecting their specimens, they assisted with the more serious work of surveying and charting the region. Despite the almost constant rain which hampered their explorations, they ranged over wide areas in the mountains.

Occasional diversions broke the routine of camp life. For a few days Shaler entertained some distinguished visitors who came to see what was going on. Among them were Colonel W. C. P. Breckinridge, of Lexington, who was with Jefferson Davis for a part of his "flight into oblivion," and Colonel Gordon Mackay, the millionaire shoeman. But it was the natives who never ceased to interest the Harvard boys. Big Jim, their camp cook, asked to be relieved of his duties for a few days so that he could go to Pineville to stand trial for killing his father-in-law, his third victim. Jim was back in a little while. He reported that he had come clear because his father-in-law had been a "mighty pestering old man."

The students sent out calls for rattlesnakes to pickle in alcohol for specimens. They set the price at five dollars each. Soon the natives were scouring the ridges. They brought snakes in abundance and the price dropped to twenty-five cents. Early one morning an old man who had not heard of the glut in the market

arrived with a big rattler coiled up in a makeshift box. Shaler was ready to leave on a field trip and rather brusquely explained that no more snakes were needed. After all the men had left camp, the old man lingered with the ladies. He took Mrs. Shaler aside and said with a glint in his eye: "I'm a-goin' to let him loose. Yes, right hyar, erlong them tents. I worked turrible hard to git that sarpent, walked nigh on to fourteen miles, and now I am a-goin to git five dollars fer 'im er know the reason why."

Thoroughly alarmed at this prospect, Mrs. Shaler invited the old man down to her tent for a cup of coffee. While the coffee was boiling, her guest smoked his pipe complacently, talked freely of his adventures, of moonlight search for herbs, and how he had brought down his man on occasions. Then he reverted to his snake.

"He's the gamest thing I ever seed. I reckon he's got pizen enough in them thar fangs of his'n to kill nigh on to a dozen folks. I tell ye he's jist a bustin' to get atter them students, and what's more, all the whisky in creation, nor lard nuther, couldn't cuore his bite. He's a he snake, as strong as Samsin and as live as a kitten."

He paused to let the effect of his words sink in. Then lowering his voice in a bargaining concession, he said: "Bein' hit's a woman who's dickering, I'll take two dollars for 'im."

After feeding her obdurate visitor a full breakfast and supplying him with plenty of coffee, Mrs. Shaler finally induced him to take a dollar for the rattler, with the understanding that he would kill it immediately. Convinced it was the best trade he could make, the old man took the dollar, tore off the slats and, as the snake wiggled out of the box, he struck it dead with one swish of his hickory walking stick.

With such interludes of comedy, Shaler and his crew continued their work of mapping the region and collecting their specimens. Crandall extended his survey from Cumberland Gap to Rockcastle River, covering most of the rugged area bisected by the Wilderness Road. The deposits of coal and iron ore

interested Shaler and his geologists the most. They discovered twenty seams of bituminous coal in Yellow Creek Valley between Cumberland Gap and Cumberland Ford, four of workable thickness. They checked the outcroppings of the Clinton iron ores on the Tennessee and Virginia side from which the old forge near the cave had been supplied for more than a half century. They extended their investigation of the veins of ore for more than fifty miles along the Poor Valley Ridge which runs parallel to the Cumberland wall.

On August 22, 1875, Shaler reported to Dr. Eliot that he was ready to close the work for the summer. He sent Mrs. Shaler to Cambridge and divided his crew into four parties. One went on a three-hundred-mile pack-mule journey down Powell Valley on the Tennessee side to Big Creek Gap, then along the border of Kentucky and Tennessee to Glasgow, Kentucky, to check the feasibility of a rail line which might come directly east from St. Louis. He sent Crandall with some helpers to make a reconnaisance of Cumberland River, and instructed Talbutt to collect specimens of soil along the way. He dispatched Moore with a party to range the mountains to the southeast along Boone's old trail to Abingdon, Virginia, to determine if a rail line could be laid in that direction. He directed Norwood and another group to go back over the Wilderness Road to Livingston and report whether the L. & N. could be brought to Cumberland Gap.

The versatile young scientist was enthusiastic about his summer's work. Back at his teaching duties in Harvard in the fall of 1875, he prepared his reports for publication in the *Kentucky Geological Survey*. A prolific writer, he enlarged on his field notes and painted a rosy picture of the region through which the Wilderness Road passed. For the first time, an official and authoritative account was given of the industrial possibilities of the Cumberlands.

Shaler's description of the region was that of the professional geologist:

On the Kentucky side is a broad valley in the mountain downfold, or synclinal, giving as in miniature some of the phenomena of the parks of Colorado. Beyond this valley on the west, at a distance of six miles, rises a sombre, wooded range of excavated mountains, whose tops are 3000 feet above sea level, and 2000 above the valley, their outlines varied by deep-cut ravines. On the Tennessee side the eye ranges over a vast extent of country ridged by low mountains and intersected by the many tributaries of the Tennessee. In the distance are the Unaka and the Great Smokies. . . . The geological section exposes 10,000 feet of beds, giving a range through nearly the whole of the life-bearing rocks of the most ancient period of our world's history.

Impressed with the peculiar geological features through which the Wilderness Road ran north of Cumberland Gap, he said:

It seems likely that the series of breaks which opened the passage of Cumberland [River] through the Pine Mountain, at Pineville, formed the half dome of Rocky Face, cut the Cumberland mountain at the Gap, and formed Double Mountain, are all either at one and the same fault line, or constitute a series of faults closely related in direction.

It was the iron ore south of the Cumberland wall rather than the great deposits of coal on the Kentucky side that appealed especially to Shaler. He reported that it was imperative that the ore deposits should be made available by a rail line from central Kentucky through the Gap to connect with the line running through East Tennessee. He was sure that the ore could be pigged and shipped at a profit, even to Europe. He visioned the establishment of manufacturing industries in the mountains and stated that the agricultural possibilities of the upland country had been greatly underrated.

Shaler returned in the summer of 1876 to conduct another school, but it was not so large as the session the year before. He

induced the U. S. Coast Survey to make a triangulation survey of Kentucky, beginning at Cumberland Gap and extending to the Mississippi, the first interior survey done by that branch of the government service. State and federal men remained in southeastern Kentucky for several years, and Shaler continued his work during the summers until 1880, when he was succeeded as state geologist by John R. Procter.

Time moved slowly in the hills during the decade after Shaler's abrupt intrusion. The shirt-sleeved, one-gallused mountaineers scratched in their raw ground, raised their big families and went about the even tenor of their ways. They were now calling the old Road which connected them with the outside world the "Kaintucky hog road," having dropped the former "wilderness" and "turnpike" terms. Occasionally it was still called the "state road," but the long years of its use for marketing livestock, particularly hogs, gave it the more rustic name. When, if ever, it would be supplanted by the railroad Shaler talked about no one knew. The mountaineers were patient, if skeptical, and although the L. & N. was slowly reaching deeper into the wilderness, they could wait awhile longer.

A new herald of the long-awaited improvement visited the mountains in the summer of 1885. James Lane Allen, of Lexington, Kentucky, was looking for something to write about. He had given up schoolteaching at thirty-five to devote himself to a literary career. Quiet and impressionable, and with a flair for pretty phrases, he was the product of the culture which had flowered into a full richness since the days of Boone. He had started humbly enough on a central Kentucky farm and had felt the ache of toil and struggle. But Kentucky had been good to him, and he delighted in its traditions and folklore. Now he wanted to see the mountains where he understood a distinct type of civilization had grown up quite different from that in the prosperous Bluegrass country.

Allen rode on the Cincinnati Southern Railway from Lexington to Burnside on the Cumberland River, considerably west of

the area served by the Wilderness Road.[3] He hired a horse and native guide for the cross-country journey eastward to Cumberland Falls, a miniature Niagara with a sixty-two-foot fall. After admiring this outstanding attraction, he continued eastward across Whitley County, in a section known as "Little Texas," and turned into the Wilderness Road at Barbourville, about halfway between Cumberland Gap and Crab Orchard. Barbourville was the oldest and still the principal town in the original stretches of the difficult mountain country of southeastern Kentucky, and from it had come a number of prominent local and state leaders who represented the more progressive element.

Allen had a profound respect for the old Road. When he turned south on it for its exit into Virginia and Tennessee at Cumberland Gap, he reflected on its significance. But as he jogged along he found little to inspire lofty sentiments. He later wrote:

> Despite all that has been done to civilize it since Boone traced its course in 1790 [1775], this honored historic thoroughfare remains to-day as it was in the beginning, with all its sloughs and sands, its mud and holes, and jutting ledges of rock and loose bowlders, and twists and turns, and general total depravity. . . . It is known that the more pious companies . . . as they travelled along, would now and then give up in despair, sit down, raise a hymn, and have prayers before they could go any further. Perhaps one of the provocations to homicide among the mountain people should be reckoned this road. I have seen two of the mildest of men, after riding over it for a few hours, lose their temper and begin to fight—fight anything—fight their horses, fight the flies, fight the cobwebs on their noses.[4]

Allen wanted to see developments along the way and learn how the mountain people were living. By taking up his southward journey at Barbourville, he was missing one interesting development he had heard about in Laurel County, some thirty miles north. In 1881, Paul Schenk, of Bern in Switzerland, had estab-

lished a Swiss colony, known as "Bernstadt," on 4,000 acres of rolling forest land five miles west of Pittsburg, the former station of Ricetown on the Road. Within four years, more than a hundred families from Bern, Zürich, St. Gallen, Basel, Fribourg and other Swiss cantons had settled on the tract selected by Schenk, started small farms, planted vineyards, set out orchards and engaged in dairying, cheese making and truck farming. The thrifty, industrious Swiss had brought into the region south of the Rockcastle country a craftsmanship which was rapidly extending its influence into the surrounding mountain communities.

Along the Road south of Barbourville, Allen observed a totally different people. He noted that the prevailing type of homes was still single-room cabins, built of logs, chinked and daubed, much like the crude structures put up hurriedly by the first settlers. The low chimneys were usually made of laths and poles and were often so low that it was a common saying that a person could sit by the fire inside and spit out over the top. The household furnishings were of the plainest kind, and the contents varied according to the economic standing of the owner. Allen heard of a mountaineer who testified in court that a neighbor's household possessions consisted of a string of pumpkins, a skillet without a handle, and a "wild Bill." That was the local name for a bed made by boring auger-holes into a log, in which sticks were driven and covered over with hickory bark and sedge grass.

The people whom he saw along the way showed the effects of generations of skimpy living. They were straight, slim and angular; their features were unanimated but intelligent. The men were fierce and crafty; the women listless and sad. A depressive melancholy pervaded every home, and everyone spoke in a drab monotone. They were little interested in the outside world and had apparently lost the initiative characteristic of their Saxon forebears. Their farms were small patches on the hillsides where they grew corn, potatoes, beans and other vegetables, and occasionally flax. For many of the poorer families the principal

problem through the year was to accumulate a few dollars to pay their state and county taxes.

For diversion, the menfolk met around country stores and mills and at crossroads to gossip, whittle, pitch horseshoes and take part in shooting matches for beef, turkeys or liquor. Trivial personal enmities arrayed families against one another in bloody feuds. Politics, moonshining and old animosities stemming from the Civil War frequently caused strife. Allen observed that on the whole the people were polite, kind and unoffending toward strangers, although it was the common practice to find out the business of all newcomers before extending any hospitality.

He was particularly depressed by the lonely and neglected graveyards he passed along the road. He found them in wild, isolated spots, usually on some knoll where dense oaks made a midday gloom. Nameless and unknown were most of the graves, with no headstones or footstones to show whether the person buried was a father, mother, son or daughter. Sometimes a few rough rails had been laid around an enclosure like a little pen for hogs. Weeds, briers and underbrush were prevalent. Most of the burying places were cleaned off only once a year. Only on rare occasions did he find a picket fence around a grave, or a stone with identifying inscription. The sons of the pioneers were as quickly forgotten in the mountains as the hundreds of nameless travelers who perished along the way during the perilous migration days.

The observant Lexington man was impressed with the sharp contrast between the life of the fat Bluegrass region and that of the picturesque mountain country through which he was passing. In Boone's paradise of rolling meadows and sweet waters, a century of prosperity, education and culture had created standards of civilization on a par with the finest in the nation. Yet the people Allen found in the hills had advanced little beyond the station attained by their ancestors who chose to stop in the westward march. Their isolation and the barren-ness of their homesteads had retarded their progress. Honest, devout and courageous, bearing fine old English, Scotch, Ger-

man and French names, they were as proud, independent and loyal as their richer cousins in the Bluegrass. In his hurried and superficial observation Allen discovered these latent qualities of mind and character, and his sympathy for their present lot was mixed with admiration.

He stayed all night at a little tavern at Flat Lick, where the Warriors' Path branched off to the north. The next day he passed into Bell County, formed from Knox, Harlan and Whitley in 1867. He spent several hours with a mountain woman eighty years old. She had never been out of the neighborhood, and she knew every path and trail in the surrounding country. She explained casually that she had whipped many a man single-handed and had kept a good supply of deer and wild turkey by her own rifle. Now that she had grown infirm, she had to sit in her cabin door and send her trained dogs out into the forest to bring in the game.

When Allen arrived at Cumberland Ford, the historic crossing of the pioneers, he found the river two or three feet deep. The stream was clear and placid. He paused under the sycamores to admire the scenery and to recall the legions who had passed that way in the settlement of the West. He rode a half mile up the river to the narrow gorge where the stream cuts through Pine Mountain. Here was located the little village of Pineville, the seat of Bell County, built up since the war around a log court-house.

He did not linger long. He found the town tense with repressed excitement. A few days before, there had been a shooting affray in the streets, and a dead line had been drawn through the town. Those living on either side crossed to the other at the risk of their lives. Allen was a stranger, and innocent and peaceful. But he was told that being a stranger and innocent and peaceful did no good. He had stopped to eat, but when he learned of the trouble, he would have hurried on, had he not feared to give offense. He gulped down his food, and remembered especially the corn bread: "It would have made a fine

building stone, hardening rapidly upon exposure to the sun, and being susceptible of a high polish." As quickly as he could, he exchanged his tired horse for another, which tripped off briskly as though expecting at every step to cross the dead line and be shot.

Turning into Yellow Creek Valley, Allen rode through the forest of magnificent timber along the Road. Oak, walnut, poplar, maple, chestnut, beech, gum, dogwood and elm abounded. He knew some of these mountains had been logged; he had seen big sawmills on the Cumberland River where timber from Bell and Harlan Counties had been floated. But the forest here was still virgin and untouched, except for occasional clearings and little cultivated spots in the hollows and on the ridges.

Familiar with the published reports of Shaler and other geologists, Allen was especially interested in the outcroppings of coal which he frequently saw. On Clear Creek which he crossed near the point where it flows into Cumberland River above the "Narrows" at Pineville, he learned that there was one seam of coal fourteen feet thick. He speculated on the coal fields of southeastern Kentucky, estimated to include 10,000 square miles. As he considered the inevitable development of this coal, he wondered how it would affect the native people. They faced two futures. Either they would be swept out of the mountains by the inrushing industries, or be absorbed and assimilated in a new civilization.

He rode into the great bowl immediately northwest of Cumberland Gap and got his greatest thrill. At last he was in sight of the gateway in the Cumberland wall which separated Kentucky from Virginia and Tennessee. There was the Pinnacle, looming high on the left of the big notch like a never-sleeping sentinel. On the right stood the more modest and diminutive peak where the three states cornered. The long wall continued southwestward until it was lost in the blue haze of massive hills. These are the emotions that possessed him as he and his local guide climbed into the gateway:

It was late in the afternoon when our tired horses began the long, winding, rocky climb from the valley to the brow of the pass. As we stood in the passway, amid the deepening shadows of the twilight and the solemn repose of the mighty landscape, the Gap seemed to be crowded with two invisible and countless pageants of human life, the one passing in, the other passing out; and the air grew thick with ghostly utterances—primeval sounds, undistinguishable and strange, of creatures nameless and never seen by man; the wild rush and whoops of retreating and pursuing tribes; the slow steps of watchful pioneers; the wail of dying children and the songs of homeless women; the muffled tread of routed and broken armies—all the sounds of surprise and delight, victory and defeat, hunger and pain and weariness and despair, that the human heart can utter. Here passed the first of all the white race who led the way into the valley of the Cumberland; here passed that small band of fearless men who gave the Gap its name; here passed the "Long Hunters"; here rushed the armies of the civil war; here has passed the wave of westerly emigration, whose force has spent itself only on the Pacific slopes; and here in the long future must flow backward and forward wealth beyond the dream of avarice.

Allen slept that night beneath the shadows of the Pinnacle on the Tennessee side, the limit of his journey reached. He had the material for his story, "Through Cumberland Gap on Horseback," published in *Harper's*, June 1886. Like Fenn and De Fontaine he wove around the old Road and the historic pass in the Cumberlands an aura of romance. Unknown to him at the time, Thomas Speed, a fellow Kentuckian of a distinguished family, was preparing a history of the Wilderness Road which the Filson Club, the historical organization of Louisville, was to issue early in 1886. Speed's book contained the first factual account of the annals of the Road, but it was of limited distribution. Allen's idealized portrayal of the wilderness, its people and the ancient Road was more widely read and was more effective in bringing to the attention of the nation that hidden wealth of the region which Shaler had discovered.

1 For the complete story of the Harvard Summer School of Geology, 1875, see *The Autobiography of Nathaniel Southgate Shaler* (Boston and New York, 1909) pp. 270-275; Letters of Shaler, July 31, August 22, 1875, to Charles W. Eliot, Harvard University Library; Samuel Eliot Morison, *The Development of Harvard University* (Cambridge, 1930), p. 308; *The Harvard University Catalogue, 1875-76* (Cambridge, 1875), pp. 164-165; N. S. Shaler, "Harvard Summer School of Geology," *American Naturalist,* 1876, X, 29.

2 David Starr Jordan, *The Days of a Man* (New York, 1922), I, 138-139. This was not the only trip of Dr. Jordan over the Wilderness Road. In the summer of 1876, he passed through Kentucky on his way to Rome, Georgia, to study the fish of the region. He heard a joint debate in London, Kentucky, between John Marshall Harlan, afterward a member of the U. S. Supreme Court, and James Bennett McCreary, at that time Harlan's rival candidate for the U. S. Senate.

3 James Lane Allen, "Through Cumberland Gap on Horseback," *Harper's New Monthly Magazine,* LXXIII, June (1886), 50-66; also *The Blue-Grass Region of Kentucky* (New York, 1892), pp. 230-268.

4 *Harper's,* LXXXI, September, 1890, 565.

Chapter 23

Boom in the Wilderness

SCARCELY had the ink dried on the June 1886 issue of *Harper's* containing James Lane Allen's article on the Cumberlands, when a stockily built man rode up late one afternoon to the home of Dr. James Monroe Harbison on the Tazewell road three miles south of Cumberland Gap. He was worn and tired after a long day's ride from Morristown, Tennessee, over the route of the pioneers from Bean's Station. He asked to stay all night. Dr. Harbison liked the looks of the big, handsome stranger, with friendly blue eyes, wavy reddish hair, and a bronzed face with red sideburns and mustache. He spoke with a pleasant Scotch burr and bore a remarkable resemblance to Chester Alan Arthur, recent President of the United States.

Alexander Alan Arthur, distant relative of the President, was the man of destiny whom Allen, Shaler and other writers had predicted would come to the old wilderness.

In the hospitable Harbison home Arthur explained the purpose of his trip to the Cumberlands. He had been employed by the Richmond & Danville Railroad Company to investigate the desirability of a rail line from Morristown to tap the Kentucky coal fields. Long into the night Arthur and Harbison talked, getting acquainted and exchanging confidences. Harbison was interested to learn that his charming visitor had been born in Glasgow in 1845, and that since boyhood he had lived in Montreal. His mother, Catharine Allan of Glasgow, was related to the noted family of Macaulays. He was the oldest of five

312

brothers and five sisters, and from the age of twenty, when his parents died, he had been responsible for the rearing and education of the younger children.

Arthur explained to his genial host that he had returned to Scotland after reaching maturity, and had married Mary Forrest, of Birkenhead. He had joined the 104th Highlander Volunteers and had drilled on the Glasgow Green. He was fond of outdoor sports and had established the Caledonia Lacrosse Club, the first of its kind in Scotland. Next he had formed a business connection which sent him to Norway and Sweden for a year. When he came back again to this country he brought his wife and baby boy to Boston, Massachusetts, where he became American agent of a Sheffield steel company.

His wife had died in Boston, leaving him with two children. The young Scotsman had met a charming Boston maiden, Nellie Goodwin, who became the second mistress of his home. Then he had been employed by a Scottish firm to go to Newport, Tennessee, and manage a big lumbering operation there. He had explored the mountains of western North Carolina and East Tennessee, stopped often at the Warm Springs Hotel and resorts around Asheville, and had become acquainted with Eastern guests vacationing at the newly developed summer playgrounds. He had learned that many men of wealth were being attracted to the Southern highland region, and he had watched for an opportunity to expand his own activities. When he was at last approached by officials of the Richmond & Danville Railroad Company about the extension of their line to Kentucky, he had been quick to accept their request to make an investigation.[1]

Arthur found in Dr. Harbison an intelligent informant. In his practice, the Powell Valley physician had ridden over all the trails through the neighboring mountains and knew about the iron ore south of the Cumberland wall and the bituminous coal deposits on the Kentucky side. He was the son-in-law of Captain Daniel Huff who had been fatally injured in 1861 when he was thrown from a buggy while riding down the Gap Road after a dinner with Confederates at the pass. Dr. Harbison had built

a modern dwelling on the Huff estate on the Tazewell road which had come down from his wife's grandfather, John Walden, one of the early pioneers in Powell Valley and believed to be a son of the Long Hunter, Elisha Walden.

When the night was over, Dr. Harbison took Arthur out under the trees and showed him the long wall of the Cumberlands, with the lower parallel barricade of Poor Valley Ridge. The view of the sharp depression in the great barrier was somewhat obscured by a spur of the ridge, but the entrancing landscape captivated the impressionable Scotch adventurer. He said it reminded him of his native country. He was impatient to be off on his tour. He followed the Tazewell road across the low gap in Poor Valley Ridge and down into the little dale overlooked by the Pinnacle. He spent some time visiting the points of interest, and was particularly impressed by the old forge, no longer in operation, and the corn mill and carding machine operated by the stream flowing out of the face of the mountain.

The silence of the dead furnace, the roar of the gushing stream, the rhythmic swash of the big mill wheel and the creaking of antiquated machinery created many emotions within him. These were heightened by the view of the bare precipitous side of the mountain towering 1,400 feet above him. He wondered how the soldiers managed to place their forts and rifle pits on the narrow shelves. At the base of the mountain he found shells, bombs, bullets, old muskets and other equipment, bent, rusted, weatherworn and useless. But there was a pristine freshness about the place. Young timber had grown up in the twenty years since the mountain had been stripped by the soldiers; birds and saucy squirrels played about; and wild flowers and floral shrubs abounded. Arthur caught the spirit of the place. Trooping through his mind were crafty Indian, sturdy pioneer, gallant soldier, dusty ironworker, thrifty miller, half-starved squatter and peaceful trader. But the future lured him with its possibilities.

He continued his trip across the mountain into Yellow Creek Valley, talked with the natives there, visited the openings in a

number of thick coal banks and picked up samples. He climbed near-by peaks and looked over the vast forests. He inquired about the prevailing price for land, studied the physical contour of the territory and noted the old Road winding through the hills. He saw what thousands before him had missed. Here was unlimited opportunity, ready-made and waiting.

Arthur hurried back to Newport. He was disappointed to learn that in his absence the Richmond & Danville Railroad had been merged with the East Tennessee, Virginia & Georgia and that for the time being an extension from Morristown to the Kentucky coal fields was held in abeyance. But he was so completely possessed that he could not rest. He left his timber company and went to Asheville to look up some young men from the East with whom he had become acquainted. Among them were tubercular F. Randolph Curtis, of New York City, John Barnard, James S. Churchill, Edward Herrick and J. H. Martin. Members of wealthy families of New York City and Baltimore, they had little to do except to gossip over their cups and think up exciting adventures.

The ebullient Arthur charmed the idle young men with an account of his exploration. He wove into his story the romance of the region, its scenic setting and its hidden wealth. He exhibited his specimens of coal and iron ore, and persuaded them to go and see for themselves.

On the night of August 31, 1886, Arthur and his young companions camped by the side of the Road in the Saddle of the Gap. As they lay around their campfire under the stars, they felt the earth quiver beneath them. The violent tremors lasted several minutes, and when all was still they knew that they had experienced an earthquake. They speculated on the phenomenon, and later learned that Charleston, South Carolina, four hundred miles away, had been wrecked by the quake. They also found that in the yawning cave on the mountain under them, huge boulders had tumbled down from the ceilings and covered the floor of the caverns with torn and jagged rock.

Arthur and his associates spent several days tramping over the

hills, through the ravines, along the streams. They collected more samples of coal and iron ore, made estimates of the timber and optioned more than 20,000 acres of land from the natives. Then the prospective empire builders returned to Asheville, organized themselves into the "Gap Associates," and began to consider ways and means of enlisting capital in their project.

Arthur, the daring dreamer and promoter, had the answer. He said that he knew the heads of financial organizations in London and could talk their language. Let him go to London with the story. The playboy capitalists thought it was a sporting idea. They pooled their funds and sent Arthur off with his samples to the financial capital of the British Empire.

The friendly, persuasive Scot found ready listeners among the steel men of England. Britons, with fingers in many pies, had been attracted by the undeveloped resources of the South for a generation. Already they had invested heavily in Birmingham, Alabama, and their fortunes were pyramiding. They were associated also with the development in the Ducktown basin in Tennessee on the Georgia line where there were inexhaustible stores of copper and iron. Arthur's story that another region north of these areas was rich in coal, iron and timber stirred many members of the British Steel Syndicate. The news that vast acreages of mountain land filled with minerals and covered with virgin timber could be bought at almost giveaway prices sharpened their appetites. Sir Jacob Higson, world-famous engineer and geologist, was designated the leader of a group to go with Arthur to America and see with their own eyes.

The Englishmen arrived early in the spring of 1887, and Arthur piloted them over the territory. They journeyed through the old pass, down into Yellow Creek Valley and up the streams. They rode along the Wilderness Road from the Gap through southeastern Kentucky to Woodbine, Kentucky, fifteen miles north of Barbourville, where the L. & N. had finally brought its line south from Livingston. These new pioneers did not hurry through a desolate area, like the followers of Boone; they marveled at the rich and neglected natural resources.

Higson and his English and Scottish companions were more than satisfied. They immediately dispatched a cable from Woodbine to London substantiating Arthur's representations, saying the "half had not been told." They recommended the purchase of the options of the "Gap Associates" and other adjacent mountain lands. Arthur was showered with congratulations and effusive appreciation. One Scot said to him: "You maun feel a prood mon th' day!"

Before Higson and his companions sailed for London, they made the preliminary arrangements for the formation of a company known as "American Association, Ltd." Arthur was named general manager and chief American representative. He and the other "Gap Associates" transferred their paper holdings at good profits for stock in the larger company. While Higson lined up investors in England, Arthur engaged local land buyers to take up the options on the 20,000 acres and to purchase adjoining lands. Within a few months, more than 80,000 acres in the three states joining at Cumberland Gap had been either bought or optioned.

Arthur moved from Newport to Knoxville and set up his headquarters. Operating from that point he crowded his enterprise with dizzy speed. One of the first problems facing his company was the building of a railroad into the new area. The L. & N. had already pushed its line south from Woodbine to the Jellico coal fields, but had skirted west for the new development. Knoxville was sixty-five miles away, and Morristown, another point of contact, was nearly as far. Arthur immediately launched a campaign in Knoxville for $250,000 of local capital to supplement the investment of the English company and build a railway from the East Tennessee capital to the Kentucky coal regions. Speeches, bands and parades whipped up enthusiasm for the sale of stock. Money flowed in and the Knoxville, Cumberland Gap & Louisville Railway Company was chartered with the English company subscribing the controlling interest.

The L. & N., acting independently, at first did not envision a direct line to Cumberland Gap, but planned to leave the Wilder-

ness Road at Pineville, follow the Cumberland River into the
Harlan County coal fields and then go through the mountain to
Big Stone Gap in Virginia to connect with the Norfolk &
Western converging there. But Arthur and his associates moved
so rapidly the L. & N. officials changed their plans and pointed
their rails from Pineville along the old Road into Yellow Creek
Valley.

Arthur's Knoxville road and the L. & N. were not the
only lines racing into the heart of the wilderness. A branch
railroad from Morristown by way of Bean's Station, which
Arthur had anticipated, was revived. The Norfolk & West-
ern contemplated an approach from the southeast, connect-
ing with coastal points. The old Charleston-Cumberland Gap-
Chicago proposal, agitated by Clay and Calhoun fifty years
before, was again discussed. The Western Air Line from
Wilmington, North Carolina, was turned toward Kentucky.
"Fully a dozen roads, projected or in progress, are pointed
toward the center in the race for the prize," a journalist wrote
within a year after Arthur and his English associates had set out
on their great adventure.

Arthur was soon joined by English aids representing the land-
holding and railroad companies. Young Otway Wheeler-Cuffe,
later third baronet of Lyrath, Kilkenny, became the assistant
manager in charge of operations at Cumberland Gap. Colonel
Arthur Chester Master, formerly of the British Army, became
secretary. Master was the son of a dignitary of the church of
England, tall and stout, with a full, round face, blue eyes and a
flowing auburn mustache. He became familiarly known as
"Cocky" Master. Another assistant was Captain Claude Prescott,
son of the Dean of Carlyle. He too had been in the British Army.
He was a tall, handsome man, with dark face, raven black hair
and a small black mustache closely cropped.

Arthur and these subordinates let the contract for building
the railroad from Knoxville to Cumberland Gap and set August
1, 1889, for the completion date. Road crews strung out along
the sixty-five-mile survey, and independent crews started im-

mediately to dig a tunnel through Cumberland Mountain underneath the pass. Hundreds of Negroes, Italians and native white laborers were employed to excavate and bore from both sides. Tents and temporary houses were put up, and stores, sawmills, blacksmith shops and saloons spawned in the shadow of the Pinnacle. This new settlement took the name of "Cumberland Gap," the same as that of the pass, and henceforth the town and pass became synonymous.

Impetus was given to the development when Arthur announced that the Watts Steel Company of England had agreed late in 1887 to build two blast furnaces in the area. Frank and Edgar Watts, young brothers affiliated with the company, soon arrived to begin operations. One of the first needs was a place to live. So they erected a hotel on a spur of Poor Valley Ridge which faced the pass. It was known as the "English Hotel," was five stories high and had fifty rooms and a large dining hall. With an eye to their personal pleasure, they bought a large farm two miles south of the pass, erected a handsome residence and laid out an extensive hunting range where they could ride to hounds. During the busy days of 1887-1888, while the construction was going on, visiting English noblemen and businessmen engaged in their favorite sports. Frank Watts lost his hand one day when his gun went off accidentally during a chase.

Shuttling back and forth from Knoxville to the scene of operations around Cumberland Gap, Arthur reviewed the work in the field, burdened the mails with letters and reports to officers in New York City and London and dispatched long cables to England. As news of the big operations spread to the financial centers of the United States and England, he was kept busy answering inquiries and entertaining visitors who wanted to get in on the ground floor. Spending much of the time in the English Hotel, he and his associates talked with hundreds who came to see what was going on. Hacks arrived daily from Knoxville and Morristown with prospective investors. Stages, buggies and wagons labored over the Wilderness Road bringing workmen and adventurers from central Kentucky and the Northern states.

Abram S. Hewitt, former mayor of New York City and famous geologist, lent his services to Arthur in making a survey. Charles Livermore and George R. Eager, capitalists of Boston, came to see if they could invest. H. F. Pollock, prominent barrister of Paine, Son, & Pollock, London, journeyed across the Atlantic to look into legal questions for his clients. Some arrivals came from Rugby, Tennessee, deserting that communal enterprise established in 1880 by Thomas Hughes, the English jurist, idealist and author of *Tom Brown's School Days*.

Special writers for the *Journal of Commerce*, the *Manufacturers' Record* and other trade and commercial publications came to Arthur for feature articles. Charles Dudley Warner, the popular author, arrived from Hartford, Connecticut, in July 1888, accompanied by General Simon Bolivar Buckner, governor of Kentucky, and Dr. John R. Procter, state geologist, who had figured prominently in the early surveys. The party came over the L. & N. to Pineville, where the tracks for the Cumberland Valley spur had been laid by April 1, 1888. Warner described their trip for *Harper's*. He commented on the last portion of their journey:

> We drove from Pineville to Cumberland Gap, thirteen miles, over the now neglected Wilderness Road, the two mules of the wagon unable to pull us faster than two miles an hour. The road had every variety of badness conceivable —loose stones, ledges of rock, bowlders, sloughs, holes, mud, sand, deep fords. . . . Settlements were few—only occasional poor shanties. . . . We climbed up to the top of the mountain over a winding road of ledges, bowlders, and deep gullies, rising to an extended pleasing prospect of mountains and valleys. The pass has a historic interest, not only as the ancient highway, but as the path of armies in the civil war. It is a narrow, a deep road between overhanging rocks. . . . On our way down the wild and picturesque road we crossed the state of Virginia and went to the new English hotel in Tennessee.[2]

At the hotel Arthur welcomed the visitors and talked about the transformation taking place. His rich warm voice burred the story of the new industrial empire in the making. Buckner was reminiscent, and his memory of Cumberland Gap was not too pleasant. When he had commanded Confederate forces in East Tennessee, he had run away from Knoxville and left a besieged garrison at the gateway to suffer the humiliation of surrender. Geologist Procter was pleased, because the development was a justification of his and Shaler's predictions ten years before. Charles Dudley Warner was excited. He was witnessing a revolution in the wilderness. The quiet of the forest was broken by the clank of steel, the ring of hammers, the whir of saws, the shriek of steam whistles and the shouts of sweating legions.

With his railroad under way, the tunnel being rapidly drilled, and land acquisitions proceeding apace, Arthur looked to the building of a nerve center. A natural site was close at hand. When he had first come into the giant bowl of the Yellow Creek Valley, rimmed with mountains, he had determined that this should be the place for his capital. By little valleys, like spaces between the fingers of an upturned hand, five streams flowed into slow and twisting Yellow Creek, which in its turn wound through the plain into a sharp gorge. Some geologists claimed the basin in past aeons had been a huge lake.

Across this lowland the original Wilderness Road had passed through marshes and canebrakes. Here the first settlers who followed Boone had often seen hundreds of buffalo and deer at the salt licks. In time they had turned the marshes into fields and built homes on the spurs and along the Road. John C. Colson, preacher, merchant and country squire, had built a beautiful home, tavern and store by the side of the Road, and until his death the year before had been recognized as the "king of the valley." Yellow Creek Valley had developed a quiet civilization of its own—a civilization limited to about fifty people.

Arthur's engineers agreed that the basin was suitable for a city of a quarter of a million people, with ample room for industrial plants. Feeder railroad lines could reach the coal deposits in the surrounding mountains, and the iron ore from nearby Tennessee and Virginia could be brought through the tunnel. Resting on a log one day in the summer of 1888, Arthur and his English companions looked over the old fields, fence rows and wooded spurs and discussed possible names for their town. Various suggestions were made. Someone spoke of Middlesbrough, England, which had risen to commercial greatness a few years before at the mouth of the Tees, in the North Riding, Yorkshire. Here might rise a New World counterpart of that iron center. Arthur and his engineers christened their town-to-be "Middlesborough." It was soon shortened to "Middlesboro," except for official documents.

Most of the necessary acreage had already been purchased by the American Association, Ltd. A few local citizens refused to sell some isolated tracts. Arthur formed a subsidiary organization known as the Middlesborough Town and Land Company, and reserved 5,500 acres in the valley for the new metropolis. He employed Colonel George E. Waring, Jr., of Newport, Rhode Island, and New York City, to plot the city. Waring, a cavalry leader of the Civil War, had laid out sewer systems for Saratoga Springs, Memphis and San Diego in Cuba. On July 16, 1888, the first stake was driven in a cornfield near the center of the area and began the survey.

Colonel Waring plotted the framework of the city; Arthur and his associates named the streets. For the main thoroughfare running east and west they measured off one hundred feet four miles long across the basin and called it Cumberland Avenue. To the winding Wilderness Road leading off this avenue toward Pineville they gave the name of Fitzpatrick Avenue. Parallel to Cumberland, the avenues were given English names, such as Chester, Winchester, Exeter, Rochester, Dorchester, Ilchester and Manchester. Cross streets running north and south were numbered, and the three humpbacked hills were landscaped for resi-

dences and named Queensbury Heights, Maxwelton Braes and
Arthur Heights. All the streets and avenues were wide and sym-
metrical, conforming to the level land and the undulating knobs.
Arthur was worried about the proper drainage for the low-
lying city. The natives had warned him that Yellow Creek was
an angry and uncontrollable stream during spring and winter
freshets. As recently as 1885 the entire valley had been flooded.
Waring assured Arthur he could correct that. He would begin
at the junction of Bennett's Fork and Stoney Fork creeks in the
western parts of the basin and cut a new channel for Yellow
Creek straight eastward to the center, and thence diagonally
northwestward through a section reserved for business develop-
ments, until the stream was returned to its original bed for its
exit from the valley. The abandoned bed of twisting loops would
be filled and leveled for residences. Arthur and the officials of
the Town Company imported hundreds of Italian laborers to dig
the "Canal." They made the new channel one hundred feet
wide and covered the floors and walls with heavy timbers to
provide a more rapid flow.

Waring told Arthur that an adequate water supply would
be no problem. Little Yellow Creek, a branch of the main
stream that came into the basin around an intervening ridge
next to Cumberland Mountain, was ideal for impounding. Work-
men soon built an earthen dam, four miles below Baptist Gap,
near the site of the first blockhouse built in the basin by the
Turner brothers about 1800. The artificial lake was three miles
long, with a capacity of 900 million gallons of pure, freestone
water. It was called Fern Lake.

To girdle the city, Arthur threw a railroad around the rim
of the valley 600 feet inside the designated limits and formed an
independent subsidiary to operate this belt line. He started feeder
spur lines into the converging hollows to tap the coal seams. He
laid a "dummy line" along one side of Cumberland Avenue to
carry material to the builders putting up business structures and
residences. He reserved large plots of land for industrial plants
and started a hotel on a promontory of Arthur Heights.

To detail the busy days of Arthur and his associates in the fall and winter of 1888 and the spring and summer of 1889, as they rushed the capital city to completion, would be to sketch a dramatic story of human energy. Arthur, with his mesmeric powers, seemed to be everywhere. He would suddenly appear in the city of tents, observe progress with conscious pride, untangle snarls in conflicting activities and then hurry off again. He must be away to New York or to London, to attract more enterprises. He pumped into the valley a constant stream of new capital, most of it from London banks.

Everybody began to call him the "Duke of Cumberland," and he bore the title with proud dignity. He made his development the most talked-of center of the South. Hundreds of prospective investors visited offices of his company in Knoxville, New York and London to see the displays of photographs and relief maps, and the exhibits of coal, iron and timber. Soon thousands were crowding along the roads to the center of the wilderness, rich and poor, old and young, curious and adventurous, investor and speculator. By the middle of 1889, his tent city was a surging congeries, digging, building, sawing and trading. Shanties and temporary frame structures grew by magic. The wide streets were churned into bogs of mud. Sawmills were located along the streams. Coal seams were tapped and tipples built. Business houses rose rapidly to fill in the pattern laid out on the blueprints.

It was a noisy, boisterous throng that had responded to Arthur's call. Mingling with the shirt-sleeved, slouch-hatted natives were sedate Englishmen in spats and plus fours. "Remittance men" from wealthy English families became familiar figures, easily spotted around the saloons. Hundreds of young men, scions of wealthy Bluegrass families, put up stores, livery stables, saloons and restaurants, or hung out shingles as professional men.

Arthur arranged to be on hand for one long-anticipated event. The tunnel under the pass was cut through on the night of August 8, 1889, after eighteen months of prodigious digging from both ends. When for a time it looked as though it could not be

finished by the contract date, the builders planned to run a temporary rail line over the top of the Gap to connect with the line on the north side in order to meet a technicality in the contract. But the seven-eighths of a mile of underground digging had been completed in time. When the workmen met halfway beneath the pass and broke through, they staged a riotous celebration.

Whistles screamed until they died for lack of steam, guns and pistol shots made a wild staccato echoing from the surrounding crags, and everybody went on a big spree. Drunks crowded the saloons in "Hell's Half Acre," the narrow strip of Virginia which reaches along the side of the Pinnacle to the Saddle of the Gap. Brawls broke out in a dozen dives. One Negro workman wounded another in a fight. When he was fined five dollars for the assault, he swaggered: "I'd a-give ten dollars if I could've killed that Negro."

With the rail line built from Knoxville to Cumberland Gap, Arthur rode in style on the first scheduled trip over the road. Accompanied by officers of the English company, members of Knoxville's official family, railroad officials and special guests, he sat proudly in the rear coach and talked of the days of grandeur ahead. The train steamed along the newly laid track, rounding curves, crossing streams and chugging up valleys. About thirty miles out of Knoxville as it crossed a long wooden trestle, the timbers gave way and the rear coach plunged from the track, landing bottom-up twenty-five feet below. From the twisted wreckage, the dead, dying and injured were pulled out. Among the seven fatalities were some of the most prominent men of Knoxville. Arthur suffered serious internal injuries.

Invalided for several weeks, he directed his enterprises from his hospital bed in Knoxville. He could not be on hand when the first L. & N. train whistled in from the north on September 1, 1889. In the race for Cumberland Gap, the K., C. G. & L. line from Knoxville had arrived first, although the disaster a week before had taken away some of the sweets of victory. But at

last the lines from the north and south had been connected. The engines of the two railroads nosed together and rejoicing citizens celebrated again.

Arthur recovered sufficiently to be in Middlesboro for the first big lot sale, October 14, 1889. He was wheeled out onto the front porch of a portable house near the half-finished hotel on the hill overlooking the center of town. Mrs. Arthur, young and beautiful, was mounted on a handsome black mare near the auctioneer at the corner of Cumberland Avenue and 20th Street. The sale had been widely advertised throughout the North and the East, and for days speculators had been trooping in, to pick out lots and building sites. The auctioneer mounted a wagon and declaimed upon the marvels of the "Magic City." More than $100,000 was paid for lots during the day. Some penniless purchasers bidding in property on credit resold their holdings a few hours later at large profits.

By the end of 1889 Arthur saw his sprawling capital filled with more than 5,000 people. Trains were circling the "belt line" with coal from the newly opened mines. Two blast furnaces of the Watts Steel Company were rising at a cost of $800,000. The Hall and Vaughan Tannery was being built. An electric-light, heat and power plant was under construction at a cost of $250,-000. The Middlesborough Hotel with 150 rooms was near completion. More than $10,000,000 had been spent in the old fields through which the Wilderness Road ran eighteen months before.

Arthur had his first setback during the first half of 1890. On April 20 six business houses burned and 100 people were rendered homeless. The blackened ruins had hardly been removed when another fire, on May 8, burned a livery stable and destroyed twenty mules and horses. On the morning of June 4 a grocery store caught fire, and the flames wiped out the entire business district. Arthur was in his office when the alarm sounded. He rushed out to join the amateur firemen. Merchants emptied their stores, and the contents of saloons were piled in heaps. Fearing a drunken riot, Arthur grabbed a hammer and

began to break the bottles and barrels. The gutters ran with drink, and many stopped their fire-fighting to get down on their knees and guzzle liquor. When Arthur cabled to London for loans for the unfortunate, he received quick authority to supply them with funds to rebuild their stores and homes.

Then Arthur set off to London himself. In less than three months he cabled to his local managers that $8,000,000 more had been subscribed for additional investments. This news was blazoned in the local papers, and preparations were made for Arthur's reception when he returned. On the day of his arrival, a throng met him at the railroad tracks at the tunnel, and a decorated carriage conveyed him into town. He was bringing more plants, more hotels, more industries and more improvements. His Middlesboro was continuing its skyrocket leap into greatness.

To demonstrate the opportunities in the Cumberlands, Arthur fitted out a large railroad coach with specimens of coal, rock, clay, shale, ores and timber, and sent it on a tour through Eastern cities. Later he equipped a special train of twenty-two cars, including an "Exposition Car," which circled through New York, Pennsylvania, Ohio, Indiana, Illinois, Minnesota, Kansas and Missouri. He accompanied the train on a portion of the trip, but S. C. Cary, a glib-tongued press agent, had charge and proclaimed at every stop the story of the bonanza in the Kentucky mountains.

Arthur, who knew how to put on a big show, prepared elaborate ceremonies in the fall of 1890 for the entertainment of important visitors from England, France and Germany representing the British Iron and Steel Institute. Sir James Kitson headed the delegation of 310 financial leaders and economic experts from the Old World. Their special train rolled into Middlesboro on a brisk October morning. Arthur, Mayor John M. Brooks and all the town leaders turned out to greet them. Arthur took them to the hotel for drinks, then to the coal and iron mines, to Cumberland Gap, to the big cave under the Pinnacle, and to the crest overlooking the development on both sides of the mountain.

Finally, he conducted them on an excursion around the city on the belt line.

After this kaleidoscopic review of the new wonders in the old wilderness, Arthur led the delegates to "Exposition Hall," where John R. Procter exhibited a map of the territory, made by Abram S. Hewitt, showing the location of the coal and iron seams. Procter mixed his scientific details with snatches of the history and romantic setting of the region.

> We of Kentucky rejoice that here in the sight of the great historic pass, in this beautiful valley once traversed by the Wilderness Road, the descendants of the young and hardy pioneers have clasped hands with their kin beyond the seas, and Kentuckians and Britons are striving together to build here a great industrial and commercial center.

There was much clapping of hands, stamping of feet and cries of "Hear! Hear!"

When Arthur followed Procter, he was given an ovation. Here was the master hand who had brought it all about. In a strong, resonant voice he repeated the story of his first visit and described the industrial empire rising in the hills. Kitson, the British steel king, responded to Procter and Arthur and admitted he was tremendously impressed. He assured them that Britons considered it a privilege to join Americans in the common task of utilizing nature's prodigal resources for the benefit of mankind.

After the visitors had moved on from Middlesboro and inspected other localities in the South, Arthur was much pleased with the interview which Kitson gave to New York papers. In it he declared that the Kentucky development was even greater and more promising than Arthur had· claimed.

Arthur spent some time with James Bryce, the British historian, who, on his fourth tour of America, came to see what was going on at Middlesboro. He had much to tell James Lane Allen, returning after five years to write another article for *Harper's.* He was interviewed by dozens of other writers who

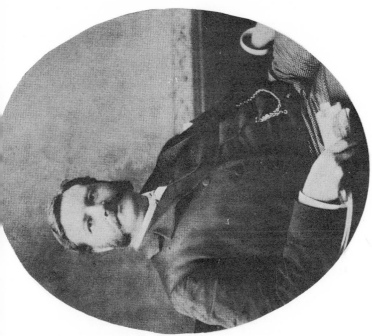

ALEXANDER A. ARTHUR

President of English development company, 1887-1892, who exploited the resources, and built Middlesboro,, Kentucky, on the Wilderness Road.

DR. NATHANIEL SOUTHGATE SHALER

Harvard geologist who made first detailed survey of the natural resources of Cumberland Mountains.

THE FOUR SEASONS HOTEL

Built in 1892 two miles south of Cumberland Gap as a health and vacation resort. The 700-room hostelry was torn down in 1895 and sold as salvage. Lincoln Memorial University, Harrogate, Tennessee, was later built on the site.

filled various trade and commercial publications with extravagant praise of his enterprises.

The promoter had more than industrial schemes in mind. In his New York office one day in 1890, he talked with Dr. Allan McLane Hamilton, grandson of Alexander Hamilton, and with Dr. Holbrook Curtis, famous laryngologist and brother of F. Randolph Curtis, one of the original "Gap Associates." He described the beauties of the region and enlarged on its wonderful climate and the health-giving properties of its mineral springs. With the industrial development a health resort should be established.

Favorably impressed, Hamilton and Curtis sent William B. Bigelow to Cumberland Gap to look it over for them. Again Arthur worked his magic. He showed Bigelow his new city in Yellow Creek, took him across the Gap to the Tennessee side where a suburban residential center "Harrogate" was contemplated. Already Randolph Curtis had erected a resort hotel known as "Harrogate Inn" on one of the southern spurs of Poor Valley Ridge. Fields sweeping around the Harbison home, where Arthur had stopped on his first trip, had been purchased and reserved for this suburb. Here, Arthur explained, was the ideal site for a great resort hotel and a spa of the South, modeled after the watering places of Vichy, Homburg and Baden-Baden.

Bigelow succumbed to the lure. He recommended the project to Hamilton and Curtis. They called in Dr. John S. Billings, surgeon general of the United States, and began work. They bought several hundred acres of the Harrogate land, employed architects, located various springs and gave them euphonious names. They left no gurgling rivulet uncharted for medicinal purposes. Arthur and the English company co-operated. Other investors were interested. In a little while a 700-room hotel was rising south of the pass, the "Four Seasons," and a large sanatorium was started on an adjoining hill. More than $1,500,000, mostly New York capital, was secured for the enterprise.

Arthur built a beautiful residence on the Harbison homesite adjacent to the hotel and sanatorium grounds. Here he brought

his wife and children from Knoxville and lived with the splendor of an English lord. With a handsome span of horses, he rode back and forth each day over the age-old trail through the Gap to the scene of his operations in Yellow Creek Valley.

The "Duke of Cumberland" was at the zenith of his achievement. His touch on the old wilderness was Midaslike. In three short years he had become an industrial executive in charge of enterprises with investments of more than $20,000,000, and his own paper fortune was estimated at a million. In his spectacular rise, he had wrought an amazing transformation along the pioneer road. The railroads were pouring new people and new supplies into fast-growing towns at former crossroad stores and taverns. Little settlements all the way from the Holston country to central Kentucky boomed with strength and prosperity from Arthur's development in Yellow Creek Valley.

The L. & N. line from Cumberland Gap was extended into Virginia to Big Stone Gap along Boone's Road, where a development in coal, iron and timberlands rivaled the Middlesboro venture. Pineville, at the Cumberland Ford settlement, was rapidly growing into a lively city. Barbourville, long the chief town on the old Road between Cumberland Gap and Crab Orchard, took on new life with its near-by coal fields. Lynn Camp, near Woodbine, where the L. & N. forked for the entry into the Cumberlands, also became a busy center. The railroad city of Corbin was to be established there.

The recognized leader of all this empire rising in the mountains, A. A. Arthur, had good reason to feel content. Surely the gods were good.

1 The details of Arthur's career in the Cumberlands have been gathered from a wide variety of sources—interviews by the author with members of the Arthur family and Arthur's associates; newspapers and magazines; printed pamphlets of the development companies; and official records of the City of Middlesboro, Kentucky. A brief account of his activities is found in an article "The Building of Middlesborough," by his secretary, Charles B. Roberts, in *The Filson Club History Quarterly*, January, 1933, pp. 18-33.

2 *Harper's*, LXXVIII, January, 1889, p. 265.

Chapter 24

"Better to Get Wisdom Than Gold"

O NE SUMMER day in 1890, a man was digging in a vacant lot in the new town of Cumberland Gap, Tennessee, where the Wilderness Road began its winding ascent for entry into Kentucky. A passer-by inquired: "What are you doing?"

The digger looked up. His brown eyes were shadowed by heavy brows, and a strange fire smoldered in their depths. "I am building a church," he replied.

A church was something new for the wild, rollicking town planted at the foot of the Pinnacle by Arthur and his associates when they began their development. In the rush to transform the wilderness into an industrial empire, it had been "business first." The digging of the big tunnel had brought stores, taverns, hotels, boardinghouses, livery stables and saloons to the little settlement on the Tennessee and Virginia sides before Middlesboro was started. The triangular wedge of Virginia reaching across the face of the Pinnacle to the corner of the three states had got its name of "Hell's Half Acre" because of the drinking, gambling, carousing and debauchery in the dives there. Officers had difficulty in maintaining order because law violators could easily step out of the jurisdiction of one state into another. Even Middlesboro, rising from the old fields of Yellow Creek Valley four miles away, did not exceed in wickedness its lesser rival, the town of Cumberland Gap, in those first riotous days of gay living and fortune making.

331

For the Reverend and Mrs. A. A. Myers, mountain missionaries laboring in Whitley County, Kentucky, the news of the boom in the Cumberlands was a clear call to a new field. They hitched old Rex, their horse, to a buckboard, loaded up their personal possessions and portable melodeon and joined the caravan of fortune seekers journeying along the Wilderness Road. They did not stop in Middlesboro but continued across the mountain to Cumberland Gap. They found no school, no church, no place for a Sunday school in the town. Here was a field ripe for the harvest, and here they would build a new temple.

Brother Myers and his wife got acquainted with the town leaders, talked with Arthur on one of his frequent visits, started a Sunday school on the second floor of a store building. Within a few days Myers selected a likely spot for a church by the side of the road. Without a dollar or the promise of any help, he started digging a foundation. "The Lord will provide," he cheerfully told his wife.

This was no new thing for the missionary team. They had been working in the Southern mountains for nearly twenty years. Graduates of Hillsdale College in Michigan and members of the Congregational Church, they had come south in 1881 under the auspices of the American Missionary Association. They went about teaching, preaching, exhorting, singing, distributing tracts, starting churches and Sunday schools and founding day schools and private academies. They used the material at hand in each community visited—organizing Baptist, Methodist, Presbyterian or Congregational centers according to the prevailing denomination. For several years they had worked in Whitley County, Kentucky, where they had established an academy and scores of churches and Sunday schools. By the time their call led them to Cumberland Gap they had sponsored forty-four public buildings in communities which they had touched by their fiery zeal.[1]

Brother Myers was a typical roving evangelist. His fervor was infectious. His booming voice could be heard at a great distance when he was preaching or exhorting. Mrs. Myers was an

ideal companion for her energetic and dreaming husband. Kindly, methodical, winning in her appeal, she accompanied him on his trips through the mountains. She would play the melodeon at meetings, where both would sing, pray, preach and exhort. They were popular with most of the native mountaineers, and their influence was soon felt. They flayed the evils of gambling, drinking and moonshining and brought many "case-hardened sinners" to repentance. On one occasion when Myers was cleaning up a particularly bad situation in the Kentucky mountains, he was shot by an irate moonshiner. He carried the bullet in his body as a proud token of his brush with the Devil.

The promoters, exploiters and ne'er-do-wells about the new town of Cumberland Gap at first accepted the Myers couple as a necessary nuisance, but before long they entered into the spirit of their effort to build a church and generously helped out. Others more sincerely interested in improving conditions volunteered their services. Arthur donated funds, and merchants and businessmen contributed material. Carpenters gave many days of free labor. In the early fall of 1890 the building was completed, Myers preached his first sermon, and his wife started a private school for children in the basement.

Myers had arrived when Arthur and his group were riding the crest. His evangelistic zeal for improving social and religious conditions in the mountains took a new turn, as he observed the scramble of the people to get rich. The worship of Mammon appeared even more godless than the excesses of drinking and carousing in the saloons and taverns. The burden of his sermons became: "Better to get wisdom than gold. . . . All this shall pass away. . . . He that layeth up treasures for himself is not rich toward God." But his prophetic words fell on deaf ears, as the people of the Cumberlands burrowed for the black gold in the hills.

Scarcely had he opened his church and school when the disturbing news broke that all was not well with Arthur's far-flung empire. In November 1890 Myers learned that Arthur had re-

ceived a cable from London that the bank of the Baring Brothers had closed. Much of the capital poured into the enterprises of Yellow Creek Valley had come through this English bank. Neither Myers nor other citizens grasped the implications. But Arthur was worried and he hurried at once to London. More than $20,000,000 had been invested in his various interlocking enterprises, and much more would be needed to place them on a productive basis. The flow of capital must not be stopped at this critical juncture.

Soon the news filtered back to Myers and the local managers in the Middlesboro valley that Arthur was in serious trouble. Millions of dollars worth of bonds in his companies had been sold to English investors. Most of the money had been spent in preliminary development rather than in active production. Profits could not come until the rail lines were completed, the mines opened, and the plants turning out their products. Only in the sale of lots by the Middlesboro Town and Land Company had there been a quick turnover, but most of the profits from that had been turned back into public improvements, the building of the canal in the town, the construction of streets and the financing of other projects. Royalties from the private coal, iron and timber operations on the company's 80,000 acres of forest land would be slow in accumulating. Thus far everything had been going out and little coming in.

With the failure of Baring Brothers, a full-scale panic in England began. Frightened bondholders were asking questions. Was their money being wisely invested in the big American venture? Were the dividends which had been paid in the summer of 1890 from earnings or invested capital? Why had shares in the American companies tumbled from £40 to £1½ in little more than six months?

Myers reflected the dismay of the local people when they learned of Arthur's difficulties in London. Their fears were confirmed when newspapers carried the story that he had been brought before his associates and charged with mismanagement, extravagance and even malversation. When the directors of the

English company met on January 12, 1891, they dismissed him as president and general manager of the two principal companies, the American Association, Ltd., and the Middlesboro Town and Land Company, and appointed E. F. Powers, one of their own number, to take his place.

To Myers and the local people this was a tragic miscarriage of justice. Never for a moment did they believe that the man who had waved his magic wand over the mountains was incompetent or guilty of any fraud. When Arthur returned to Middlesboro in the early spring of 1891 to pick up the pieces of his shattered personal fortunes, he was received cordially. His associates and neighbors stood by him when he was formally charged with misuse of money. Their faith was strengthened when the investigation of Powers, the new manager, absolved Arthur of wrongdoing and reported to the English directors and stockholders that their investments were safe. The only criticism was that there "had been a little too much booming."

The ousting of Arthur from the active management of the properties in Yellow Creek Valley and the drying up of financial sources in England did not bring an immediate collapse. Arthur retired to his home at Harrogate and began to salvage the scattered remnants of his holdings. On May 10, 1891, the second lot sale in Middlesboro showed no apparent recession. More than $350,000 exchanged hands that day. Mrs. Arthur, again in attendance on her white horse, bid in the most desirable corner lot at Cumberland Avenue and 20th Street at $410 a front foot, the highest price paid during the day. Most of the money came from investors from Louisville, Lexington and northern cities.

But the ebb tide had definitely set in. While Brother Myers and his wife went their even way, preaching to crowded congregations and building up their school in the basement of the church, much construction work in Middlesboro was halted, and most of the big companies began to feel the pinch of financial difficulties. A deterrent to further investment was the discovery that the quality of the iron ore south of Cumberland Mountain was not of the best. The Duke of Marlborough visiting Middles-

boro with the Duchess in the spring of 1891 was the first to express a doubt:

> Over four millions sterling has been spent on the development of the property. . . . So far it has all been money going out; and, moreover, the sales of land in shares that have brought in ready money only represent . . . the confidence of investors in the future of the place and the prospective worth of town lots. The real test must come in the success of the basic steel process. . . . I would rather wait and see what was the output of the two large sets of furnaces . . . before I could feel assured that the scale of prices that is being paid for town lots is justified.

While a slow paralysis attacked the building of plants and factories in Middlesboro, Myers eagerly watched the development of the hotel and sanatorium project begun by Dr. Hamilton and Dr. Curtis at Harrogate. Most of the capital had been subscribed by New York financiers and was not at first affected by the English panic. Nothing was spared in the appointments of splendor and luxury in the 700-room "Four Seasons" and the 200-bed sanatorium. Driveways were laid out; riding paths were built; carriage trails were made along the ridges; grounds were surveyed and lodges erected.

Myers and the natives were dazzled by the extravagance of the promoters in providing this playground for the idle rich. The hotel alone cost more than a million dollars. A hundred carloads of doors and frames were used. The furnishings were the best money could buy. The finest Axminster and Brussels carpets and lace window curtains were purchased, and the linen closets were stored with the best products of the loom. The sterling silverware cost $35,000. In the sanatorium, the Turkish baths of the Rue de L'Etat Major in Algiers were duplicated. Hot vapor, medicated pine-needle and sassafras baths were furnished, and mercurial, sulphur and brine atomizations installed. All this, to the humble mountain missionary, was just so much man-made luxury which was bound to pass away.

While the people of Middlesboro went about with a sob in their throats in the spring of 1892, Myers looked on with wonderment at the gala opening of the Four Seasons. New York's "four hundred" chartered a special train in April that they might attend the grand ball. For two weeks guests drove tandems over the roads, played polo and lawn tennis, danced morning germans and made heavy inroads on the wine cellars. They toured about, held balls in the Cumberland Gap Cave, which had been named "King Solomon's Cave,"[2] picnicked on top of the Pinnacle and visited Arthur's stricken city in Yellow Creek Valley. Then, when they deserted the great, rambling hotel which flew the American and British flags, it was left with an average of thirty guests daily for the season, served by a staff of 150.

Among the guests at the opening was Lady Pauncefote, wife of the British ambassador in Washington. During her stay she visited Myers and his wife at their little church and school and was impressed with their work. She saw possibilities in the school, and suggested that it be named "Harrow School," for the institution in England which had been training youth for two hundred years.

"I have been under the harrow so long," replied Mr. Myers, "I think that will be an appropriate name." He had stationery printed bearing the new name, and carrying his favorite text and slogan, "Better to Get Wisdom than Gold." While others quested for earthly fortunes, he and Mrs. Myers saw something far more valuable in the latent courage and intellect of the young descendants of the pioneers. Their school grew remarkably as eager students flocked in from the surrounding hills. In the fall of 1892 they moved from the basement of the church to an abandoned, half-finished hotel on a spur of Poor Valley Ridge facing the Pinnacle. Again with volunteer helpers, most of them working without pay, they completed the building in time for the fall opening, and "Harrow Hall" became a boarding academy of high school grade.

While Myers prospered with his school, swift was the decline of Middlesboro and its near-by towns of Cumberland Gap,

Shawanee, Harrogate and Tiprell. Added to the stoppage of English capital in 1891 was America's panic of 1893, which brought the final collapse. What had begun as the framework of a group of towns in a big industrial empire was left a raw, ghastly, unfinished wreck, deserted by thousands who had come during the first wild years. Most of those remaining were Kentuckians, Tennesseans and Virginians who had been lured into the valley. They had little to begin with, and they took over the ruins to salvage what they could. For months business was reduced to barter.

Liquidations and receiverships were the order of the day during 1893 and 1894. The four Middlesboro banks failed, with losses of all assets. The Belt Line Railroad consisting of twenty-seven miles of track and rolling stock in which more than a million dollars had been invested was sold to the L. & N. for $30,000. The value of the Town Company's properties shrank from $5,-250,000 to $476,760 in three years. The American Association, Ltd., was liquidated with every cent lost of more than a million and half in preferred stocks and bonds. At a sheriff's sale the 80,000 acres of land owned by the company were bid in for the investors at $15,000, only enough to satisfy legal and advertising fees. The building of the Watts Steel and Iron Works was too far along to be called off immediately; two blast furnaces were put in operation which continued abortively until 1898, when they were sold to an American syndicate. The Boston Gun Works operated with fitful spurts, going through various liquidations until 1897, when a disastrous fire was the final blow. Of the principal industries only the tannery survived the wreckage.

An indication of conditions was the formation in 1894 of a humorous organization known as the "Receivers Club," composed of representatives of concerns in receivership. The first meeting was held in a room "lately occupied by the Coal and Iron Bank," and J. H. Bartlett, receiver for the English land company and the Belt Line Railroad, was elected president. Then one after another was named in the roll call—defunct banks, coal

companies, brick companies, building concerns, waterworks, casket factories, handle factories, stone works and iron works. After a session enlivened by much levity, the members adjourned to the wine room of the Middlesboro Hotel, where "it was fearful that the wine would spoil with age."

The Four Seasons Hotel at Harrogate, closed most of the time since its opening in 1892, was sold in 1895 for $28,000, with the original investment almost totally lost. The Chicago Wrecking and Salvage Company bought the building for $9,000 and razed it for salvage during the summer of 1895. The furnishings were sent to Louisville and sold at auction. Only the sanatorium was left standing on the deserted grounds, with the driveways growing over in grass and weeds.

Brother Myers was disconsolate as he watched the wreckers tear down the mammoth hotel. For months he had been having his own dreams of grandeur. He would occasionally stroll through the hotel grounds and inspect the empty buildings. In his mind he peopled the great halls with sons and daughters of the mountain people, drawn to a center of learning, not to seek pleasure or wealth, but to explore the challenging frontiers of mental and spiritual achievement. He thought how fitting it would be if he could secure this magnificent structure for a greater Harrow School. But his hands and purse were empty.

At last when the wreckers were done, only the stone foundations were left to mark the site of the hotel. The big sanatorium would soon go the same way. Myers often prayed about it, talked frequently with his wife and made futile efforts to get in touch with the agents for the property in Louisville. Surely he could find some way to convert the abandoned grounds into an institution of learning.

In June 1896 he learned that General Oliver Otis Howard, veteran of the Civil War and recently retired from the United States Army, was to pass through the southern mountains on a lecture tour. He did not know how to get in contact with him, but somebody gave him the name of the general's son, Captain

Harry S. Howard, of Burlington, Vermont, his father's secretary for the speaking tour. Myers immediately sent young Howard this note:

> I hasten to ask for a visit by him [General Howard] to our home and this historic place. We will do all in our power to make his stop-over here pleasant. Should he feel like speaking we could rally a crowd and would do what we could to compensate him for his service.

Arrangements were made by telegram for General Howard's lecture at the Harrow School on June 18, 1896. The general came by train to Middlesboro, accompanied by a friend, Darwin R. James, banker, philanthropist, and congressman from New York. One of Myers' schoolboys met them with a carriage and drove them to Cumberland Gap. Howard spoke to the students on "Grant at Chattanooga." After the meeting was over and lunch was eaten, Myers took his guests out on the front porch of the Harrow Hall. With them was another visitor, the Reverend Frederick Burt Avery, of Cleveland, Ohio, an Episcopal minister who had been much interested in the work of Berea College at Berea, Kentucky, an institution founded for the education of the mountain people. He had come to see what Myers and his wife were doing.

General Howard was the central figure in the little group of four men. One-armed and white-haired, he spoke with a gentleness unusual for a veteran soldier. He was a native of Maine, a graduate of Bowdoin College, and had entered West Point after seriously considering a literary career. He went into the Civil War at the age of thirty-one and lost his right arm at the battle of Fair Oaks. Later he fought in important actions at Gettysburg, Missionary Ridge, Atlanta, and was with Sherman on the march to the sea. At the end of the war he was a major general in command of the Army of the Tennessee. He directed the Freedman's Bureau for the uplift and education of the Negro. When this service ended in 1872, he took an active part in Indian

campaigns in the West. He was called the "Christian General" and helped to organize the Y.M.C.A. Retired in 1895, he turned to writing and lecturing.

As the four men talked, Myers told them what he had done for the young people in the southern Appalachians; how he had started Harrow School, and how it had grown rapidly in spite of the disaster which had swept away the fortunes of the empire builders on the Wilderness Road. Somewhat timidly he mentioned the availability of the hotel property at Harrogate, and asked his guests if they would help him.

Something in the setting stirred memories for General Howard. Here immediately before him was the great pass in the Cumberland wall through which the Northwest had been settled. The Pinnacle loomed across the gulch, scarred with the winds of centuries and the witness of many incidents in a fading dream. Two rail lines met at the opening of the tunnel and disappeared into the mountain. The old trail of Boone and the pioneers was visible as it wound upward toward the pass, through a new growth of young trees which had sprouted after the scourge of war. The horizon over the rim of the dark wall was clear and blue, as the June sun mellowed the gentle canopy spreading over the land formerly known as the "Great Wilderness."

The general sat musing as he looked on this scene and listened to the old missionary talk about his school. Then in a characteristic impulse, he arose suddenly and strode up and down the porch, his empty sleeve tucked in the pocket of his coat.

"Gentlemen, I want to tell you a story," he said. He recalled how, while he was on his way as commander of the Eleventh Army Corps to join Rosecrans at Chattanooga, he had stopped in Washington in September 1863 to see President Lincoln. The President had asked for the interview. For more than an hour they talked about the military situation in the West. During the discussion President Lincoln rolled a map down from the wall and pointed to Cumberland Gap.

"General, can't you go through here and seize Knoxville?"

Then, speaking of the East Tennesseans who had suffered much during the war, he added: "They are loyal there, they are loyal!" He gave Howard his map, which was better for campaigning, and took the general's in exchange, saying, "Yours will do for me."[3]

General Howard explained to the President that he should work in harmony with Grant, who had recently been placed in command of the Union armies west of the Alleghenies. Perhaps Grant should be consulted about the route to be taken to the Chattanooga sector. The President agreed, but his thoughts were still on the people of the hills. General Howard noted a peculiar tenderness in Lincoln's eyes as the interview ended.

> General, if you come out of this horror and misery alive, and I pray to God that you may, I want you to do something for those mountain people who have been shut out of the world all these years. I know them. If I live I will do all I can to aid, and between us perhaps we can do the justice they deserve. Please remember this, and if God is good to us we may be able to speak of this later.[4]

General Howard turned to his listeners impulsively. "If you will make this a larger enterprise as a memorial to Abraham Lincoln," he said, "I will take hold and do what I can."

Moved by General Howard's story and promise, Myers felt like shouting. His prayers had been answered. James and Avery agreed to help. The four men spent the rest of the afternoon discussing the larger undertaking and the general policies to follow. The first move was to secure the abandoned hotel property. Howard said he would send his business agent, Cyrus H. Kehr, of Chicago, to assist Myers in acquiring the land.

Within a few days, Kehr showed up at Cumberland Gap and went over the property. He and Myers made a trip to Louisville to see the agents and obligated themselves personally for $13,500, the purchase price agreed on. Myers paid $500 down to close the deal, from money which his wife had received a short time before in a small bequest. The property consisted of 580 acres of land at Harrogate, the empty sanatorium building and the

foundation ruins of the Four Seasons Hotel and several miles of hard-surfaced driveways lined with young trees.

Howard was not on hand when the charter for the new educational institution was secured on February 12, 1897, but Myers who drafted it with the aid of local attorneys followed the general's suggestions. The charter provided for the establishment of Lincoln Memorial University, "to make education possible for the children of the humble common people of America among whom Lincoln was born." The college colors adopted were blue and gray, signifying a reunited country, and the college flag was a golden "L" in a field of white, standing for "Lincoln, Love, Loyalty, Liberty, and Labor." The sanatorium which was to be the headquarters for the college department of the Harrow School was named "Grant Lee Hall."

The board of directors was composed of Howard, Myers, James, Avery and some local people. Howard was named managing director after he refused to take the presidency. Captain Robert F. Patterson, a Confederate veteran living in the community, was named vice-chairman. Kehr was chosen the first president. Myers continued to operate the Harrow School as the academy department of the larger institution. Howard, Myers and Kehr immediately set out to raise the $13,000 owed on the property. The general made frequent trips to Louisville, Chicago, New York and other points. His acquaintance was extensive, and he soon devoted his entire time to raising funds. Working without salary, he depended on his retirement pay and lecture fees for his support.

Howard labored at his final task for twelve years. He made his home in Burlington, Vermont, his headquarters but was away most of the time. Long train rides, lectures, interviews, conferences, frequent trips to the school and horseback rides over mountain trails would have tired a much younger executive, but because of his long military discipline and abstemious living he was active until his death. His most substantial contribution to the development of his "living memorial" to Lincoln was his direction of a nation-wide campaign for endowment during the Lincoln centennial year 1909.

A personal friend of President Theodore Roosevelt, Howard had entree to the White House, and on more than one occasion secured the support of the President in his project. He enlisted the interest of other leaders. He persuaded Charles Evans Hughes and Elihu Root to become members of the sponsorship committee for the endowment campaign. He got contributions from Andrew Carnegie for a library building, and from Samuel P. Avery for a girls' dormitory. His friend William Murray Crane, of Massachusetts, made a substantial gift. His associates on the board, some of whom were lifelong friends, co-operated actively in his efforts.

As Lincoln Memorial University grew under the leadership of General Howard, it soon passed beyond the limited orbit of Brother Myers. The old missionary whose passion for service had found such a ready response in the veteran general was not used to teamwork on a large scale, and little irritations among the workers annoyed him. He traveled a great deal and spoke in many churches in the North and East. The collections were usually meager, but what he lacked in ability to reach benefactors of large means, he made up in devotion.

When his power and influence on the board of the college began to wane, he brooded over the thought that his work was not appreciated and that others were pushing him aside. After his wife died in the summer of 1897, he no longer had her counsel and wisdom to guide him. He saw his dream coming to a reality through the efforts of others, and this made him sad. But in his frequent letters to General Howard, there was never a cross word or complaint. On one occasion he confided his ideas about the future development of the college to his "Dear Brother," but he hastened to disclaim any desire to interpose his own opinions.

"Please do not consider this more than wayside suggestions from a wayfaring man, who only sees faintly. May God kindly lead you and all of us to do all in our power for this belated flock of God stumbling in these dark hills."

With the sudden death of General Howard, October 26, 1909,

in his Vermont home after an exhausting speaking tour in Canada, Myers' last close contact with Lincoln Memorial University ended. His labors bore fruit in other ways. Harrogate Inn, near the University property, built by F. Randolph Curtis in 1890, Myers bought with funds supplied by Frank E. Nettleton, of Syracuse, New York. In it he started an orphanage for little girls in memory of Grace Nettleton, who had died at the age of four. He married again, started another school in Middlesboro, which soon withered. Then he roamed about in the hills preaching to isolated gatherings, and turned to his old work of reviving churches and starting Sunday schools.

The eclipse of Myers in his educational center was paralleled by that of Arthur, who had befriended him in the first lush years of the spectacular development in Yellow Creek Valley. Myers got occasional word of what the former industrial leader was doing after he was deposed. Arthur tried to build a new town, bearing his own name, on the railroad three miles southwest of Cumberland Gap, but with the failure of Middlesboro, it, too, languished, becoming a crossroads town of a dozen farm homes and one store. He went to the Watauga Country in East Tennessee and organized the Watauga Land Company, but it proved disappointing. Then he joined the Klondike gold rush where he was associated with the British American & Trading Company, but his new connections did not last long.

In August 1897 Arthur returned for a brief visit to Middlesboro and arranged to sell his home at Harrogate to satisfy his creditors. Newspaper gossip reported that the onetime spender of millions had asked for a loan of $100 from a friend to tide him over to better times. He and his faithful wife bore their reverses with stoic calm. They went to New York, where he tried other things. Finally time caught up to him, and he suffered a partial stroke. Broken in health, he came back to the scene of his greatest triumph to spend his last days.

Wearing an English cap and bundled up in an easy chair, he sat on the front porch of his modest home in Middlesboro and

looked out on the city he had built. There was some comfort in the slow revival of the community which had passed through the shadows in the nineties. The coal which he had found did not fritter away. The buildings which had been left empty in his well-planned city were once again marts of trade. The undeveloped wealth which he had found in so great abundance when he first came into the hills could not be dissipated by reckless speculators. And across the mountain at Harrogate, his former home had become a part of the educational institution rising from the wreckage of the playground of the Cumberlands.

His Middlesboro arose again, but other hands than his controlled the mines, the railroads and the commercial activities which sustained a rapidly growing population. Still he was content. He had dreamed well, built mightily, suffered much and lost all, but he did have the satisfaction of seeing his dreams realized even though others were reaping the reward. On March 4, 1912, he came to the end. He was buried with civic honors on the crest of the hill in the Middlesboro cemetery, in full view of the Pinnacle standing guard at the gateway between Kentucky and the South. A rustic piece of granite bears only his name and the dates of his birth and death.

[1] The manuscript collection of the author and of Lincoln Memorial University, Harrogate, Tennessee, furnished most of the material for the story of the work of Myers in the southern mountains.

[2] This cave, discovered by Dr. Thomas Walker, April 13, 1750, was generally known as the "Cumberland Gap Cave," until it was changed to "King Solomon's Cave" about 1890 during the industrial development. However, for a brief period in the 1840's, local owners called it the "John A. Murrell Cave" for the famous Tennessee outlaw. About 1935 the name of "King Solomon's" was dropped for that of "Cudjo's Cave." The latter title was given to it because the cave fits the description and locale in J. T. Trowbridge's Civil War novel, *Cudjo's Cave*, published in 1863. Trowbridge never visited the region, and his escaped East Tennessee slave, who took refuge in the cave, is a fictional character. The cave is now connected with an upper level which was formerly called the "Soldiers' Cave," because of its frequent visitation by soldiers during the Civil War. Lincoln Memorial University now owns the property and the water supply.

[3] *Autobiography of Oliver Otis Howard* (New York, 1908), I, 452.

[4] *The Globe and Commercial Advertiser* (New York), October 27, 1909.

Chapter 25

Streamlined for the Age of Speed

AMONG the new leaders cast up by the shifting tides in the Cumberlands during the nineties was Joe F. Bosworth, a young Lexington lawyer. He hurried along the Wilderness Road to the development in Yellow Creek Valley when it was still a city of tents. With more courage than caution and more optimism than good business sense, he rode out the storm while many disillusioned industrialists deserted Arthur's ship.

"It's all right, boys," young Bosworth would say when the days were darkest. "Things will come out all right. Let's stick with it." He bolstered the morale of his associates, and turned to the task of salvage and reconstruction. As his law practice did not take much of his time he entered politics. He was elected a member of the first city council when Middlesboro was incorporated March 20, 1890, and later was chosen police judge. He liked that. It was pleasant to be called "Judge" before he was out of his twenties, and to be sought for political favors. He dabbled in real estate, took long shots with paper investments and formed a partnership for the operation of a coal mine. As conditions stabilized, he began to prosper; by 1905 he was well on the way to a modest fortune.

Bosworth represented the new citizenship which came to the mountains with Arthur's development. The "outsiders" who remained after the reverses were absorbed and amalgamated with the natives into a more progressive type. The railroads had come to stay, and the coal and timber operations settled down to steady

347

production. Despite Arthur's abortive beginning, the pauper counties crossed by the Wilderness Road were transformed within fifteen years to a section of wealth and promise. New pioneers like Bosworth took up the industrial enterprises started by Arthur and his associates and built more secure foundations. They encouraged schools and churches and co-operated with Myers and Howard. As the economic and social scale was lifted, they rose to positions of influence and responsibility.

Because of his popularity and background, Bosworth was a natural choice of the people in 1905 to represent the mountain district of Bell, Harlan, Knox and Leslie counties in the Kentucky legislature. Although he had been reared a Democrat in the Bluegrass, he conveniently turned Republican because the mountain people were predominately of that political party. Tutored by James Lane Allen and educated in Lexington, Kentucky, and at the University of Virginia, he knew how to speak the language of the Democratic politicians in Frankfort. He won support for many measures of interest to the mountains despite his affiliation with the minority party of the state. By the time he was elected for a second term, he was ready to take the lead in legislation which was to begin a new era in Kentucky.

When the railroads came to the Cumberlands the people gave little attention to the old, worn-out thoroughfare which had served them for a century. They felt that transportation was being permanently shifted from dirt roads to steel rails. But they soon discovered that the barriers which had imprisoned them so long had only been partially removed. They still needed to get to the rail stations and to isolated sections with their goods and produce. Traffic on the Wilderness Road and the feeder mountain trails had increased enormously, as the population grew and the towns and mining communities developed. Hacks, buggies, wagons and sleds labored in increasing numbers over the ruts and bogs of intolerable roads.

Since state aid had been withdrawn by Kentucky after the tollgate era, the maintenance and improvement of roads and the building of bridges had been left entirely to the counties. In the

mountains where road building was difficult and expensive, little had been done by the pauper counties on the main thoroughfares. The Wilderness Road which James Lane Allen found in 1885 "one of the provocations to homicide among the mountain people" had been neglected except for the improvement of stretches reaching into the Bluegrass. Through the mountains where towns were springing up at railroad stations it had steadily deteriorated under the swelling traffic brought by the industrial expansion.

Bosworth was one of the first of the mountain leaders to recognize the need of this Road's improvement. Since he first traveled it in 1889 to make his home in Yellow Creek Valley, he had observed its important place in the transportation system. He pondered its history with the same fascination that possessed his friend and mentor, James Lane Allen. Like Henry Clay when he paused in Cumberland Gap to brood on its significance in the life of the nation, Bosworth visioned the millions who would pass over the Road in the future. He understood, better than most of his mountain neighbors, the revolution in transportation which would be wrought by the queer, gasoline-driven buggies that were now chugging along the paved streets of cities in the North.

While Bosworth and town leaders in southeastern Kentucky were worrying over ways and means to improve the old thoroughfare, they suddenly found assistance in an unexpected quarter. The Office of Public Roads in the U. S. Department of Agriculture, working on a slim budget, was giving engineering assistance to "object-lesson roads" in various parts of the country. Local communities provided the funds, and federal engineers directed the grading and construction of experimental types of paving—macadam, gravel, shell, earth and sand-clay. The districts selected were scattered, in order to encourage paved road building on as wide a scale as possible.

The news of the availability of this federal assistance found its way into the Cumberlands. Leaders in Bell County, Kentucky, Lee County, Virginia, and Claiborne County, Tennessee, sent a plea to Washington for an engineer to look into the possibility of building a paved road from the town of Cumberland

Gap, Tennessee, to Middlesboro, Kentucky, along the route of the old Road looping through the pass in the mountain wall. In response to the request, Fay McClure and J. T. Voshell, engineers for the Office of Public Roads, came to Cumberland Gap early in 1907 and began their survey.

Bosworth found ready neighborhood support for the project. The newspapers trumpeted the news of the engineers' presence, and leaders in the adjoining three counties began to work up sentiment. One of Bosworth's active associates was Major E. S. Helburn, his partner in the Yellow Creek Coal Company, who had been elected mayor of Middlesboro. While Bosworth was spending much of his time in the legislature at Frankfort, Helburn organized a local committee to enlist Bell County in the Cumberland Gap object-lesson road. Judge Herman Y. Hughes, of Claiborne County, headed the Tennessee interests, and Lee County, Virginia, officials joined in the campaign.

The surveyors finished their preliminary findings, March 30, 1907. Within a few weeks, Logan Waller Page, director of the Office of Public Roads, wrote the local committees that the proposed stretch of a little more than two miles of a fourteen-foot macadam road linking Virginia and Tennessee with Kentucky would cost $15,285. On the basis of the portions of the road within the city limits of Middlesboro, and in the three counties, the amount allocated to Middlesboro was $2,795; Claiborne County, $1,130; Bell County, $6,315; and Lee County, $5,045. With the aid of Middlesboro newspapers, proclaiming in big headlines, "Opportunity Knocks But Once," the chairmen of the sponsoring committees secured the appropriations, and ground was broken for the new road on July 29, 1907.

Bosworth, Helburn and other local people watched with enthusiasm the face-lifting of the famous old Road over Cumberland Mountain, which for many years had been called the "Devil's Stairway." Of all the segments of the Wilderness Road on the hundred-mile reach through the Kentucky mountains, none was more arduous than the corkscrew through Cumberland Gap. Every step on the "stairs" had been the scene of

struggle, where a fallen horse, a broken axle, a crumbled wheel, a wrecked vehicle or a scrambling team had slowed a distraught traveler.

Ambushing redskins had been replaced by highwaymen who lurked in dark pockets to waylay victims crossing the mountain. It was here that the "terrible Harpes" began their career of crime. John A. Murrell, the desperado who wandered to western Tennessee for his lawless reign, shot a Powell Valley planter kneeling to drink from the cold water that flowed from the mountain face. In Arthur's day the Road remained the favorite lair of robbers for holdups and assaults. No man dared to cross the mountain without being well armed. At one time in the nineties the conditions were so bad that the Road was abandoned by lone travelers and the tunnel underneath was used instead. Even Brother Myers, out begging for his Harrow School at Cumberland Gap, was accosted, but the highwaymen grew softhearted when the old preacher explained that the money he carried was for "his little orphans." He was allowed to proceed unmolested.

The difficulties and hazards of the Road which were characteristic of the entire length of the ancient thoroughfare were at last to be eliminated. Drilling, blasting, scraping and filling went on during the good-weather months of 1907 and 1908, and slowly a hard-surface road was laid down across the mountain. Indian Rock was partially blasted away—the huge cleft boulder beside the trail on the Kentucky side from which Indians and highwaymen had often pounced upon innocent travelers. Two early pilgrims to Kentucky in Boone's day were known to have been buried at its base. It was ironic that in the blasting for the new road, a prominent citizen of Virginia was killed at the same spot.

After many delays caused by bad weather, the road was completed October 3, 1908,[2] and Bosworth, Helburn and other leaders from the three states took part in a gigantic celebration in the pass. The people poured out of the hills to see this smooth, paved road, with no grade greater than 9 percent. To them this first macadam link to be constructed in the whole chain of the

Wilderness Road was a miracle of convenience. They cantered their horses over it, and the rhythm of hoofs beating upon the hard pavement was music to their ears. No longer would drivers of buggies and wagons groan and curse in crossing the great barrier. The people listened to the speeches of felicitation, spread their dinners over the mountainside for a celebrating feast and rejoiced over the new day.

The object-lesson road, one of eight completed in 1908, when not over 680 miles of paved road existed in the United States, more than served its purpose. Joe Bosworth pronounced it good, and straightway went back to Frankfort with bigger ideas about road building. His first important measure to become a law empowered counties to issue bonds for road purposes. Under this provision, Bell County bonded itself heavily to continue the paved link from the terminus of the object-lesson road to the ford of the Cumberland River. Other counties along the Wilderness Road followed with similar links. Thus the great road-building program in Kentucky began.

In 1909, Bosworth organized the Kentucky Good Roads Association and became its first president. For eight years, he labored incessantly in the legislature for constitutional amendments permitting the state to join with counties in building roads. He went all over Kentucky to work up sentiment for them. His ceaseless efforts to "get Kentucky out of the mud," resulted in a State Department of Good Roads in 1912. By his foresight he prepared his commonwealth for the paved roads movement, which would sweep the nation with the development of the automobile.

The first transcontinental road organization was the Lincoln Highway Association, formed in 1912 by Carl G. Fisher, of Detroit, to connect the Atlantic and Pacific. Fisher found ready support and financial assistance among automobile and tire manufacturers. The publicity stirred industrialists throughout the country. It was only a short time until leaders in Northern cities were in touch with officials in Georgia and Florida for a cross-country highway from Detroit to Miami. Fisher sponsored this

movement, but others took over and formed a new organization known as the Dixie Highway Association. The proposed all-paved road would link Detroit with Cincinnati, and reach across Kentucky and East Tennessee along the entire length of the Wilderness Road. It would wander through the Great Smokies and Unakas past Asheville, then straighten out from Augusta, Georgia, to its southern terminus in Miami.

Bosworth and Helburn led Kentuckians in co-operating with this proposed highway because it meant the streamlining of the old thoroughfare through their city. By constant agitation, conferences with county officials and local leaders, and with support from the State Department of Good Roads, patchwork paving was pushed all along the road. In 1916 the Federal Post Roads Act was passed, launching the federal government on a co-operative road-building program, and in 1919, $1,269,849.70 was allotted to Kentucky for the improvement of the highways. Most of the funds so allocated were combined with state and county appropriations to be spent on the main highways, and the Wilderness Road link of the Dixie Highway got its share.

Long before it was finished, intrepid motorists began to venture over the widely heralded Dixie Highway. The first automobile known to travel over the major portion of the Kentucky road came from Lansing, Michigan. Four businessmen, with more faith than good sense, started south in January 1909 in a gaudy, brass-trimmed car with acetylene lamps and a load of spare tires. They found it fairly easy going until they reached Big Hill, south of Richmond, Kentucky. There they had plenty of time to contemplate the trouble General Bragg had in getting his long wagon train over the peak where Boone first saw the glories of the Bluegrass. Slowly they churned through the bogs of the Rockcastle country until they reached London. Here they employed a guide for the rest of their journey. Making an average of three to four miles an hour, they managed to negotiate the mudholes and swollen creeks of Laurel and Knox Counties. Often they had to enlist farmers with teams of mules, horses or oxen to extricate them from particularly bad holes. At last they reached

Pineville. Cumberland Mountain with its inviting stretch of "object road" was fourteen miles away, but they were told the quicksands of Yellow Creek often sucked in whole teams and wagons. Unwilling to risk such a catastrophe, they loaded their shaken and wheezing car on the train to be shipped back to Lansing.

The following year a man from Detroit on his way to Florida drove a Packard over the route. Equipped with jacks, mudguards and specially constructed blankets to give traction in bogs, he pushed his way slowly along the trail, plowed through the Yellow Creek quicksands and raced over the paved strip across Cumberland Mountain. But he got stuck irretrievably in the Carolina mountains and was forced to ship his car by railroad for the rest of the journey.

Bosworth and Helburn, who watched these first efforts of motorists to pass through the mountains, realized that the traffic would rapidly increase if the Road was improved. Some of their friends ordered cars and tried them out on the city streets and the paved road across the mountains. Judge J. L. Manring, a florid-faced bachelor who had grown wealthy in Middlesboro by dickering in real estate and mining coal, was among the first purchasers. He had his car shipped in and hired the best mechanic in town to drive it. They roared about the streets for two or three days, showing it off. Suddenly it picked up speed and nearly ran out from under them. The mechanic discovered that he had been driving in low gear all the time, and that he had accidentally slipped into second. It was his first intimation that the car had more than one speed.

Dr. H. C. Chance, a country doctor in the town of Cumberland Gap, bought an International in 1909 for use in his hill practice. A high-wheeled, solid-tired, chain-driven machine, with the crankshaft on the side, and bleary kerosene lamps for headlights, it was made to order for the mudholes in the mountains. He traveled thousands of miles in this high-slung vehicle. Parked by cabins of the "sick and ailing," it was an odd but familiar sight. In 1910 he proved an unwitting herald of doom. Halley's

Comet appeared in the heavens. Among the mountain people there was much talk of the world coming to an end when the earth should pass through the comet's tail. Dr. Chance received a midnight call in the hills of Claiborne County, Tennessee. He rattled out over the road with his International. Family groups waiting to see what would happen when the comet switched its tail, saw the tongues of light from the doctor's car pierce the darkness along the road. Convinced the end of time had come, they prayed and shouted fervently.

As the Wilderness Road was improved, the day soon passed when automobiles were a novelty. Bosworth continued his legislative program in Frankfort, Helburn became a member of the Highway Commission, and together they slanted much of the available funds to the completion of the Dixie Highway. But the work was slow, and promoters of the steadily growing tourist traffic were impatient. Asheville leaders for a time led in the agitation, and sent representatives to the towns in the areas where the links were not completed. They secured contributions from hotels, filling stations and restaurants, and organized volunteer crews to surface the unpaved stretches. A number of towns along the road responded generously to their appeals. Filling station operators were induced to put on a voluntary sales tax which raised thousands of dollars, expended independently of the state and county authorities.

A wide-scale effort was begun in 1923 to close all the gaps in Kentucky. By 1926 the last paving projects were completed in Rockcastle County and the section between Williamstown and Georgetown in Grant and Scott Counties. There was great rejoicing all along the way from the road's entry into Kentucky at Cumberland Gap to its terminus at the Ohio River opposite Cincinnati. Its popular name, "Dixie Highway," was changed to Federal Highway No. 25, with alternate routes between Corbin, Kentucky, and Asheville, North Carolina, numbered 25-E and 25-W. Tourists driving through from the North to Florida points began to fill the hotels, restaurants and garages. The people in the "Great Wilderness" saw that a new industry had come.

Chamber of Commerce secretaries added to their industrial promotion extravagant descriptions of the mountain beauties and attractions. They issued pictorial booklets about the history of the road, referring to it as "Boone's Road," "the Wilderness Road," "the Dixie Highway," over which legions had traveled in search of a place in the sun. They invited the people of the nation to tour it again, and linger at the spots where their forefathers had camped in their migration westward.

It was easy for Bosworth and other leaders to promote this new business for the "Cumberland Empire," because much had already been done. Added to the earlier nationwide industrial publicity of Arthur had been the widely read writings of historians, novelists and magazine writers who discovered abundant literary material in the Southern mountains. In 1903 the excellent historian, Archer Butler Hulbert, had made the Wilderness Road the subject of a volume in his *Historic Highways of America*. H. Addington Bruce followed in 1910 with *Daniel Boone and the Wilderness Road*, drawing heavily on Roosevelt's *Winning of the West* and the earlier works of Hulbert and Thomas Speed. Dr. William Allen Pusey in 1921 published *The Wilderness Road in Kentucky*, giving a profusely illustrated and technical definition of the trail which his own ancestor, William Brown, had traveled in 1782 and described in a detailed diary.

These factual discussions were surpassed in popular appeal by stories and historical novels. Winston Churchill, New England novelist and descendant of the Kentucky Logans identified with the Road, visited East Tennessee shortly after the turn of the century and wrote *The Crossing*, published in 1903. This portrayal of the leap of the Appalachians in the westward march of civilization went into many editions and was long accepted as the best on the subject. James Lane Allen, who had been one of the first to strike literary pay rock in the mountains, found a worthy successor in John Fox, Jr., a Bluegrass boy who had been drawn to the Cumberlands during the boom days.

Living at Big Stone Gap not far from the section of southwest

Virginia through which Boone's Road passed, Fox became the accepted romancer of Cumberland life and customs. He tramped the hills, talked with the natives, got acquainted with feudists, observed the effects of the industrial revolution. His stories during the first decade of the twentieth century did more to popularize the region throughout the nation than any other factor. The pathos and human drama in his *Hell fer Sartain, The Little Shepherd of Kingdom Come, Christmas Eve on Lonesome, The Trail of the Lonesome Pine* and other works, though not altogether pleasing to the native mountaineers themselves, captivated millions of readers elsewhere.

By the time Bosworth had completed his Road and America was on wheels, these millions who had learned the Road's history from Allen, Roosevelt, Hulbert, Bruce, Churchill and other writers, and who had wept over Fox's heroes and heroines in homespun, were ready to journey into the land of Boone and see it for themselves. In the late twenties and early thirties they came in endless caravans expecting to find drab cabins, bearded men with long rifles and moonshine jugs, gaunt, sad-eyed women with dresses sweeping the ground, and dirty, half-clothed children ready to flee at the approach of a stranger. That had been the type to which Allen and Fox had given glamour in their romantic tales.

The tourists were surprised. They saw that the typical mountain cabin was fast disappearing with the progress brought by the railroads and the highways. Drabness and poverty were indeed still to be found in isolated pockets, especially in the hollows where ugly, black coal camps were built around mine openings. Privation still lingered as the mountain people shifted from skimpy agricultural pursuits to digging coal, getting out timber and working in stores, businesses and small manufacturing plants of the rapidly growing towns. But substantial homes, pretty churches and improved schools had risen all along the main roads. The tourists found the hills alluring, the dark glens inviting, and the valleys lush and green.

Bosworth was gratified to see the end of the isolation in the

"Great Wilderness" from the outside world. He worked for further improvements of his favorite road. Back in the legislature after a period of retirement, he promoted more short cuts and feeder lines for Highway 25. One of his pet projects was a more direct route through a little populated section of southeastern Kentucky along the original Warriors' Path, the northern terminus to connect with the main road at Richmond, Kentucky. He talked so much about this new route his associates called it "the Bosworth Trail." Before his death, April 11, 1940, he had placed the Bosworth Trail in the primary road system, listed for early completion. No less a pioneer road builder than Boone, Logan and Shelby, he had deservedly won the affectionate title of "the Father of Good Roads in Kentucky."

1 Autobiographical sketch of Joe F. Bosworth in author's collection. For brief biography of Bosworth's career, see *History of Kentucky*, edited by Charles Kerr (Chicago and New York, 1922), Vol. V, 84-85.

2 For report on Cumberland Gap object-lesson road, see Logan Waller Page, Director, "Report of the Office of the Director of Public Roads for 1909," U. S. Department of Agriculture (Washington, 1909),

Chapter 26

Events in the Making

THREE youthful governors sat at a luncheon table in a tourist hotel on the Kentucky side of Cumberland Mountain, August 28, 1943. They chatted informally, exchanged quips about mutual state problems, called themselves the "Big Three" and got down to the business which brought them and their associates together.

The three governors were Keen Johnson of Kentucky, Colgate W. Darden, Jr., of Virginia, and Prentice Cooper of Tennessee. They had met to sign a compact pledging their respective states to participate in the establishment of the Cumberland Gap National Historical Park. The preliminary steps had already been taken—the passage of an act by Congress in 1941 authorizing a National Park as a memorial to the pioneers who passed along the Wilderness Road, and the appropriation of funds by the three states for the purchase of the minimum acreage required by the National Park Service.

Since the governors were meeting on Kentucky soil, it was suggested that the host state should have the original copy of the compact. But Governor Johnson was good-natured and offered to flip a coin for the honor. A Kentucky delegate produced a pair of dice. Darden rolled a ten, Johnson an eight, and Cooper a three. Someone remarked that fate had cast appropriately, since Virginia was the "mother state," Kentucky her first child, and Tennessee, carved out of North Carolina, was as much settled by Virginians as Carolinians. With friendly levity, the governors

concluded the formalities and adjourned to inspect the environs of the pass through which the Road led. Their tour ended at the three-states' corner on the western portal of the pass.

The governors looked down on the concrete marker set low in outcropping sandstone on the crest of the rounded peak. In the center was imbedded a brass disc of the U. S. Geodetic Survey. Three letters, "K," "V" and "T," indicated the tips of the states which came together. The governors took their places in their respective states and exchanged greetings with mock solemnity. Governor Johnson was twitted because he did not dare to step out of Kentucky. Lieutenant Governor Rhodes Myer had threatened to call an unwanted special session of the legislature should Johnson leave the state. Governor Darden was reminded that at the point where he was standing in Virginia he was nearer nine other state capitals than his own, nearly 500 miles away.

A local guide gave the governors a brief review of the controversy which had raged for more than a century around the corner and the dividing line. In the "hard winter" of Kentucky, 1779-1780, Dr. Thomas Walker had extended the line between Virginia and North Carolina for the advancing frontier toward the Mississippi, but Colonel Richard Henderson, heading a surveying crew for North Carolina, protested that Walker was four miles too far south and quit in disgust when he reached Cumberland Gap. A compromise in 1802 split the difference, but other commissioners were appointed and surveys made at long intervals, and the controversy was not finally settled until the United States Supreme Court decreed in 1903 that the compromise line of 1802 should be validated.

The governors seemed more interested in the region which was to be set apart as the pioneer memorial. Below them in the pass ran the broad paved ribbon which had once been the packhorse trail entering the jungles of Kentucky. Along it was passing a constant stream of cars, vans, trucks and other motor vehicles with the speed of the wind. Across from them on the eastern portal was the shaggy head of the Pinnacle, which they had ascended previously by driving over a curving two-mile private

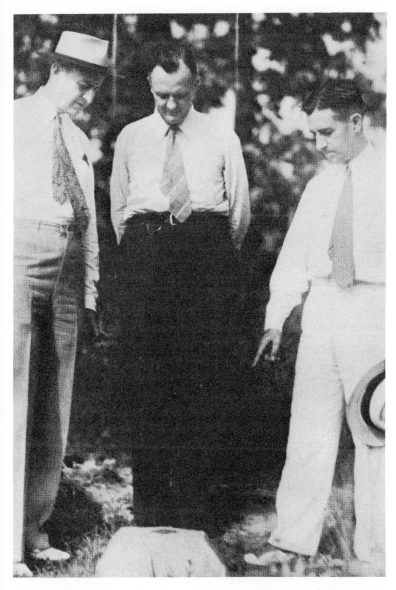

GOVERNORS AT THE THREE STATES' MARKER

On August 28, 1943, at the point where Kentucky, Virginia, and Tennessee join near Cumberland Gap, Keen Johnson of Kentucky, Colgate W. Darden, Jr., of Virginia, and Prentice Cooper of Tennessee, met to plan the Cumberland Gap National Historical Park.

TYPICAL ANTE-BELLUM WAGON

Driven by Charles Millar from Virginia over the Wilderness Road in 1847 to Sangamon County, Illinois. Now in the Museum of the New Salem State Park, Illinois.

BUILT FOR THE AGE OF SPEED

Bridge built above the Cherokee dam on Holston River by TVA between Bean's Station and Morristown, Tennessee, on alternative route of the Wilderness Road through East Tennessee.

toll road built in 1930. The remains of trenches and battery placements on the twin peaks were reminders of the stirring days of 1861-1865. Many names of soldiers, carved on ledges, were still discernible despite the weathering of time.

In coming to the meeting Governor Darden had followed the general route of the Wilderness Road from Ingles Ferry on New River, through the Holston Valley in southwest Virginia to Bristol, and then along the route marked out by Boone to Cumberland Gap. Instead of the unbroken forest penetrated only by animal and Indian-made trails which the Long Hunters followed, Darden found thriving towns and cities, big fields of corn, grain, tobacco and pastures, hundreds of pretty homes, scores of country stores and garages at crossroads, and many commodious schools and churches. Long since had the forest line been pushed back from the valleys, and only on the rolling hills were the mantling shelters of green.

Governor Darden was pleased with the evidences of progress in this mountain country, rich in natural resources. The streams were harnessed for electric power, manufacturing plants were running to capacity, and the bluegrass lands were yielding bumper crops. In the rich coves along the Road enormous herds of sleek cattle grazed on thousands of acres of pasture land reaching to the wood line on the hills. The marks of the hard existence of the early settlers had completely disappeared. The coming of good roads had brought a new day to the region where the first settlers had stopped a little while to make clearings in the march westward.

In backtracking the Kentucky portion of the Wilderness Road from Crab Orchard to Cumberland Gap, Governor Johnson noted a different type of development. The hundred-mile stretch of the former wilderness from the forks of the Road at Mount Vernon to Cumberland Gap bore the blackened evidences of the industrial revolution brought by Arthur a half century before. Coal tipples sprawled on the hillsides, near spur lines of the L. & N. Railroad and back in hollows reached by coal trucks and wagons. The hills, once dark and forbidding but majestic in their

wild beauty, were gashed and scarred with ugly openings, and shabby black hovels of coal camps housed thousands of families who had quit the freedom of the woods to dig underground.

The double-track railroad running parallel with Highway 25 rumbled with long strings of loaded coal cars moving north, and big loads of empties returning south. This coal business made the Cumberland Valley Division the most profitable of the entire L. & N. system. Southeastern Kentucky had become one of the richest bituminous coal fields in the United States, with great areas still to be tapped and exploited. Johnson was as proud of this useful product as Darden was of the farms in his beautiful and more picturesquely developed southwest Virginia. The livestock of Darden's domain along the Wilderness Road might help to feed the workers of the world, but the coal of Johnson's mountains kept the wheels of commerce turning.

Although Governor Cooper had only a secondary interest in the Wilderness Road, since it touched only the eastern edge of Tennessee, his trip from Nashville to Cumberland Gap took him through a section where the Tennessee Valley Authority was spreading its revolutionary results. The Powell, Clinch and Holston Rivers draining the region crossed by the Road were yielding power for industry and emancipating thousands from farm and household drudgeries. Flood control, soil erosion, land improvement and recreational facilities were being expanded on a vast scale. The alternative route of the Road down the Holston to Bean's Station and across to Cumberland Gap cut through an important portion of the T. V. A. area. The agricultural region of East Tennessee was fast turning into a manufacturing center. Notable among the new industrial cities was that of Kingsport, Tennessee, at Long Island, where Byrd's military highway of 1760 tied in with the trail made by Boone fifteen years later. The city had been built by Eastern capitalists for a variety of related industries—among them the Kingsport Press, one of the largest printing plants in the world.

With a three-way interest in the historic Road, the governors talked and speculated on this warm August day. When they left

the cornerstone to return to the Saddle, the sun was dipping into the Kentucky hills. They rested for a little while by the side of the marker erected to Daniel Boone, and watched the cars and trucks stream by.

It was easy for them to reconstruct the pageant of history which had unfolded there, as James Lane Allen had done in 1885. Indians, dark and silent, passing like shadows on moccasined feet. Daniel Boone, with strong and resolute face set toward the "dark and bloody ground." George Rogers Clark, bound for Williamsburg, to demand his 500 pounds of powder with which to win the Northwest. Countless thousands of men, women and children, trudging with heavy packs along the trail, braving ice, snow, rain and danger in their journey to the Bluegrass paradise. Soldiers tramping in long lines, ragged, hungry and suffering, rushing to victory or trailing in defeat. Moneymad promoters, skinning and gutting the hills in the exploitation of nature's prodigal wealth.

For more than fifty years efforts had been made to provide some suitable commemoration of the old trail and pass. The first builders of Middlesboro had proposed to erect on the Pinnacle twin equestrian statues of General Grant and General Lee, one facing north and the other south. A substantial appropriation had been made from a provident town treasury before the ruin of the nineties, and an agent was hired to solicit further donations. But the plan went the way of other grandiose schemes in that era of ruined hopes. Later they proposed to build a statue of Boone in the Saddle or a massive figure of a settler or a man on horseback accoutered with gun, knife and shot pouch, trailed by a heavily loaded packhorse.

As Lincoln Memorial University rose to prominence at Harrogate, Tennessee, a New York sculptor, taking a cue from Gutzon Borglum at Stone Mountain, proposed that a gigantic head of Lincoln be carved in the limestone face of the Pinnacle. But protests poured in, saying that such a figure on the Gibraltar rock would be a ghastly desecration. Not to be outdone, another sculptor submitted a plan for the building of a

two-hundred-foot statue of Lincoln on the mountain crest; an elevator would carry sight-seers to a giant head where they could look out upon the wide landscape through the sad eyes of the great Emancipator.

As the governors considered these colossal conceptions of an appropriate monument to memorialize the role of the Wilderness Road in the heroic age of America, they felt that the proposal for a national historical park at Cumberland Gap was more fitting. Let this most prominent physical feature on the Road, about halfway between Kingsport and Boonesborough, the termini of Boone's original trail, be landscaped and restored to its original beauty and grandeur. Let touring Americans linger awhile to hear the stories of hardship and suffering, of staunch adventure and indomitable purpose. Let them feel the impulses of the frontiersmen, sense the might and mastery of the mountains and brood over the drama of a nation widening its frontiers, developing its heritage and building its civilization.

Glad of their part in the establishment of the memorial, the governors rested as the shadows lengthened. In their sober reflections, there was a tinge of sadness. They knew that the great wilderness of the old frontier was gone. Civilization had come in and destroyed its temples of natural beauty. The broad belt of the Appalachians, the original barrier to the limitless reaches of the West, had been conquered by the pioneer and his sturdy progeny. The hills and valleys, cut and slashed in the unending conflict, were now open to a speeding world. The Wilderness Road, no longer a route of hardship and terror, was a great thoroughfare over which millions would travel in the long future.

Quitting the quiet spot in the old gateway, the governors got into their automobiles and drove down into Yellow Creek Valley for a town meeting in their honor. With the whisper of phantom legions still in their ears, they spoke of new events in the making.

ACKNOWLEDGMENTS AND
BIBLIOGRAPHICAL NOTE

ACKNOWLEDGMENTS

In my search for material on the Wilderness Road, I have had a pleasant historical adventure which has brought me in touch with many people. Personal mention of all to whom I am in debt for information, material and assistance is impossible. But I must express my gratitude to a few who have been of major service.

I am especially grateful to Mr. Wheeler Kesterson, a historically minded conservationist of Virginia, with whom I spent a delightful two weeks traveling over the Road from Ingles Ferry to Cumberland Gap and in exploring the byways and scenic spots in the Holston country. Valuable aid was given for specific chapters by Dr. John W. Wayland, Winchester; Judge John S. Draper, Pulaski, namesake and descendant of John Draper of Draper's Meadows; and Mrs. Isaac S. Anderson who from her husband's papers furnished considerable material on the Block House and the Road's location in Virginia.

Judge Samuel C. Williams, Johnson City, Tennessee, venerable dean of Tennessee historians, made available the resources of his great library of early Tennessee and regional Americana, and time and again settled moot questions. I have drawn heavily upon his research and writings in preparing the early chapters.

J. Winston Coleman, Jr., Lexington, Kentucky, was especially helpful in supplying information from his comprehensive library of Kentuckiana and in taking pictures of a number of historic spots. Dr. Thomas D. Clark, Lexington, made available the large travel section of the University of Kentucky Library, gave me many of his personal notes gathered in his own research and suggested many topics for treatment. The late Judge Samuel M. Wilson, Lexington, shared some important manuscript material from his extensive collection.

The staffs of various historical societies have been most co-operative, including the Filson Club, the Kentucky Historical Society, the Tennessee Historical Society, the Virginia Historical Society, the Chicago Historical Society, the American Antiquarian Society, the Peabody Museum and the Wisconsin State Historical Society. Much aid has been given by the staff members of the New York Public Library, the Library of Congress, the Cincinnati Public Library, the Louisville Free

367

Public Library, the Lawson McGhee Library, the University of Chicago Library, the Harvard University Library and the Lincoln Memorial University Library.

I am particularly appreciative of the aid given by R. C. Ballard Thruston, Louisville, Kentucky, who supplied important information concerning the industrial period in the Cumberlands; Otto Rothert, Colonel Lucien Beckner, and Miss Ludie J. Kinkead, of the Filson Club, Louisville; Mrs. James Jouett Cannon and Bayless Hardin, of the Kentucky Historical Society; and Dr. Willard Rouse Jillson, Frankfort, Kentucky.

For technical information concerning the location of the Road in Kentucky, I am indebted to Elmer Decker, Barbourville; Russell Dyche, London; Dr. William N. Craig, Stanford; and Dr. J. T. Dorris, Richmond. Mr. Dyche supplied much data concerning the Indian depredations on the Road during the migration days, and Dr. Craig provided Whitley and Logan material.

In the preparation of the manuscript, Jay Monaghan, editor of the American Trails Series, guided me step by step along the main road when I was prone to wander off into inviting bypaths. Whatever merit the story has as to form and treatment is due largely to Mr. Monaghan, but its imperfections are my own. To the Bobbs-Merrill Company editorial staff, particularly D. L. Chambers, I am indebted for their expert assistance, and their kindness and encouragement when the going was difficult.

I thank Dr. Stewart W. McClelland, president of Lincoln Memorial University, who graciously gave me the time for the necessary research and preparation of the manuscript. I must thank also Miss Patricia Knight, who knew what went on behind the scenes, protected me against interruptions when I was deep in the wilderness, and cheerfully typed the manuscript.

BIBLIOGRAPHICAL NOTE

Early in my research on the migration to the Northwest over the Wilderness Road, I turned to the Filson Club, Louisville, Kentucky, an organization established more than fifty years ago for the collection of Kentucky historical material. There I met R. C. Ballard Thruston, the president, who long ago retired from business as a civil engineer to devote himself to the development of the Club. I asked for suggestions about material on the Road. With an appropriate pause for emphasis, he drew himself up, spread his arms wide and said: "It is endless!" That I have found.

Through the voluminous manuscript material in widely scattered collections, and thousands of books and pamphlets on early American history, the story of the events along the Wilderness Road is a dominant theme. My difficulty has been to gather the more important relevant references about the personalities who influenced events and to weave them into a unified story. The search has been an exciting exploration in dusty tomes and yellowed documents which may be likened to a pioneer journey in the unbroken wilderness itself.

The greatest reservoir of material is the Draper Collection in the Wisconsin Historical Society on which I have drawn more heavily for the early period than on any other source. But much information has been secured from the Durrett Collection in the University of Chicago and the various collections of regional material in the Filson Club, the Kentucky Historical Society, the Tennessee Historical Society, the Virginia Historical Society, the Library of Congress and the libraries of the University of Kentucky, Duke University and Lincoln Memorial University.

I have combed the files of various historical publications for letters, memoirs, reminiscences and articles. Among the publications rich in material dealing with the migration period are the *Filson Club History Quarterly, Kentucky State Historical Society Register, Virginia Historical Magazine, Virginia Magazine of History and Biography, Tennessee Historical Quarterly, East Tennessee Historical Society's Publications, Mississippi Valley Historical Review, Ohio Archaeological and Historical Quarterly, American Historical Review* and *Journal*

369

of American History. Much information was dug from the *Calendar of Virginia Papers, Henning's Statutes of Virginia, Official Letters of the Governors of Virginia, State Records of North Carolina,* the American Historical Association's *Annual Reports,* the *Reports* of the Kentucky Bureau of Internal Improvements and the *Reports* of the Bureau of Ethnology.

The standard authority for the first efforts of Virginia colonists to probe the unknown reaches across the Appalachians where later the Wilderness Road penetrated is Clarence Walworth Alvord and Lee Bidgood, *The First Explorations of the Trans-Allegheny Region by the Virginians, 1650-1674* (Cleveland, 1912). No work excels in flavor and feeling of pioneer life Joseph Doddridge, *Notes, on the Settlement and Indian Wars of the Western parts of Virginia and Pennsylvania from 1763 to 1783* (Wellsburgh, Va., 1824). The fullest account of the Draper's Meadow massacre is given in John P. Hale, *Trans-Allegheny Pioneers* (Charleston, W. Va., 1931). A. S. Withers, *Chronicles of Border Warfare* (Clarksburg, Va., 1831), is the basic authority for the struggles of Virginians in pushing west, and this is excellently supplemented by Joseph Addison Waddell, *Annals of Augusta County, Virginia* (Richmond, Va., 1886). For a continuation of the story as the Road advanced across the New River and down the Holston Valley, no writer has done more to collect the important facts than Lewis P. Sumners, in his two source books, *History of Southwest Virginia, 1746-1786, Washington County, 1777-1780* (Richmond, Va., 1903) and *Annals of Southwest Virginia, 1769-1800* (Abington, Va., 1929). In a later work, Thomas W. Preston has a valuable little volume in *Historical Sketches of Holston Valley* (Kingsport, 1926). Important also is F. B. Kegley, *Kegley's Virginia Frontier* (Roanoke, Va., 1937). Much detailed information concerning Boone's road from Kingsport through southwest Virginia is given in Robert M. Addington, *History of Scott County, Virginia* (Kingsport, 1923).

For the development on the Watauga where the Virginia and North Carolina streams joined to supply the flood of migration over the Wilderness Road into Kentucky, and for a little while to the Cumberland settlements in Tennessee, the principal source books are John Haywood, *The Civil and Political History of the State of Tennessee* (Knoxville, Tenn., 1823), and J. G. M. Ramsey, *The Annals of Tennessee to the End of the Eighteenth Century* (Charleston, S. C.,

1853). However, the voluminous writings of Judge Samuel C. Williams are much more embracive and exhaustive for the modern student. Most valuable for this study of the personalities in the story are his *Dawn of Tennessee Valley and Tennessee History* (Johnson City, Tenn., 1937), *Early Travels in the Tennessee Country* (Johnson City, Tenn., 1928) and *History of the Lost State of Franklin* (Johnson City, Tenn., 1933).

Dr. Archibald Henderson, descendant of Colonel Richard Henderson, has compiled much material on the Transylvania adventure when Boone marked the first road to Kentucky. He has covered the story admirably in *Conquest of the Old Southwest* (New York, 1920), but elaboration in his other writings on Dr. Thomas Walker, Isaac Shelby and the westward movement have been most important in this study. Excellent objective works are William Stewart Lester, *The Transylvania Colony* (Spencer, Ind., 1935), George W. Ranck, *Boonesborough* (Louisville, 1901) and Robert S. Cotterill, *History of Pioneer Kentucky* (Cincinnati, 1917).

For the early Kentucky history when the Wilderness Road was the principal connection with the eastern colonists, the printed material is extensive. John Filson's charming little book, *The Discovery, Settlement and Present State of Kentucke* (Wilmington, 1784), was not only a great stimulus to the migration of the period but furnished the basis of all future histories of Kentucky. It immortalized Daniel Boone, and without Filson as his press agent, the old pioneer might have been forgotten when more important leaders were in the ascendancy. Humphrey Marshall, *History of Kentucky*, 2 vols. (Frankfort, 1834), and Lewis Collins and Richard H. Collins, *Historical Collections of Kentucky*, 2 vols. (Covington, 1874), constitute a vast mine of information, particularly Collins, from which has been drawn much valuable ore.

For the material on George Rogers Clark the Draper Collection has been used, and the letters, diaries and reports of Clark edited by James A. James in *George Rogers Clark Papers*, Vols. VIII and XIX, *Collections of the Illinois State Historical Library* (Springfield, 1912 and 1926). Clark belatedly has been the subject of many excellent biographies, but one of the best sources is William Hayden English, *Conquest of the Country Northwest of the River Ohio, 1778-1783 and Life of Gen. George Rogers Clark*, 2 vols. (Indianapolis, 1896). The detailed journey over the Wilderness Road by Lord Henry Ham-

ilton, captured by Clark at Vincennes, is from the unpublished manuscript journal of Hamilton in the Harvard Library. Previous printed accounts of this episode have been taken from Hamilton's more abbreviated report after he returned to England. Family records and genealogy gathered by Cass K. Shelby, descendant of Governor Isaac Shelby, furnished considerable data for the Shelby story.

It has been possible to take quotations and information from only a few of the more interesting travel accounts over the Wilderness Road during the migration. These have been selected for special reasons. Some of the more outstanding have been cited in notes. No story of the "Hard Winter" in Kentucky, 1779-1780, is more graphic than that given by Colonel William Fleming, in Newton D. Mereness, *Travels in the American Colonies* (New York, 1916). The diary of the observant Moses Austin, published in the *American Historical Review*, Vol. 5, depicted conditions in 1796 along the newly made road after Shelby's administration. *The Journal of the Rev. Francis Asbury*, 3 vols. (New York, 1821), is studded with picturesque references on the hardships and suffering of travelers to Kentucky.

The importance of the Wilderness Road as a trade route to southeastern markets and its prolonged legislative history is best covered in Mary Verhoeff, *The Kentucky Mountains* (Louisville, 1911). From the files of early Kentucky and Virginia newspapers much information has been gleaned. Excellent articles on the development of livestock in Kentucky and the growth of the state as an agricultural center have been published in various historical magazines. An interesting document in the Road's history is the minute book of the Crab Orchard and Cumberland Gap Turnpike Company, 1837-1844, preserved in the Levi Jackson Wilderness Road State Park, London, Kentucky.

Events along the Wilderness Road and its place in the strategy of the Civil War have been gathered from the *Official Records of the Union and Confederate Armies* (Washington, 1901), regimental histories, personal narratives and unpublished letters and documents. The more important collections used were the Samuel P. Carter Papers, the George W. Gallup Papers, the U. G. Owen Papers and the T. A. R. Nelson Papers. Dr. F. M. Dearborn, New York City, furnished from his Civil War manuscripts some interesting letters, and the Major George B. Cockrell Collection of Lincoln Memorial University

yielded intimate details. Interviews with a number of Union and Confederate veterans who had served in the campaigns along the Road, gave color to the story. Files of newspapers of the period in Knoxville, Cincinnati and Louisville were examined for dispatches of correspondents in the field. Other sources for East Tennessee's importance in the strategy of the War in the West are Thomas W. Humes, *The Loyal Mountaineers of Tennessee* (Knoxville, 1888), Oliver P. Temple, *East Tennessee and the Civil War* (Cincinnati, 1899), D. Sullins, *Recollections of an Old Man, Seventy Years in Dixie, 1827-1897* (Cleveland, Tennessee, 1910), and W. R. Carter, *History of the First Regiment of Tennessee Volunteer Cavalry* (Knoxville, 1902). Valuable data concerning the fighting around Cumberland Gap is contained in R. W. McFarland, *The Surrender of Cumberland Gap* (Columbus, Ohio, 1898) and B. F. Stevenson, *Letters from the Army* (Cincinnati, 1884).

Little has been written except by novelists about the mountain region traversed by the Wilderness Road since the Civil War. Only in local newspapers and dispatches in metropolitan journals is there a record of the industrial boom in the nineties. Articles were published in *Harper's*, *Scribner's*, and *Century*, commercial journals such as the *Manufacturers Record* and in London newspapers. From these dispatches and from interviews with many leading participants in the events, the full story has been gathered. Most helpful in supplying information have been Mrs. Nellie M. Arthur, wife of Alexander A. Arthur, Knoxville, Tennessee; Harry A. Arthur, a nephew, New York City; William Arthur, a brother, Long Beach, California; Mrs. Clarence Cary, New York City, wife of one of the attorneys of the development companies; John Sanderson, London, England, who kept a scrapbook of activities during his stay of more than a decade in the section; and Herbert L. Satterlee, New York City attorney who made three trips to the mountain area as a representative for New York interests. Among prominent citizens, often interviewed, who followed Arthur into Yellow Creek Valley, were Judge Joe F. Bosworth, Major E. S. Helburn, Judge J. L. Manring, J. Warren Cunningham, Captain W. E. Cabell, H. J. Williams and Mrs. D. G. Hinks. All of this group have died. Many others still living have also furnished much information.

The private papers of Charles Blanton Roberts, secretary of Arthur, were examined before his death. He wrote a number of articles for

Knoxville and Louisville papers after he had retired. His papers are now in the Filson Club, Louisville, Kentucky. The files of the local newspapers of the period are preserved by H. C. Chappell, editor of the *Three States*, Middlesboro.

The *L. & N. Magazine*, the reports of the U. S. Geological Survey, and of Kentucky, Tennessee and Virginia, furnished the background for the discussion of the mineral resources and the building of the railroads into the section. The autobiographies of Nathaniel Southgate Shaler and David Starr Jordan are the principal sources for their part in the story. The papers of Dr. Charles W. Eliot, president of Harvard University, were examined for information concerning the Harvard School of Geology at Cumberland Gap in 1875 and 1876. Albert Mathews, Boston, a member of the geology class of 1876, gave sidelights on his interesting instructors.

The Wilderness Road has been the subject of three important books, but all deal only with its place in pioneer history. The first of these is Thomas Speed, *The Wilderness Road* (Louisville, 1886), which perhaps inspired Dr. Archer Butler Hulbert to make *Boone's Wilderness Road* volume six in his *Historic Highways of America* (Cleveland, 1903). The most factual and authentic treatment of the Road's location is given in Dr. William Allen Pusey, *The Wilderness Road to Kentucky* (New York, 1921). H. Addington Bruce treated the Road in a major way in his biography, *Daniel Boone and the Wilderness Road* (New York, 1910). Prominent treatment is given in Theodore Roosevelt, *Winning of the West*, 4 vols. (New York, 1889), a great history of the old Northwest which is still a favorite. A book often erroneously believed to be about the Wilderness Road of Kentucky and Virginia is Charles A. Hanna's magnificent two-volume work, *The Wilderness Trail, or the Ventures and Adventures of the Pennsylvania Traders on the Allegheny Path* (New York, 1911). It contains much material concerning the events along the southern route.

For background and general material in the westward movement, the standard histories and reference works have been used. These are well known to every student. The tools for this work have been countless.

INDEX

INDEX